BERNARD BERENSON

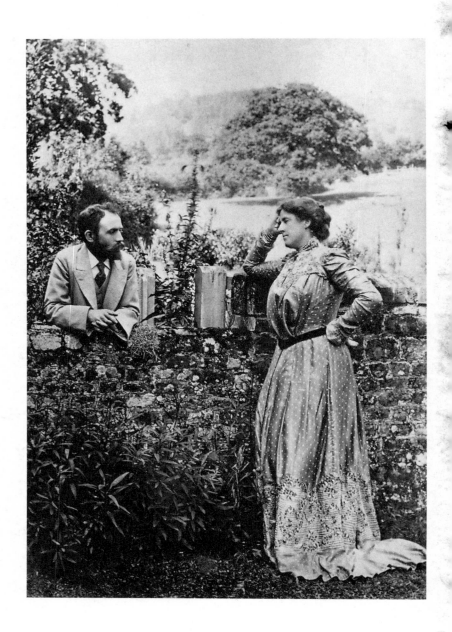

Bernard Berenson

A Life in the Picture Trade

RACHEL COHEN

Yale

UNIVERSITY
PRESS

New Haven and London

Yale University Press books may be purchased in quantity for educational,
business, or promotional use. For information, please e-mail sales.press@yale.edu
(U.S. office) or sales@yaleup.co.uk (U.K. office).

Set in Janson type by Tseng Information Systems, Inc.
Printed in the United States of America.

Library of Congress Cataloging-in-Publication Data

Cohen, Rachel, 1973–
Bernard Berenson : a life in the picture trade / Rachel Cohen.
pages cm. — (Jewish lives)
Includes bibliographical references and index.
ISBN 978-0-300-14942-5 (hardback)
1. Berenson, Bernard, 1865-1959. 2. Art historians—
United States—Biography. I. Title.
N7483.B47C64 2013
709.2—dc23
[B]
2013022541

A catalogue record for this book is available from the British Library.

Frontispiece: Bernard and Mary Berenson, Friday's Hill, 1901. Biblioteca
Berenson, Villa I Tatti—The Harvard University Center for Italian Renaissance
Studies, courtesy of the President and Fellows of Harvard College.

This paper meets the requirements of ANSI/NISO z39.48-1992
(Permanence of Paper).

10 9 8 7 6 5 4 3 2

For Matthew Boyle

In the eye would lie for him the determining influence of life: he was of the number of those who, in the words of a poet who came long after, must be "made perfect by the love of visible beauty."

—Walter Pater, *Marius the Epicurean*

CONTENTS

CONTENTS

BERNARD BERENSON

Introduction

IN THE SUMMER OF 1895, Bernard Berenson, who turned thirty that June, was laboring over a follow-up volume to his successful first book, *The Venetian Painters of the Renaissance.* He wanted the projected book on the Florentine painters to convey to his readers not dry details of biography or composition but what he thought of as the "artistic personalities" of the painters. He disdained experts who simply pronounced paintings genuine or not; he wanted to formulate an aesthetic philosophy that would give his readers an understanding of a deep personal experience of art. That summer, he and his companion, Mary Costelloe, who would later become his wife, were living in separate apartments close together in Florence. After years of relative poverty, he was beginning to make a little money on commissions for paintings he helped collectors to find. Within a few years, he would be one of the most celebrated connoisseurs of Italian Renaissance art and would find that much of his

time was given to authenticating pictures for dealers and entertaining wealthy guests, but that summer his time was still his own, and he and Costelloe spent long afternoons arguing about what a person really *felt* standing in front of a Botticelli.

If you look closely at the lines of a Botticelli, Berenson wrote in the *Florentine Painters*, if you really give yourself over to "the lines that render the movements of the tossing hair, the fluttering draperies, and the dancing waves in the 'Birth of Venus,'" you will see how the "lines alone" have the "power of stimulating our imagination of movement." Anticipating the coming century of abstract work, Berenson noted that here we are seeing the "pure values of movement abstracted," and the effect of this on us is that the painting seems to be "directly communicating life." A Botticelli painting is not merely telling a story, it "holds the same relation to representation that music holds to speech." This, Berenson said, was the "art of arts." Berenson worked with an unusual breadth of reference for his day: "Sandro Botticelli may have had rivals in Japan and elsewhere in the East, but in Europe never." He was, Berenson concluded, "the greatest artist of linear design that Europe has ever had."[1]

Berenson's approach to art galvanized American readers, who, when they came across this passage, had generally never seen a Botticelli. The phrases are still surprisingly evocative of what we feel faced with a Botticelli—the sense of rippling movement, the exhilaration of the wind. The *Birth of Venus* has become a pervasive painting, the object of pilgrimages and constantly present in reproductions, but when Berenson wrote his consideration in 1895, Botticelli was not much studied and was widely considered a minor painter. Just the year before, Berenson had helped Isabella Stewart Gardner to acquire a Botticelli, of *Lucretia*. She had paid for it the equivalent of about $16,000. It was the first Botticelli in America. A few years later, in 1898,

when an important Botticelli of Saint Jerome was offered to the British National Gallery for £500, or about $2,500, the museum declined. As the century turned, though, tastes changed. More and more American viewers and collectors came into contact with the paintings of medieval and Renaissance Italy, and Berenson's works were an important guide to their appreciation.

Bernard Berenson was one of the leading figures in a new generation of seeing — one that grew up on the works of Walter Pater and John Ruskin, was newly open to the intellectual and sensual excitement of the paintings of the Italian Renaissance, and had new access to these pictures because travel had been made easier and photographic reproductions had become common. What Berenson made of these influences and opportunities was remarkable. He had an encyclopedic visual memory, and he mastered the careers and paintings of hundreds upon hundreds of Italian painters. His gift for discerning the artistic personalities of different painters and for naming their qualities with a few choice phrases meant that, when his readers encountered the works of these artists, the pictures seemed to come forward, ready to be seen — Cosimo Tura: "His world is an anvil, his perception is a hammer, and nothing must muffle the sound of the stroke"; or Fra Angelico: "The sources of his feelings are in the Middle Ages, but he *enjoys* his feelings in a way which is almost modern."[2]

In the Gilded Age, a generation of American collectors and art historians and museum professionals came to their understanding of what interested them in Italian Renaissance art in significant part by reading Berenson's work and by listening to him talk. In Berenson's descriptions, they heard echoes of their own interests — in scientific experiment and in the progress of humanism — and of their own deep involvement in commerce. The cohort of Berenson's listeners and readers built most of

the major American collections and museums, and the effect of Berenson's way of seeing goes on being felt to this day.

But Berenson himself is an odd figure—he was dignified and erudite but also capricious and heedlessly romantic; his arrogance was matched by his self-contempt. His contemporaries thought of him as one of the greatest perceivers of paintings, a man whose sensitivity to art had seldom been surpassed. Now he isn't especially well known outside of art historical circles, and when his name appears, it seems smudged around the edges by questions about his reputation and by patches of secrecy that obscure aspects of both his private and public lives. For, along with being a connoisseur of paintings, he, too, was deeply involved with business. His fine eye made him a great authenticator of the notoriously difficult-to-attribute Italian old masters, and this led him to have, for twenty-five years, a profitable, and secret, partnership with the famous dealer Joseph Duveen. The obscurity with which Berenson shrouded this relationship followed in part from a lifelong practice of keeping his origins, and methods of survival, to himself.

During his lifetime, Berenson had an august reputation in the minds of wealthy and educated people on five continents. He was said to live like a Renaissance gentleman in his Villa I Tatti in the hills outside Florence, where he was a fixture for sixty years, graciously receiving and instructing merchants and scholars. He worked in the mornings, took two walks a day, and every summer made a tour of the great European museums. He hoped by his villa and erudition to suggest that an aristocratic life had been his since birth. But he had, instead, been born, in 1865, in modest circumstances in the Lithuanian town of Butrymancy. When he was ten, Berenson and his family were part of the tumultuous issuing forth of Jewish émigrés from the Pale of Settlement, and they had lived, crowded together in the poor West End of Boston, on the wages of his father's tin peddling.

It was a youth of rapid transformations. When Berenson arrived in Italy at twenty-three, he was a Harvard-educated gentleman, baptized into the Episcopalian church, and a man with an impressive knowledge of art, literature, and languages, whose funds were supplied by wealthy friends, including his most important patron, Isabella Stewart Gardner. Thirteen years after that, by then a widely known critic, he had converted to Catholicism, married Mary Costelloe from a prominent Quaker family, rented the Villa I Tatti, which he would eventually bequeath to Harvard, and begun summering with the Rothschilds in Saint Moritz. As Elizabeth Hardwick says drily in a memoir essay of Berenson, "His success . . . aroused superstitious twitchings in people everywhere. . . . Hadn't life turned out to be too easy for this poor Jewish fine arts scholar from Boston? Was knowledge, honestly used, ever quite so profitable, especially knowledge of art?"[3]

Kenneth Clark, although he considered his early art historical training with Berenson formative, thought of his mentor as an "exquisite little conjuror," and a business associate at Duveen's recalled that "BB always reminded me of Svengali."[4] The idea that he was a magician, and in some way a Jewish magician, was part of the atmosphere in which Berenson moved. His reputation among the great collectors was always trembling between light and shadow, and they may well have wanted it that way. After all, in the cutthroat competition to acquire old masters, when getting the picture you wanted was often a matter of having it cut down off the wall of a monastery and spirited out of the country before your rival could get there with his knives, you didn't want the men working for you to be checking manuals of conduct before they acted on your behalf. In fact, you wanted them to take the roles that have often fallen to Jews: you wanted the sultan's doctor, the emperor's banker, the gentleman's pawnbroker—the man whose knowledge of your intimate desires did not give him more

5

power over you than your knowledge of his religion and credibility gave you over him.

Berenson himself felt his own career to be a constant and disturbing battle between scholarship and commerce. His professional life took place in the context of an explosive American market for old master paintings. Work on his books, and his relations with other art historians and museum curators, seemed to him to be encroached upon and disrupted by the increasing demands of picture dealers, and especially of Duveen. But then he wanted a secure place in the world of the wealthy; he came to feel he needed the chauffeured car, the room at the Ritz, ever more rare volumes for his library. Gradually, he became more and more of an expert, attributing pictures and writing scholarly articles, but no longer writing for the general reader. Berenson at last broke with Duveen not long before World War II. He survived the war in hiding outside of Florence, and circumstances transformed him again.

Berenson emerged from the war as a kind of sage; people saw in him a last link to a European and Jewish culture now destroyed. In the final decades of his very long life, Berenson published a succession of memoirs that became extremely popular. But were these prose meditations—aphoristic, wonderstruck, cynical, sepia-toned—at last the authentic Berenson? When the writer S. N. Behrman went to interview Berenson in his late age, Behrman observed: "One doesn't quite get from his imposing appearance an impression of serenity. . . . When his face is in repose, there is, at the most, the suggestion of a fleeting truce between the warring of what he has called his 'many selves.'"[5] Life, from the age of ten, had been a scramble to maintain a surface impression of belonging, with all the while a sense of incoherent and alien depths roiling beneath.

In notes he wrote around 1939, Berenson reflected that, "almost from the cradle to the grave one has an audience to whom

one is playing up." He felt that his own life was continually affected by the force and expectations of other people. "The story of these audiences succeeding one another," he continued, "their character and quality should be treated as an important part of a biography or an autobiography."[6]

Given the immense pressures on him as a young Jewish man making his way without money or connections in the rarified art world, it is not surprising that Berenson formed a view of life as a succession of performances for changing audiences. Still, this certainly presents challenges for the biographer who is attempting to create the sort of coherent picture Berenson himself demanded in matters of attribution. The sense of who Berenson was changes not only with the direction of his attention but with the historical era and with his geographical allegiances, and this is reflected even in his name. He began in Lithuania as Bernhard Valvrojenski. When his family came to Boston, they all changed their surname, and he became Bernhard Berenson. As a young man, soon after he arrived in England, he began signing himself B.B., and it was in this way that he was known to his friends and lovers and even distant acquaintances. Meanwhile, in his given name, he retained the German "h" until World War I, when, wishing to ally himself with France and not Germany, he became Bernard. In Italy, in his maturity, he was fondly referred to as "Il Bibi." In this book, he is referred to by the name he used in a given period; when his whole life is meant, these various identities are understood to assemble under "Bernard Berenson."

Different aspects of this various self came into play within Berenson's wide network of friends and acquaintants. He maintained a prodigious correspondence with more than twelve hundred people, leaving an archive of some forty thousand letters at his death, and was a slightly different Berenson with every new person he encountered. A biography of the present length is naturally more distillation than excavation, and it has

been necessary to make compact mention of relationships that have in some cases produced whole volumes of biography and published correspondence.

Instead, this book focuses on a handful of relationships that allow Berenson to be seen in the round. In the past twenty-five years or so, a wealth of new material has become available about Joseph Duveen and about six women to whom Berenson was devoted. These central women were scholars, art historians, librarians, collectors, and writers: Berenson's sister Senda; his patron Isabella Stewart Gardner; his companion and wife (referred to in this book first as Mary Costelloe and then as Mary Berenson); the mistress for whom he had a towering passion, Belle da Costa Greene, who was also J. P. Morgan's librarian; Berenson's friend Edith Wharton; and the companion of his last forty years and collaborator in building the library at I Tatti, Nicky Mariano. In addition to Ernest Samuels's foundational two-volume biography of Berenson, wonderful new books on Duveen, the art market, and the lives of these women have been an important resource for this book. My indebtedness is detailed in the acknowledgments and endnotes.

In memoirs and letters, the women of Berenson's life left records of the strong impressions they had taken of him and of his work. "What do I not owe you?" his sister Senda wrote. She was looking back over old letters, which "brought that first rapturous experience of Italy so vividly to mind." She remembered how, when she was thirteen, "you opened the world of poetry to me and it has been a passion ever since—and later you revealed the world of paintings, sculpture, architecture—and they were always a sweet solace—a joy. God bless you for being yourself."[7] Writing of the period when she first knew him, Mary Berenson said his letters "made me feel I was taking part in the kind of life I longed for; free, devoted to beauty, fortified by study and leading to endless spiritual and aesthetic adventures."[8]

These women found, around Bernard Berenson, a sense of a place to belong to, a set of values to aspire to, and a life's work to uphold. That they themselves did a great deal of the work and were shouldered with many of the burdens was sometimes a frustration, but not, for them, a prohibitive one. Mary Berenson's widely attended lectures on Italian Renaissance painting, Isabella Stewart Gardner's museum, the collection Belle da Costa Greene made for J. P. Morgan, Edith Wharton's writings on art and travel, and the library of I Tatti itself—these were lasting monuments of education and of a certain vision of culture that flourished in the world around Berenson and that his own exhilarated looking helped to sustain.

Bernard Berenson and his colleagues in turn-of-the-century Florence saw how Italian Renaissance culture—its secularism, its self-consciousness, its business sense and innovations in scholarship, its ideas of collecting, display, and magnificence—anticipated, suggested, and influenced our own. By the end of Berenson's career, it had become common for people concerned with the making and preserving and consuming of culture to think of their ideas as, in some special way, related to the view of life expressed by the men and women of the Italian Renaissance. For a while, people attributed this transformation of their taste and self-perception to Berenson himself, and this was a part of his magical appeal. But even if Berenson was not the cause of this change, his life may still be an unusually fine record of its happening. Berenson, busily reflecting his audiences back to themselves, became a kind of turning mirror in which are to be seen the dark and bright conflicts by which he was surrounded. It may even be that, as we watch his life unfold, we can catch a glimpse there of our arriving selves.

I

Jews of Boston

Sometimes now as I walk . . . I see again the
world as it was to me when I was five years of age.
There is the same mystery to everything, the same
feeling of standing in the presence of things that I
see, but have not yet thought of, the same feeling of
saturating coolness that I used to throb with when
I was a child of five years old, in the orchard of a
spring morning, listening to the call of the cuckoo
at the end of the garden by the brookside.
—Bernhard Berenson, early journal

WHEN HE WROTE THESE LINES, Bernhard Berenson was
only twenty, but already when he spoke of the Lithuanian land-
scape of his childhood, it seemed to him, and to those who heard
him, a mysterious place, poignantly far away. Berenson's place
of origin, to which he would never return, was almost always

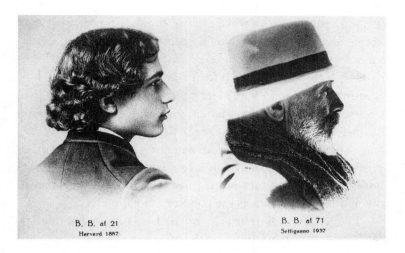

B. B. at 21
Harvard 1887

B. B. at 71
Settignano 1937

Bernard Berenson at twenty-one and seventy-one. Biblioteca Berenson, Villa I Tatti—The Harvard University Center for Italian Renaissance Studies, courtesy of the President and Fellows of Harvard College.

present in how he was understood, though it was taken in quite different ways by different people. The art dealer René Gimpel referred to Berenson as a "feline Pole," while Edith Wharton wrote tenderly of his "little Russian childhood."[1] In conversation, Berenson's allusions to his childhood were often more in the realm of legend than of fact, and this added to the feeling people had, listening to him, that his wisdom and insight had distant sources, accessible to him alone.

At the time that he wrote in his diary about his first experiences of "standing in the presence of things that I see," Berenson was struggling to stake out a place for himself in teeming Boston. He had discovered that one of the things which distinguished him was his phenomenal capacity for talk. Berenson could hold the attention of an audience for hours with what later auditors remembered as his "whiplash epigrams" and "the vast layers of learning that seemed to rise up behind him."[2] He

seemed a sorcerer with words, his incantatory power associated in the minds of many with his Jewishness. In 1887, when Berenson was nineteen, he encountered the future justice Louis Brandeis, then thirty-one, and a man who knew only too well how Boston responded to Jews. The impression Brandeis took gives a sense of how Berenson, talking, seemed against the backdrop of Boston society: "Saturday at the Salon met an extraordinary man—Berenson, I think, is the name, a student at Harvard of great talents—particularly literary talent. A Russian Jew I surmise, a character about whom I must know more. He seemed as much of an exotic lure as the palm or cinnamon tree."[3]

In the young Berenson's crowded household his talk, already of poetry, painting, and the wide world of culture, was a way to draw the attention of his mother and sisters. In his adult life, although he sometimes wished for solitude, he kept his home thronging with interlocutors. One of his most frequent commendations was to say approvingly of this or that person that he "did everything to draw me out."[4] His stature as an interpreter of paintings was in part founded on his talk. When he guided people through the long cool galleries of the Uffizi and the Louvre, and spoke of the particularities of the paintings, their colors and forms, the qualities of figure, space, and light, his listeners *saw* as never before.

In the full strength of his maturity, Berenson, like one of the fifteenth-century humanists who were his constant reference, could speak with knowledge and sensitivity of the literary tradition in seven languages. He had a lively curiosity and an astonishing range of reference. He was familiar with, and wry about, the habits of medieval French princes and modern-day Greek shepherds. And his talk, he felt, brought him close to the spirit of the great creators whose work he loved. Kenneth Clark said of Berenson that "through talk he made himself into a work of art."[5]

It was part of Berenson's aesthetic creed, articulated in his

late work *Aesthetics and History*, that the artist, when creating, did not plot his way through already-worked-out ideas but was spontaneous. The brilliant talker, Berenson wrote, is "almost unconscious and even surprised to hear what comes out of his own mouth," but while his "winged word" amuses many, it also "stings others, and deeply offends a few." The born talker had a helpless need to talk, and even if he sometimes became a "verbal clown," his talk went on: "No amount of whippings cured the mediaeval court jester."[6] In Berenson's colloquies ran the conflict between being a Renaissance humanist and being a medieval court jester, between the power of secular knowledge and the experience of struggling at the margins of a religious society, and both of these were facets of his family's experience from the beginning.

Berenson's father, Albert Berenson, had an apprentice, and the two used to go peddling in the towns around Boston together. It was from the apprentice, Louis Aron Lebowich, that Berenson's first biographer, Sylvia Sprigge, learned a story that gives a glimpse of the young Berenson talking. In this story, Albert Berenson, peddling pack on his back, arrived at the door of a Concord house only to be told: "Guess who is in the drawing-room! A young man called Bernhard Berenson." The host or hostess apparently had no idea that Bernhard Berenson's father was a peddler or that this peddler might be he; it was simply good fortune to be able to hear a young talker of such prowess hold forth. But Albert Berenson hurriedly gathered his things and rushed away. The father was, Louis Lebowich said, "shy of disturbing his children's progress in the New World." Bernhard Berenson never went peddling with his father: "Even sixty-five years after these events, Mr. Lebowich remembered that Albert and his eldest son did not get on well, certainly not well enough to go on these journeyings together."[7]

Elements of Albert Berenson's life can be seen, redrawn,

in the life of his son. Albert Berenson, too, was a great talker. Louis Lebowich remembered his holding forth brilliantly on Voltaire. But unlike his son, Albert Berenson did not generally find delighted audiences. "Lebowich still, in old age, maintained that Albert Berenson was unappreciated at home, unlistened to, so that often he would just go on talking to himself in a kind of *sotto voce*."[8] The young Berenson did not want to be the two things he saw his father as: a frustrated intellectual and a man who got his livelihood in a demeaning trade. But Berenson would grow up to be an intellectual who frequently encountered great frustrations and to work in a trade that, though much more luxurious and outwardly significant, still seemed to him sordid. Part of what differentiated them was that the son was the darling of salons where his father felt embarrassed. Berenson's uncomfortable stronghold lay in being the center of his mother's world.

"My mother was born tidy and so was I," Berenson used to say, and this was not the only affinity between the mother and the son. Both were small, precise, elegant, and had what a friend described as "natural chic" and "enormous dignity." The mother was "very charming, but with a whim of iron."[9] Bernhard was her first and favorite child, and all his growing up took place in the atmosphere of her constant and doting attention. He said that his earliest memory was of "the sensation of rapture with which he stretched out his baby-hands, while he was still in his mother's arms, towards a picture of a bunch of grapes on a wine bottle."[10] The image suggests that his passion for painting began as soon as he could see, and the memory seems almost to be a painting: the adored son on his mother's lap reaches toward the icons of his future. As he grew, Bernhard found his mother's complete attention both necessary and intolerable. Eventually, one of the world's most sought-after

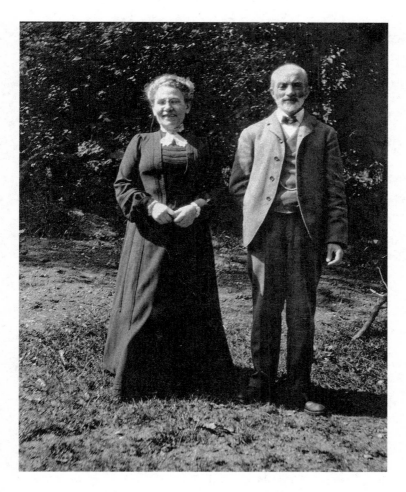

Judith and Albert Berenson, 1904. Biblioteca Berenson, Villa I Tatti—
The Harvard University Center for Italian Renaissance Studies,
courtesy of the President and Fellows of Harvard College.

talkers could hardly bear to speak before the mother who hung on his every syllable.

The children who followed were not seen by their mother with the same halo of glorifying attention, but they all shared in the same family culture and played important roles in one another's lives. Bernhard was born in 1865, and his sister Senda in 1868. A brother, Abie, was the last of the children born in the old world, in 1873. Two more daughters, Bessie and Rachel, were born in Boston. Abie was a sullen child, whom Louis Lebowich described as "a rough lad whom no one could get on with," and whom the family found it convenient to blame and disparage.[11] The father was feckless and did not succeed in the new world as some of his relatives did. The life of the household revolved around the women, and the women hovered anxiously over one another and over Bernhard.

"Above all things be careful this summer mother dear," Rachel wrote. "It is generally in the summer that your little Tummy goes wrong—so be extra careful what you eat."[12] Rachel teased that she was expecting from her mother "a telegram to say that you lie awake nights wondering whether I have tuberculosis or Bright's disease or a stomachache."[13] Family life was humid. At the bottom of a letter from Rachel to another sibling, Rachel added, "Mother wants to write one word of reassurance," after which came, in Judith Berenson's scrawl: "My dearest love to you my precious child and to your beloved friends God bless you all your always loving and devoted mother I feel fine."[14]

They were a family that suffered and surveyed illness, but they were long-lived. The father lived to eighty-three, the mother ninety-one, and three of the children lived into their late eighties and even well into their nineties. The mother's "little Tummy" was a central feature of life. Bernhard Berenson, too, had endless stomach complaints and became a fussier and fussier eater as time went on. (Berenson's great-niece,

Rachel Berenson Perry, would remember that her father, Bernard Perry, complainingly referred to "his 'Berenson' or 'Jewish' stomach.")[15] Senda Berenson suffered an almost crushing fatigue and muscular atrophy until she seized the matter firmly in hand in her early twenties and began the gymnastic training that she would later be responsible for teaching at Smith College. She told Abie that he wouldn't feel so low if he would "take exercise every day" and "*eat a luncheon.*" "I hope and pray," she said (it was his birthday), "that this may be a happy year for you full of *health* and contentment and my great wish is that you should make up your mind to live this coming year as hygienically as possible."[16] Bessie Berenson had chronic depression and exhaustion. Rachel Berenson had cluster headaches and debilitating migraines. When Rachel's son Bart brought home the small and delicate Harriet who was to become his wife, Harriet remembered Rachel saying that "she hoped I was not so healthy that I couldn't sympathize with someone who wasn't."[17]

Along with his mother, Berenson's sisters—Senda, Rachel, Bessie—played roles in his life that would subsequently be taken over by other women; glints of these originary personalities reappeared in Isabella Stewart Gardner, Mary Berenson, Belle da Costa Greene, Nicky Mariano, and many of Berenson's mistresses and friends.

Berenson's most formative relationship with a sibling was with Senda Berenson. Forceful in her work and convictions, insightful, genuinely self-sacrificing, a worrier and a keeper-together of the family, Senda was Bernhard's great confidante in youth and remained the person to whom he was closest in the family. She was, he said late in life, "the nearest to me in age, in looks, in bringing up, of all relations."[18] She was a person of large accomplishment in her own right—not only did she hold the first documented game of women's basketball at Smith, but

Senda Berenson, photographed by Bartlett F. Kenney.
Biblioteca Berenson, Villa I Tatti—The Harvard University
Center for Italian Renaissance Studies, courtesy of the
President and Fellows of Harvard College.

she chaired what became the national women's basketball association and played a significant part in a national movement that encouraged physical activity in women as part of their education.[19] In photographs, her face is a mixture of loveliness and concern.

For many years alone and lonely, Senda, at forty-three, married Herbert Abbott, like her a professor at Smith. As was true of all the other Berenson spouses, Abbott was not Jewish, and like all the other Berenson spouses, he was an ambitious intellectual. Writing to Bernhard of the new marriage and its happinesses and difficulties, Senda referred to the family's shared institutional passion as the solution to all problems for her husband: "If he could *only* get a professorship at Harvard — I feel *that* is the only place where he would be encouraged to do his best and where he could be appreciated."[20] Not too long after the marriage, Abbott became seriously ill, and he died relatively young.

The youngest child, Rachel, had good luck where Senda did not. Rachel was extremely funny, the most vivacious member of the family, and the most selfish, according to her siblings; she seems to have been the one besides Bernhard to see what she wanted and to seize it. She took a master's in classics from Oxford, and her letters home from frequent travels are always full of charming, and expensive, sights and sounds, rendered with a verve that is sibling to Berenson's own descriptions. Rachel maneuvered around Senda to marry Ralph Barton Perry, who had been interested in Senda when both were teaching at Smith. By the time he declared his intentions to Rachel, Perry had a credential much prized in the Berenson household: he was a professor of philosophy at Harvard. Rachel wrote to Bessie pleading with her to take her side, "Everything I know would have been different if these former relations between Ralph and Senda had never existed. That's all the more reason why I long to feel that you are with me — thinking *with*

me & *for me*—and about *it*."[21] Senda, writing home around the same time, commented drily of Rachel, "She has not lost *all* her selfish tendencies with *me*."[22] Rachel was the youngest, but the first of the siblings to marry and the only one to have children. It was, apparently, not easy to be a Berenson child and to grow up and leave home.

Bessie—melancholic, self-diminishing, often exhausted, and never married—was, among the sisters, the most solitary and the most dissatisfied. Languishing at home for decades, she at last came into her own when, over the course of many European visits to Bernhard, she discovered her talent for sculpture. By the time Nicky Mariano met her, Bessie had "lovely silver white hair" and was "cultivated, well read, subtle in her appreciation of literature and art, gifted as a sculptor," and "in artistic sensibility . . . nearest to B.B."[23] Like all the others, Bessie looked down on Abie, to whom she wrote letters that chastised and pitied him. Abraham—morose, ineffectual, using in his letters only the most rudimentary language, and that shot through with a kind of bleary resentment—was the child least favored by fortune and his parents. He never once made the European voyage that became common for the others; he lived at home or in a rooming house not far away. Bessie, writing to Senda after Abie had been briefly away and returned, gave vent to the family criticism of Abie, "To tell you the honest truth, I don't care to have Abie live in Boston. His friends here are all among the 'sheeney tribe' & I suppose he will go back to them."[24]

The family's quickness to criticize on the grounds of seeming too Jewish might be one of many manifestations of their perfectionism. Berenson periodically quoted Heinrich Heine's assertion, which could be a kind of family motto, "A Jew, to be taken for silver, must be of gold."[25] Meryle Secrest, another of Berenson's biographers, noticed Berenson's ardent effort: "Every aspect of his life and thought must be flawless, a work of art, even if he might be dimly aware that he could never learn

enough, master enough, or accomplish enough to appease the inner tyrant."[26] Things always ought to have been done better or turned out better than they had. Each Berenson was self-critical, and each was critical of the others. Probably because of both their collective temperament and the chaotic injuries of emigration, they fought to maintain some sense of control of their lives. In the new land of business, secularism, and what felt to them like a chaos of opportunities and pitfalls, the Berensons tried to enter the world each day immaculately turned out and accomplished. Tidiness was not merely a healthy and sensible way to live, it was a compulsion among many compulsions, to have everything exactly in place, to present a perfect facade to the world.

In all the brilliant conversation that his friends and mistresses recorded, and in all the hundreds of pages of autobiographical musings that Berenson later published, there is hardly any mention of his family. His sisters came fairly often to visit him in Italy, and he sent large sums of money home, but he didn't tell stories from his childhood, and those he told were masked in layers of romantic invention. In his late autobiographical work, *Sketch for a Self-Portrait*, he said that his childhood was "spent in an aristocratic republic. . . . There my family was among the first if not the first."[27] But the realities of their life in the Pale of Settlement must have been far from the aristocracy of Berenson's aspirations.

If the Berenson family, then the Valvrojenskis, had stayed in Butrymancy, he might never have come to visual art as his central subject. That picture of the grapes on a wine bottle would have been one of the very few painted images he encountered. Not only was the Jewish community wary of possible idolatry, but the paintings that belonged to the Christian communities, and to the nobles and the tsar, were in great measure inaccessible to the Jews, especially to relatively poor, rural Jews.

Butrymancy was only forty miles away from Vilna, which was a great center of religious learning, but forty miles was a long way then, and there is no mention in the record that the Valvrojenskis ever went there.

Russia at that time was a place ruled by a complex bureaucracy, one that managed to keep something in the neighborhood of fifty million serfs and state peasants, almost 80 percent of its population, in servitude until the emancipation of 1861, four years before Berenson was born. The Valvrojenskis were among the five million Jews restricted to the Pale of Settlement. Berenson remembered that, on this fertile land, Jews were often prevented from attempting agriculture and were sometimes close to the brink of starvation.[28] In 1868 and 1869, when Berenson was three years old, the governor-general of Vilna appointed a commission to make new statutes for the Jews. The commission advocated for the abolishment of Jewish community institutions altogether, asserting that the Jews "remain a contemptible and abominable nation. As members of civil society, they are like a diseased limb in the body politic, infecting all that it touches."[29]

A constant worry for Jewish families was conscription into Russia's standing army of more than a million men. Conscription was for twenty-five years and could be a family tragedy — one did not expect to see the conscript again. The practice also deprived communities of their young men and, during the Crimean War in the 1850s, sowed conflict among those who remained and who accused one another of having had a hand in what felt like, and sometimes were, abductions. These bitter denunciations became vivid stories, which Berenson remembered hearing in his childhood. Family rivalries took on force as other traditional sources of authority declined. Rabbis had less prestige and power, and so did the schools, the *heder* for boys, like the one Berenson attended.

In Butrymancy, as in many of the villages and towns of the

Pale, Jews made a life in those trades and services that grew up around the open marketplaces. Jews worked in the market stalls, were tailors, blacksmiths, and cobblers, and worked as factors for the landed gentry. Their positions were as inter-mediaries—between farmers and townspeople, between land-owners and peasants, between cloth manufacturers and indi-vidual customers. With the advent of railroads, which came slowly and late to Russïa, centralization in cities meant that the traders of small towns had less work. Jews, who worked pri-marily in the professions threatened by the changing economy, were in grave economic circumstances.

These were the forces buffeting the Valvrojenskis when their first son, Bernhard, came into the world, in Butrymancy, on June 26, 1865. The boy's young parents had been married the previous year, in 1864; Albert was then nineteen and Judith Mickleshanski seventeen. Early marriages were common— they allowed young Jewish men to be exempted from conscrip-tion—and the new couples usually lived with one of the sets of parents. Berenson's sense was that his own mother, "herself too much the young girl—lovely, and perhaps giddy," did not "play the mother. She left the happy task to her own mother." Beren-son was very close to his grandparents. "My giant grandfather," Berenson wrote, "used, like St. Christopher, to carry me seated on his right shoulder."[30]
One of the picturesque details that Berenson would occa-sionally let fall about this grandfather was that he was employed in the timber trade, overseeing the peasants who felled the deep woods of Lithuanian timber and rafted the logs down its rivers to western markets. In his carefully documented biography of Berenson, Ernest Samuels contents himself with saying, "One surmises that [Solomon Mickleshanski], like many other liter-ate Jews in that timber-rich district, was engaged as a subcon-tractor to one of the great Polish landowners."[31]

Solomon Mickleshanski lived into his nineties, but after their departure his grandchildren never saw him again. Berenson's grandmother died when he was quite little and still living in her household in Lithuania. In describing this loss, his prose turns suddenly stark and clear: "My grandmother died before I was five. Her departure stunned me. She had meant more to me than all other people put together, including my mother. I not only missed her day and night but could not understand what had happened."[32] Later in life, he was haunted by a terrible dream-image of his grandmother "encased like a mummy" in a "tomb-like chamber of polished black stone."[33] The recurrent fears he had, both of being buried alive and of his remains being moved after his death, seem to hearken back to the traumas and beliefs of his childhood.

Berenson's grandmother died the year after a severe famine had struck the region of the Pale where the Valvrojenskis lived. Many Jews in this period were so-called *luftmenschen*, men who contrived to survive on air. Samuels conjectures about Berenson's father that his "prospects had evidently been very slight, for he had been bred to no trade or profession."[34] But it could be that the family remembered Albert not working because there was no work to be had. If Bernhard Berenson had any memories of being four years old, as he claimed to do, they would have been from the period of the famine, another thing he never mentioned, and about which perhaps none of the people by whom he was surrounded in his later life would have known to ask.

Berenson's house, I Tatti, was an essential security for him throughout much of his adult life, and this, too, may have had a source in his childhood, when the loss of their house precipitated the great movement and change of his early years. The Valvrojenskis' house burned down, probably early in 1874, though whether from accidental or pernicious causes is not

known. Little Senda Berenson was saved, so the family used to say, by being carried out in her mother's arms. In Albert Valvrojenski's mind, the disaster apparently settled the question of whether to stay.

The communities of the Pale were long isolated, but the beginning of the 1860s had seen the founding of Hebrew-language newspapers, which brought news from Germany and beyond. Men selling third-class tickets on steamers for England and America now passed through the towns. Even in these years, before the worst of the pogroms and the great flood of emigration, people began to talk about going, and to go. Albert Valvrojenski decided on Boston, which until this period had not had much of a Jewish population, but where enough people from Butrymancy, including cousins of his, had already gone that, within a few years, Boston would have a Butrymancy Society. Boston had a reputation for learnedness. A Hebrew guidebook published in Berlin at that time gave Boston the label "the Athens of America," adding that the city was "the nation's foremost seat of wisdom and learning."[35]

In 1874, Albert and a young nephew of his, who would take the name Louis Berenson, departed from the Pale. And the following year, the boy who would become Bernhard Berenson, his mother, and his two younger siblings, left the four thousand people of Butrymancy and took ship for a city with a population of nearly four hundred thousand, a city that had itself recently had a disastrous fire but was already vigorously rebuilding.

In the life of Bernard Berenson, certain cities played a role of central significance, and it is no exaggeration to say that, when the Valvrojenskis' choice fell on Boston, everything followed from that. Their Boston houses—first at 32 Nashua Street, which was nearly in the North Station railroad yard, and then around the corner at 11 Minot Street—were Judith Berenson's domain. Many of the women in the new commu-

nity of Jewish immigrants took in boarders; the Berensons, of whom there were soon seven, had regular paying diners, one of whom remembered the dining room: "Mrs. Berenson presided there with a special kind of distinction, and the dinners became popular because of her nice ways, as well as because the food was good."[36] Even without the diners and the periodic cousins and the boys who were helping Albert on his peddling route, there can't have been much room in the house. Berenson is supposed to have had an attic room to himself—scorching in summer, frigid in winter—where he immersed himself in reading. This took on a heroic cast in memory. As Mary Berenson would later describe those years: "To save his coat he did his home work, even in the coldest weather, in his shirt sleeves in a big unused and unheated room at the top of the house, but he so quickly absorbed himself in what he was learning that he hardly noticed the discomforts and privations he underwent."[37]

Berenson probably felt these privations more keenly than his comfortably middle-class wife could really imagine. Sometimes, with other Jewish immigrants, he would allow a little more of the picture to come through. When S. N. Behrman came to interview Berenson, they fell to talking about their early days in America. Behrman remembered building a hut for Sukkoth in their yard, and Berenson raised an eyebrow, "You had a yard? You must have been very rich." Behrman asked whether they had a sukkah in Boston and received the dry reply: "The ambiance of the North Station in Boston where we were shunted when we arrived from Lithuania did not encourage pleasure domes."[38]

The Berensons' houses were in the West End of Boston, just before the neighborhood becomes the North End. In 1880, five years after their arrival, when Berenson was fifteen, their neighborhood in the West End had only one hundred Jews. The North End, too, was predominantly Irish, with fewer than a thousand Italians and a few hundred Central European Jews.

The Berensons were part of a community on the edge of establishing itself, and the young Bernhard Berenson felt the insecurity keenly. The Berensons' cousin, Louis Berenson, had a scrap metal and tinware shop on Salem Street in the North End, which would eventually be a main thoroughfare of Jewish commerce. Albert Berenson and his young helper, Louis Lebowich, used to take all the scrap metal they collected on their peddling route to Louis Berenson's shop on Salem Street at the end of the day.

Many of the new arrivals began by doing the hard peddling work that native-born Yankees were abandoning. A good number of the Russians who came to Boston were skilled in the needle trades. From peddling one came to tailoring, from tailoring to the clothing business, and soon one might be a family to compete with the earlier-arrived German Filenes. The Berensons' cousin, Louis Berenson, did well with his tinware shop, and he was able to move his family to a fine house on Highland Place in genteel Roxbury. But the Berensons themselves watched such prospects dissolve. Albert Berenson had no talent for business—perhaps he argued too much, perhaps he daydreamed too often. Their one venture at a storefront, at the house in Minot Street, was a dismal failure. They stayed where they were, and Albert went back to peddling.

In his youth, Albert Valvrojenski had been fired by the ideas of the so-called Jewish Enlightenment, or *haskalah*. In the eighteenth century, German Jews, including Moses Mendelssohn, entered into the broader European philosophical conversation and conceived of possibilities for reform and "modernization" of Judaism. These liberalizing ideas took their time to arrive in the Pale, but when they did, they made of Albert Valvrojenski a dedicated enthusiast. So radical was Valvrojenski's adherence to haskalah that when they left the Pale, he mocked Jews who attended synagogue, and Bernhard Berenson did not have a bar mitzvah or participate in any of the rites of passage for which

he had begun training in his heder. Judith Berenson, however, returned to her religious practices, though it is not clear exactly how observant she was.

In the old country, his reformist ideas had set Albert Valvrojenski in opposition to his powerful and traditional father-in-law, Solomon Mickleshanski. If Solomon Mickleshanski wanted a relationship to scholarship, he could undertake the customary support for the scholars in his community who studied the Talmud, but Albert Valvrojenski had wanted to be a scholar, and a secular scholar, himself. Trade seems to have been a mark of dishonor. In his American life, Albert Berenson was given to rages, and perhaps an echo of his bitterness can be heard in his son's self-castigations over his own involvement in the picture trade. Still, for Bernhard Berenson, not to succeed in business was hardly an option either, if only because Albert Berenson had by then so thoroughly failed. Parents would look to children for support in their age, and Bernhard Berenson had three younger sisters and a not-to-be-relied-on younger brother. The eldest son in the status-conscious Berenson family knew perfectly well that while they made do in the rail yard, their cousins had fancy silver from which to drink tea.

Members of the Jewish community in the old world had thought scholarship of great importance, but here in Boston, they concentrated on business success. The *Hebrew Observer* and later the *Advocate* had regular columns devoted to profiles of business heroes but, unlike the Catholic papers, paid scant attention to the plight of labor or to men working in other professions.[39] As in the culture of genteel Boston, a scholar was valued as a late ornament in a long family line of practical men. One made sure to have material security first.

Later there would be one place where intellectual and material successes would seem, to the Jewish community, to join, and this was within the walls of Harvard. The Berensons had arrived before there was a significant Jewish population to focus

its attention on Harvard, but the institution certainly loomed large for their family. In Berenson's mind, Harvard would stand as judge of his ambitions throughout his long life. Within a couple of decades of Berenson's attendance there, Harvard had become an important symbol for the larger Jewish population. Historian Jonathan Sarna avers, "To enter the hallowed halls of Harvard became a sacred rite of initiation for Jews, a sign that they had been accepted into the priesthood of the intellectual elect. Even if they remained social outcasts as students, as many Harvard Jews did, the fact that they had successfully passed through the university's portals gave them a feeling of both superiority and belonging."[40] Eventually the Harvard ambition was so prevalent that when the Jewish newsboys of Boston organized a union, part of its purpose was to raise money to send one boy every year to Harvard.

Boston had never been particularly welcoming to Jews—in the eighteenth and early nineteenth centuries only a few Jewish merchants had worked there on and off, while thriving Jewish communities were growing in Charleston, New York, and Saint Louis, places that had synagogues long before Boston did. Boston Puritans were interested in the Hebrew language and the Old Testament, but for centuries their interest in followers of the Jewish faith was confined to producing some of the most widely read pamphlets on strategies for converting them. Boston was a place that applied itself diligently to knowing about Jews but in large measure avoided actually knowing any.

In 1875, when Judith Berenson and her children arrived in this inhospitable climate, Boston had among its inhabitants fewer than five thousand Jews, almost all from Germany and from what is now Poland. These Central European Jews had founded a first synagogue in 1843; their small and somewhat fractious community had its ways, and some of these were the exclusionary ways of Boston. As in many parts of the coun-

try, the more established Central European Jews wished to dis-
burden themselves of the fast-arriving Eastern European ones.
Writing of the tensions between Boston's older immigrant
groups and the new Russian arrivals, Jonathan Sarna mentions
what he calls the Jewish community's "unfortunate decision
in 1882 to ship a group of 415 impoverished refugees back to
New York."[41] One imagines that the seventeen-year-old Beren-
son was not made to feel any more at home by this public-
spirited act.

Around this time, in the 1880s, the German Jews of Bos-
ton established a fancy social club, the Elysium Club, which,
though there wasn't anything explicit in the bylaws, never had
any Russian Jewish members. Following the Boston pattern,
the Russian Jews founded their own club, the New Century,
but not until 1900, when the community had solidified, and
Berenson himself had been in Italy for twelve years. The slights
Berenson felt at the hands of the earlier-arrived German Jews
pained him even "in his old age," when he is supposed to have
told "an intimate" that the scorn of the German Jews "bred
the desire in him to avenge himself by rising above them and
compelling their admiration."[42] This ambition reflected a dis-
appointed expectation, for the Berensons as a family had felt a
strong allegiance to the German language and German intel-
lectual life, and they seem to have followed some earlier-arrived
cousins in taking the name Berenson precisely in order to be
identified with the more prosperous community. Bernhard
continued to spell his name with the German "h" until World
War I. In the early years in Boston, he counted on his name to
promote him at least one rank in society.

Of course, none of the members of these Jewish clubs could
be members of Boston's many elite Protestant clubs. In 1891,
in the Boston *Social Register*, which listed about eight thou-
sand members of the upper echelons, there were "fewer than
a dozen Catholic families and exactly one Jewish man, Louis

Brandeis."[43] Even as late as 1916, more than fifty socially regis-
tered Bostonians signed a petition asking the US Senate to deny
confirmation of Brandeis's nomination to the Supreme Court.
Writing to his brother of Boston some years later, Brandeis
commented: "Antisemitism seems to have reached its Ameri-
can pinnacle here."[44] If it was your ambition to become an aris-
tocrat, as it certainly was Berenson's, Boston wasn't the easiest
city in which to effect the transformation, and a Russian Jew-
ish household by North Station was hardly the place to begin.
Berenson's own anti-Semitism, his suspicion of Louis Bran-
deis (whom he thought might be too radical and Zionist and
egalitarian for the Supreme Court), his frequent criticisms of
other Jews and their manners, and his late-in-life exhortations
to American Jews to assimilate all bear the hallmark of the early
anguished metamorphosis he went through in the attic room in
Minot Street.[45]

Berenson transformed himself, as he would accomplish a
great many things in life, by reading. He had some help from
the free Boston schools, but there is little record of his career in
these schools, except for one year, 1881, which would have been
roughly his junior year, when he attended Boston Latin, an ex-
cellent public school that every year sent many of its graduates
to Harvard. We know that at the end of that year, "he stood
first in English, history, geography, and zoology and ranked
seventh in his class."[46] But perhaps he was not made to feel at
home, for at the end of the year, he went to the less prestigious
Myers-Richardson School, where he said he would be better
able to study for exams but, possibly more to the point, could
earn money for coaching others.

The institution that had the greatest effect on Berenson's
education was the Boston public library, the first in the coun-
try that allowed people to take books home to read them. The
central library, on Boylston Street, was an imposing Italianate

stone edifice, which had opened to the public with great fanfare in 1858. When library founder Edward Everett gave a speech at the building's dedication, he recalled Benjamin Franklin's devotion to libraries and said that the purpose of the library was "to give to the rising generation and to the lovers of knowledge of every age that access to books, of which [Franklin] so much felt the want."[47] Something close to this spirit would be part of Berenson's lifelong project of building his own library and of in effect giving it back to Boston as a bequest to Harvard University.

Berenson went to the library several times a week and reportedly astonished librarians by the number of books he consumed. He absorbed both what recalled his old world—the verses of Gavrila Derzhavin—and what explained the new— "the advance in mileage of the railway systems."[48] He read books on "interstellar space" and on Greek myths; he read Samuel Taylor Coleridge's poems and George Eliot's essays.[49] Like many of the people who would become his friends, his close associates, and his lovers, Berenson was a lonely child who read not only to keep himself company but to create a realm outside of a noisy, chaotic life, a place in which his mastery would be unchallenged. Decades later, when Edith Wharton wrote that she was comforting herself with the Old Icelandic "Edda" tales she had loved as a child, he replied, "You dear, we truly were if not made at least brought up for each other. Think of you as a small girl & I as a small boy living within a couple of hundred miles of each other, probably the only human beings in America of any age who wallowed in those northern incantations."[50]

At fifteen and sixteen, Berenson was already a romantic. He later claimed to have, on a hot summer's day, finished Goethe's *Werther* lying half-submerged in the Merrimack River. Not too long after they came to know each other he dictated to Mary Costelloe, who would later be Mary Berenson, a list of some

seventy writers—including Milton, Dante, Heine, Persian poets, and Gogol—whom he claimed to have read before he was nineteen; she dutifully copied it down with all his asides. The concluding comment was, "Gods: Pater, Arnold, Browning."[51] All three of these last wrote on Italy; all three were interested in the excavation of long-ago artistic lives. Berenson said he was still in high school when he found Walter Pater's *Studies of the Renaissance*, and this seems likely to be true.

An essay Berenson wrote in college, in his early twenties, and published in the *Harvard Monthly*, "How Matthew Arnold Impressed Me," describes his discovery of Arnold's work, at seventeen. The essay gives us one of the most direct reports of what reading meant to Berenson as a young immigrant. He began, he says, "while taking my solitary luncheon after returning from school." The first poem, "Quiet Work," led him on to read all the rest that day and to go on reading them every day for the next two years.

> It was as if I had all at once, after living speechless for sixteen years, been endowed with a voice. . . . After living alone with one's thoughts, and anguish, and despair for ten years, what a wonderful, new thing it was to find one day that another had lived the same inner life. . . . I was not a creature apart, alone, with no hope of finding a fellow. Here was one surely; and others there must be. I may say that my social life began with Matthew Arnold. I may almost say that it was caused by him.[52]

The recognition of the companionship of language is, among other things, also sometimes the recognition of one's own desire to write. To be a writer was a very serious ambition of Berenson's and one that he would profess and work toward through the whole of the next decade. Even after his primary focus became the study of art, his ability, and his inability, to write would remain one of his life's central preoccupations.

If the ambition to write developed privately, in the attic room and the library, mastery of what was in the library more readily became a public affair. Reading was material for talk, which connected him, above all, to women. Berenson was often competitive with, and distrustful of, men, but toward women he leaned with confiding hope: "women," he wrote, "especially certain society women, are more receptive, more appreciative and consequently more stimulating."[53] It was only many, many years later that he admitted to his father, "I found you the most stimulating and fascinating of companions. . . . I don't know what I don't owe to the talks I used to overhear between you and your friends."[54] Fortunately for Berenson, in the country parlors of Concord the distaff side generally presided. In his adolescence, Berenson was to be found where soft chairs were gathered, making his mark by talking.

Talk was a way of leaving behind the family home, but it was also a way of repeating the life lived there, surrounded by sympathetic women listeners from whom he would sometimes seclude himself by going into his library. The arrangements of his later households would echo this foundational one, in which a radiantly tidy mother served dinners of "special distinction" as three sisters struggled to help one another and to make their way. The adult Berenson would play both his father's role and his own. Downstairs, the tin peddler talked quietly to himself about an intellectual life he had been obstructed from pursuing, while, in the attic, a young, impassioned devotee of Pater and Browning attempted to live his life burning "with this hard, gemlike flame."[55]

Berenson first matriculated at Boston University, perhaps because it was not very expensive, perhaps because he could not yet envision himself at Harvard, where there were so few Jewish students. The other students in Berenson's Boston University class had fond recollections of him, but he was ambitious for a

wider field and stayed but a year. It seems that he met Edward Warren, a wealthy Harvard student just a few years older than himself, with whom he shared an interest in classical antiquities, and that Warren generously offered to pay the fees that might otherwise have prevented Berenson from attempting to transfer to Harvard. The earnest Warren, a bachelor aesthete who would go on to be a collector of note, was to be one of Berenson's most important benefactors. Berenson was nineteen when he took on the complicated position of being an object of patronage.

Already by his first year of college, Berenson marked the periods of his life by which paintings he looked at with which women. At Boston University he had been keeping company with a young woman named Elizabeth, a girl, he told his diary, of "wealth and culture."[56] They went together to the new Boston Museum of Fine Arts and lingered there before a reproduction of Botticelli's Venus, and longed to "unite their vision of beauty forever."[57] When his admission to Harvard was settled and he took his new rooms on Mount Auburn Street, he and Senda went shopping for prints to hang on the walls. One of these showed a fresco by Correggio of Diana of Parma, the chaste huntress mounted in her chariot. The image bore a motto that would have appealed to the combative young romantic: "IGNEM GLADIO NE FODIAS," "You will not poke out the fire with the sword."

2

First Conversions

Nothing is so cliquy and exclusive as the schoolboy
or the schoolboy-minded Anglo-Saxon of all ages.

—Bernard Berenson, *Rumor and Reflection* (1952)

IN THE AUTUMN OF 1884, Bernard Berenson entered the
gates of Harvard Yard, a boyish, serious student, in a worn suit.
Still closely tied to his family, he began by pursuing a course of
study that had at least something in common with the yeshiva
training he and his father had both broken off. He immedi-
ately enrolled in courses involving the comparative study of
languages and of ancient civilizations, including advanced He-
brew. His professors of Arabic and Sanskrit were enthusiastic
about their new pupil, with his fantastic memory, great preci-
sion in careful comparison, and gift for acquiring, and using,
languages. Berenson's early published writings for the new
Harvard Monthly displayed impressive erudition. A study of the

works of Leo Tolstoy, a writer only just available to English-speaking readers, was followed by a careful biographical reconstruction of the course of Muhammad's career. These works show Berenson beginning to become the kind of specialized scholar he and his professors admired. He was hard at work in the study of two geographical regions and civilizations with which he felt an affinity: the Semitic Near East and Russia.

But other currents were forceful in his undergraduate project of self-definition. Berenson, already devotedly reading Walter Pater and Matthew Arnold, also felt the pull toward the literature of England and the art of Italy, as well as toward a sort of aesthetic Christianity. Harvard was a Christian world; estimates based on existing records suggest that by 1886 only about a dozen Jewish students had graduated from the university.[1] In the fall of 1885, his second Harvard year, Berenson converted to Christianity and was baptized at the Trinity Church in Boston. The conversion, however, was perhaps a sign more of tension than of resolution. In his third and last year at Harvard, Berenson was engaged in what seemed opposing pursuits. While living at home and completing a long thesis on the subject of "Talmudo-Rabbinical Eschatology," he was also writing a short story about aesthetic dilettantes, taking Charles Eliot Norton's famed courses in the history of art, and hoping to obtain a traveling fellowship to study art and literature, especially works then hardly to be seen in the United States, the extremely Christian paintings of the Italian Renaissance.[2]

All his life, Bernard Berenson was a person whose capacity for metamorphosis approached that of the moth. His self-transformations had to reconcile tendencies that often conflicted: his passion for looking at art, his desire to be wealthy and independent, his hope to write seriously, and his grave self-doubts. Almost always, one result of the struggle would be a deeper involvement with the study or sale of Italian pictures. Again and again, Berenson's personal transformations would

coincide with changes in the trade with which his life was so deeply entwined.

The Harvard of the mid-1880s was a place of new intellectual developments and curricular reform. President Charles William Eliot had introduced a new system of electives, including, most significantly for Berenson, studies in the new field of art history. Other changes, ones that reflected the institution's gradually diversifying student body, came a little late for Berenson. Attendance at chapel, for example, would stay compulsory until 1886. Berenson kept to himself. He had two associates who were also dark-eyed, foreign-seeming, and socially somewhat marginal, and these were the future philosopher George Santayana, whose father was Spanish and Catholic, and Charles Loeser, who was Jewish and came from Brooklyn. Loeser's father, though, unlike Berenson's, was a wealthy textile merchant, and Charles Loeser had been educated in Switzerland. He would become a serious art collector and an important patron and colleague of Berenson's; their eventual break would lead to long years of bitter rivalry.

Berenson, Santayana, and Loeser were all drawn by aesthetics and literature, fields that, at Harvard, had long been the purview of gentlemen at leisure; the three were grateful to their more broad-minded professors, like Barrett Wendell and William James, who did not scorn their ambitions or tastes. Some of the students who were encouraged to write creatively in Wendell's "English 12" together founded the *Harvard Monthly*, of which Berenson became editor-in-chief in his senior year. Meanwhile, with James, Berenson would have taken "Logic and Psychology."[3] James had begun teaching the material that he would develop into the *Principles of Psychology*, published in 1890; both his lectures and the later book were to exert a powerful influence on Berenson's ideas about aesthetics. Perhaps more important still, the kindness and encourage-

ment of James were things Berenson invoked as a source of comfort and hope even in the diary entries of his last decade. Berenson—precocious, intellectual, and both over- and under-confident—remained one of those young people whose social life revolved more around the professors than the students.

Along with Loeser and Santayana, Berenson belonged to a literary club at Harvard called the O.K. There is a picture of the membership—large, upright Anglo-Saxons in well-cut suits arranged solemnly in two rows, while Berenson, small and eager, and wearing the long pre-Raphaelite curls he then affected, crouched on a little hassock toward the front. Ernest Samuels finishes the portrait of him in this era: "A classmate who used to see Berenson cross the Yard recalled that, small and frail in body, he gave the impression of an ascetic, an impression which was heightened by a certain delicacy and sedateness in his walk."[4] For Berenson, Harvard was an anxious pinnacle of achievement, bestowing on him a status he coveted while constantly threatening to take it away.

It was against this background that Berenson made what can be understood as a double conversion: to Protestantism in 1885 and to aesthetics in 1886. One writer had a significant impact on Berenson's view of, and relation to, both religion and art, and this was Walter Pater. Writing to Isabella Gardner in 1888, the year after his graduation, Berenson described how, in college, Pater's *The Renaissance* was known to him "almost by heart. Many a midnight in coming home I would take it up, and meaning to glance only at a passage here or there, would read it from cover to cover."[5]

Pater's *Marius the Epicurean* was first published in February 1885; Berenson fastened eagerly upon it. *Marius* is the allegorical tale of a young Roman aesthete and Epicurean who gradually, and in large part as a matter of sensibility, converts to the new religion of Christianity. In the late nineteenth century,

religious conversion was relatively common, and people converted for a great variety of reasons—as a means of expressing more fully who they felt they were; to be closer to friends, lovers, spouses; even, not infrequently, to bring their lives into harmony with their professions or the subjects of their intellectual pursuit. In Pater's book, the evocative scenes of Marius's religious experiences—some pagan and some Christian—all take place in beautiful, spacious surroundings, and it is understood that fundamental to his conversion is aesthetic experience.

If Berenson looked in Boston for an atmosphere like those that sustained Marius, the place that would immediately have suggested itself was Trinity Church. The architect of Trinity Church, H. H. Richardson, had designed it especially to house the fine dynamic preaching of his friend, rector Philips Brooks. The church had an unusually large square central space, dappled with colored light from its stained glass windows; several of these were designed by the Pre-Raphaelite painter Edward Burne-Jones, while others were among John La Farge's most impressive glass creations. Completed in 1878, Trinity became the central congregation for the fashionable Back Bay and was just the sort of place a young Marius of Boston would have sought out. On November 22, 1885, Berenson was baptized there by Philips Brooks.

There is no record of what his family thought of his decision, if they knew of it; Berenson himself remained uncertain about it, even a little bewildered. Six years later, contemplating another conversion, to Catholicism, he would write to the woman who was soon to become his lover, Mary Costelloe, herself a convert to Catholicism, about what had happened:

> I meant it all so well; and somehow it turned out so ill. In a way being baptized into the "Episcopal Church" by Phillip Brooks simply killed all religious strivings for the time. I

don't know how this came about. Much was my own fault I am sure. I had seen that Christ was the postulate of any rational scheme of the universe, so I wanted to take Him up, but He would not be taken that way, and somehow I did not care, and soon I began to think it was all *blague* [a joke, a trick].[6]

Berenson's relationships with women were always a significant part of his decisions about where and how to live. His first religious conversion had the effect of bringing him closer to women who had a great interest for him, those who lived in Boston's Back Bay and held sway in the realm of culture.

One of the feminine sanctuaries Berenson found was at the home of Grace Norton. He sometimes took his sister with him so that she might share in the pleasures of conversation with the refined circle of people who gathered there. Grace Norton was the sister of the man who was perhaps the single most forceful intellectual influence on Berenson in his years at Harvard, Charles Eliot Norton, a cousin of the university's president and Harvard's first professor of art history. Grace and Charles Norton were descended from a line long of ministers, and their father had also been an influential Harvard professor. The Nortons were to turn up over and over in Berenson's life — Charles's daughter Sara was a close friend of Edith Wharton's, Charles's son Richard was a rival for Isabella Gardner's patronage. But, most significantly, Charles Eliot Norton himself took a negative impression of Berenson that was to have a determining effect on the younger man's career.

For Berenson in his college years, it was a relief to find other people who wanted to talk of the arts and of Italy. Berenson would have been aware of Charles Eliot Norton's position as a great advocate of Italian arts and letters in Boston society. Norton had a close friendship with the most important early American collector of Italian paintings, James Jackson Jarves; Jarves dedicated his *Art Studies: The "Old Masters" of Italy* (1861)

to Norton. In the 1860s, Norton made a concerted effort to get the museum trustees of Boston to take Jarves's glorious collection of Italian pictures when offered it for a modest sum. But at that time Americans had so little use for Italian works before Raphael that Jarves's triumph of taste was completely ignored. Edith Wharton used a character and situation like that of Jarves for a story, "False Dawn," that would have been a sort of bitter joke between her and Berenson.

From observing Norton, Berenson may also have better understood the ways good writing could bring the art of Italy across to America. It is hard now to imagine a world in which reproductions of paintings were scarce (Norton taught his art history classes without them) and in which cities rarely had public collections of paintings (those that did exist contained almost no original Italian works). Americans, for the vast majority of whom travel to Europe was prohibitively time-consuming and expensive, got their first introductions to Italian art by reading. Berenson would aspire to follow Charles Eliot Norton in being, not only a lover of art and a bibliophile, but a friend of writers and a literary man.

Norton was close to John Ruskin, one of the English writers most responsible for the new view of Italian art that emerged among certain writers in the mid-nineteenth century. The brilliant Ruskin considered the younger Norton to be "my first real tutor."[7] Members of the New England literary world joined the British vogue for Italy with books like Nathaniel Hawthorne's *Marble Faun* (1860) and Henry James's *Roderick Hudson* (1875). Norton was a friend and mentor to Henry James, and was still the figure of authority on matters Italian when Edith Wharton was at work on her first long novel, *The Valley of Decision* (1902), a historical book set in late-eighteenth-century Italy. As Wharton did her research, Norton leant her rare books from his famous library. Norton's bookplate bore the motto "Amici et amicis"—friends and for friends. Perhaps Berenson knew

that after Norton's death a committee of friends ensured that Norton's books were donated to the Harvard Library.

In his literary publications and public lectures, Norton explained to audiences what to read, and privately he advised Boston's elite on books to buy. It was at Norton's series of Dante lectures that Isabella Gardner began reading her way through the *Inferno* and the *Purgatorio* in 1878. Norton helped Gardner to begin one of her first collections, that of manuscripts and autographs. Among her purchases were two bound editions of the *Divine Comedy*, from 1481 and 1508. It is not known for certain where Gardner and Bernhard Berenson met, but biographers frequently assume that the occasion was one of these Dante lectures and that Norton himself effected the introduction.

In his senior year, Berenson was caught in a choice between an old way and a new one, and the drama of his decision about which direction to pursue was intricately bound up with Charles Eliot Norton's opinions. That year, Berenson enrolled both in Norton's Dante course and in the two semesters of his art history course. At the same time, due to insufficient funds, Berenson had returned to living in the little house near the rail yard with his sisters, his resolutely secular father, and his still-devout mother, and he had thrown himself into work on his senior thesis, the last scholarly work he would do that was directly related to his family's origins.

In "Talmudo-Rabbinical Eschatology," the manuscript believed to be Berenson's senior thesis, are detailed the beliefs of Russian Jews on eschatological questions: how many kinds of fire are there in Hell, how many angels sit about your body after death, what are the mnemonics for remembering your own name in the forgetfulness that comes after death, what is the meaning of the eight hundred thousand trees that occupy each corner of Paradise, what was it that Rabbi Chaiiah "repeated in concert with his sons"? It is a fine specimen of biblical scholar-

ship. At the manuscript's end, Berenson sounded the wistful note that would become typical for him in all the unpublished notes he later made to himself about Jewish life and culture. "All the superstitions, no matter how hoary, all the legends, all the mythology, so plentiful among them, is fast dying, and may even before the next century be practically extinct."[8]

Berenson's work was admired by his professors in ancient languages, and when he came to apply for the Parker Traveling Fellowship in March of his senior year, they wrote eagerly of him as "a man of unusual ability and brilliant promise."[9] Professor Toy, with whom he had studied Arabic, added, "His reading is enormous without being superficial. He combines in a very unusual way acquaintance with Eastern and Western literatures."[10]

But Berenson was no longer sure he wanted to pursue this work. Increasingly, he found comparative philology to be "a fact-feeding, uncultivating system," as he wrote in a story called "The Third Category," published in the *Harvard Monthly* in the fall of his senior year.[11] The first piece of his that dealt directly with painting, this story suggests how exciting art history seemed by contrast with the academic work Berenson had been doing. It was, the story's narrator points out, at "lectures in certain art courses where the handsomest men of the college used to congregate as if by unconscious attraction. Very gods, many of these men seemed to him—gods in the beauty, and strength and majesty of youth, whom he gladly would have worshipped, and with a fervor equal to any he had felt."[12] Erotic excitement, imitative desire, religious fervor—all seemed to congregate in art history class. Norton himself, however, as he stood before the hall of some four hundred students, was pointedly concerned, not with the sensuality of aesthetic experience, but with, as scholar Linda Dowling points out, "ethical knowledge in an embodied form."[13]

Before Norton had become Harvard's first professor of

that discipline, art history had, in general, been considered, not a field of study, but a matter of craft and technique to be taught by painters to other painters. Scholarship about art, and especially about Italian art, entered a new era as the German universities began developing large-scale historical studies like those of Swiss scholar Jacob Burckhardt, whose *Civilization of the Renaissance in Italy* was published in English in 1878. In Great Britain, tastes were influenced by the work of Norton's close friend Ruskin in books like *The Stones of Venice* (1851–1853) and *The Seven Lamps of Architecture* (1849).

Following Ruskin, Norton loved best in Italy the powerful moral uplift of Dante and of Italy's medieval Gothic architecture. In Norton's art history courses, the Renaissance was the unhappy termination of the Middle Ages, which had been the last great era of spiritual unity and well-being. There was a joke current among Harvard undergraduates that Norton had died and was just being admitted to Heaven, but at his first glimpse staggered backward exclaiming, "Oh! Oh! Oh! So Overdone! So garish! So Renaissance!"[14] "Norton," Berenson commented drily years later, had done what he could at Harvard to restrain "all efforts toward art itself."[15]

One student of Norton's noted in her diary of the day's lecture in "Italian 4," "The dear old man looks so mildly happy and benignant . . . while he gently tell us it were better for us had we never been born in this degenerate and unlovely age."[16] Norton was a public intellectual, committed to the education of working people, who ran one of the country's first night schools, but he was also a sometime supporter of the repressive anti-immigrant and anti-Catholic Know-Nothing Party, who praised an article in the *North American Review*, written by a close friend of his, that deplored the new power of "the immigrant races," with their "ruthless touch" and their "rush into the forum . . . and libraries."[17]

Norton, though, was famously kind to young cultural aspi-

rants, and Berenson, in a quandary over whether to pursue phi-
lology or the arts, looked to Norton for guidance. In the win-
ter break of his senior year, he wrote to Norton, "The feelings
I have had in hearing you speak are like those that come to one
when a dear friend speaks to one of the things that are near-
est and dearest to both of them." He wanted Norton to know
"how large a part of my consciousness you have become."[18] If
Norton replied to Berenson's confidences, there is no record
of it. Instead, his opinion of Berenson came back to the young
man by word of mouth. "I cannot forget," Berenson wrote,
still wounded more than sixty years later, "that when still an
undergraduate at Harvard, Charles Eliot Norton said to Barrett
Wendell who repeated it, 'Berenson has more ambition than
ability.' Norton never changed his mind."[19]

Four years later, and far from the university world, Beren-
son would write to Mary Costelloe, "Unhappily there is some-
thing of the earnest student, of the would-be scholar in me,
so much in fact that I must ask myself the question seriously
whether the 'ultimate professorship' in a remote University
would not be the sort of thing into which I should fit natu-
rally."[20] Why did he open this question with the word "un-
happily"? Did something prevent him from taking up this pro-
fession "into which I should fit naturally"?

The first Jewish professor at Harvard was hired in 1888, a
year after Berenson had graduated; Charles Gross taught medi-
eval history. Jewish faculty were subsequently added, sparingly,
in Slavic languages and literatures, in philosophy, and in eco-
nomics. Even in the 1930s, Jewish graduate students at Harvard
were routinely told that they might be able to teach "if they
were to find a Jewish donor who would pay their salary."[21]

And as Isaac Adler, a Jewish student writing on "The Jews
at Harvard" in 1892 noted ruefully, although "three members
of the Faculty are of Jewish descent. Not one is 'a professing

Jew.'" All had felt the pressure to convert, and one regularly attended the First Parish Church in Cambridge. Adler was struck by what this situation suggested about the inner lives of these professors: "This attitude," he wrote, "of cultured men of Jewish descent towards Judaism is perhaps the most surprising result of these investigations." Adler conducted an informal survey of what Harvard's forty-one Jewish alumni had chosen as professions, which is instructive: "Seventeen have entered or anticipate law, ten are in business, three physicians, ten teachers, one engineer."[22] In this list, Berenson is already a surprising outlier, "one art-critic," but he did not have to vanquish an entire institutional culture in order to become an art critic.

As professors, Jews were most acceptable in disciplines where they might be presumed to have specialized knowledge—in Slavic languages or in Hebrew. Had Berenson wanted to continue the sort of work he did in "Talmudo-Rabbinical Eschatology," he could have attempted to do graduate work in Germany and to hope that something would become available for him in a "remote University." But difficult as it would have been to become a professor of Hebrew or ancient Near Eastern civilizations, to teach art history in the university was, even for a converted Jew, next to impossible. Art history, as Charles Eliot Norton and his later colleagues understood it, was not a discipline for the pushing immigrant classes with "more ambition than ability." It would be another twenty-nine years before a Jew, Paul Sachs, would enter the art history department at Harvard, and he, having left the family business of Goldman Sachs with a secure fortune of his own, entered through the back door by beginning to work at the Fogg Museum. Berenson would later negotiate the bequest of his Villa I Tatti to Harvard through Sachs, with whom he had many decades of lively correspondence and shared students. But in college Berenson had no ally in the field of art history, let alone an independent fortune with which to back his studies. He needed help; in par-

ticular, he needed the Parker Traveling Fellowship on which he had set his heart.

Berenson asked Norton to join his professors of Arabic and Hebrew in recommending him for the fellowship. Norton refused. Berenson, in a more tenuous position than he had hoped to be, tried to explain in his application that "art prevails in this programme because it is there where I feel myself weakest." His daunting variety of goals may not have endeared him to the fellowship committee, and his tone seems self-justifying and, sporadically, arrogant. Comments like "It was quite natural, however, that I should find Boston University insufficient for my needs. . . . I have given a fair summary of my college work which never, in reality, meant anything to me compared to the reading I was doing. . . . Few men sleep less and devote themselves to their true interests more than I do" may well have seemed to the committee to support Norton's view, with its undercurrent of the stereotype of the "pushing" Jew.[23] Still, Berenson had a stellar record and excellent references. His biographers are united in speculating that, because Berenson wished to study paintings, the absence of a recommendation from Norton was a significant factor in his being denied the fellowship. In turn, the lost fellowship seems to have represented for Berenson a definitive rejection from the pursuit of an academic career in the study of art.

The conflict between Berenson and Norton was in part a generational one, and the change between generations was represented for them both by Walter Pater (1839–1894). Pater, though himself a thoroughly proper and conservatively dressed man, stood, as certain icons of the 1960s and 1970s would do a hundred years later, for long hair, sexual freedom, and self-cultivation. Berenson considered it a mark of distinction to have been, as he said, "one of the longhair grands," and no book meant more to him than Pater's *Renaissance*.[24] But when he

took the book to Charles Eliot Norton, he was rebuffed. Both Berenson and his wife told versions of this anecdote so many times that none is reliable, but the repetition suggests that the story mattered a great deal to Berenson. In one version, told by Mary Berenson, Norton, with a firm pat on Berenson's shoulder, said, "My dear boy, it won't do," adding "it's a book you can only read in your bathroom."[25]

In the battle of the generations, Berenson felt himself to be allied with the Edwardians, the new devotees of art for art's sake, and against the Victorians. In Boston, he and Senda frequented a young crowd of arch-medievalists, who had what he called "the delightful touch of Bohemianism."[26] The group included the poet Louise Imogen Guiney and the future architect Ralph Adams Cram, who would later publish Berenson's first article in art history.[27] In the medievalism of these "Boston Bohemians," unlike that of Norton, the Middle Ages were a land of the imagination where an individual could roam free, aesthetically, religiously, and sexually.[28] Berenson would go on to lead an unconventional sexual life. He lived in adultery for many years before marriage, had a great many affairs and overlapping partners, and eventually settled into his most stable configuration with both a wife and mistress sharing his home. That he managed to make this all seem dignified, aristocratic, and "old world," rather than revolutionary and Bohemian, had in large part to do with the wealth and erudition that provided the setting for his actions. None of it, however, belonged to Charles Eliot Norton's conception of the moral uplift of the study of art history.

The story Berenson published in his senior year, "The Third Category," reflected the tension he felt about embracing an aesthetic conception of life. It was a blueprint of the relationships he would have to art, women, and himself in the next decade of his life. In "The Third Category," Beren-

son's typical aesthete belongs, necessarily, to the Christian world and is called "Mr. Christie." After several years abroad, Mr. Christie—an entirely self-centered being, who "found no room in the universe for another than himself"—has returned to wander around Harvard and Cambridge in search of sensory experience.[29] He "knew no greater pleasure than to look with [Miss Rosalys Storer] at some drooping, poppy-saturated pre-Raphaelite sketch, or at a drawing of the divine Sandro Botticelli."[30] With "Miss Senda Vernon," whose name and "rich olive" complexion were so like that of Berenson's sister, Mr. Christie reads "the old French poets . . . while she sat bending over her guitar."[31] (In life, Senda was a good musician, and Berenson for years had his heart set on her becoming a professional.) It is with Miss Cecily Grampian that Mr. Christie has the strongest experience of all. Not that he falls in love with her, but he begins to educate her. He brings Miss Grampian into contact with the church; "he thought Christianity the greatest work of art in the world," and, furthermore, "he could not see how in the long run he could bear to live with a woman who could not appreciate Fra Angelico's frescoes, or Raphael's Sistine Child."[32] For him, though, the church is but another kind of aesthetic experience, and when she becomes devoted to church work and takes the Christian spirit of self-sacrifice seriously, then he is at a loss and cruelly cuts off all contact with her.

Over and over, Berenson would educate his mistresses, taking them into the churches of Italy to raise their aesthetic awareness. The presence of women stimulated his powers of thought and talk, but he worried about his relations with them. He describes Mr. Christie's realizations about Cecily Grampian: "He could not help feeling that hers was a much more real, more living, more intense soul than his own. He saw now how easy it is for an inferior nature,—and he had to confess

himself inferior,—to rouse a superior one from deathlike slumber."[33] In Berenson's view, women were more self-sacrificing and more likely to be part of the wide moving world—he saw his mother and sisters this way and would imagine his lovers this way—whereas the role of the scholarly man or aesthete, a role he felt uncomfortable about, was to be selfish and concerned only with what he would later demand for himself, "purely artistic enjoyment."[34] At each stage of his life, at least one woman, and sometimes a chorus of them, would be the means through which he uncovered aesthetic experience and determined his own vocation, but as he moved on to the next era, he might drop that woman entirely.

It seems possible that when Berenson decided to give up Talmudo-Rabbinical eschatology in favor of "drooping, poppy-saturated pre-Raphaelite" sketches, the woman he felt he was turning his back on was Judith Berenson. His sisters might follow him into the lands of culture, but his mother never would. And perhaps his doubts about this choice accounted for the contemptuous tone he took toward Mr. Christie. When Berenson formed a new self, he did so in part to leave behind old circumstances in which he felt self-critical, but it was never possible to leave behind the self-criticism itself. Sometimes self-contempt seemed to increase precisely as he moved toward a life he felt he ought to have rejected or that seemed to have rejected him.

In the spring of his last Harvard year, denied the traveling fellowship but desirous of immersing himself in European culture, Berenson floundered. But then, as would so often be the case in his future life, capital came to his rescue. A small committee of people, including Edward Warren, Thomas Sergeant Perry, and Isabella Gardner, banded together to give Berenson seven hundred dollars, enough for a year's study in Europe. Pri-

vate wealth, not institutional scholarship, was willing to make a place for the young man, and patronage, with all the bounty and servility it implies, was thus solidified as the mode through which Berenson would gain access to culture throughout his adult life. If he was not to have Judith Berenson any longer, he would have Isabella Gardner.

3

Isabella, Mary, Italy

It is awful to think that I have no right to all
the *culture* I can get. . . . It will be so hard, so
nearly impossible for me to give up "culture" —
not the Boston thing, but the real selfish passion for
training oneself to have enjoyment of one exquisite
and beautiful thing, leading on to the enjoyment
of one even more beautiful.

—Bernhard Berenson to Mary Costelloe, 1890

SOME OF THE YOUNG Bernhard Berenson's most treasured intimations of the world of culture beyond Boston came to him through Mrs. Jack Gardner, who was, as Boston would be quick to tell you, from New York. Isabella Gardner liked demonstrations—of both wealth and intelligence. She was showy, and Boston enjoyed being scandalized by the cost of her fashionable Charles Worth gowns, her round-the-world trips to

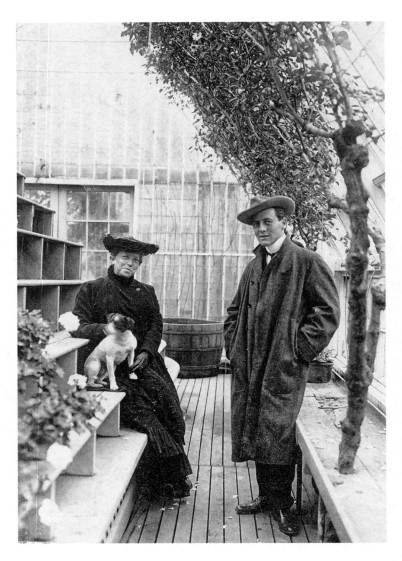

Isabella Gardner in the greenhouse at her summer home,
Greenhill, with Giuseppe Della Gherardesca, 1906.
Isabella Stewart Gardner Museum, Boston.

Egypt and China, her diamond tiara shaped like giant antennae, the lion cub she drove about with in her carriage, and the large parties she regularly threw for her young favorites. She had always had money. Her father's had been in Irish linens, but with the coming of the railroads he had seen the advantage of iron mines; her husband's had derived, as with that of many Bostonians, from shipping, but his fortune was to grow in banks and trains. She was a woman of independent tastes and intelligent curiosity, and she lived on a wide stage of aesthetic experience that, to careful Boston, seemed alternately an education and a rebuke.

Berenson, reading the society pages in his years at Harvard, would have found in *Town Topics* that "Mrs. Jack . . . throws out her lariat and drags after her chariot the brightest men in town, young and old, married and single," or that "the first of Mrs. Jack Gardner's dancing parties fully satisfied everybody's expectations . . . gay, brilliant, magnificent."[1] Gardner's entertainments were not merely brilliant; they often featured serious music performed by musicians from the Boston Symphony. It was an idea of Gardner's that the many fractious clubs of Boston's society life might be reorganized toward the aim of culture. One newspaper at the time went so far as to assert that, whereas "Boston society consists of antique genealogical distinctions and exclusive standards," what Gardner had accomplished was "to break down social barriers," and to make of society gatherings "a vehicle for the cultivation of art, music, and intellectuality, and to create a social renaissance."[2]

There is a well-known portrait of Gardner, painted by Anders Zorn, that shows her at the Palazzo Barbaro in Venice, where the Gardners had begun making long stays with their Boston friends Daniel and Ariana Curtis in 1884. In the portrait, Gardner is coming into the room from the balcony and has just flung open the French windows; behind her is the light of the Grand Canal. Taut, supple, imperial, Gardner always

seemed ready to be gazed at. Throwing open her doors was a characteristic gesture — it was how she welcomed young writers, musicians, and artists to her house. Gardner was a close friend and famous subject of the painter John Singer Sergeant, and she had her first encounter with James McNeill Whistler, who did her in pastels, at a party to which she went with Henry James. James, who seems to have drawn on aspects of Gardner for Isabel Archer in *Portrait of a Lady* and for the collector Adam Verver in *The Golden Bowl*, and who used the Palazzo Barbaro to house one of his characters in *The Wings of the Dove*, wrote to her, "If you 'like being remembered,' it is a satisfaction you must be in constant enjoyment of, so indelible is the image which you imprint on the consciousness of your fellow-men."[3]

The world Gardner gathered about her, in Boston, and especially in Venice, was a world of talented young men, many of whom were homosocial or homosexual. The scholar Elizabeth Anne McCauley explains that Gardner was "an intimate confidante and sympathetic listener for the emotional trials of sensitive young men whose romantic interests had to remain underground."[4] In the late nineteenth and early twentieth centuries, Italy was a place where American and British men and women could express these underground interests more fully.

Gardner's sympathy with the young men she sheltered was in part maternal. She had had a stillborn son in 1860, she lost her only surviving child, also a boy, in 1865, when he was two, and a subsequent miscarriage seems to have ended the possibility of children of her own.[5] This was a tragedy in her life, and some of her museum's curators have felt that the way she surrounded herself with images of the Madonna and Child later in life commemorated her losses. Long before she became a serious collector, the absence of children of her own seems to have been an aspect of her relationship with Berenson. In 1869, the death of her husband's brother and sister-in-law had made the Gardners the guardians of three nephews. Gardner threw

open her doors. The eldest of these nephews was an aesthete. Joe Junior was a friend of Berenson's patron Edward Warren and possibly the lover of Berenson's future brother-in-law Logan Pearsall Smith. It was while Joe Junior was at Harvard that Gardner began to go to Charles Eliot Norton's lectures, and through this nephew she met many bright young men. For Gardner, this relationship, too, ended in tragedy. Joe Junior committed suicide in 1886. There is speculation that his suicide was related to his homosexuality.[6] After her nephew's death, Gardner had a renewed sense of her childlessness, and she may have been especially receptive to the arrival, just at that time, of the young and appealing Bernhard Berenson.

More than one biographer has found it inevitable that Berenson and Gardner would be drawn together. Hers was the most famous salon in Boston, and whether it was a living room in Concord or a Rothschild's suite in Saint Moritz, Berenson loved a salon. Yet even though he must have impressed her enough that she helped to bankroll his voyage to Europe, no one left a record of Berenson scintillating at one of Gardner's evenings. Instead, the story was that Berenson and Gardner met at one of Norton's lectures. In Boston, everyone went to lectures, and lectures had about them an aura of romance, even of revelation.

The future Mary Berenson, later herself an acclaimed lecturer, left an impression of the powerful effect of these presentations on Boston audiences. She and her brother Logan Pearsall Smith had gone to hear a lecture on the visual arts given by the well-known English man of letters Edmund Gosse. She wrote that "when [Gosse] mentioned the sacred word 'Botticelli,' I remember looking at my brother with eyes brimming with emotion and excitement and saying: 'Oh Logan! We are at the very centre of things!'"[7]

Lectures could produce a kind of conversion experience. "We became pre-Raphaelites," she said, "and hung photo-

graphs of Rossetti's picture in our rooms."[8] The young Bern-
hard Berenson had been at the same lecture, and as he later told
Logan, after it, he had gone out and bought a reproduction of
Botticelli's *Primavera*.[9]

Soon enough, no Bostonian's walls would carry the banner
of Italian art with more gusto and loyalty than Isabella Stewart
Gardner's. Her collection, one of the great passions of her life,
was to be shaped and refined in decades of correspondence with
both Berensons. But when the idea arose that a few wealthy
friends should sponsor the European training of the promising
young Bernhard Berenson, it was his future in literature that
they all banked on, and it was an idea of himself as a man of let-
ters that he carried with him when he went abroad.

It was not easy to cross the ocean again, and to go without
his family. Just before leaving, Bernhard gave Senda a story
he'd finished. It was called "The Death of Israel Koppel." He
wanted her to submit it to *Harper's*. He could have mailed it
himself, but he often relied on her to do the things that made
him anxious: dealing with visa applications or watching care-
fully over the daily life and health of their parents.

"Israel Koppel" concerns a young Jewish man who, after
four years at a gentile university, returns home to his parents'
house in a Lithuanian village. The villagers do not know what
to make of him, and revile him. In a room alone with his ador-
ing mother, Israel Koppel falls into a sudden coma, and she
believes him dead. Confirmed by the village pharmacist, his
death must, according to Jewish law, be immediately followed
by burial, which his father insistently arranges. The later part
of the story, which is a work of quite beautiful literary inven-
tion, mingles the consciousnesses of the father, dreaming, with
horror, that his son has been buried alive and that of the son,
awaking in the coffin. *Koppel* in German means a paddock or an
enclosure, and this was a story of Berenson's many enclosures:

a Lithuanian Jew enclosed within a German name, further enclosed by a gentile education. To go home to a traditional Jewish life would be to be buried alive; the story asks whether it is a solution to bury that old way of life within oneself.

Berenson wanted to separate himself from his family, but in his experience separations were fatal, terrible, and irrevocable. To the end of his life he held this same view: "How resigned I am to the idea that I may never again see places I am now visiting, and persons. All one's life through, one has done the same, leaving behind what can never be recalled. One is always, always being parted, separated."[10] Berenson seemed to carry out this hidden conviction even when later realities did not actually so constrain him. It was not for reasons of circumstance or finance alone that Berenson did not return to America for seven years.

On his arrival in Paris, he was, he wrote to Isabella Gardner, "plunged into the most horrible of solitudes," and "for a few weeks, I barely lived."[11] He began to write to her often, in a pattern he followed with his female correspondents throughout his life. He reviewed performances he attended and sent her books, often ones of personal importance to him. He urged her to read one called *Bartek:* "I wish you to read the introductory essay, especially. . . . The analysis he gives of the Lithuanian character I found true of myself in so many different ways that it seemed to me like a confession written by myself."[12] He also gave her details of his physical health, in a tone that might seem presumptuous, but she indulged her protégés, and he was obviously very clever. She read the recommended books; she sent letters back.

His other main correspondent was Senda. When he later described this lonely period to Mary Costelloe, he said, "My only connection with the world was the weekly letter to my sister."[13] With Senda, he was more didactic than ever. She was to practice a certain number of hours a day; she was to memorize

some poetry as she was getting dressed and undressed (this was a habit of his own). He wanted her to share in the transformation he felt himself to be going through. During this first fall in Paris he began to sign his postcards to Senda "B.B.," the name by which he would be known. And he urged her: "You must not lose an opportunity to see people who are in society even if that be of the outer rim." And he added, "I wish it for my sake. I am looking forward . . . to living with you—who knows all my life perhaps—and seeing as much as you can of that world now will help not a little to make you a pleasant hostess."[14] For a long time, the siblings had the fond plan of setting up house together.

Senda sacrificed readily and continually for her brother. Somehow she found a steady stream of money to send him. Unable to afford to live independently, she moved back home, but there she was subject to her father's rages. Albert Berenson was angry when Senda refused a proposal of marriage. Some years later, Bernhard would write to Mary about this refusal of Senda's with what feels like satisfaction, "I knew that from the moment she found she really did not love the man she was going to marry [that] all her affections were concentrated on me."[15] Despite an ailing back, Senda attempted to keep on with her musical studies as Bernhard wanted her to do. She wrote encouraging letters to him on his glamorous tour of Europe, and she faltered only a little when he wrote to tell her that a friend had offered him enough for another year, and he planned to stay.

After his first uncertainty, B.B. had taken to Europe. In his three months in Paris he had become acclimated, met some interesting young men, and written a thoroughgoing survey of recent Yiddish literature, which he placed in the *Andover Review*. Much of this long essay is sympathetic to the early stirrings of Jewish literature and seeks to show the inevitability of the literature's romanticism, its realism, and even its anti-gentile

nationalism. Berenson evokes memorably a life of "beautiful ritual" and describes how "every picture, fancy, and exhortation that the Old Testament can yield is stamped upon the mind of the Jewish child."[16] At the same time, he carefully refers to Yiddish as "Jewish German," which he does not admit to speaking. And his tone becomes strangely self-alienated when it comes to considering "the puzzling character of the Jews," about which the best to be hoped for is that "we might . . . begin to understand . . . for comprehend them we never shall. Their character and their interests are too vitally opposed to our own to permit the existence of that intelligent sympathy between us and them which is necessary for comprehension."[17]

Here he sounds, in fact, a bit like Isabella Gardner, who often wrote to him in a tone of casual, unguarded envy and disparagement about the acquisitions of Jewish collectors, an envy that was curiously stirred together with a desire to be like these opposing figures. As she put it, in her own fragmentary way, a decade later, in 1897: "I have seen wonderful things in Paris, bought by those Jews, Kann, and Dreyfus. They have had great luck and have packed up and walked off with the things they bought in Italy. Don't you think the best way to do is that. Put the Giorgione in a trunk and presto! Do you fancy they realize how their behaviour appears to an Anglo-Saxon? I have no more illusions."[18]

When Berenson, in his Gardner-underwritten first year, went on to Berlin, he wrote to her of the "beautiful singing" at the great synagogue but felt obliged to criticize "the behavior of many of the worshippers," repeating a friend's remark that the swaying men seemed to be "selling old clothes."[19] It is hard to tell if a gibe like this is more a reflection of her anti-Semitism or of his own discomfort, but such comments were less prevalent in his correspondence with other people.

Berenson did not want to be what later generations would refer to as an "ethnic" writer, and yet he loved and was drawn

to the literature of the new writers in Yiddish. "The Death of Israel Koppel" is clearly his own attempt in this direction, and it is a story that belongs in the broad German and Central European romantic tradition, with antecedents in E. T. A. Hoffmann and Heinrich Heine and leading toward writers like Stefan Zweig and Joseph Roth. Or anyway, it might have taken up such a place if it had been published in one of the better-known American journals. But all the while that Berenson was in France and England, apprising Gardner of the supposed progress of his writing career, Senda Berenson was getting rejection letters for the story.

In January 1888, Berenson went to England. England would always represent for him, as it manages to do for so many people from around the world, all that he was not. He was to go up to Oxford to stay with Edward Warren, but he went first to London for the purpose of outfitting himself with a dress suit, a day suit, a new umbrella, and "an impressive new top hat."[20] He was already planning to borrow twenty-five pounds from Senda but now wondered if she couldn't get some of their Boston friends to add another twenty-five. Berenson almost never considered economizing; he considered ways to find more money. And he was quite right, of course, that Oxford would be much more impressed by his good suit than by his ability to live within his straitened means.

If the beautiful boys in Mr. Christie's art history class had been "gods in the . . . strength and majesty of youth," the young men in Edward Warren's Oxford circle were some very high order of deity indeed.[21] "At first," he wrote to Senda, when he'd been there a month, "the men here dazzled me and I still think they are incomparably finer than any I met in America. They all are well-read, many remarkably so." Once again, however, the aesthetic life seemed achievable only at the cost of the Jewish one. He had made up his mind, he told her, "to toy no more

with things Jewish and Oriental." It had been a waste of "my life and energy," and he wished he "had put it all into Latin and Greek." He went on to define a better program: "If I had a boy to educate he should never learn Sanskrit, Hebrew, Assyrian or any of those barbarous jargons. He should know his classics & his English by heart, and I should take care that until a certain age he should know nothing else." Writing, especially writing stories, was curiously bound up with this self-criticism. "You almost break my heart urging me to write," he told Senda. "I am going through a stage of almost ferocious hatred toward all things literary." And then: "Yesterday I received a pile of Jewish books, and merely to look them over made me sick to fainting."[22]

In the same letter, he told Senda to keep trying to publish "The Death of Israel Koppel"; she was to "send the grave story to 'The American Magazine,'" but he entertained no very high hopes: "when that refuses it," the story was to go to the *Harvard Monthly*, where his junior associates could be relied upon to put it into print.[23] They did, and this was the last of Berenson's published fiction, though the rejection of further stories would continue as he traveled on from England through Europe. "I feel at times," he wrote to Gardner, "that I am going to pieces." But he did not see how to "take these pieces and reconstruct another self out of them." What were his choices? "I have cut with scholarship. I am as yet far from being a writer and farther still am I from having the means or the spirit to be what on the whole I might best be—a man of the world." This was perceptive, and so was his sense of the difficulty: "But you see that is not a profession anywhere, and in America least of all."[24]

By "a man of the world," he seems to have intended a man of taste and means, someone free to pursue the ideals of the English aesthetes, whom Gardner also admired. At Oxford, Berenson was disappointed that Walter Pater, who shrank somewhat from new people, would not allow him to sit in on

his lecture course. Berenson did, however, quickly becoming friends with Lionel Johnson, the person who introduced Lord Alfred Douglas to Oscar Wilde. Berenson was to encounter "the immortal Oscar" many times, and the reported gossip was that he both preened himself on having been propositioned by Wilde, and denied insistently that any such thing had ever happened.[25]

Ambivalence ran through his relationship with Wilde. Much later, after Wilde's trial and his death in disgrace, Berenson wrote in a reminiscence that when he had seen Wilde in 1891, a few years after this first English reconnoitering, Wilde had given him the first copy of *The Picture of Dorian Gray*, which had just come from the press. "The next day Oscar came for lunch, and I did not hesitate to tell him how loathsome, how horrible the book seemed to me."[26] *Dorian Gray* is a story about a man who preserves his youthful attractiveness and his appreciation of art, while the portrait of him in the attic shows his actual hideous corrosion. It is interesting that Berenson found the story intolerable. Perhaps, like Wilde's character, Berenson saw quite a different picture of himself when he was alone in his attic than the one he chose to present to the world. Certainly the way he felt about covering the traces of his own Jewishness resembled the veiling of sexuality common among his English acquaintances.

In 1906, at her request, Berenson wrote a long account of his theories of sexuality for Baroness Léon Lambert, née Rothschild. The prejudice against homosexuality, he explained, was merely a social taboo, but it had weight with him, and he felt he ought to conform to this social expectation as he did to others. "We being social beings, if we act against the taboos of society, we feel, if not at fault, at least singularized, we tend to keep with those who have the same tastes, we grow mysterious, we lose our ease of frank intercourse with the run of mortals, and end by becoming a sort of unnatural abnormal being." This, he

intimated, was the explanation for his own choices. "*I* therefore, with a delight in the beauty of the male that can seldom have been surpassed, and with an almost unfortunate attractiveness for other men, have not only never yielded to any temptations, but have deliberately not allowed temptations to come near me." But he had an affection for whatever his youthful experiences might have been:

> And yet, how well I understand! I have spoken of the facts from the outside. Now let me speak from the inside. When one is young—and *only* when one is young—love possesses one completely. . . . And when it gets to the pitch where union occurs, it is an infinite longing to become one with the beloved, to mingle with in every way, to leave no effort of interpenetration untried.[27]

If, in his early moments of being possessed by love, Berenson had leanings toward men, he seems to have taken toward them the attitude he had at this period toward his Jewish fiction— wiser to keep the inner experience separate from the outer one.

Mary Costelloe, née Smith, the woman whom Berenson eventually married, was at this time already living in England, and so were her parents and siblings. Her brother, Logan, was at Oxford, among a crowd of bachelors who would grow cautious in the years after the Oscar Wilde trial. Logan Pearsall Smith has been described by Hermione Lee as "a fastidious, depressive Anglicised American essayist, best-known for his collections of belletrist pieces, *Trivia* and *More Trivia*."[28] He would later be a significant figure in the Berensons' household and would travel with Edith Wharton, another formidable woman around whom gathered what the Berensons and Nicky Mariano called her "male wives."[29]

Since Logan and his sister Mary had attended that Boston lecture and heard "the sacred word 'Botticelli,'" Mary had

precipitously married an Irish barrister, Frank Costelloe, but then found herself rather longing for the artistic life she had begun in New England.[30] She was always on the lookout for young men who met the description she would use of Berenson: "beautiful and mysterious youth."[31] In 1887, Mary received a letter from Gertrude Burton, a friend of Berenson's, asking what Mary knew "of the aesthetic circle in London" and wanting to know whether she had encountered either Pater or "my friend Bernhard Berenson." Burton rhapsodized, "I believe that he is a genius — but I love him for his beautiful personality, and our friendship is as close as the friendship of two girls and seems to belong to another age it is so spontaneous, so lofty, and so tender."[32] When Gertrude Burton announced Berenson's arrival in England, Mary Costelloe promptly dispatched an invitation to dine. He went on Sunday, March 4, in that spring of 1888.

No record, however, remains of their first encounter. Berenson went on to the continent — to Brussels, Amsterdam, Berlin, Vienna — and Mary returned to the life of politics she shared with her husband. But she did send Berenson the new edition of Walter Pater's *The Renaissance*, which he received in Dresden. (In this new edition, Pater had expunged the famous "Conclusion," with its exhortation to "burn always with this hard, gemlike flame.") Neither of the Berensons referred to this early meeting and exchange in the accounts they later gave of their relationship. They would both describe its beginning as coming two years later, when Berenson returned to England in the first flush of his Italian discoveries. It would be in part because of Italy that Mary would fall in love with him, and it would be in part because of Mary that Italy would mean to him what it did.

When he left England, Italy was but one of the places in which he planned to stop. "For a week I have been careering

about Belgium in search of the beautiful," Berenson wrote to Isabella Gardner, "which exists here, but not in masses."[33] There had not been so very much of art and museums in his letters to this point, but as soon as he crossed the channel, Berenson seemed to emerge, full-fledged, an art critic. He wrote to Gardner of Hans Memling and Jan Van Eyck, and of how, even from looking at the northern collections, he now felt the Dutch painters to be inferior to the Venetians, "the painters *par excellence*, the freest from all affectation, the most sensuous the most beautiful."[34] And all this turned out to be merely preliminary when, at last in early autumn of 1888, he crossed the Alps into Italy.

Italy was Pater's ideal, and Ruskin's; it was Charles Eliot Norton's and Isabella Gardner's. Berenson arrived ready to fall in love. Later, he would write to Mary Costelloe of his first impressions of Venice, how he went, early in the morning, to the great central piazza: "When I . . . had my first look at the campanile and S. Marco I thought they would fall on me. I have read since that blind people suddenly restored to sight feel just so about their first glimpses of the world."[35] The first passion for Italy came in Boston's beloved Venice, but he settled in Florence and spent the winter there. Only rarely in the rest of his long life would he miss winter and the coming of spring in Florence.

The study of painting was in a great flurry of new enthusiasms in 1888. Not only had Jacob Burckhardt (1818–1897) and other German-trained scholars begun to study the intellectual currents of the Italian Renaissance with both more breadth and more detail, but the Italians Giovanni Morelli (1816–1891) and Giovanni Battista Cavalcaselle (1819–1897) had begun trying to be more systematic about the characteristic styles of painters, a line Berenson would pursue through his whole career. When Berenson got to Rome in the winter of 1888–1889, he made a

point of finding Cavalcaselle and shortly afterward sought out Morelli, too.

These two Italian experts had originally collaborated but then had disagreed bitterly; Cavalcaselle thought historical documents were much more important in evaluating paintings than Morelli did. Both men, though, had a significant influence on Berenson, who would eventually own three editions of the multivolume guide to Italian painting assembled by Cavalcaselle and his British colleague J. A. Crowe. Mary Berenson later noted that sometimes they forgot how much of their work was based on Crowe and Cavalcaselle in their "hot partisanship of our adored Morelli."[36] Mary Berenson thought that, for her husband, "the great event of his life was meeting, on his first visit to Italy . . . Senator Giovanni Morelli." This encounter had "turned him from a talented lad with interests pulling him in many directions—toward literature, towards criticism, towards journalism, towards philology—to a man with a definite profession, that profession being Italian Art." She added, "It was through my influence, some years later, that he began to look upon it (rather unwillingly) in the light of a professional career."[37]

Charles Eliot Norton dismissed the Morellian method as the "'ear and toenail' school," but by bringing a scientific spirit of comparison to the study of works of art, the new method actually did allow for great advances in the accuracy of attribution.[38] Morelli noticed that every artist has signature ways of doing small details—drapery, hands, ears—and that distinguishing these traits made a firmer basis for authentication. Although Morelli was interested in a full confrontation with the painting, in which intangibles, too, played a part, it was his feeling that exclusive reliance on vague assessments of quality had made attribution, as Berenson would remark, "more or less of a quack science, in which every practitioner, often in spite of himself, was more or less of a quack."[39]

Berenson was given a letter of introduction to Morelli by another mentor, a German living in Florence, Jean Paul Richter, also a Morellian, and an expert on the works of Leonardo da Vinci. At Richter's, Berenson had seen something that must have been of interest to a young man without resources who liked Europe very much. Richter was both a connoisseur and a dealer: the new, more accurate methods were important not only to scholars but to collectors.[40] The market for Italian art was still small and specialized, and chiefly for a few European buyers, but Berenson was extraordinarily sensitive to changes in taste and finance, and possibilities were in the air. In 1889, Berenson began the merchant side of his career by buying a Bronzino on behalf of his friend Edward Warren. It would be another three years before Gardner purchased her first old master, but Berenson seems to have felt that an American market was coming. In an 1889 letter to Gardner he speculated about his eventual return to the United States: "I shall be quite picture-wise then, not unlearned in the arts, perhaps they will enable me to turn an honest penny."[41]

The rest of that letter was careless: he lectured his benefactor on literature and said airily that he hadn't time to write the novel she expected of him, since "the thousand nothings of the hour have driven every capacity for writing out of me."[42] It appears that his stalwart supporter Warren had offered him a third year of funding. Gardner seems never to have replied to Berenson's letter, and correspondence between the two suddenly dropped off. When, five years later, Berenson wrote again, he was fully aware of Gardner's requirements and took a careful, ingratiating tone.

Assured of funds for the present, Berenson immediately threw himself into connoisseurship and pleasurable travel. He went to Greece and to Spain, and he tromped the Italian peninsula from one end to the other in pursuit of paintings. He rode donkeys up to obscure monasteries and persuaded abbots to

let him have wax tapers with which to examine shadowy frescoes; he went to village churches and to Roman palazzi; he became a regular at the galleries and libraries of Florence. Ernest Samuels writes of this period that "the paintings of the masters and the histories of art became for him a new Talmud, in which the beauty of the visible world was inscribed."[43]

A life dedicated to a vocation should have a scene in which the call is heard, and Berenson's *Sketch for a Self-Portrait* contains such a scene, which could well be apocryphal but was a touchstone for Berenson and his household. The time, he says—and it makes clear that the criticism from Norton marked an epoch in his life—was "two or three years after Norton made his remark on the disproportion between my ambition and my ability." Berenson and his traveling companion, Enrico Costa, also a gifted young Morellian, were sitting "one morning toward the end of May at a rickety table outside a café in the lower town of Bergamo." Berenson was struck with a revelation. He turned to Costa: "I recall saying, 'You see, Enrico; nobody before us has dedicated his entire activity, his entire life, to connoisseurship.'" Berenson noted that there were people who had joined connoisseurship to other professions as "museum officials" or "because they were teaching art history." But he and Costa were to be "the first to have no idea before us, no ambition, no expectation, no thought of a reward. . . . We must not stop till we are sure that every Lotto is a Lotto, every Cariani a Cariani . . . every Santa Croce a Santa Croce."[44]

This is Berenson looking back, at the wistful distance of nearly sixty years, and asserting a purity of ambition, "no thought of a reward," that would have been a very hard standard for his penniless younger self. Later, he might have preferred to forget it, but he had acquired Edward Warren's Bronzino just at this time, and the desires this painting had unleashed in him had been disquieting in the extreme. He would write to Mary Costelloe in 1890 of what he felt while the picture remained

with him: "It almost drove me mad. I could not take my eyes off from it. Every day I saw something more and more wonderful in it. At last it threatened to swallow up the whole world, and I packed it off. It made me understand how easy it was to fall into the collector's frame of mind, which dwells upon the things he owns until it shuts off the sunlight, as it were."[45] What "threatened to swallow up the whole world" was, it seems, not only the Bronzino but the desire to be part of that thin layer of society that owned and traded in beautiful things.

From the beginning of his career, and in his first letters to Mary Costelloe, Berenson felt keenly the opposition between his scholarly projects and the sale of paintings. But as curator David Alan Brown has pointed out in an essay on Berenson's connoisseurship, the separation of the scholar and the dealer really emerged only as there began to be university departments of art history and large museums with curatorial staff: "Berenson was, in fact, the last great representative of a type, the connoisseur-dealer."[46] Whereas earlier connoisseur-dealers saw little conflict between their two roles, for Berenson this would be a raging internal battle, and one that would frequently involve Mary Costelloe. In 1890, Berenson returned to England and met Costelloe again, and it was this meeting that Berenson would later call "the determining factor in the rest of my life and career, lasting fully fifty years and more."[47]

Mary Smith had always been a headstrong young woman, and when she had decided to marry Frank Costelloe, she didn't get noticeably less so. She was a student then, briefly, at the new Harvard Annex (which would become Radcliffe), and Frank Costelloe was a lawyer from England, Oxford-educated, Irish Catholic in background. In Boston for a visit, he had been taken with the young beauty. She had a kind of openness—widely spaced features, a broad humor, eyes that met the large world with amusement. After their initial meeting, she

Mary Costelloe in England, ca. 1890. Biblioteca Berenson, Villa
I Tatti—The Harvard University Center for Italian Renaissance Studies,
courtesy of the President and Fellows of Harvard College.

and Frank Costelloe had an energetic correspondence, on the strength of which she became engaged to him, much to the dismay of her parents.

Mary Smith's parents—Robert Pearsall Smith and Hannah Whitall Smith—were well-known evangelical Quakers. Or rather, they were from old Quaker families and had turned to evangelism in a period of American revivalism, eventually going abroad to work at converting Europe. (The family retained certain Quakerisms, and in her letters, Mary always addressed her intimates as "thee.") Hannah Smith was the author of *The Christian's Secret of a Happy Life* (1875), which goes on being widely read today. She was a powerful matriarch, with a tendency to deplore men and the difficulties they got into. Robert Pearsall Smith was considered a great speaker and proselytizer. He had a gift, his son Logan said, "of persuasion and blandishment, almost of hypnotization." His meteoric career in the European capitals—his picture hung in shop windows in London, the Empress Augusta met with him in Germany—ended quite suddenly when it came out that he had been promoting a physical consummation of spirituality with some of his female subjects. The family retired from its European missions in some disgrace and went back to the United States, where Robert Pearsall Smith proved himself, as his son wrote, "a magnificent salesman" in the family glass factory.[48]

The Smiths gave their children a lot of advice and then did what their children felt like. As a young college student, Mary became enamored of Walt Whitman's poems (a daring taste at that time, and in that family). She decided, impetuously, that she must meet the poet. Her father, having at first demurred, went along on the visit and, having liked Whitman, impetuously invited him to come back with them. The day was fine, the carriage a good one; Whitman stayed with the Smiths nearly a week. That's what the Smiths were like. They advocated strongly against Mary's marriage; she prevailed. Even-

tually, the entire family moved to England to be near their son Logan at Oxford and Mary and her new husband. "Our children are the comet," Mary's mother wrote to her, "and father and I are only the tail, and of course where the comet goes there we *have* to go."[49]

Like her father, Mary Costelloe threw herself into things. His side of the family was given to alternating bouts of mania and depression.[50] This tendency would become more pronounced in Mary as she aged. But even in these early years her proclivity for the all-consuming was evident. She joined her husband's political projects—both were committed to Irish Home Rule, and she campaigned strongly and effectively for his political career. And she also assimilated his religious convictions, converting to Catholicism and agreeing that their two daughters would be raised as Catholics. The Smith parents were upset by this, but religious conversion had been important in their household, too.

Mary Costelloe liked eccentricity, and treated the people she liked with the same combination of advice and indulgence that her parents used toward her. Eventually her delight in unconventionality made her restless in her relationship with the rigorous Frank Costelloe. She discovered in herself a love of the beautiful that seemed to vie with his stern love of the good. She wanted to behold wonders; he wanted to sway committees on workmen's compensation. Whitman, who found Mary delightful and called her his "bright particular star," saw the danger for her that pure political activity might push aside the creative life.[51] He told a friend that she had "almost swallowed the whole camel," and in a letter to her said, "Don't invest thyself too heavily in those reforms or women's movements over there . . . take it easy."[52] She began to go regularly and carefully to museums.

By the time Berenson returned to England, Mary Costelloe's parents had taken a house called Friday's Hill in the

country southwest of London. All the Smiths were gifted at attracting the gifted, and the house became a kind of repository of giftedness. The future philosopher and logician Bertrand Russell, who would later marry Mary's sister Alys, was a regular guest. Alfred, Lord Tennyson was a friendly neighbor. Later, through Berenson, Gertrude and Leo Stein came now and again. George Bernard Shaw was often there, as were George Santayana and various Oxford connections of Logan's. In the early years of her marriage, Costelloe and her children regularly stayed at Friday's Hill, and they were there in August 1890, when Berenson, now an expert in the new scientific connoisseurship, arrived.

Years later, in the chapters she wrote of her *Life of Bernard Berenson*, Mary Berenson reconstructed the scene. In careful preparation for meeting "the already much talked-of Bernard Berenson," she had read a book by George Moore that she thought would be just the thing to talk about:

> Upon this book I turned the conversation as I sat by him the first night at dinner. To my surprise and discomforture [sic] he said, "Oh, that rotten book!" He has since confessed to me that he thought my conversation very silly, but my pink satin dress very becoming. And in spite of my silly and artificial conversation I suppose he must have felt in me a spirit that reached out towards the things he cared for.[53]

Although Mary made light of her own preparations, her biographer, Tiffany Latham Johnston, writes that, in the years since she had first met Berenson, Mary had actually gone through an arduous process of seeking and self-education.[54] Pink dress or no, Berenson was interested in talking to intellectually powerful women, and a great many of the very many women with whom he fell in love were accomplished connoisseurs or writers or archivists or *salonières*, the sort of path Mary Costelloe now envisioned for herself. Her later descrip-

tion continued: "Even my dear Quaker Mother listened to his strange doctrines in admiring silence, and we all ordered large photographs of the pictures of Giorgione and Botticelli. At last I felt I really *was* at the centre of things, not sitting on a bench in Boston listening to a lecture, but partaking, in imagination at least, of the real feast."[55]

The future Mary Berenson was aesthetically discerning, wrote and spoke sharply and engagingly, and had a voracious appetite for talking to talented people. Though younger than Isabella Gardner, she was a bit like Mrs. Jack in offering a combination of cheerful camaraderie and mothering to a long succession of bright young men. Berenson also seems to have liked a woman already belonging to someone else, someone with lovers hanging about. One wonders if he would have pursued Mary Costelloe so thoroughly had she been less thoroughly married. While Frank worked in the office, it seemed natural for Berenson to begin going to the National Gallery with Mary, and when, in September, Berenson went over to Paris, both Costelloes went, too, to be ciceroned around the Louvre by their newfound companion.

In the next few months, Berenson went on from Paris to make the circuit of museums in Germany, Hungary, and Vienna, and he wrote Mary eighty letters, which covered about six hundred pages, several small books of exhortation, devotion, and, above all, descriptions of paintings. He was bursting with the very thing Mary Costelloe found missing in her world, a passion for art. For this most attentive reader he re-created the experiences of standing in front of paintings and he traced the painters' development evocatively, with touches of humor: "As Bacchiacca advanced, he grew colder and colder, until at last he becomes as leaden grey as a sky with a snow-storm brooding over it. His type of face, too, became more and more long and flat-nosed. . . . In his last pictures Bacchiacca is as delightful as a new grave-yard on a dirty autumn day."[56] Mary Berenson said

that later, when she visited these same galleries, she knew all the paintings immediately and could find her way around from having practically memorized his letters. A friend later recollected that she "was the one person in the world" whom Berenson "desired most to educate."[57] He seemed a perfect teacher to her then; there was in him intrepidness, patience, and a delight in adventure that appealed to her very strongly.

The more she read his letters, the more she began to wish to be in Italy, becoming a connoisseur, with him. She copied over a particularly appealing passage in which he described the sort of excursion typical of the connoisseur's life:

> We had to stay two nights at Loreto, for a picture by Lotto we went in search of at a little town near Loreto was locked up. The Canonico had the key in his pocket and he had gone off somewhere for the day. Various people went out to scour the neighbouring villages to find him, and after four or five hours the key came and we saw our picture. It was well worth the trouble, for it was a great beauty, but we missed our train. We drove back to Loreto by moonlight with a couple of big white oxen to pull us up the hill, and lightning storm playing over the distant sea.[58]

The work of the Venetian painter Lotto, the subject of Berenson's first monograph, was an excitement discovered, like many, in part in correspondence with Costelloe. Theirs was a shared education: Mary Berenson was *the* interlocutor for Berenson. Her idea of what to do with that education bore a complicated relationship to his own ambitions. All her upbringing had encouraged the project of publicly persuading others of one's private convictions. It's no surprise that she began prodding him to write for other people about painting.

Certain women found irresistible in Berenson the sense that he was about to become something else, potentially quite

different from what he was. Other women loved that with him they themselves could become entirely new, sensitive creatures, born into the radiant air of Italian paintings. The capacity to convert was part of his character, and his desires to convert and be converted—to ideas, countries, religions, schools of art—stemmed in part from his childhood sense that you really could shed an old world and leave it behind forever. Though, for Berenson, the possibilities of new worlds were frightening, they were also tempting. Mary Costelloe soon had her husband, Frank, convinced that Berenson was ripe to become a Catholic. This became a joint project of the Costelloes. At Christmas in 1890, they went to visit him. And the first conversion was hers: Berenson took Frank Costelloe's wife to see what seemed like every painting in Italy.

Going to look at paintings in Italy, where the pictures often hang in the churches and palazzi for which they were originally commissioned, still has something of the aura of adventure that charmed Mary Costelloe. Pictures were to be discovered—away in the corner of a dim chapel, up a stairway and at the back of a monk's cell—one at a time. "We used to wonder," she wrote, "if Adam had half as much fun naming the animals as we were having renaming these ancient paintings."[59] The world of art was revelatory and sensual: "It seemed to me that we passed through gardens and *poderi* filled with exquisite verdure, and Bernard's eyes were scintillating with that aspiring 'uprush of flame.'"[60] She would not be the last woman to share such moments with him, and this would sometimes drive her wild with envy, but for both of them this first falling in love in Italy was an illuminated, rapturous time. She wrote:

> I do not believe any two people existed in Italy at that moment who were so much under the spell of its beauty, who were so intoxicated with new enchantments of thought and feeling as were the couple who trudged through the rain and

glued their eyes to the "sights" of Rome and Florence—the tall, only half educated young American woman, escaped from a round of philanthropy and politics in London, and breathing for the first time an air that invigorated her whole nature: and the slim young student with eloquent grey-green eyes and dark curls, who was already preparing to be Italy's most enthusiastic lover and interpreter of her art.[61]

The Costelloes returned to England, and exchanged with Berenson impassioned letters, many on the subject of Catholicism. Motives for conversion were several. Mary Costelloe and Bernard Berenson were not yet lovers; he wanted to be nearer her. There was a feeling at that time that the rituals of Catholicism were more aesthetic. Berenson must have known that Isabella Gardner worshipped devoutly at Boston's Anglo-Catholic Church of the Advent. One wonders, too, if for Berenson a certain self-loathing surfaced as he became more involved with the privileged Christian Costelloes. He wrote Mary a strange letter from Naples, in January 1891, in which he described meeting a Dr. Hugo Eisig, "a German, and, as his name implies, a Jew besides." Berenson always gave detailed descriptions of Jewish manners and physiognomies in his letters and diaries, commenting carefully on clothes, postures, even shapes of nostrils, and his uneasiness toward himself is often revealed in these descriptions. It was Dr. Eisig's laugh that made the strongest impression:

> The way people laugh is always appalling to me. Something comes out in their laughter which at times, in some people, sounds to me as if Satan from the bottomless pit was laughing at their best intentions. I never hear myself laugh without having a quick sharp desire to kill myself. Poor Eisig's laugh is of a sort that makes me wish to kill him. It is not only dreadful in itself, but so much like my father's that I can scarcely believe when I hear him that it is not my father. The accompany-

ing expression, gestures, and shape of the head, too, are quite the same. In carriage he is even more like my father, holding himself straight as an arrow. But there the resemblance ends, for my father's face, five years ago, was still beautiful.[62]

The following month Berenson would convert to Catholicism and depart for England, and this passage suggests his self-disparagement, his pride, and his wistfulness at a further turning away from his family: "my father's face, five years ago, was still beautiful."

It was February 1891 when Berenson decided on conversion. He wrote to Mary Costelloe, "How I used to loathe myself for being one of those whom I knew, as Dante describes, Heaven rejects and Hell disdains. . . . How glad I am to take sides, to give up the fancied freedom. . . . I am so sick of constantly questioning my own pulse, and of making believe that I can comprehend the Universe."[63] Berenson went up to a remote monastery at Mount Oliveto, where the devout abbot had previously made a great impression on him. In a peculiar gesture of ambivalence, he took, as a sort of double, his college friend Charles Loeser. He and Loeser had been living in adjacent lodgings in Florence and traveling together in pursuit of paintings, and Loeser was beginning to assemble what would be a famous collection. Loeser was not in the least interested in exchanging his Jewishness for a mystical aesthetic Catholicism. Berenson, though, wrote enthusiastically to the Costelloes of how he felt in the wake of the change: "My blessed Italy is now more divine than ever. I can't tell you how much more *en rapport* with it being truly a Catholic makes me."[64]

Later, as she lived with him and wrote about him, Mary Berenson thought a lot about what this conversion meant to the man who had become her husband and about why, as she laughed about it, "the vaccination . . . did not 'take.'" She saw in it "his love for Italy itself . . . his tendency to lose himself in

beauty," and what she thought was a quality of his, but actually sounds more like one of hers: "his never shaken-off New England preoccupation with religion." There were shades of Marius the Epicurean in what she described as Berenson's "longing to escape from the sordidness of ordinary existence and live in a purer atmosphere." She recognized that the two of them "were drawn together" by "being members of the same Church," but saw that "it was never more than a symbol," which eventually "seemed to fade gently and tenderly from his mind." In a further passage, she observed that after his conversion, Berenson, "turned with even greater zeal than before to Art." And she drew an important distinction between the satisfactions of art and those of religion. Berenson, she felt, "was an extremely self-conscious person, aware to an almost pathological degree, of his reactions, and his nature cried out for firm support in the world outside him." Religion, she thought, "drove him in upon himself, upon the examination of his motives and actions, whereas Art drew him out of himself, made him ask not *What am I?* but *What is It?*" She noted that just before he made the trip to Monte Oliveto he had written to her: "I am sure very much of my love for Italy arises from the fact that it so completely makes me forget myself." [65]

The Costelloes were pleased with their influence; Berenson hastened to meet them again in England. On this visit, he and Mary became lovers. They saw one another constantly through the spring and early summer, and then the two of them went abroad, to study pictures in Paris and Germany. She took a radical step. She left her two young daughters and her husband and she moved to Italy, took an apartment near Berenson's in Florence—for them to live together would have been the end of all social life forever—and began to study connoisseurship with alacrity. Her parents strongly disapproved. She made her

explanation, and it is a complicated one, to her elder daughter Ray, then five and a half, "I love thee dearly, dearly, my precious Ray. . . . Now that I have found studying of my own I really like to do, I do not want to give it up in order to stay with thee all the time." The desire to study was absolutely real, and proved by subsequent years of serious labors in the field of connoisseurship, but she also did not scruple to lay blame for the separation on Frank Costelloe's intransigence, though in fact Berenson did not want her children in Italy: "If thy father would let me have thee always with me, I should be perfectly happy. . . . But he wants you in London. So I go away, and only come home now and then, so that I can go on with my studying."[66] She suffered over leaving her daughters and remained angry with Berenson for not loving her family more and for complaining about her long visits home. But she made her life in Italy, and with him.

It was through Costelloe that Berenson first felt his way into writing art criticism. Although he had meant to begin, he had found it very difficult. Aspects of writing seemed to him antithetical to the feelings he had for pictures. He explained to Costelloe after two hours spent looking at Botticelli's *Primavera*:

> It seemed so much greater than ever, and an everlasting rebuke to people that want to submit art to newspaperology. There is nothing to be said about the "Primavera." You can say that it is beautiful of course, you can call people's attention to the transparency of color, to the half tints of golden cherry and olive green, to the flowers painted in low relief, to the mane-like hair, and a thousand other things, but you can't "give away" the secret of the picture.[67]

Undaunted, Costelloe took over the role of writing-encourager previously occupied by Isabella Gardner and Senda Berenson. She pleaded with him to try to share the secrets of pictures that he had communicated so thrillingly to her.

As often happened for Berenson, Boston exerted its influence. He might have an unconventional companion, but underneath she was a Boston-educated woman from a prominent family. He might be living a hedonistic life of sensory experience, but he would put it to didactic purpose. And he would begin with Boston's favorite city; he would start with Venice.

4

Looking at Pictures with Bernhard Berenson

We must look and look and look till we live
the painting and for a fleeting moment become
identified with it. If we do not succeed in loving
what through the ages has been loved, it is useless
to lie ourselves into believing that we do. A good
rough test is whether we feel that it is
reconciling us with life.

—Berenson, Preface to *Italian Painters
of the Renaissance*, 1952

LOOKING AT A painting was, for Berenson, an experience both sensual and spiritual. In looking at paintings, his divided and contentious soul became resolved, complete, expansive. As a great writer lives fully in language or a great general in battle, so Berenson was alive in every aspect of himself face to face with a painted canvas.

Berenson at I Tatti, 1903. Biblioteca Berenson, Villa I Tatti—
The Harvard University Center for Italian Renaissance Studies,
courtesy of the President and Fellows of Harvard College.

Berenson's talent had a number of dimensions, the first of which was an extraordinary visual memory, in particular for faces. He wrote to Mary, in 1890, from Berlin, that he had recently seen, in a gallery, "two English women who sat opposite to me one night at the table at Perugia two years ago," and that the previous day he'd been passed by a man with whom he'd been on a boat in 1888: "So I remember faces and my brain is peopled with them, faces I know nothing about, but which come back to me so often."[1] These faces that, for most of us, disappear into a blur, hung in Berenson's mind like a portrait gallery. What he saw he could compare, at the level of minutest detail, to everything, painted and actual, he had already seen.

When he was a young man, the precision of his eye accorded well with the new scientific outlook of the times, and he embraced the analogy between deciphering the authorship of pictures and botany. But his understanding of connoisseurship, and of looking, matured with time. His delight in nature, for example, was not in dissection or classification. Taking the same walks each day, he was able to see how the harmonious scene was always a little different: the light, the shades of color, what bloomed and what fell away.

"To my great satisfaction," Mary Berenson wrote, thinking back to her first experiences with him in museums, "he was then, as he has always been, a *slow* looker, willing to give a picture time to make its full impression." His practice seems to have been almost one of meditation: "He always said you could only enter into the spirit of a work of art when you reached the stage of concentration upon it where nothing else, scarcely even you yourself, existed."[2] Mary Berenson wrote that, looking at paintings, he would lose track of all else. "He would hang for hours onto the railings in front of pictures when he was literally trembling with nervous exhaustion," and she would sometimes have to pry him away and persuade him to rest and eat.[3]

Berenson's ideas for attribution came from a combination of quick instinctual understanding and long experience. In describing, in 1927, his internal experience of making one particular attribution, Berenson wrote, "The instant I looked at the fresco with a seeing eye, I mean with all faculties cooperating, I felt that it must be by Antonello." After he had looked "with a seeing eye," he tested his guess against his accumulated understanding. "Such a spontaneous recognition is not yet knowledge. It must first withstand every challenge. Has it got the mood, the music, the *tempo* of the Master? Does it resemble him in essential details?"[4] Essential details came readily from his years of immersion in arcane historical knowledge: the styles of dressing hair in the fifteenth century, the pyramidal constructions favored in certain regional schools. "The mood, the music, the *tempo*," might also be described as the coherence of style.

It is an often overlooked point that when an expert determines whether a certain painting is by Botticelli, this judgment affects not just how we perceive and value a single painting but how we understand Botticelli himself—a man who would, or would not, have made the painting before us. In making attributions, Berenson was characterizing what he thought of as the "artist's personality." Berenson was gifted in discerning coherence in the painted works of a life. More than once, he noticed a pattern of similarity in paintings that had never been associated together; he would group them and give a provisional name to their painter, and then have the satisfaction of seeing the documentation discovered that would affirm the existence of that very man.

When Berenson encountered a new work by a familiar hand, it was grippingly clear to him how the artist's choices and instincts about gesture, feature, color, shadow, spatial definition, narrative, paint texture, and emotional tone *went together.*

"By 'connoisseurship,'" Berenson wrote in another of his *Three Essays on Method*, "I mean that sense of being in the presence of a given artistic personality which comes from a long intimacy."[5] Berenson's identification of a painter often came with the kind of sureness that we might feel if someone familiar walked into the room, and we knew by his movements, the resonance of his voice, the objects he lingered over, the way he addressed us, and the feeling we had, that it could be no one but him.

Memory, historical knowledge, persistence, concentration, the sense of personality—all these aspects of looking were of great importance in the unusually difficult task of attributing Italian Renaissance pictures. In the Renaissance, not only were paintings often unsigned, but frequently they had not even been made by a single individual. Groups of artists worked together, in schools, and devoted themselves to reproducing the effects of their master. Many paintings were done by apprentices and finished by the busy hand of the director. And, contemporary copying was a practice both for study and for the market. To make attribution even more challenging, by the nineteenth century, Italian Renaissance paintings had been restored and retouched, and sometimes forged, by centuries of other, often skillful, hands.

One of the reasons that Berenson's attributions of Italian paintings were, and have remained, persuasive is that he was able to prevent himself from overlooking inconsistencies. In looking at a painting, it is the inclination of the eye of an unpracticed museumgoer to make a work as coherent as possible and to find in it traits that support the attribution it has already been given. The eye passes over any areas where the paint looks different or the shading modulates inexplicably, and it quickly wrestles the painting back into seemly homogeneity. The eye of the connoisseur halts over these roughnesses and seeks their ex-

planation, and the use he or she makes of inconsistencies gives strength and argument to the attribution.

Attribution was the foundation of Berenson's professional career. In the early 1890s — in need of professional standing and financial liquidity, with Mary and Senda both pushing him to write and to earn — he began the three projects he would work on for the rest of his life. These were: writing about painting and painters for general audiences and for experts; assembling vast, encyclopedic lists of who had painted what; and authenticating paintings for the picture trade. He found each of these activities fraught. He saw them all in conflict with one another, and worse still, each seemed to him to pose a threat to the disinterested contemplation of art, which was the closest he felt he came to the sublime.

Berenson did not want looking at painting to have anything to do with the darker or more pitiable aspects of himself, with his anger or bitterness or petty rivalries. He defended his contemplation, furiously, against any incursions. "Paintings," he wrote to Mary Costelloe, "hate people that come to them with anything but perfect *abandon*."[6] For Berenson, in front of works of art, it was troubling to feel his desire to be an authority in the world, or his encyclopedic, record-keeping sense, or his great need of money. He was constantly separating out and setting in opposition to the satisfying and "good" experience of looking at painting various other "bad" enterprises — writing, codifying, dealing — which he claimed he would never have undertaken himself and for which he could instead blame his wife or Joseph Duveen or other patrons and partners. Black was his rage against these defilers of his contemplative soul.

"At moments of conjugal tension," Mary wrote, "I am accustomed to hear that I have ruined his life by turning him from the disinterested contemplation of beauty into its vulgariser."[7]

Over the many decades of their relationship, this account solidified, so that by the time she was writing what in some senses was their joint biography, she was full of self-doubt and justification: "Perhaps I was, after all, wrong, as sometimes, even now, I am charged with having been, to try to turn this creature, so rarely gifted for enjoyment of a not ignoble kind, into the 'worker.'" She takes note of her husband's system of ranking experience: "Not that knowledge did not always interest Bernard profoundly . . . but all this time he had never ranked it above *the real thing*, the *IT*, as he has always called the inward realization of beauty, the absorption of his whole being into the beautiful object." And still she is not sure: "Yet my baleful—if it was baleful?—influence profoundly modified his life, and gave him a secondary 'conscience' about work, and especially about writing that has never ceased to harass him."[8] Troubles of money and writing long antedated the entrance of Mary Costelloe. Berenson had already described to Senda a period when the avidly pursued literary life had made him "sick to fainting," and he had already said to Mrs. Gardner that he intended his connoisseurship to "enable me to turn an honest penny."[9] Nevertheless it became the story between the Berensons that it was Mary who had forced the pen into his hand, as it would always be Joseph Duveen who had hornswoggled him into dealing.

It was in 1892 that everything—the writing, the dealing, the lists—began to take shape at once. Mary, who had put in an appearance in London in December 1891, managed to get her husband to let her take the two girls with her to Florence, and that winter she set up house in an apartment near Berenson's. He was then living in town, right on the river, near the Ponte Vecchio, in a "huge castlelike palace," his apartment "some hundred steps up." From his desk, "as I looked out from work, I could see the crowd streaming across the pea-colored river, and San Miniato lit up by the sunset glow."[10]

In the 1890s, the dust was just settling in Florence after a grimly determined project of civic restoration had destroyed the ancient buildings at the city center. But the Duomo stood unperturbed, its red-tiled dome catching the morning and evening light, and the dusty churches still held their treasures behind massive doors. In the days, Berenson would go to see the Masaccios at Santa Maria del Carmine or the Medici tombs sculpted by Michelangelo. Sometimes he would rest himself and his eyes in the great geometry of Brunelleschi's church of Santo Spirito.

Tourists certainly came to Florence, in numbers, but in the galleries of the Uffizi Berenson could look long and quietly. He did, occasionally, run into other members of the small Anglo-Florentine world of collectors, writers, and expatriates, moderately wealthy American and British citizens who had found they could live well in Florence. Encounters among these sometimes quite uncollegial aesthetes often took the form of mutual quizzing. From the first, Berenson had a sparring friendship with two of the fixtures in the Anglo-Florentine world, Vernon Lee and her companion, Clementina Anstruther-Thomson; this would eventually become one of many angry rivalries.

Berenson, youthful and insistent, with his eloquent gray-green eyes and soft beard, was becoming a person of authority in the galleries and the drawing rooms. He was introduced into the upper echelons of Italian society by the irrepressible Carlo Placci, a close friend and gentleman of leisure who often accompanied the Berenson-Costelloes on their excursions after paintings and who was a great introducer of people to one another. Later Berenson would know well other key figures in this society, like the writer and agrarian expert Janet Ross and the British connoisseur and scholar of Botticelli Herbert Horne, as well as the social butterfly Lady Sybil Cutting.

The Anglo-Florentines rented and bought the charming old farmhouses and villas that clustered along the roads up

through the hills outside Florence. They redesigned their gardens to look like what they believed Renaissance gardens had been and invited one another over to sit on terraces and to dine in the old conservatories known as *limonaia*, which sheltered lemon trees in winter. They gossiped, and they criticized. "Art in their hands," William James noted with amusement while he was living in Florence, "is a mere instrument for indulging self-pride and scorn of their fellow men."[11]

In Florence's more bohemian households, Berenson and Mary were welcome together, but there were still many places where, in her compromised position, she did not feel able to venture. In 1892, he was twenty-seven, she a blooming twenty-eight. William James still thought her "that rare and radiant daughter of Pearsall Smith"; he found her a little hardened by the years but "very handsome." James was a bit dubious about Mary Costelloe's life in Italy, writing to a friend that Costelloe had come to Florence "to sit at the feet of young Berenson . . . the profoundest and most voluminous of the various connoisseurs of the history of art with which the age abounds."[12]

In fact it was Mary Costelloe who had drafted the first version of Berenson's first book, on the Venetian painters, in the fall of 1891. Berenson and Costelloe had spent more than a month together in Venice, and then some time in Vienna, looking at Venetian paintings. The result of these researches was that she wrote an essay which she described as "a very heavy article on 'How to Study the Venetian Paintings at Vienna.'"[13] She sent it, together with a catalog they had been working on of the paintings on view at Hampton Court, to the publisher Putnam's, which eventually turned it down. Mary wrote to her father that "as I was not in possession of sufficient knowledge to do anything else with it, I gave it to Berenson and advised him to make lists of all the genuine works of the Venetian painters."[14]

Berenson did the lists and undertook further revisions with some editorial help from their friends Katherine Bradley and Edith Cooper, an unusual pair of women, an aunt and her niece who lived together and wrote poetry and dramas under the combined name "Michael Field." Bradley and Cooper loved to go to galleries with Berenson and hear his fine flow of speech, but they were more cautious on the subject of his writing and, like many of Berenson's friends, frequently sent correctives. He also mailed a draft to Senda and a colleague of hers at Smith College, asking for their comments, but then was offended when they sent criticisms. Gradually, the essay became a very small book, in which it is now hard to distinguish Costelloe's contributions from Berenson's. The published version is, in some sense, as scholar Paul Fisher has pointed out, a work in which several authors have coalesced into one.[15] The book did, though, have many of Berenson's characteristic turns of thought and phrase. Later, Senda would respond to the published book by wondering if it could not have been even a bit more "personal," suggesting that Berenson's way of seeing could come through more clearly still. "It seems to me that in trying to eliminate 'self' we take away individuality," she wrote, "and as long as the world lives, individuality will mean a great force."[16]

Berenson had a strongly marked, idiosyncratic way of seeing, which at the same time was supported and shaped in collaboration with the women around him. Most of Berenson's friends and lovers were at one time or another pressed into service as editors, Costelloe chief among them. She herself has not been the only one to attribute Berenson's literary insecurity to her own firm style and equally firm criticisms of his; this suggestion crops up repeatedly in considerations of Berenson's work. She did, though, feel that many of the fundamental ideas were his and that he was himself a generous collaborator. She wrote to her mother in 1893: "He has placed at my disposal all

he knows, and has urged me to work for myself and in my own name far more than I have done."[17] Eager for their ideas to take their place in the larger world, Costelloe took the Venetian book back to Putnam's. This time they accepted it.

It seems to have been the understanding of both Costelloe and Berenson that they would appear as coauthors of the Venetian book, and Costelloe wrote to her father, "My idea of course was to have both names," as testament to the fact "that we have been doing serious and scholarly work together."[18] She had written to her mother announcing their coauthored book, but Hannah Smith was vehemently against the joint project, as she was against the unconventional relationship with Berenson more generally. Costelloe's mother believed that a coauthored book would be tantamount to a public declaration that her daughter and Berenson were living as lovers. Mary Costelloe acquiesced and explained the switch to her father: "Mr. Putnam wanted both names, but mother opposed it so decidedly that I yielded the point and asked Mr. Putnam to leave out my name. This I thought was only fair, as the smaller part of the work is mine, and then I am using [Berenson's] notes for the Hampton Court book which is to appear in my name."[19] As this suggests, the catalog of the Hampton Court exhibition would eventually be published under her penname, Mary Logan, but *The Venetian Painters* was given to Bernhard Berenson alone. Ironically, it was the feminist and matriarchal Hannah Whitall Smith who helped to deprive her daughter of a more lasting place as a recognized connoisseur.

The Hampton Court book was quite a success and to Costelloe brought considerable satisfaction. She was writing articles regularly and now had her first major work in the new field for which she had forsaken England and family. The success of *The Venetian Painters*, however, was of a different order. It put Berenson on the map as one of the important young scholars of his generation. Many publications reviewed the book respect-

fully and with interest. (Mary also published a significant essay lauding Berenson's method of connoisseurship.) Putnam's soon asked Berenson if he might do a series of such books. Berenson planned a cycle of four small volumes, organized by geographic region. These eventually formed a primer for educated American and British travelers on how to establish an intimate relation with Renaissance painting and would be the foundation of his reputation; they were sometimes referred to as Berenson's "four gospels." *The Venetian Painters*, and the small books that followed, gave an interested general reader something of the sense that Mary Costelloe had had in reading Berenson's letters. One has the impression of walking through a gallery and of encountering someone of intelligence and fine perceptions who says, "Stop here, have a look at this."

Berenson's early writing about painters focuses more on personality than on brushwork or use of pigment. In some of his astute observations, there is a glimmer of autobiography. Tintoretto, for example, is given as someone "born to the new order of things and not having to outlive a disappointment before adapting himself to it."[20] Lorenzo Lotto is described as depicting "people in want of the consolations of religion, of sober thought, of friendship and affection. They look out from his canvases as if begging for sympathy."[21] Berenson often thought of himself as begging, and he felt a deep personal affinity for Lotto, who seemed to him to see human need in all its variety. Immediately after *The Venetian Painters*, Berenson devoted himself to a monograph on Lotto, and he dedicated it to his first patron, Edward Warren.

Berenson's *Lorenzo Lotto: An Essay in Constructive Art Criticism* was the first extensive study of that painter's work and one of the first of the kind of long monographs on an individual painter's work that have since become standard. After an exhaustive study of the artist's corpus and development, the

book's final section consists of a beautiful meditation on the nature of the interior and the psychological in Lotto's work and makes a compelling argument for what, in fact, modern viewers did begin to see anew in Lotto. "The chief note of Lotto's work is . . . personality, a consciousness of self, a being aware at every moment of what is going on within one's heart and mind, a straining of the whole tangible universe through the web of one's temperament."[22] Here Berenson has given expression not only to what is personal in Lotto's art but also to how internal Berenson's own experience of a painting could be. It was extremely painful to have this book be the subject of a scornful unsigned attack in the influential British literary journal the *Athenaeum*, an attack written, it turned out, by Charles Eliot Norton.

In Norton's short review, he found space to deride the idea of a long monograph on a minor painter, to advise Berenson that he would have done better to write an article than a book, and to ridicule his discipleship in the "'ear and toenail' school." "It is," Norton sneered, "when he approaches the sacred precincts of the 'second phalanx of the thumb' that his marvellous insight is most fully revealed."[23] To Norton, Berenson still stood for the intolerable new methods—whether the scientific classifications of Morelli or the personal responses of Pater—and Paterism, too, came in for its share of biting derision. Mentioning nothing of the heartfelt originality of the author's stance, Norton disdained Berenson's use, in the final section of the book, of language suggestive of powerful internal experience, particularly objecting to Berenson's phrase "cosmic emotion." The review got under Berenson's skin, but when he discovered its author to be his old admired mentor, then, says Samuels, he "realized at last the depth of [Norton's] hostility."[24]

The review of the Lotto book confirmed Berenson in his sense that the world of art reviews and art criticism required

a combative stance, one that may have suited him. Paraphrasing a close friend of Berenson's, Ernest Samuels suggests that Berenson's "passion to share his ecstatic feelings came from a deep-seated drive for self-assertion and intellectual domination."[25] In a way, his codified lists of the attributions of every extant Italian painting were a version of his arguments with all the Anglo-American collectors and experts who flocked to the Florentine hills—with Charles Loeser and Vernon Lee and Roger Fry and Herbert Horne. Berenson's lists asserted that the paintings of the Renaissance spoke first and most clearly to him.

In the Berenson household his compendia were referred to as "the lists," but "the encyclopedia" might suggest more about one of Berenson's greatest accomplishments. Only a man with his rare combination of vision, memory, and stamina could have determined attributions for so many thousands of paintings and drawings, works that had been chaotically misattributed for generations. Art critic and historian Robert Hughes remarks, "No student of Renaissance art today can do more than imagine the obstacles that lay in Berenson's path of connoisseurship. In the age of art history, they have vanished, but their disappearance was very largely Berenson's doing."[26] Berenson made his attributions in a way that offered a consistent understanding, and could be made use of by generations of scholars. In assessing Berenson's contribution to the field, art historian Michael Rinehart writes of "the concept of 'artistic personality'" that "it was Berenson who developed it as a real instrument for organizing, classifying, and interpreting groups of paintings."[27] Berenson's lists allow one to see each painter working within a vast context—leaning on his teachers, collaborating with his friends, influencing his pupils—and they remain at the foundation of scholarship on Italian paintings.

Berenson, who carried the memory of his father's love of

Voltaire, had something deep in common with men of the enlightenment like Voltaire, Rousseau, and Diderot. He thrived on the intellectual pursuits of the *philosophes:* in study he sought to be encyclopedic; in conversation he sought to be paradoxical; in correspondence he sought the world; in leisure he preferred a long, didactic stroll. People sometimes compared the estate the Berensons would eventually own, I Tatti, to that of a Renaissance prince, but A. K. McComb, in his introduction to a selection of Berenson's letters, remarks that "a rather closer parallel . . . must have been that of Ferney." At I Tatti, as at the home of Voltaire, one would have found, "the same cosmopolitanism, the same coming and going of celebrated persons from all parts of the civilized world, the same atmosphere of esprit and 'enlightenment,'" and, McComb adds with a dry touch, "the same centring of attention on the Master of the House."[28]

Berenson's early lists, in which he was extremely stringent about what works he would include, were the means by which he established himself as a force to be reckoned with. His predecessors Crowe and Cavalcaselle had claimed a thousand paintings for Titian; in the list at the end of *The Venetian Painters*, Berenson argued for one hundred and thirty-three. In 1897, there was an exhibit in London of Venetian pictures belonging to English private collections. Although thirty-three Titians were trumpeted, Berenson, in a pamphlet that made him notorious, said only one was genuinely a Titian. The exhibition featured eighteen supposed Giorgiones; Berenson accepted one drawing. Winnowing the numbers down disappointed many English lords with wishfully attributed Raphaels and Giorgiones hanging in their ancestral homes. Henry James, with his great eye for watching Americans making their way in the European world of art, caught the dramatic flair of Berenson's project. In his final novel, *The Outcry* (1911), James told the story of a young connoisseur who bursts into a chilly aristocratic British household and causes havoc by reattributing its

pictures. James's young connoisseur Hugh Crimble is thought to have been based in part on Berenson.

It was, as perhaps will not be surprising, the well-organized Mary Costelloe's idea to keep the lists in the first place, and, perhaps also not surprisingly, the making of them remained divisive between the two connoisseurs. "Thirty years did we keep up a continual fight between my 'pedantry,' as Bernard called it, that wanted a note of every Italian picture wherever we were . . . and Bernard's conviction that a work of art took you to its bosom only when you gave yourself up to it completely without ulterior motives."[29] Later lovers would coax and fight with Berenson on these same grounds. When, in 1919, Nicky Mariano arrived in the Berenson household and gradually transformed it from what was by then a warring dyad into a more peaceful triad, she was also pressed into service on the lists. According to Mary Berenson, Mariano noticed that, when Berenson was writing, he would go into a great rage if no notes were available about a relevant painting, and she took it upon herself to make sure such notes were made. Mary Berenson, in her memoir, describes what their shared efforts were like from then on:

> The visits to galleries were often scenes of strife, the "Maestro" escaping from us, as we carried our notebooks conscientiously from picture to picture, glaring fiercely at us when we broke in upon his musings to ask irrelevant questions as to the authorship of pictures he was not at the moment interested in—all this is most recent history; but its roots are in the past.[30]

The scene is comical, but the lists were serious—all three, Bernard, Mary, and Nicky—believed that systematic, correct attributions were the cornerstone for understanding not only the corpuses of individual painters but schools of paintings, relationships between masters and pupils, and regional styles.

There were many iterations of Berenson's lists; he would re-work them all his life, and Mariano would publish final versions after his death.

The project would not have been possible until the historical moment in which Berenson undertook it. "The hitch," Berenson wrote, "in connoisseurship has always been in comparison."[31] How was one to remember the way that folded rug had looked in a Lotto seen years ago in a faraway city? But two technological advances made an enormous difference just as Berenson began to work: the railroad, which made it easy to see paintings in distant cities within a few days, and the new "scientifically objective" photograph. An innovator in the use of photographs for connoisseurship, Berenson had begun collecting them in his first European journeyings, though they were expensive for his student budget. In a great deal of his correspondence there is mention of photographs—he thanks people for sending them, requests prints, and encloses ones of his own. By 1899, Mary, who indexed the collection, thought they had twenty thousand. Later in his career, he may have come to rely too much on reproductions, but by then his proclivity for collecting had produced a further legacy. At Berenson's death, he left some three hundred thousand photos as part of the bequest of his library to Harvard University.

In 1895, Berenson began, with Putnam's backing, the second volume in his series: *The Florentine Painters of the Renaissance*. This was the volume in which Berenson made his most well known aesthetic pronouncements and began to discuss the formal qualities of painting in the terms for which he became known: "tactile values" and "life-enhancement." It is fitting that Berenson came the closest to presenting a general theory of art in writing about the Florentine paintings that he lived among and knew with such intimacy.

Berenson's task, to explain to a general reader what was ap-

pealing and important about the works of the Florentine Re-
naissance, was more challenging then than it would be now. A
general reader now might have a rough sense of the Floren-
tine school, of the pioneering forms of Giotto and Masaccio
and the radiant works of Fra Angelico and Benozzo Gozzoli.
Names like Fra Filippo Lippi, Domenico Ghirlandaio, and
Sandro Botticelli would be resonant, and the grand finale of
Leonardo and Michelangelo obvious. In Berenson's era only
the last two—Leonardo and Michelangelo—were names ap-
preciated by the general reader. This extraordinary group of
painters—with their mathematical ideas about depth and per-
spective, their rigorous architectural sense of space and sculp-
tural sense of the body, their severe portraits, and the elabo-
rate erudition of their allegories and biblical scenes—are not
easy for a novice viewer to immediately come to grips with.
Berenson and Costelloe found the challenge exhilarating.
"Every day," Costelloe wrote of their long conversations, "we
saw deeper in to the 'why' of real art enjoyment. Practically the
whole will come out in Bernhard's books but I do wish I had
kept a record of our discussions from day to day . . . one of the
happiest and most growing in our lives."[32]

The idea of perception that Berenson and Costelloe were
attempting to define was one suited to the Florentine pictures
they loved, and especially to the changes in perspective that had
been so crucial to the development of that art. In the Renais-
sance in Florence there had been a strong emphasis on turning
the plane of the picture. Paintings were no longer to proceed,
like mural illustrations, along a wall but to face out toward a
viewer. Innovations in perspective allowed a viewer to feel al-
most as if he or she looked into a window in which figures and
landscape receded appropriately to distant horizons.

At the very beginning of his guide to the works of the
Florentine painters, Berenson presented his newly formu-
lated idea of how a viewer perceives artistic work: "Painting

is an art which aims at giving an abiding impression of artistic reality with only two dimensions. The painter must, therefore, do consciously what we all do unconsciously—construct his third dimension. And he can accomplish his task only as we accomplish ours, by giving tactile values to retinal impressions." What was important in the experience of the Florentine paintings was not so much color, which was, in some sense, the *content* of the painting, but our sense of being able to touch the shapes of things, our awareness of form. Berenson asserted, "I must have the illusion of varying muscular sensations inside my palm and fingers corresponding to the various projections of this figure, before I shall take it for granted as real, and let it affect me lastingly." As he put it, "By this means, and this alone, can the art make us realize forms better than we do in life." The understanding of forms gives an "exhilarating sense of increased capacity in the observer." This, Berenson felt, is why we take more pleasure in the painted version of an object than we do in the object itself.[33]

Berenson elucidated this principle as he worked through the Florentine painters from the founder of the school, Giotto, to its culmination, Michelangelo. Giotto, *the* painter of tactile values, had such "a thorough-going sense for the significant in the visible world," and such a genius for rendering only those lines of a figure that brought out its form, that as soon as you saw one of his massive figures, you were "actually realizing it," more quickly than you would a real person standing in front of you.[34] Berenson began his discussion of Michelangelo with a vigorous defense—in the 1890s still a brave stance—of the artistic importance of painting the nude. Michelangelo, he went on to say, was the "most invigorating" of the artists after those of classical Greece. To his "feeling for the materially significant" and his "power of conveying it . . . Michelangelo joined an ideal of beauty and force, a vision of a glorious

but possible humanity, which, again, has never had its like in modern times."[35]

One of the innovative aspects of Berenson's idea of "tactile values" was that it allowed him to connect the experience of seeing works by the masters of the Italian Renaissance with that of seeing canvases by the painters of his own time. In the next book in his series, the *Central Italian Painters*, he would gain the honor of being the first American critic to mention Paul Cézanne in print, writing of him that he "gives the sky its tactile values as perfectly as Michelangelo has given them to the human figure."[36] This appreciation of Cézanne, published in 1897, while that artist was still alive and working, was astonishingly ahead of its time. Berenson admired the works of the French Impressionists, especially Edgar Degas; he wrote a spirited defense of Henri Matisse; and throughout his career, he was engaged with the arts of the Far East. He had the idea that one did not need to be steeped in history or iconography in order to respond to paintings, that the formal qualities of Italian paintings appealed directly to the eye of the viewer, as did Japanese woodcuts and the landscapes of Claude Monet. This was, of course, very like the position that the new French painters had been taking against the grand historical pictures demanded by the French Academy.

That one might look at the construction of a Michelangelo nude and a Cézanne landscape with the same eye would become an accepted tenet of formalist art criticism, which, throughout the twentieth century, remained indebted to Berenson's initial insights.[37] One of those debtors was Roger Fry, with whom Berenson would have a complicated personal relationship. In Fry's later work, particularly in *Vision and Design* (1920) and in his classic book on Cézanne of 1927, he employed concepts he called "plasticity" and "significant form" that drew in part on Berenson's ideas of the "material and spiritual significance

of forms."[38] But, despite the elements of shared conceptual understanding, Fry would be seen as a visionary, the man responsible for converting all Bloomsbury to postimpressionism, whereas Berenson found, to his frustration, that he was more often quoted for his dismissals of the avant-garde.

Berenson's theory of "tactile values" has since been discarded as a sort of late Victorian craze, like those for mediums and table-turning and Fletcherizing one's food. But it offered a general understanding based in an accurate, and illuminating, description of Berenson's own subtle experience of paintings. Kenneth Clark said that, looking at paintings with Berenson, he "could almost see his frail little body reacting physically to the tactile values or space-composition of the work before him."[39] The thought that one could be in an active relationship with paintings, and that having one's own private and profound experiences of them was not just for the rich or gifted but a natural capacity of the human mind and therefore available to everybody, became identified with Berenson. And all of us who have taken quick souvenir photographs in museums and then at home wondered why the record gives so little reminder of what captivated us there can concur that, faced with a painting, one does not merely record a flat image, but instead one seems to enter a world and to understand its space and the weight of its shapes or figures and to feel a sense of movement, both of oneself and of the air.

In the era of intellectual life when Berenson came to prominence, many people were concerned to put the arts and humanities on an equal footing with the sciences, and his was far from the only attempt to find general and physiological bases for aesthetic experience. Berenson's effort came relatively early and reached a popular audience, but he drew on a variety of sources.

One man who was genially pleased to have contributed to Berenson's aesthetic theories was Berenson's old and much-

admired professor William James. James was in Florence for a sabbatical in the winter of 1892–1893 and saw a fair amount of Berenson and Costelloe then. James's recently published *Principles of Psychology* (1890) was being pored over by many in the Florentine hills.[40] In *Principles of Psychology* James argued that "aesthetic emotion" is connected to sensation and that visual perception is linked to tactile and motor experiences. James discussed his own reliance on tracing, or "motility," in conjuring up visual memory. Like James, Berenson worked from a combination of physiology and self-observation. James was pleased with Berenson's work and, reviewing the *Florentine Painters* in *Science*, described it as the "first attempt" at using "elementary psychological categories" for the "interpretation of higher works of art."[41] Later he sent enthusiastic praise of the *Central Italian Painters* to Berenson: "You've done the job this time and no mistake. So full of love for the things you write of, so true psychologically, and then such an English style! it is simply delightful. Of course I like particularly what you say about habits of visualizing etc. in their connection with taste."[42]

In his copy of James's *Psychology*, Berenson had marked up James's passages on "tactile imagination."[43] Berenson wanted "tactile values" to be a way of understanding the formal qualities of painting—their shapes, the contours of which you could also seem to touch—but the word *tactile* was not necessarily the easiest way to bring this formal understanding across. Most people focused on the act of touch in tactility. Many decades later, in 1939, writing respectfully of Berenson's career, *Time* magazine quipped of the effects of Berenson's theory that "naive tourists have consequently stood before masterpieces in the Florence Academy waiting for their palms to tingle."[44]

In a way the word *tactile* might have evoked for Berenson a sort of combination of the conceptual and the emotional—touch has a physiology, but it also has something gentle, ineffable, personal. In his essay on Lotto, published in 1894,

Berenson had written of striving to maintain this difficult combination: "A sympathy, kept under the control of reason, has a penetrating power of its own, and leads to discoveries that no coldly scientific analysis will disclose."[45] This balance, of sympathy and reason—neither of which were the coldly scientific—was something Berenson worked to strike through his whole long life of looking at pictures, and it was a method increasingly difficult to champion in the twentieth century, as a preoccupation with scientific evidence transformed connoisseurship.

Along with studying James, Berenson and Costelloe were affected by the work of a number of other people. He had a prolific correspondence with the two poets who together were "Michael Field." In Florence, Berenson and Costelloe were in frequent, sometimes daily, social contact with other aestheticians and collectors. Long, argumentative discussions went on with the German painter and writer Adolf von Hildebrand, the Italian painter Egisto Fabbri, and the sculptor Hermann Obrist, who was also a love interest of Mary Costelloe's.[46]

Another familiar influence may have been Berenson's sister Senda, whose own researches into the physiology of graceful movement and strength were becoming more interesting to Berenson, after his initial disdain for her having chosen to be a professor of physical education at Smith. After a visit from Senda, some years later, when the Berensons had married, Mary Berenson expressed their shared change of view in her diary: "And her work, the using of bodily exercise as an aid to spiritual development, is wonderful." It was an embodiment of "the real Greek ideal. I do admire her enormously."[47]

Berenson and Costelloe were constant readers of Goethe and were avidly imbibing Nietzsche in the period when the *Florentine Painters* was written. The German critical tradition, and shades of Nietzsche's thought in particular, are present in Berenson's other central idea, that a person looking at paintings could experience a sudden rush of consciousness of his

or her own capacities, which was how Berenson defined "life-enhancement."[48] Working with concepts that were part of nineteenth-century German philosophy and psychology was something Berenson's work had in common with that of William James and with the influential essays of Vernon Lee. Berenson had begun reading Lee's work in college and had praised it in the pages of the *Harvard Monthly*. Lee articulated an idea of what she termed *empathy*—of how a viewer actively projected him- or herself into a work of art or architecture—which built on what German psychologists called *einfuhlung*. Despite her theoretical interest in empathy, though, when Berenson encountered Lee in Florence, he reported to Isabella Gardner an alienation that would recur in his interactions with the experts he might have seen as colleagues. Lee, he said, "not only looked at me thro' the wrong end of a telescope but what is even more disagreeable almost succeeded in making me regard myself quite in the same way."[49] Still, Berenson and Costelloe went regularly to Vernon Lee's and had involved conversations about paintings with her, and Lee was an important goad for Berenson's writing. She once wrote to him, "That is why I want you to learn to write. You do not do justice to yourself. Your conversation, your demonstrations in the gallery are full of suggestiveness and grip; your writings are almost empty of them."[50]

Berenson was at his best when he spoke of individual works and artists, but his ambition was to present general principles that would gain him recognition as a theorist. To do this well, he would have had to draw more carefully not just on the artists and writers among his friends and neighbors but on the more theoretical work being done around him. The German art historian Aby Warburg, for example, also living in Florence at that time, was writing in a suggestive and complicated way about the sense of movement in Botticelli. But, always wanting to place emphasis on the work of art itself, Berenson resisted

the use of historical and documentary evidence and dismissed the kinds of considerations that Warburg brought out about the iconography used both in the images and by the commissioning patrons. Berenson engaged with his contemporaries mostly to refute them. From the philosophers, Berenson could borrow a term here and there, but he had difficulty bringing their insights into his own language. His brother-in-law, Bertrand Russell, remained entirely unconvinced of Berenson's use of William James and urged him to reread the book. "My thinking," Berenson wrote late in life, "is salutatory, inspired, not logical. For which reason I am short of breath intellectually, and have little to develop and argue on any subject."[51]

These limitations were a source of frustration to him; throughout his life, he was conscious of the paucity of both his influences and his own language. At the age of eighty-one, he wrote unhappily of how Heinrich Wölfflin's doctoral thesis "contains in essence and more than in essence my entire philosophy of art." And continued, "He, however, had Burckhardt and Volkelt as teachers, and generations of German thinkers, while I had what? Only Pater. For I had not read anybody else who wrote of art, and Norton's interest was only historical and illustrative." Often he would grow "despondent about my writing" and complain of his inability to render the experience of his thoughts: "If only I could put down on paper what still flashes through my brain, and flashes often enough to convince me something is there worth organizing, composing, and expressing in intelligible speech!"[52]

Berenson's uncertainty about whether he had made his ideas clear contributed to his fury when he felt, as he frequently did, that other people were taking them. Mary Costelloe reported in her diary on gossip brought by a sometime friend, to the effect that "Berenson had a reputation of being a man who could not bear other men, since he was furiously jealous

of their reputations." Costelloe recognized "the justice of her remarks."[53] Indeed, she sometimes contributed to, and was frequently called on to manage in correspondence, the antagonisms and rare reconciliations to which her husband was subject with Roger Fry, Herbert Horne, Robert Langton Douglas, and many others.

With Herbert Horne, who was for some time a close friend, Berenson had a falling out over the attribution of Botticelli panels in the collection of John Graver Johnson (Horne, considered the world's authority on Botticelli, was correct), and the two men were only awkwardly brought together literally at Horne's deathbed by Mary's herculean efforts. Shortly after she succeeded in engineering this deathbed reconciliation, Mary Berenson attempted to patch things up with Roger Fry, but relations there remained distant at best.

The charismatic Fry first sought out the then more-established Berenson in 1898 as Fry undertook a monograph on the Venetian painter Giovanni Bellini. Berenson was warmly receptive. Fry's published monograph contains an acknowledgment of Berenson's "generous encouragement and learned advice."[54] The two men was both personally and professionally cordial for some years—Fry painted an elaborate marriage plate for the Berensons as a wedding gift—but this soured as Fry, with a world of established English families and Cambridge connections behind him, went on to seemingly easy success with ideas Berenson felt Fry had coopted from him. Leo Stein, brother of Gertrude, who would live not far from the Berensons and frequently availed himself of their library, wrote to a friend that one got used to Berenson's egotistical assertions, in which Stein saw some justice: "He will tell you for example that 'Roger Fry is the only man writing decent criticism in England chiefly because he has managed to get my ideas straight instead of mangling them as all the rest . . . do.' But then this is quite true."[55]

For his part, Fry felt he had taken his fair share of knocks for being part of Berenson's camp. When Fry published his monograph on Bellini, he complained that the book was "the subject of a mighty attack from Loeser & Co., who think they will be dealing a blow at B.B."[56] Loeser, as he became more and more of a collector and expert himself, was in an ever-escalating rivalry with Berenson and was frequently named as the head of the faction against him. Loeser, in turn, was in the background of another rupture, one between Berenson and Vernon Lee.

Berenson and Loeser had broken in 1895, but both remained friends with Lee. Then, in 1897, after years of mutual education and admonishment, Berenson accused Lee of having stolen his ideas about tactile values in an essay she wrote with her companion, Clementina Anstruther-Thomson. Their essay was called "Beauty and Ugliness" and in it was developed, with much more detail and many more scientific examples than Berenson himself had used, the idea that, as Lee and Anstruther-Thompson wrote, "the perception of Form . . . implies an active participation of the most important organs of animal life."[57] Berenson, in Saint Moritz, and egged on by his friend Carlo Placci, concocted a withering letter in which he said how pleasant it had been to him to encounter all his own ideas and recent conversations in the essay. A battle ensued in which Mary had to write many hundreds of pages of defensive letters. The Berensons eventually went and examined the notes of their rivals and had to admit that these were substantial, and then Lee and Berenson did not speak for more than twenty years.

To all these quarrels, Berenson brought the fury and ferocity of a Capulet or Montague. He saw the conflicts in quasi-medieval terms, as the warring of clans, a view that would be especially consequential in the case of a later fight with Langton Douglas, which was to go on affecting Berenson's reputation for many decades after his death. Berenson wasn't, though, the only one in Anglo-American Florence to treat the

life of the mind as so many battling fiefdoms. "These people," William James observed, "are eaten up with contempt for each other's blunders, blindnesses, perversities and ignorances. . . . The goal is peace, harmony and easy insight, the way is over rocks of wrangling, bitterness and every repulsive sort of difficulty and pedantry, and personal grotesquery. Yet it *is* the way after all."[58]

The lone individual seemed to Berenson desperately unprotected, and he thought the later Renaissance painters, no longer sheltered by their medieval guilds, were in a position similar to his own. He had written to Mary Costelloe in 1890: "Think of all that has to be gone through before the individual can so tear himself away from the body of his guild. . . . It is to his perdition, generally."[59] He took up this idea again in a passage in *The Venetian Painters* that it is tempting to read as autobiographical: "The emancipation of the individual had a direct effect on the painter in freeing him from his guild. It now occurred to him that possibly he might become more proficient and have greater success if he deserted the influences he was under by the accident of birth and residence, and placed himself in the school that seemed best adapted to foster his talents."[60] Berenson had already begun to see the uneasy liberty of the men and women of the Renaissance as anticipating his own and that of his contemporaries in the Gilded Age.

In his new mode of life, that of writing art books, beginning to work as a dealer, and building catalogs of photographs and attributions, Berenson felt a companionable, religious life, the world of mystical devotion and childlike innocence, slipping away from him. His solitude found expression in an unpublished essay written out at the beginning of a notebook, labeled "1892–1894," that lies in the I Tatti archives. Titled, possibly in Nicky Mariano's hand, "Jewish self-government in B.B.'s childhood," it begins with a lamentation: "I am perhaps

the only living person who can appreciate Jewish institutions as they were in full swing in my childhood."[61]

When Berenson, at twenty-seven, wrote this, both his parents were alive, the Butrymancy Society of Boston was active, and his maternal grandfather appears to have been living in the town still. "The only living person" reflects the profundity of the young man's sense of isolation and his feeling that he carried the whole of that culture within himself and that it would die with him. In fact, this sense of absolute finality in departure was common among émigrés who left under duress and then heard from afar of wholesale transformation.[62] As Berenson took his place in what he thought of as the secular and mercantile picture trade, old customs seemed to evaporate around him. Every transition in life was the crossing of a great divide, and each time the Pale disappeared forever.

Berenson comforted himself by finding reminders of that earlier home in his new life. In the essay on Jewish self-government, he pointed out similarities between Jewish institutions and those of medieval and Renaissance Florence. The central figure of power in his village, as Berenson recalled it, was the head of a group of deputies with a title that in Berenson's hand is difficult to make out but seems to be "*shorshchik*," a man "of considerable arbitrary power," responsible for tax assessments in the shtetl.

> The office was sought for, as it meant comparative immunity from taxation for the *shorshchik*, & his party, & put in their hands an instrument with which to oppress their rivals. Readers of Florentine history will quickly recognize in this a trait in common with Florence under the Medici, who frequently used taxation as a means of reducing their enemies to poverty, & of compelling them to exile.[63]

Participation in these offices of power had created schisms involving Berenson's own family. "Almost within my memory a

shorshchik of my family sent the son of a prominent rival, one who had been a *shorshchik* himself to the army, & so crushed this clan for ever." The consequences of these acts were not to be shied away from: "The hatred, it may well be imagined that prevailed between my own kindred & their rivals was not a whit less than the [enmity] of the Medici, & the Pazzi." Berenson then offers a tantalizing bit of information: "Indeed my kin were never called their real names by the other clan but Shmurgles." About the meaning of "Shmurgles," though, he was coy. "As to the origin of the nick-name . . . I prefer to leave it unexplained."[64]

One has a picture of all these families, the Valvrojenskis and Mickleshanskis among them, scrabbling for the few scraps of power that the Russians permitted the Jews. Nicky Mariano wrote later of Berenson's "suspiciousness" that she "could not help connecting this with generations of ancestors living in small secluded communities, always on the look-out for trouble, for persecutions, for clashes with Russian police or officials."[65] The conflict-ridden world of art critics, collectors, and dealers may have been in some respects familiar.

In the midst of his inward strife with real and phantom enemies, Berenson remained insecure about whether he was in fact accomplishing the brilliant things expected of him by his family, by Harvard, and by Boston. By 1897, when the third small volume in Berenson's series, *The Central Italian Painters of the Renaissance*, was published, Berenson had begun to feel that, despite the admired discussion of "space composition" in that book, he did not have enough interesting ideas to continue this kind of writing, and he had started to see himself as corrupted by his entry into the picture trade. The next books—*The Drawings of the Florentine Painters* and *North Italian Painters of the Renaissance*—would be painful to complete, and from there he would enter into a full-blown crisis that he would manage to resolve only after World War I. Even in his first published

work, there were already suggestions of his divided and self-recriminatory ambition, as he announced at the book's opening: "The Renaissance has the fascination of those years when we seemed so full of promise both to ourselves and to everybody else."[66]

5

Selling and Building: The Gardner Museum and the Villa I Tatti

The one and only real potentate I have known.
She lives at a rate and intensity, and with a reality
that makes other lives seem pale and shadowy.
—Bernhard Berenson writing to Mary Costelloe
of Isabella Gardner, 1897

THE SALE OF AN old master painting is an ethical quagmire. The seller, the authenticator, the dealer, and the purchaser are all constantly being implicated in uneasy compromises and having to fend off worries about forgery, misattribution, gaps in provenance, contested wills, the transfer of works out of their countries of origin, import tax evasion, hasty and destructive restoration, and the wildly fluctuating value of paintings. Everyone involved in the transaction stands to gain the most if the painting is considered to be a great work by the hand of a

master, but no one wants to be caught holding the thing at the moment the tide of opinion suddenly turns.

Faced with a picture, grimy with age and of uncertain attribution, Berenson was beseeched on both sides: on one side stood the importunate seller, often a team of salesmen, all claiming a percentage of the take. As Mary described it to her mother, "I hear the sound of disputing voices out in the hall"; it was "the *'Capo di Famiglia'* and half a dozen antiquarians who are disputing over the price of another Monsterpiece."[1] On Berenson's other side were the clamoring clients. Of one picture, for example, Gardner demanded of Berenson, "Please *grab it.* Don't let any one else have it, and if it really can't be got out of Italy, take it away from him and have it put somewhere in *greatest secrecy* for the present. *Tell no one* and *let no one see it*—please."[2]

Finding the pictures that the collectors wanted involved Berenson in shady worlds now hard to imagine as one stands in front of carefully restored old masters glowing on pale museum walls. Gardner, like many of her fellow collectors, tended to be dismissive of the claims of the country of origin to its treasures. She read with amusement Berenson's accounts of the long drives to cajole intransigent nobles; the canny negotiations to persuade church authorities to accept a good copy to hang for their parishioners while the masterpieces painted for their churches went off to Boston; the excursions to the back-alley workshops of forger-restorers in which sometimes genuine, important paintings were to be found; and, finally, the complicated proceedings to get the pictures across the borders.

In all this, Berenson had a cheerful partner in Costelloe, who sent home ebullient sketches of the daily life of the expert. Writing to her family of a day when Berenson's sister Bessie was staying with them: "Bessie's French teacher called . . . and clashed with a man who had a bronze to sell, who overlapped a dealer with a real Fra Angelico. At the same time two photogra-

phers were working here . . . a man was studying B.B.'s Persian Manuscripts, and some rascals of the fiercest description were trying to sell me a lame horse."[3]

Mary was concerned more about the preservation of pictures than about their geographic location. She had often seen that "here in Italy the pictures are apt to go to ruin from carelessness," and saw no harm in disregarding the national patrimony laws.[4] "I now have a great piece of news for you," she crowed to her family on one occasion, "the PICTURE is out of Italy! . . . Did I tell you my invention for getting it out?" They had had made a large, false-bottomed trunk in which to pack the painting. "To explain the size and shape of the trunk I had a lot of *dolls* made and Signor Gagliardi went as a commercial traveler in the doll trade."[5]

For collectors, and for dealers, part of the excitement of the picture trade was its proximity to scandal. The difference between masterpieces and forgeries, between triumph and humiliation, could be so slight. Isabella Gardner loved the chase and, especially, the conquest, though she did not expect to take any share of possible blame. In a period when American collectors were piling up lumber-rooms full of fakes and misattributed second-rate pictures, Gardner's collection is the record of a long string of daring successes and very few mistakes. But it was a risky trade, and more than once Berenson was closer than he liked to the quagmire.

Berenson's life in the picture trade can be broken into two main periods: the second, from 1912 to 1937, centered around Joseph Duveen; the first belonged to Isabella Gardner and began in 1894. *The Venetian Painters* came out in the early spring of 1894, and one of the first things Berenson did was to have a copy sent to Gardner and to write her a hopeful letter. If his work, he said, "succeed[ed] in reviving some of the interest you once took in me, I shall have had my reward."[6] It had been her

turn to write, five years earlier, after his careless letter putting off the literary life she thought she was sponsoring. But now, pleased that he had made good, she wrote, happily admonishing, as if the silence had been all his fault, "I have heard nothing of you for a long time which was bad of you!"[7] She seems to have gone to some lengths to make sure to encounter him on her next European visit. A change in her circumstances meant that Berenson, who had been just one of her many protégés, was now poised to be a partner in what was gradually dawning as the great enterprise of her life. In 1891, Gardner had inherited $1.6 million from her father, and she had begun, cautiously, to buy old master paintings.

Her first old master purchase, Vermeer's *The Concert*, had cost her about $6,000. In 1892, it was the first Vermeer in Boston and the second in America. Gardner had two of the most important qualities of a great collector—taste and timing. *The Concert* was exquisite, and within a few months a Dutch art expert thought it was probably worth five times what she had paid for it.

Newly aware of the value of expertise, Gardner, in the summer of 1894, sent Berenson photographs and asked him to attribute the paintings they showed. Whether Berenson had anticipated her being a prospective client is not clear, but when he replied, in August of that year, he made a proposal about a painting she might like to buy. This was a picture that would turn out to be of great significance to Gardner's collection, to Berenson's career, and to the annals of American collecting. "How much," he wrote to her, "do you want a Botticelli?"[8]

The painting Berenson was offering, Botticelli's *Tragedy of Lucretia*, is rigorous and austere. It shows, simultaneously, three scenes from the story of the virtuous Roman maiden, who is raped and then commits suicide by dagger. Each scene is framed by carefully defined architecture, which gives the viewer something of the feeling of watching a play on a stage. The

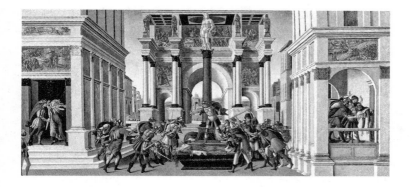

Sandro Botticelli, *The Tragedy of Lucretia*, ca. 1500–1501, oil on wood.
The first Botticelli in America, purchase arranged by Berenson in 1894.
Isabella Stewart Gardner Museum, Boston.

old master picture market was beginning to take off, but Italian pictures were not yet generally in demand, and Botticelli, and this picture in particular, still seemed ethereal and strange. Gardner's interest in the *Lucretia* aligned her with British aesthetes and gentleman-collectors, who were years ahead of the New York millionaires. But to her the price, £3,200, or about $16,000, seemed a large one. In her collecting career, Gardner would learn that hesitation could be fatal. But she had not yet tasted the collector's bitter gall: cabling yes for a painting only to discover that someone else had taken it first. She took her time.

Berenson, though he had been helping various acquaintances to find pictures, was still much more the budding scholar than the great authenticator, and it was as a newly recognized scholar that, in the fall of 1894, he returned to America for the first time since his departure seven years earlier. Despite his recent success, he worried about being swallowed up by the old family life; in his letters to Mary Costelloe, he kept his distance from his family, saying merely that he was relieved to see

that his parents' new home was comfortable, that they were "a good ten times better situated than I ever dreamt of," and that America was "not as apocalyptic as I dreaded to find it."[9] Although he enjoyed walking and driving in the countryside with Senda, his mind was on Europe, and his correspondence with Costelloe and Gardner was perpetual. On November 21, he parted from his family in Boston and embarked for England. Within three weeks, he was in Paris with Gardner, touring the Louvre, and on December 19, she concluded the purchase of Botticelli's *Tragedy of Lucretia*, the first Botticelli in an American collection.

At the time of Gardner's purchase Botticelli was a key figure for Berenson as he developed his central concepts of "life-enhancement" and "tactile values." Writing to Costelloe two days after he had proposed the *Lucretia* to Gardner, Berenson made a strong argument for the value of Botticelli in the terms that he and Gardner thought were most important. Botticelli belonged, not to the realm of art historical pedantry, but to living and breathing aesthetic experience: "To imply in the least that the pleasure I take in Botticelli is in its essence even remotely connected with satisfaction of knowledge seems to me in every way more questionable than my statement that it heightens directly—keys up, fortifies—my capacity *for life*."[10]

The purchase of the *Lucretia* was arranged, as a great many of Gardner's acquisitions would be, through the firm of P. & D. Colnaghi & Co. Berenson had relationships with a number of dealers, but in these years his steadiest was the long and close working understanding he had with Otto Gutekunst at Colnaghi. Gutekunst, whose very name—"good art" in German—seemed to destine him for the profession, had a fine eye for pictures and an enterprising business sense. Altogether Gutekunst and Berenson sold Gardner three quarters of a million dollars' worth of the most spectacular old master pictures.

Sometimes Gutekunst would let Berenson know they had a picture, and Berenson would write an enflamed letter of praise to Gardner; at other times Berenson would hear of a picture for sale and let Colnaghi's and Gardner know about it. Often Berenson would suggest that he was in direct touch with the painting's private owner, keeping from Gardner that she was buying through a dealer at all. Colnaghi's put up the money to secure the paintings, and when Gardner bought, Colnaghi's would pay Berenson a commission. But Gardner, who believed Berenson to be an independent scout working for her, paid him a commission, too. Berenson had begun by charging her 5 percent of the purchase price of a picture. At that rate, the commission from one of Gardner's transactions could be £1,000, in those days the equivalent of roughly $5,000. The Berenson-Costelloe household sent money home to their families and stayed at the Ritz on $10,000 a year. But the fee was actually on the low end in the market. Berenson heard of other agents taking as much as 30 percent. He could have renegotiated his fee with Gardner and ceased to be paid secretly by Colnaghi's, but, curiously, he didn't.

Since at least the time of his youth in Boston, when he kept his family and his social world from knowing much about one another, secrecy played a complicated and important role in Berenson's personality and dealings. He tried to keep his family in the dark as well. At the end of 1895, Berenson had written to Senda committing to sending $500 each year to their parents, and at the end of 1896 he wrote, "In the year that is just ending, I have earned no less than $10,000. This will take your breath away, but it is true. Yet I wish you not to speak of this to the family. My reasons are that their heads may be turned. Mine is not. . . . I allow myself few luxuries except helping the family and one or two friends."[11] Senda, who would, in the summer of 1897, travel with Berenson to Venice and be his guest at the first of what would become his annual stays in Saint Moritz, may

well have thought that her brother's idea of a "few luxuries" was rather an elevated one.

In the middle of 1897, Berenson and Costelloe decided to move to new neighboring villas and chose places quite close to the home of Vernon Lee, with whom they no longer spoke. Mary and her brother Logan engaged carpenters, upholsterers, and gardeners for their Villa Frullino, while Berenson wrote to Gardner sending a floor plan of his villa and detailing delights of decoration: Aubusson carpet, yellow damask, Louis Seize baldachin over the bed. Some of these pieces were familiar to her from shopping trips they had made in Venice. She was "enchanted" by his depiction: "I think I shall arrive and take your room. It is much too good for anyone but me!" she wrote in her bold, enthusiastic scrawl.[12] It was one of the fictions of their epistolary relationship that they lived on a similar plane, pursuing the great with heedless disregard for money, which they, incidentally, had plenty of. The Berenson-Costelloes, anyway, recently had much more than they had had; Berenson's new 1897-style of living came in the year after he made a small fortune from sales to Gardner.

In 1896, Berenson, Gardner, and Gutekunst had the coup of their shared career in the acquisition of Titian's *Rape of Europa*, still considered by many to be the greatest Italian picture in America. The painting shows Zeus, who has turned himself into a white bull, making off with a sensual Europa, whose soft body and white dress are draped across the bull's back. Then, as now, the subject of the picture struck many as an apt representation of what Cynthia Saltzman has called "America's raid on Europe's great pictures." Gardner paid for this masterwork $100,000, which, within a few years, would seem a great bargain. Berenson, as usual, took fees from both Gardner and Gutekunst in the course of the transaction, but Gardner was too busy enjoying her moment of glory to notice anything amiss.[13]

Titian, *Europa*, 1560–1562, oil on canvas.
Isabella Stewart Gardner Museum, Boston.

When the *Europa* arrived in Boston there was nothing re-
motely like it in the United States. "Painters have dropped be-
fore her . . . many came to scoff; but all wallowed at her feet,"
Gardner wrote to Berenson. The purchase had but increased
her ambition for what she called "a *whacker* . . . don't you agree
with me that my Museum ought to have only a few, and all of
them *A. No 1.s.*" She hurried on, "How about the great Velaz-
quez you had in your head for me? Let us aim awfully high."[14]

The thicket of financial details sometimes obscures the
fact that aesthetic and civic aspirations were of real significance
to both Gardner and Berenson. From the beginning, Gard-

ner conceived of her museum as a resource for her city, and for American scholars and painters. For Berenson, Gardner's museum was a chance both to give back to, and to guide, Boston. He never forgot the Boston child he had himself been, a boy hungry for culture, with little access to it. Both Gardner and Berenson wanted to make generally available an experience usually accessible only to the most wealthy and privileged — the chance to be in the presence of great art and to enjoy it simply for its own sake. For them, this was a nearly religious experience. As Berenson wrote, in the hyperbolic praise that Gardner loved, "I know not how to describe you, but a miracle certainly, a goddess, and I — your prophet."[15]

If the religion that Gardner and Berenson were both acolytes of were given a name, it might be called Paterism. Gardner, like Berenson, had read *Marius the Epicurean* early on, in 1886, and afterward wrote to Pater, whom she had met socially, asking him for a few lines that she might put in her copy of the book. Pater's warm note was still there, twenty years later, when she included *Marius* in a select list of the important books in her library. As they built their collections and libraries, and the institutions to house them, Gardner and Berenson were united, as scholar Robert Colby has observed of them, in a very Paterian project: "the pursuit of sensation raised to philosophical significance."[16]

Berenson and those around him saw devotion to art as a way of resisting commercialism, and it was not unusual for them to describe the structures of their lives — the houses they lived in, the calendars they lived by — in quasi-religious terms. In 1897 and 1898, Berenson, Mary Costelloe, and Mary's brother Logan Pearsall Smith published together a few issues of a little magazine called the *Golden Urn*, in which, among other articles, they made a sketch of a mythic place where people such as themselves could live, to be called Altamura. The "high walls" of the place's name were to keep out the baying world, leaving the inhabi-

tants free for a kind of Roman-inspired life of pastoral retreat, pagan pleasure, and contemplations of the soul. These American aesthetes who went abroad—Berenson and Gardner, and people who were soon to be Berenson's friends, Henry Adams and Edith Wharton—wanted to leave behind the clattering of factory towns and the dollars-and-cents talk of American businessmen. The places that they made for themselves—Gardner's museum, Wharton's French houses, the Berensons' villa—were attempts to achieve a new harmony that remembered an old way of life. Unlike Gardner and Adams and Wharton, however, Bernard Berenson was in physical, irremediable exile from his personal history, and this makes the continuity he achieved at I Tatti an all the more unlikely achievement.

Berenson sent the issue of the *Golden Urn* that contained "Altamura" to Gardner with the declaration: "You are the only person in the world who could really live it."[17] Gardner agreed with Berenson, writing to him that she was "the only living American who puts everything into works of art, I mean, instead of into show and meat and drink."[18] To seclude her collection from the commercial world, she decided that, at Fenway Court, there would be opaque walls to face the street, with the revelation of the Italianate interior courtyard hidden until one was well within.[19] The effects of her careful design were such that, as would later be true at I Tatti, Gardner's visitors felt something special in the atmosphere and carried away with them an invigorated idea of how to live. Henry Adams, writing to Gardner of her museum, was to call it "pure Special Creation in an adverse environment," adding, "as long as such work can be done, I will not despair of our age."[20]

Berenson genuinely did want to build a meaningful collection for Gardner and for Boston, but it is also true that he went on being dishonest with her about the prices of pictures. Earlier in the same year that Berenson sent Gardner the *Golden Urn,*

she and her husband, Jack Gardner, nearly caught him doubling the price for a Raphael. Later that year, in October 1898, a letter came from her saying that Mr. Gardner had been hearing things about Berenson and that Mr. Gardner had begun quoting "the differences in prices." About to purchase two Rembrandts and a work by Gerard ter Borch, she wrote, in a serious warning tone, to tell Berenson that her husband was on the lookout for anything untoward. "'Now we shall see,'" she reported Jack Gardner saying, "'if he is honest.'"[21]

Costelloe forwarded the letter to Berenson, who was away, traveling with his future brother-in-law, Bertrand Russell. Berenson saw his life folding up around him. "It wouldn't do to ask for less now," was Costelloe's first advice. "Gutekunst will stand by thee," she wrote, and suggested the plan that they eventually adopted, that they add another person to the deal to explain "the extra."[22] Costelloe had, seemingly, no sense that her own extravagances or ideas of business might be part of the problem. As was her wont, she advised and immediately indulged. Writing again two days later, she hoped it would "be a severe lesson for the future. Not that it is not what everyone does."[23]

Similar situations soon arose around a pair of works by Hans Holbein and the Chigi Botticelli, now one of the prizes of the Gardner collection. In the latter case, Costelloe's solution was to say that the extra money had been an outright gift to Colnaghi's to thank them for their labor. Gardner accepted this, too, but it increased her mistrust of Colnaghi's. Dodging Gardner's suspicions threw Berenson into paroxysms of guilt and despair. Costelloe kept track of the seismograph in her diary: "Business complications with Mrs. Gardner — Bernard was simply awfully worried and felt at times almost suicidal."[24]

Gardner preferred Berenson's account of events. Eventually she would refuse to do business with Colnaghi's, though later, when she looked back, she felt that her acquisitions

through them were "splendid pictures & now in 1909 I can say more than worth the money."[25] In weighing the question of Berenson's legacy at the Gardner Museum, the Gardner's former curator of paintings, art historian Alan Chong, wrote that Gardner might have felt something similar about whatever extras went to Berenson, even if she did not say so aloud.[26] Still, all the while, there was a simple solution, which Gutekunst himself recommended to Berenson: "Might it not be safer and better in future to do business for her openly, for 10 percent or 15 percent rather than take such risks?"[27]

Many possible explanations for Berenson's unwillingness to renegotiate suggest themselves: Berenson was genuinely grateful to his patron, and also Gardner was stingy and might have refused. The record also suggests that Berenson may have found the narrow escapes exciting. Berenson wrote to Costelloe that, after reading Gardner's warning letter, he had gone out with Bertie Russell for the day, and his "mouth was bitter and my heart in my throat, yet I doubt I ever enjoyed more. Strange paradox of sensation!"[28] It's possible that the pleasure of Houdiniesque maneuvers was enhanced in the presence of Russell, who maintained the sort of private condescension toward Berenson that a sensitive-souled person is apt to pick up on. Russell once said of spending time with Berenson, "If only he would not permit himself the physical liberties which Jews indulge in of touching one and putting their hands on one's shoulder and so on."[29]

Perhaps cheating Gardner was a sort of resolution of the painful position Berenson was in with people who looked down on him but made use of his services. In 1899, after another Gardner catastrophe was averted, Berenson wrote to Costelloe: "And thus we great souls and illumined intellects live suspended on the whim of people to whom our secret attitude is to say the least a patronizing one."[30]

A great soul and illumined intellect is not rich from trade;

Berenson wanted to be an aristocrat. And, in an odd way, he was right that if the world did not know exactly where his money had come from, the world would go on thinking of him as a gentleman scholar of independent means. When the writer S. N. Behrman completed his sketches of Duveen in 1951 and 1952, he was very impressed by his interviews with Berenson and seems to have reported Berenson's version of the Gardner story just as Berenson liked it to be told. In Behrman's account there is no mention of fees at all. Behrman wrote that, in Berenson's youth, Gardner had loaned Berenson the money for a second year in Europe and that "Berenson ultimately repaid this loan, and, by way of dividend, helped Mrs. Gardner assemble her collection, which cost her three million dollars. Duveen later offered her fifteen million for it, and the offer was refused."[31] It seems possible that Berenson wouldn't renegotiate his fee with Gardner for narrative reasons: because then this munificent version of events wouldn't become the story.

In 1898 and 1899, when Berenson was repeatedly almost caught by Gardner, he was reading every day in the newspapers about "l'affaire Dreyfus," which had gripped the attention of all of Europe. At the beginning of 1898, Émile Zola had published his courageous "J'accuse," and after that many intellectuals were more and more convinced of what was subsequently borne out by the historical record: that the Jewish army officer Alfred Dreyfus had been maligned by his superiors and was deserving of the later-awarded Cross of the Legion of Honor that described him as "a soldier who has endured an unparalleled martyrdom." Berenson quietly sided with Dreyfus and believed that the accusations of treason against him had been fabricated by French army officials, but Berenson's high-class Italian acquaintances often took the reactionary, anti-Semitic stance. His dear friend Carlo Placci, in these years a regular, often daily, companion, was anti-Dreyfus.

During this period, Berenson seems to have felt closer to two of his friends who were Jewish—Salomon Reinach and Israel Zangwill. Reinach was a Parisian scholar of ancient and medieval art, with a prominent position at the National Museum of Antiquities, who translated many of Berenson's books into French, and placed articles by both Berensons in the *Gazette des Beaux-Arts.* Zangwill was a successful English novelist, whose book *Children of the Ghetto,* published in 1892, had impressed Berenson. He insisted to Senda that she read it, believing it to have caught something important about their own experience of growing up.

In 1898, Berenson and Costelloe stayed for a while in Paris visiting with Reinach where, Samuels writes, "they relaxed in the Dreyfusard atmosphere."[32] Reinach was a leading Dreyfusard, and later the Berensons would dine at his house with Colonel Georges Picquart, whose disclosure of an army forgery led to the reopening of the case. But, the following year, when the subject of Dreyfus arose in the strongly anti-Semitic company at Saint Moritz, Berenson was quiet. News of his silence reached Reinach, and when Costelloe understood what had happened, she relayed Reinach's reaction to Berenson. Reinach had heard "that thee sat silent when the most outrageous things were said about Jews. This seems to Reinach dishonourable . . . he thought thy motive was to 'get in' with those swells, and of course lost his respect for thee," though, she added, "he is personally very fond of thee."[33]

Zangwill, who worked closely with the great Zionist Theodor Herzl, was boisterous, less refined than Reinach, and held quite a different perspective than Berenson did on the prospects of assimilation. Berenson felt that the world was becoming more tolerant; Zangwill replied: "I wish I could share your optimism as to the trend of Anglo-Saxon civilization."[34] Toward Zangwill, Mary Berenson displayed ambivalence. She thought Zangwill was dirty and would, Samuels says, "fumigate

his room" after a visit, but as she wrote in her diary, "he is per-
fectly goodnatured, very kind, extremely witty, large-minded
and sees the irony of things, and he is one of the few people we
can talk freely with and with no fear of being misunderstood."[35]

Although she shared her lover's relief from constraint in
the company of Dreyfusards and Zionists, Costelloe appears to
have been somewhat surprised one day in 1899, when Berenson
listed the people he felt closest to and made a point of including
"Reinach, Zangwill."[36] Others who made the list were not Jew-
ish, like Robert Trevelyan and the writer Hutchins Hapgood;
Carlo Placci was too beloved to be omitted. Part of Costel-
loe's surprise was that Berenson did not include men whom she
thought of as their intimates—especially the German sculptor
Hermann Obrist and the young, aesthetically minded Ameri-
can Wilfrid Blaydes. Mary pointed out to her diary that he had
been quite sympathetic to these men. It seems almost not to
have occurred to her that he would mind her romantic inter-
est in them.

Since 1894 or so, the couple had been grappling with Cos-
telloe's serial infidelity. The pattern of letting an attraction run
away with her—as it had with her first husband and then with
Berenson—persisted. The talented Hermann Obrist, about
whom her diary suggests an affair and a towering passion, was
the first. In letters, Berenson admonished, but he and she both
continued to see Obrist, separately and together. Then, while
Berenson was in America, in 1894, Costelloe spent more than a
week staying at the same hotel in Paris as Bertrand Russell, who
was engaged to her sister, Alys. Mary was pleased to have adjoin-
ing rooms, decided she and Russell should breakfast together,
and initiated a routine of "brotherly and sisterly kisses," which
did not make the absent Alys any too comfortable.[37]

Later, in 1895, in an attempt to clear the air, Berenson and
Costelloe read through the whole of Costelloe's Obrist corre-

spondence together. Even Costelloe was shocked and downcast at how far she had gone and how hurt Berenson was. She wrote in her diary, "To be a person fickle in soul, to have loved once, as I really loved Bernhard, and then to waver, to be unable to hold fast the good thing."[38] From then on his stance toward her friendships with men was critical, and he tried to get her to exercise self-control. After that there was the young Epicurean Wilfrid Blaydes, later a doctor, who was in Florence for a period. Her diary again "glowed with tumultuous passion."[39] When she and Blaydes separated, she turned to Berenson for comfort, which, she said, he was "equal to," though he did say "it was an original situation for *him*."[40]

These romantic complications were part of the background as Berenson and Costelloe responded to the difficulties of Isabella Gardner's warning letters. As soon as he had seen Gardner's first missive, he wrote anxiously to Costelloe, "Could I count on you you would suffice me."[41] She swore that she was "thine in good and bad."[42] Berenson eagerly took up the suggestion of her letters: "This fight will have had its uses if it has succeeded in making you realize that you do love me—at least as one loves the dearest friend on earth."[43] Costelloe replied, "Yes—the danger has done that—it has revealed to me how inexpressibly dear thee is to me."[44] It probably was not good for either of them that the crisis of wrongdoing made Berenson and Costelloe feel that they were at last returned to one another.

While Dreyfus was being tried and Costelloe was having affairs and Berenson was hiding things from Gardner, he went on writing. He added a further concept to his ideas of "tactile values" and "life-enhancement" with his discussion of "space composition" in *The Central Italian Painters of the Renaissance* (1897). Space composition, too, was, in Berenson's lexicon, a property of paintings that had a physiological effect on the viewer. Unlike the surface pattern of composition more gener-

ally, space composition extended "inwards in depth as well. It is composition in three dimensions, and not in two, in the cube, not merely on the surface." The effect, as Berenson understood it, happened in "the vaso-motor system," and the result was that "with every change of space we suffer on the instant a change in our circulation and our breathing—a change which we become aware of as a feeling of heightened or lowered vitality." And, although this may seem overly anatomical as an expression of artistic experience, even a skeptic might agree that, looking at a Raphael, one does have a sensation of "greater freedom" and feel that the painting works to move us away from "our tight, painfully limited selves," and "to dissolve us into the space presented, until at last we seem to become its indwelling, permeating spirit."[45]

As was generally the case for Berenson, he articulated the concept in terms of the works of specific painters, tracing out the idea in a series of aperçus. Writing of Duccio, Berenson drew attention to the way the artist gives us a tender scene and we are "not only brought in intimate relationship to it, but are obliged to become aware of, to attend to, the space as space." Piero della Francesca, whose virtues Berenson was early to recognize, had the ability to bestow on his painted worlds "majestic . . . heroic significance. . . . Impersonality—that is the quality whereby he holds us spellbound, that is his most distinguishing virtue." Perugino: "You get the feeling of being under a celestial dome, not shut in, but open and free in the vastness of the space." And, finally, Raphael, a man "with a visual imagination that has never been rivaled for range, sweep, and sanity." In front of his picture the *Sposalizio*, "you feel a poignant thrill of transfiguring sensation, as if, on a morning early, the air cool and dustless, you suddenly found yourself in presence of a fairer world, where lovely people were taking part in a gracious ceremony, while beyond them stretched harmonious distances line on line to the horizon's edge."[46]

After the fresh revelations of the *Central Italian Painters*, Berenson wrote to Senda that he seemed to have come to a pause. And, faced with completing the series with the *North Italian Painters*, a less exciting group, no new conceptual understanding seemed to arise. Instead, much of 1897 was given over to pleasant travels. Costelloe, as usual, went in the summer to England to be with her family, and Berenson invited Senda to join him at Saint Moritz. He also traveled with Gardner and stayed with her in Venice for a week. But underneath the surface of pleasures, he was working hard. His interest in comprehensiveness was becoming a guiding principle of his connoisseurship and his writing, and it would be the foundation of the book that turned out to be his magnum opus, *The Drawings of the Florentine Painters*.

The Drawings of the Florentine Painters, labored over for many years and published in 1903, is the one work of Berenson's that is still in use among art historians and museum curators. The first of its two massive volumes contains Berenson's prose considerations of the drawings of individual Tuscan painters, organized by style and biographical relationships into twelve groups; in the second are reproduced as completely as possible the drawings of the entire Florentine school, each with Berenson's attribution. No such comprehensive catalog of old master drawings had been attempted before Berenson, who had a spectacular eye for drawings at a time when many had no patience for them at all. The special nature of drawings, the circumstances in which Berenson worked, and the particular outlook and skills he brought to the task made of his compendium a lasting achievement.[47]

Drawings differ from paintings in that they are reliably made by a single hand, often in a single sitting. As is the case with handwriting, in a drawing the lines of pen or pencil are deeply expressive of the character of the individual artist.

Berenson's interest in discovering and elucidating an artist's "personality" was especially appropriate to the study of drawings. The medium of drawing also forced him to avoid two, related, weaknesses. Especially in the latter half of his career, he sometimes paid insufficient attention to how pictures might have been restored, and he relied too much on photographs. Drawings, however, are very difficult to retouch or restore; one can't add on to drawings without the additions being remarkable. And at the time Berenson worked, photographs of drawings were uncommon. Instead, work on *The Drawings of the Florentine Painters* took Berenson to consult the originals in eighty museums and seventy private collections. He used to say that his habit of keeping warm shawls handy dated from the long shivering afternoons he spent in the Uffizi's frigid print room.

More than an arduous feat of comprehensiveness and stamina, though, or an avoidance of the pitfalls of restoration and reproduction, *The Drawings of the Florentine Painters* was a triumph of judgment in the Berensonian manner. All his life, Berenson was trying to join the Paterian idea of elusive artistic "quality," with the Morellian principles of thoroughgoing detailed knowledge. Each of the two volumes of the *Drawings* depends on one half of this guiding pair, and it may be the one time at which an equation between them worked out with full success. In perusing these volumes, a reader can watch the stupendous erudition and precision displayed in the second volume of attributions becoming the basis for the judgments of quality in the first volume of prose and, in turn, see how the judgments of quality organize, correct, and subtilize the assembled knowledge.

From intensive study of individual drawings, Berenson would spin out ideas about how to understand groups of drawings as coherent bodies of work. So, for example, in comparing certain pen sketches to the frescoes for which they were

studies, he noticed that Fra Angelico did the legs of one figure, its form, well in the drawing and less well in the painting, while certain linear draperies that were muddled in drawing had "a flow, a silent speed," in the painting.[48] This suggests that, although it is easy to mistakenly think that Fra Angelico, with all his fineness and delicacy, is an artist for whom line is paramount, in fact, he is more closely cousin to Giotto and Masaccio, one who "turned more naturally to form than to line."[49] A perception like this can transform how a viewer understands an artist's work. Looking in this case more toward form than line, feeling the weight and balance of the figures more than searching for movement, the viewer will see more vigorously and with greater understanding. For experts, observations like these allow for more accurate judgments about what belongs in the canon of Fra Angelico's work. Although the *Drawings* has errors, even ones of large scale, in which whole groups of drawings are misattributed, this vivacity and penetration, the interplay between minute observation and overarching understanding, keeps the work alive throughout.

The Drawings of the Florentine Painters marked a turning point in Berenson's career and in his sense of himself, and it did this in a peculiar and unexpected way. One would have thought that this monumental work would have opened the way to further such projects; instead it was the last work of its kind that Berenson ever undertook. One would also have thought that its completion would be a matter of particular happiness and pride; instead it became a point of severe self-criticism and was the work Berenson referred to as having set his feet on the path of dry pedantry and market expertise.

The change in Berenson's feeling about this project happened while he was still at work on it, in 1900 and 1901, as he entered a new stage of life in several dimensions simultaneously. While he was finishing the volumes, he realized he would have

to seek clients beyond Gardner, got married, refused to have a child with his wife, and moved into the house that would be his home for the rest of his life.

In early January 1900, Berenson wrote to Senda of the *Drawings*, "I have been working incessantly, joyfully," and described his study: "Marius sitting in the midst of the ruins of Carthage may have resembled me for confusion at least." There were "thousands of photographs and hundreds of books," running riot alongside notebooks, cigarettes, bills, carnations, and "a 17th century globe shaped like a chuppah."[50] All three of Berenson's central women correspondents were kept carefully informed of his progress. To Gardner he declared that it would not be long "before I shall take rank as indisputably the first authority on Italian paintings," and, ever-conscious of building the links between them, he added, this "will give a considerable added lustre to a collection I have humbly helped to form."[51] A fortnight later, he wrote to Costelloe: "I feel as dumb as a fish or rather as ruminative as a cow, but also as placid. Just now nothing touches me so close as the question whether certain drawings are or are not by Michelangelo. It would be bliss if I could decide and nothing else interests me half as much."[52]

With perhaps slightly more bite to it, in a further letter to Costelloe, he added, "This morning I got stuck on one of the Oxford drawings. Religious doubts or doubts about a woman's fidelity can be no more distracting than those of the connoisseur while they last."[53]

Berenson's stray thoughts of "chuppahs" and "woman's fidelity" had not come from nowhere; at the beginning of 1900, he was contemplating marriage. Just at the end of 1899, Frank Costelloe had died. Mary Costelloe had gone home to be with her husband at the end, and though something of a reconciliation was effected, his will had not been changed, so that custody for the two girls was unresolved. The girls expected

that at last their mother would take them, but Berenson himself did not want them. In the end, they remained with their grandmother Hannah Whitall Smith. Their aunt, Alys Russell, was a nearby presence. Costelloe and Berenson were now free to marry—this she wanted; he was uncertain. In the end, he agreed for a combination of reasons—"inertia," he would say much later, but also his great need to have her with him, and their longstanding and successful professional association.[54] Passion, however, does not seem to have figured centrally. Costelloe planned that the wedding would be at the end of December 1900, after the decent year of mourning would be over, but, she wrote to Senda, she hadn't yet told Berenson the date, as he was deep in Michelangelo, and "I do not wish to distract his mind."[55]

The families, on the whole, approved the end of the demimonde liaison. Their mothers wrote in two very different and characteristic styles. Judith Berenson began:

> My dear Mary . . . Your dear letter I received. It was a great surprise but a very happy one. It was my wish for a long time that Bernhard should marry. . . . He shows his greatness in that he does not take a very young girl who loves gaiety and forgets her duty to her dear husband. So I am very happy that he has selected a sensible lady who has already gone through a little in the battle of life and will know how to take care of him in an emergency. . . . I need not tell you that he made the best son in the world.[56]

Hannah Whitall Smith's matriarchal comment was from her own perspective: "Frank has been lifted out, so there is room for Berenson and very likely he will be an easier load to pull."[57]

Near the end of his life, Berenson reflected on how the period of not marrying had made secrecy a part of his romantic life, too: "The furtive life Mary and I necessarily lived for ten years before we could marry encouraged a habit of isola-

tion, except with the very few who accepted our situation and with whom we felt free of concealment."[58] One household that had been notably welcoming to them was that of Janet Ross, whose great hillside villa Poggio Gherardo, thought to be the place where Boccaccio had set part of the Decameron, was one of the centers of Anglo-Florentine society. Ross's biographer, Ben Downing, describes the decidedly feminine culture of this society at the turn of the last century and how, from her vantage point at Poggio Gherardo, Ross "stood above the rest, a queen bee among queen bees."[59] Mary, like other intimates, fondly called her "Aunt Janet," and the fact that Janet Ross lived a little further up the road was one of the advantages of the villa that Berenson and Costelloe now, on the eve of their marriage, could rent together.

This was the storied Villa I Tatti that they would eventually purchase and which was to be Berenson's home for nearly sixty years. Set on the road up to the small village of Settignano, I Tatti commanded beautiful views. The villa—an expression of both Berensons' personalities, and of the life they shared there with Nicky Mariano—was to house Berenson's library and to become one of Berenson's lasting legacies as a scholarly center bequeathed to Harvard. Generations of friends and scholars would climb up along the winding road, cut in at the lower gate, and traverse the steep grounds and cypress allée. Now along this road, one passes a marble plaque that lists luminary residents of the hillside: Boccaccio and, more recently, Mark Twain, who stayed at one of the neighboring villas, and, in affectionate conclusion, "Bernardo Berenson."

Mary Costelloe and her brother Logan Pearsall Smith first looked at the house together, and before the move, the two siblings oversaw the initial round of those renovations that were to be a perpetual feature of life at I Tatti. The villa was a sixteenth-century farmhouse, with a chapel built in 1724, and some of its amenities were correspondingly ancient. The owner,

Lord Westbury, had done some nice things with the property but had left the interior of the house in rudimentary condition. Even as renters, they needed new water closets and plumbing, marble statues for the gardens, a new tile roof. At the end of this first round of improvements there was a celebratory dinner for forty workmen. Berenson, preserving propriety, stayed for a month up the road at the Rosses, who, he wrote to Senda, "are spoiling me and I fear when I return to Mary's housekeeping I shall be inclined to be more impatient with it than ever."[60]

The civil ceremony took place on December 27, 1900, and two days later there was "some more hocus pocus," as Bernhard put it to Senda, in the chapel of their new villa.[61] Their close friends Carlo Placci, Janet Ross, and Herbert Horne were there for the wedding, as were Logan and Hannah Whitall Smith and the Costelloes' two children, Ray and Karin. The whole event was very quiet and perhaps seemed more like a formalization than a new beginning. Still, Isabella Gardner was jubilant: "If you two can't be happy together, no one can."[62]

In the months after his marriage, Berenson suffered from a miasmic illness that he referred to as dyspepsia, or neurasthenia. Samuels writes that trying to account for "his unruly digestion, he entertained the fancy that it was the result of his being fed sour bread and vodka as a child, a fancy that in time took on the coloring of fact."[63] This association of childhood and illness came as Mary Berenson argued with her husband that he should come to England for the planned visit of his mother and sister. He went, but the photographs of this family reunion are stiff in the extreme. While there, Berenson spoke very little, refusing to shine in the presence of his too-doting mother, but she was content. "What bliss I had those mornings I could sit beside him and see him eat his breakfast," she later confided to Mary.[64] Berenson's health was very bad during the stay, and the three women persuaded him, perhaps not against his will, to

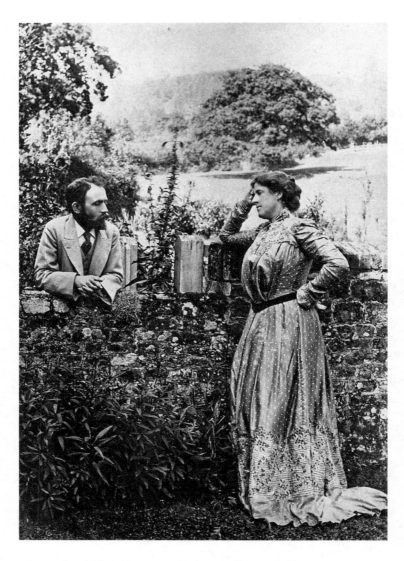

Bernard and Mary Berenson, Friday's Hill, 1901. Biblioteca Berenson, Villa I Tatti — The Harvard University Center for Italian Renaissance Studies, courtesy of the President and Fellows of Harvard College.

leave early and go to rest at Saint Moritz. Mary then patiently took her new mother-in-law around and listened to her lamentations about her son's long exile.

The Berensons' own relationship was more and more built around shared work, while each looked elsewhere for romance. After Bernhard left for Saint Moritz, Mary saw a great deal of a new beau, the dashing Arthur Jermy Mounteney Jephson, who had been a member of an adventurous expedition into the Sudan, about which he had written a successful book. Jephson had been in Florence in the months before their wedding, and Berenson, perhaps as a gesture of his ambivalence, had encouraged the two to go about together and had lent Jephson money. Now he remonstrated. When the Berensons were reunited at the end of the fall, it became clear that Mary was pregnant. Bernhard was not convinced that the child was his, and he never wavered in his position that he did not want children. Mary went back to England to have an abortion.

Mary Berenson's letters from this period do not seem angry about this decision, but she loved children, and the possibility of a family with Bernhard must have been acutely present to her. She did write to him: "Sometime—maybe?—what does thee think? It might be a good provision against dreariness in old age?"[65] In the years that followed, Mary Berenson's feelings for her own children and her passionate attachment to her grandchildren were often a divisive subject between her and her husband. The decision not to have a child together may have added a bitterness to these later arguments.

Mary Berenson no longer really considered leaving Bernhard. She seems to have decided that her life with him was permanent and not to have taken the affair with Jephson too seriously. Jephson did, however, remain in the picture as a correspondent, to her husband's discomfort. The Berensons always communicated all the details of their affairs to each other, and then both sometimes suffered painfully from jealousy. For his

part, Berenson began to say that he might have liked to marry the young and beautiful American heiress Gladys Deacon, who had become a frequent visitor to the Berensons'. Mary found Deacon both bewitching and impossible with "her soft elixir ways."[66]

With his marriage, Berenson may have felt that he had entered another too-tight family circle. He had never entirely gotten over the fear expressed in his college story "The Death of Israel Koppel" that, like his character there, in the presence of a hovering mother, he would be fatefully overcome. For him, a smothering maternal presence was embodied not only in Judith Berenson but, increasingly, in Mary. The pictures taken during the Berenson family visit at Friday's Hill show Mary grown into maturity, while Bernhard has remained a slight, boyish figure. The Berensons' physical ailments and emotional uncertainties had opposite effects on their bodies—within a few years, he weighed 118 pounds, and she 190. In the winter of 1901–1902, after this first difficult year of marriage, Berenson alternated between bouts of working and bouts of illness.

Perhaps the clearest evidence of a change in Berenson's outlook is given by his new experience of working on *The Drawings of the Florentine Painters*, formerly a source of joy. All through 1901, he spoke of the book as an "incubus" that seemed to drag the life out of him. He wrote to Gardner that "with my present state of nerves I would be sincerely happy to die at any moment" and that he would "never undertake so crushing a task again."[67] To his brother Abie he wrote, "It seemed as if the task would kill me."[68] Later, when he wrote of the "huge tomes" of the *Drawings*, he would complain that they had almost buried him and would say that he had spent ten years on them that ought to have gone to books on appreciation and aesthetics.[69] And yet a grudging pride creeps through; the volumes had for the first time included "drawings as an integral part of the art-

ist's creativeness" and had let sketches throw light "on the creative process of the artist as well as upon his individual gifts."[70]

He seems angry with his tomes for having turned him, almost before he saw what was happening, into an expert, just the kind of expert that the new market for old master paintings required. Is it possible, however, that he was angry because *The Drawings of the Florentine Painters* represented, not a path taken, but rather a path abandoned? For he never again pursued a work of like scholarship or managed with such success the double project, the Pater-Morelli unification that gave greatest play to his own unusual talents.

Through the second part of his career, Berenson went on expanding his lists and he became more involved in the market. Samuels points out that when the *Central Italian Painters* was first published it was accompanied by seventy-five pages of lists of pictures and their attributions. When the second edition came out, twelve years later, in 1909, the lists had more than doubled, to one hundred and eighty pages. Expanding and revising the lists was partly a matter of more mature judgment. Initially, Berenson said, he had had the young man's intolerance for lapses of quality in the works of masters and had discounted many genuine paintings. With time, he grew more patient. But the modification of the lists also reflected another shift. Berenson the young revolutionary attacking the holdings of the exclusive British aristocracy was becoming Berenson the respected authority, whose lists were of use to dealers and whose attributions were valuable to the new class of collectors. The changes Berenson made to the lists reflected his wiser judgment, but may also have opened the way for more profitable status for certain pictures. Sometimes it is hard to distinguish motivation from effect.

In some peculiar fashion, *The Drawings of the Florentine Painters*, possibly his greatest achievement, became a receptacle of Berenson's guilt, into which he put his feelings about

his profession in trade, his cheating at that profession, and his directing his creative energies toward a kind of aesthetic book-keeping. The volumes in which he wrote so well came to stand for the limitations and constraints that, despite all his twisting, he could not seem to free himself of. Flashes of anger that he expressed toward the world were closely connected to a sense of inner inadequacy, and he sometimes described these feelings along religious and cultural lines. Years later, in his auto-biographical writings, Berenson described his sense of guilt as "a double dose of Hebraism, an original Jewish one and, piled tower-high above it, a New England Puritan one."[71]

As usual, in the background was money. In 1898, after a sudden apoplectic fit, Jack Gardner had died, at the early age of sixty-one. This was a terrible loss for Isabella Gardner, who had adored her husband and been adored by him. She went into deep mourning. Her financial circumstances changed. When her husband had managed his own investments, they had been very profitable, but now the advisers chosen by his will insisted on conservative choices; there was much less money. She felt vulnerable and began, rather eccentrically, to save money by not heating her house, feeding her guests very sparsely, and burning only short bits of candles at a time. She did go on buying pictures, but she was primarily focused on building the museum that had been a project shared with her husband and was now to be a kind of memorial. By the middle of 1899, Berenson could sense that his best client was moving on, and Gardner repeatedly turned down his offerings of paintings in the pivotal years up to 1903. For her part, Gardner and her long-suffering architect, Willard Sears, were hard at work. She was down at the construction site nearly every day. She fought building inspectors to prove that marble columns would indeed support a heavy load, invented a new sponging technique to make the painted walls look like marble, climbed up on ladders to coach

Isabella Gardner on a ladder during the construction of Fenway Court,
ca. 1900. Isabella Stewart Gardner Museum, Boston.

workmen on hewing beams, and brought her lunch in a pail to
eat with the laborers.[72]

Gardner had always intended for her collection to be a pub-
lic museum, but hers, as Berenson had found, was a demand-
ing benevolence. When the museum opened its doors in 1903,
the public was to be allowed in on only four days a month and
was charged a dollar a head. After an incident with a tapestry,
an ambitious woman, and a pair of scissors, Gardner began to
prefer that the public should consist of vetted Harvard under-
graduates. Gardner had avoided the then-draconian customs

payments in part by declaring that all the works were intended for public display. By 1908, customs officials felt the museum was still essentially a private collection, and eventually Gardner paid $350,000 in taxes and fees. Still, in many of the ways she cared about, the museum *was* an offering to the public. Its great rooms of Italian masterpieces, its long stone, tapestried concert hall, and its salon with the glorious Rembrandts and the Vermeer were a respite for the aesthetically sensitive in the busy world. William James observed the unusual effect of the place, one still noticeable even today: it made its visitors "quiet and docile and self-forgetful and kind, as if they had become as children."[73]

In 1902, when Berenson had written the last pages of the *Drawings*, he went to England to shepherd the book through complicated negotiations with printers, lithographers, and expense-conscious editors. England went on being the place of Mary's allegiances and Bernhard's rejections. But an opportunity seemed to arise when a group of men, including Roger Fry, now established as an art critic, asked Berenson to be part of a new art magazine, to begin publication the following year, and to be called the *Burlington Magazine for Connoisseurs* (a magazine still in existence and among the most respected of art historical journals). Berenson put up £50 and was pleased when an article of his, well illustrated, was the lead in the first issue.

Quickly, though, controversy broke out. Enemies that Berenson had antagonized—in particular, the rival connoisseur Langton Douglas—were ready to bring the fight to this new territory. In the pages of the *Burlington*, Berenson and Douglas both claimed priority in the scholarly appreciation of the paintings of Siena, and in particular of the Sienese artist Sassetta. Berenson, initially quite dismissive of the Sienese school, had gotten more and more interested in it. Late medieval Sienese painting seemed to him to embody "quality" and "the spiritual"

in ways that his work on *The Drawings of the Florentine Painters* had made him want to define and grapple with. Mary noted to her mother that "it is a new departure for him to be looking for expression and 'soul' in pictures."[74]

It was also a matter of some pride that the Berensons had lately spotted panels of a great Sassetta altarpiece in a little "hole-and-corner" shop and had purchased them for about four hundred dollars.[75] These panels became a central treasure in their collection.[76] It was thus somewhat galling that the *Burlington* published an article by Douglas about Sassetta before Berenson had a chance to get to it, more galling still that the editors had checked this article with Mary Berenson but she hadn't thought to pass it on to her husband. Then insult was added to injury. Berenson wrote a long two-part meditation on Sassetta for the *Burlington*, and one of the magazine's other editors allowed Douglas to add sneering annotations to it before it was published, and to write a riposte afterward. Berenson could hardly feel that he was being accorded much respect in an enterprise in which he had been told he was to be a significant figure.

The *Burlington* wranglings had large consequences. Berenson came to distrust Fry, whom he would later class among "the most perfidiously hypocritical of my enemies"; he left the magazine; and he concluded that there was no place for him as an art critic in England.[77] In her family memoir, Mary Berenson's granddaughter Barbara Strachey notes that "the unfortunate episode left Bernhard with one of his almost irreversible rancours against both Fry and the English art world."[78] Berenson had also left himself with enemies who were on the qui vive for errors that he might make in attributions or in the business dealings that were to take up more and more of his time and effort in the coming decades. Criticisms and accusations from Douglas and others would lay the groundwork for battles that went on with Berenson's shadow long after Berenson's death.

For Berenson at the time, his exit from the *Burlington* seemed like one more sign that he couldn't rely on institutions or colleagues and would have to take care of himself. Money was a pressing issue. Family ties strained: the new business venture of Berenson's brother Abie (for which B.B. had guaranteed the loan) did not seem to be going well; the other Berensons in Boston depended on remittances; Mary Berenson felt increased obligations to her daughters and family. Isabella Gardner was not buying, and the market was tightening up.

Gutekunst, who had all along been pragmatic about their good fortune—"make hay while Mrs. G. shines," he had advised Berenson—was ready to pursue other avenues, and somewhat surprised that he heard less and less from Berenson.[79] Berenson may have felt a bit distrustful of Gutekunst. In April 1901, Berenson had sent Mary to meet with Gutekunst and propose a possible partnership that would allow them to, as she put it, create "a corner" in Italian pictures. Berenson felt, according to Mary, that he "must be connected to someone who *has* a market," but the plan for a partnership with Gutekunst came to nothing.[80] Berenson would continue to cast about for a secure place for the next decade, when he settled into a working pattern with the man Gutekunst called "the 'Anti-Christ' Octopus and wrecker Duveen."[81] For the immediate future, though, a trip to America to rustle up business seemed unavoidable.

Mary Berenson, who had long advocated such an expedition, secured passage. They left Liverpool on the *Majestic* on September 20, 1903. It was to be a triumphal and in some ways transformative tour. They took in, according to Samuels, "New York, Boston, Chicago, Detroit, Cleveland, Buffalo, Pittsburgh, Philadelphia, Baltimore, Washington, and cities in between."[82] When Berenson had gone back to America in 1894, just before Gardner bought her first Botticelli, he had been a promising art critic and had spent much of his time in Boston, with his family.

Now, as a passion for collecting old masters began to take hold among the recently, and enormously, wealthy men and women of American cities far from Boston, Berenson found that he was becoming a figure of consequence. "They take it for granted here," Mary Berenson wrote in her diary, "that he is honorable and learned and sincere whereas in England from Roger [Fry] down they take the opposite for granted and of course in Germany and Italy and France he is much more loathed than liked. To be always on the defensive is extremely disagreeable, if you care at all and he seems to care." [83]

In America, Mary Berenson herself was a significant attraction. She developed a series of lectures out of the material of connoisseurship, which she delivered to huge audiences (sometimes of a thousand or more), and to great acclaim. Altogether she gave nearly twenty lectures in America. [84] These offered an important education to American audiences and helped to establish the authority of both Berensons with the new collectors. Over the next decades, Berenson would bring the same acumen to righting American collections that he had previously brought to bear on those of the British nobility. He ruthlessly weeded out forgeries, copies, and school pictures while correctly attributing to interesting but more obscure painters works that millionaires hoped were Leonardos. [85]

If, in general in America, Berenson was treated as "honorable and learned and sincere," in Boston, he still found it hard to be taken seriously and in an unprejudiced way. His acquaintances there did not forget his origins. The painter John La Farge, having liked Berenson, wrote to Henry Adams to urge Adams to receive him in Washington and, teasing Adams about his attitude toward Jews, added, "knowing your love of the race." [86] Later, when Adams and Berenson were quite good friends, Berenson would remark that Adams "was always more embarrassed than I was that I happened to be a Jew." [87]

Berenson also had problems with the next generation of

Nortons. Richard Norton, the son of Charles Eliot Norton and himself an archaeologist and occasional dealer in Italian works, was spreading rumors that Berenson had acquired a forgery for the American collector Theodore Davis. This was the so-called Donna Laura Minghetti Leonardo — one of two would-be Leonardos that were to cause Berenson difficulties in his career.[88] It was true that Berenson had not, at first, contradicted the attribution of his mentor, Morelli, who had owned the painting and claimed it, perhaps facetiously, as a Leonardo, but Berenson did discover his mistake, and it was not true that he had profited by the picture's sale to Davis. He had sometimes advised Davis but had no role in this particular transaction. So significant was the fear of being associated with a forgery that Mary Berenson wrote to Davis asking him to make a public declaration that Berenson had not been a part of the purchase. Davis wrote a letter to the *Nation* at the beginning of 1904, shortly after the Berensons had returned to Europe, with the salutation "My dear Berenson," in which he affirmed, "You had not the slightest connection with the purchase and did not know of it till some weeks thereafter, when I told you."[89]

This was in the background, as the Berensons spent a chilly hour visiting with Professor Charles Eliot Norton. Berenson noted that, of all the libraries they had been to, Harvard alone had yet to acquire his recently issued and magnificently published *Drawings of the Florentine Painters*. One of the people they met at Norton's was James Loeb, a retired banker who was later to found the Loeb Classical Library. Mary's response to him, recorded in her diary, suggests an atmosphere of Anglo-Saxon gibes. She saw Loeb as "a handsome, fat, prosperous philistine Jew" who, as she wrote to her mother, "is in with all the rich Jews in New York, and as we want to be in with them too, his acquaintance is a good beginning."[90]

In her crass way, Mary Berenson was noting the same sort

of social dynamics that Edith Wharton would make the subject of *The House of Mirth*, published in 1905, with its figure, Simon Rosedale, a "prosperous philistine Jew," attempting to make his way in New York social life. Jews might not be acceptable among certain New York families, but the nature of wealth and the patterns of its prejudices were changing. In America in the first decade of the new century, money, and art collections, might still be inherited, but more than that, they were to be *made*. Self-made men, unlike the Nortons, were not necessarily committed to preserving culture from grasping immigrants, and it was these men who were now in control of the financial and art markets.

By the turn of the century, "the art buyers," as Gerald Reitlinger, author of the classic work *The Economics of Taste*, pointed out, "were no longer the nobility, whose fortune was frozen in entailed lands, but great merchants, industrialists and bankers, who could realize their capital."[91] The railroads were the single greatest force in the development of international financial capital in the latter half of the nineteenth century. The price of art went up in tandem with the value of railroad stock, and the highest prices for pictures came when that wealth began to concentrate in the pockets of men like J. P. Morgan, Henry Clay Frick, John D. Rockefeller, and Andrew Mellon. Of course, it was still true that many of these men did not particularly like associating with Jews, but they wanted the best pictures money could buy. Some of the new industrialists and bankers would be among the most important contacts Berenson made on this trip, and they would be central clients when, a few years later, he began to work with Joseph Duveen.

If you are about to begin collecting mysterious four-hundred-year-old paintings that are easy to forge and hard to tell apart, and you have in view that you'd eventually like to

build a museum in your city and help to furnish it with pictures, then when the man who has written the books everyone refers to on Italian paintings comes to town, you invite him to dinner.

Bernhard Berenson, at this time thirty-eight, made an elegant guest. The dark curly hair had thinned and receded and was cut close, the high brow was distinguished, and the mouth had a firm set to it. Carefully tailored suits hung well on his narrow frame. Mary, though, had become rather larger and was troubled by the necessity of trying to find the right sorts of dresses, though she tended to be amused by the sartorial excesses of the Americans they met. At one dinner, in Chicago, Mary was told the assembled company were worth $900 million. "Alas," she wrote to her family, "human imagination (all accept Mrs. Gardner's) is so poor that all they can think of doing with all that vast sum is to eat, night after night, the most elaborate deadly, wildly expensive dinners, and to let their wives blaze out into jewels and wear dresses so frail that one evening's use finishes them."[92] Gardner, who had come out and met them in Chicago, was also present, and Mary delighted in her unconventional gorgeousness: "She wore on her head two immense diamonds . . . sparkling and quivering with every movement. They were like a butterfly's antennae."[93] In Chicago, the Berensons were a great success; Mary lectured to packed houses, and both were feted and toasted and asked for their expert opinions.

As the Berensons' American tour progressed, several avenues of work suggested themselves. Berenson entered into a financial understanding with the dealer Eugene Glaenzer. The Berensons met (and encouraged toward buying Italian pictures) some of the biggest collectors: Mrs. Potter Palmer and Charles Freer, John Graver Johnson and Peter Widener. And an exciting possibility developed that Berenson might be asked to be the director of the Metropolitan Museum in New York.

"With so many fish biting at our hooks, it will be odd if we don't haul some to shore," Mary wrote to her mother.[94]

Berenson knew that if they were opening a new, and possibly opulent, chapter of their lives, they were also closing one. Helping to build the collection of the Gardner Museum had given him a relationship to Boston which he never ceased to seek, and that project was essentially complete. On their first swing through Boston, the Berensons had stayed with Gardner, but she held off showing them Fenway Court to get them to return and prolong their visit. Gardner's eccentricities were coming through more and more fully. Although she was very glad to have the Berensons with her, she refused to burn any coal and had maids follow them around the house switching off the gas and putting out the candles they lit.

The Berensons returned later in the fall, and on November 14, 1903, Gardner threw open the doors of her museum to them. It was an emotional moment. Then, as now, from the street one saw only the imposing, closed stone facade. It was a delightful surprise to enter the central courtyard, lush with greenery and sibilant with fountains. Then, too, one stood in the arcade of the courtyard and looked upward at the massive walls with their arched gothic windows giving on to the galleries. Gardner had arranged the galleries themselves to give the sense that the paintings were her intimates. Underneath the *Rape of Europa* that had been Berenson's greatest offering to her, she had hung a panel of brocade made from one of her own gowns.

For the Berensons, the effect of seeing all their work assembled was powerful. Mary Berenson confided to her mother, "We were quite overcome." She felt that "the whole thing is a work of *genius* . . . they ought to pardon her everything for the beauty of it and her generousness in making it to leave to Bos-

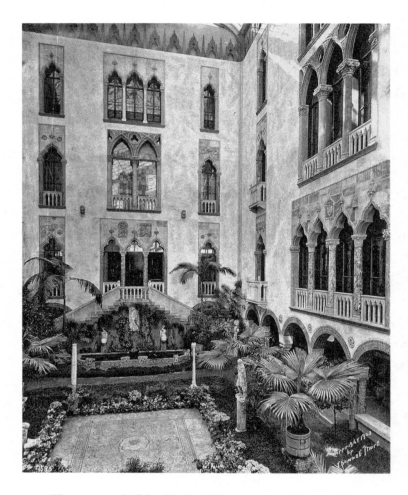

The courtyard of the Gardner Museum, 1903, photograph by
T. E. Marr and Son. Isabella Stewart Gardner Museum, Boston.

ton."[95] In her diary, Mary expressed similar sentiments: "In beauty and taste it far surpassed our expectations, which were high. There is very little to find fault with. . . . One room is more entrancing than another, and the great masterpieces of painting seem mere decoration in the general scheme. I thought there was remarkably little that was not of Bernhard's choosing, but that little annoyed him immensely and hurt him too."[96]

There were a few dark moments when Berenson caught sight of one of these intruding paintings. As, for example, when he saw, across from the Botticelli *Madonna and Child of the Eucharist*, which is one of the great works by the master, another painting attributed to Botticelli, which Gardner seemed to have gotten through Richard Norton and which Berenson had refused for her two and a half years earlier on the grounds that it was a mere school picture. He was weak in the knees to think that he would be blamed for Norton's mistake. When he said something to Gardner, she replied curtly that it couldn't be the same picture, she'd had this one for years, and said not another word about it. If they saw the forged Cellini chalice that Norton had gotten for Gardner and which Gardner had put next to the genuine Cellini bust that Berenson had helped to arrange for her to purchase, it isn't mentioned in Mary's recounting of the visit.[97] Mary later reassured him that really Gardner had done extremely well, given that "every dealer in the world, professional and amateur, has been after her all these years."[98]

For two such perfectionists as Gardner and Berenson, the grumbling tour of the museum may be taken as one of the pinnacles of satisfaction in their shared enterprise. In 1903, the National Gallery in Washington was thirty years away from construction, and the Metropolitan Museum in New York had, as Roger Fry would soon be pointing out, "no Byzantine paintings, no Giotto, no Giottoesque, no Mantegna, no Botticelli, no Leonardo, no Raphael, no Michelangelo."[99] Along with her Titian, Gardner had both Botticellis and Raphaels. With the

exception of the Jarves pictures, tucked away in New Haven, there was nowhere in the United States to see the kinds of paintings that Berenson and Gardner had brought together, and no American museum experience offered such a complete immersion in sensibility.

The stone palazzo full of masterpieces lingered in Berenson's mind. In May 1904, when they had been back in Italy for a few weeks, Mary Berenson wrote to Gardner that B.B. had begun to think of building a Boston monument of his own, although, fixed in Florence, it would reflect his outsider's relationship to the city of his youth. He now spoke of "leaving his collection and his library to Harvard."[100]

6

The Picture Trade: Joseph Duveen,
Belle Greene, Edith Wharton

My career has followed from my being
regarded (even by my worst enemies) as the
safest attributor of Italian paintings.
—Berenson, *Sunset and Twilight*

IN MARCH 1904, the Berensons returned from their
American expedition and immediately flung themselves into
hurried and passionate distractions. Mary Berenson was in and
out of England, while Berenson dashed off to Paris and began
an affair with Lady Aline Sassoon. Sassoon was a Rothschild,
a salonière, and the person who would eventually introduce
Berenson to Joseph Duveen. The fourth book in Berenson's
series, *North Italian Painters of the Renaissance*, was long over-
due—seven years had elapsed since the last volume—but he
couldn't settle down to work. His friends among the European
elite were hurtling around at the new top speeds made possible

by automobiles. If you weren't motoring, you were buying, and if you weren't buying, you were getting your loot home. It was a time of hectic ambition and nervous strain. Later people recalled the decade before the war as a peaceful and optimistic period, but at the time many acted as if in a frenzy. It was to be one of the most difficult periods of Berenson's life: he would have his most overwhelming, and frustrating, affair, with Belle da Costa Greene; he would find writing excruciating; he would begin to be employed by Joseph Duveen; and, when war came, he would be forced to reinvent himself again.

By 1905, the crisis of self-definition was well under way, and Berenson framed it as another adolescence, a period of piecing himself back together such as he had faced when he arrived in England in the year after college. From Saint Moritz, where he had taken shelter from his own storms, Berenson wrote to his poet friends who shared the name Michael Field:

> So while I am very ill at least I am far from unhappy over my present almost adolescent indecision, yearning, blindness and hope. I want the future to be much more than the mere outcome of the obvious past. I do not want to "walk a corpse all the rest of my life." Strange I feel again as twenty years ago, that a hundred paths flower before my feet, and as then I sicken for not knowing which to take.[1]

Berenson, who had turned forty two months previously, may well have longed for the time, twenty years earlier, when "a hundred paths flower[ed] before my feet," but did he really believe such paths appeared now? He was married to a woman of definite ideas and expensive tastes. He was in Saint Moritz. His mistress was the daughter of Baron Gustave de Rothschild, who was then at the helm of the Paris branch of the family bank, and she was the woman after whom the Prince of Wales had named his yacht. If Berenson wanted to return to Saint Moritz the

next year, and he did, he would have to make money again. And money was to be made, not in a hundred flowering paths, but in one way, from his expertise, from "walking the corpse." Things that Berenson both despised in himself and was proud of—his Talmudic scholarship, his gift for trade, his family origins, and his family's dependence on him—were bound up in the life of the expert that sometimes seemed to him a living death.

Family affairs in England and America and immediate domestic life in Florence contributed to Berenson's anxiety and increased his need of income. Annually, he sent his family about $4,000. Mary Berenson estimated that, if Berenson's sister Rachel married, that would save them about $1,200. Rachel's near-engagement to Ralph Barton Perry, formerly an admirer of Senda's at Smith, had been announced at the Berenson family home in the summer of 1904. According to Mary Berenson, who heard Rachel's account of it later, the news created "a wild carnival of sentimentality," with each of the three sisters and the mother shut up in different rooms, raging and weeping. Rachel, Mary wrote, was "firmly convinced" that Perry had been "really in love with Senda and that Senda is furious at the transfer of his affections."[2] Later Nicky Mariano would observe that Mary, from her world of "security, affluence, and optimism," was ill equipped to understand the women of Berenson's household, despite her good intentions: "Mary was too rough-hewn for these quiveringly sensitive women whose feelings were easily hurt, for whom small attentions and proofs of affection—considered by Mary beneath contempt—were vitally important."[3]

In the end, Rachel did marry Ralph Barton Perry; they were extremely devoted to each other. Berenson came to like his brother-in-law, a professor in the Harvard philosophy department and the biographer of William James. But for Senda it was a last anguish after several exhausting years, and she ar-

rived at I Tatti, in the late fall of 1904, in the midst of a nervous breakdown. She stayed seven months, and she brought with her the unwelcome news that Abie was unlikely to be able to pay back the $10,000 loan Berenson had guaranteed for him.

Senda was far from the only guest; I Tatti was becoming more and more like a scholarly hotel, with a sizable staff and the constant presence of young intellectuals, dependent family, and distinguished visitors. Elizabeth Hardwick, writing much later of visiting I Tatti, said somewhat caustically of Berenson that "whether he loved humanity or not, he had an enormous appetite for meeting it, being visited by it, for serving it lunch and tea."[4] As his fame and the attractions of his house grew, multitudes of people began to come and visit. He corresponded with statesmen and museum directors, Italian art historians, French writers, American collectors, and Swedish royalty. He got his news from Benedetto Croce, Franz Werfel, Rebecca West, Gabriele d'Annunzio, Ezra Pound, Bruno Walter, and Meyer Schapiro. Eventually Nicky Mariano would inventory more than twelve hundred correspondents in what she referred to as "B. B's spiderweb."[5] The house was at the center of the web; visits, made or intended, often began the correspondence, and encountering Berenson in his environment often created the first intimacy.

Berenson loved the parade of people passing in review before his eyes, but he kept track of each person's usefulness, too. As scholar Patricia Rubin has noted, his myriad "letters have a range of voices, each matched to its purpose."[6] The house, with its aura of culture, was also practical. Writing of Berenson's relationship to the collector Henry Walters, Stanley Mazaroff explains that I Tatti itself figured in making Walters Berenson's most important client in the years leading up to 1912 (when Berenson signed with Duveen and abruptly broke off with Walters): "Even for a person as wealthy, cultivated, and worldly as Walters—who was among the richest men in America, who

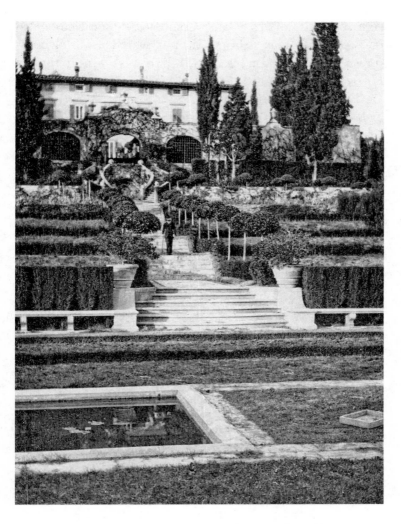

Berenson standing on the steps of the grounds at I Tatti,
October 1915. Biblioteca Berenson, Villa I Tatti—The Harvard
University Center for Italian Renaissance Studies, courtesy
of the President and Fellows of Harvard College.

controlled the country's largest railroad . . . and who circled the earth aboard his luxurious yacht in search of worldly treasures—to be Berenson's guest at I Tatti was an extraordinary experience."[7]

For Mary Berenson, the house was not only a constant fair of hospitality but a way to occupy young people whom she could adore and indulge. In 1906, she wrote to her sister, Alys Russell, asking for recommendations of some nice young men who might come down to I Tatti at Easter and amuse her girls, now eighteen and seventeen. Alys Russell recommended Lytton Strachey, Geoffrey Scott, and Maynard Keynes; the latter two in due course came. The future authors of *The Architecture of Humanism* and *The Consequences of the Peace* were at that time willowy young Cantabrigians whose chief romantic interests were in other young men. Their arrival was the beginning of a long association, delightful and, at times, difficult. Eventually, both Costelloe daughters would marry into the Bloomsbury circle: Karin married Adrian Stephen, the brother of Virginia Woolf; and Ray married Oliver Strachey, of the large clan of talented Strachey siblings. Mary herself had a complicated and strenuous passion for Geoffrey Scott that was to last more than a decade.

Scott and another of Mary's favorites, Cecil Pinsent, became the architects of a great many, often expensive, changes at I Tatti. These improvements—to the library, the roof, the gardens—often involved terrific chaos and improvisatory solutions, an atmosphere in which Mary throve and which drove her precise husband into terrible rages. He would actually beat his head against the wall, scream, and cry. Mary documented some of these episodes in her diary: "Another of those devastating rages," she wrote, adding that she had managed to hold on to her own temper, and "at the end I opened my arms and he came trembling and laid his silly, furious, unkind, ungoverned, throbbing head on my shoulder."[8]

Scott and Pinsent learned to tiptoe around the master of the house, and for his part, Berenson accepted some of what he felt was their proclivity to over-ornament. Kenneth Clark recalled that, instead of the "grand volutes and formal staircases that [Scott and Pinsent] imposed," Berenson "much preferred a little path beside a stream at the bottom of the garden 'out of reach of architectural ambition.'" [9] Still, the results of this frustrating collaboration were by and large good. Scott and Pinsent had talent, and the Berensons themselves had a feeling for how to create repose for both the body and the eye. Indoors, there were the rooms of the great library and the views of their beautiful paintings and sculptures seen down long corridors and through opening doorways. Outside, steps went down to the large, graceful, sunken limonaia building, where tea was taken in the afternoons. From there, one looked out over the cypress allée, the statuary, the descending planes of the gardens.

All this required capital. Berenson made a variety of efforts to secure the funds he needed, but for many years each new step seemed uncertain. And during all this time, two figures kept turning up, almost as if in a recurring nightmare. There would be J. P. Morgan, bulbous with authority, and there the tall, bespectacled Roger Fry, arriving just in time to witness the very troubles Berenson would have preferred to shield from the world's eyes.

Berenson was still seething about the treatment he had received from the *Burlington Magazine* when Fry published a delayed and rather critical review of *The Drawings of the Florentine Painters*. Fry's lucid prose was making him more and more influential as an art critic, while writing was a ferocious struggle for Berenson, who decried "Roger's shallow way of rushing into print." [10] It would take weeks for Berenson to turn out a few more pages of the *North Italian Painters*, then he would get his friend R. C. Trevelyan, "Trevy," to improve what Berenson

took to calling his "over-continentalized English," and then he would leave the project for months, to play host at I Tatti or to travel about with a mistress.[11]

Meanwhile, there was the job Berenson hoped for at the Metropolitan Museum of Art, which would offer a regular salary and, for the first time, a kind of institutional bulwark. Berenson himself was noncommittal about the possibility, but Mary expressed hopefulness to her mother, "Would that something might come of it! let some droppings fall on me."[12] Berenson wanted, at least, to be made the museum's buyer for Italian pictures. But Berenson's supporter at the Metropolitan, board president Frederick Rhinelander, abruptly died, and J. P. Morgan became the president of the board. Morgan seems to have had an unfavorable impression of Berenson. In 1905, Roger Fry was offered a job, not the chief position Bernard wanted, but one of assistant director. Berenson wrote to Mary, "I wish Roger well, and I shall do my best to remain fair-minded and unembittered even if he does reap all that I have sown in fifteen years of writing and six months in America."[13] Fry, though, thinking the job did not pay that well and that it would be too hard to work with Morgan, turned it down. Then, early in 1906, as Berenson dragged his heels in revising the *North Italian Painters*, came the news that the museum had chosen a new curator of paintings: J. P. Morgan had passed over Berenson entirely and settled instead on Roger Fry. Samuels writes, "It was a severe blow to [Berenson's] pride."[14]

There are indications that Morgan had critical, and possibly anti-Semitic, reports of Berenson's dealings. News of the trouble over the forged Donna Laura Minghetti Leonardo had, despite Berenson's efforts to explain that he had no connection with its sale, reached Morgan's ears. Another explanation, proposed in Colin Simpson's *Artful Partners*, has it that Joseph Duveen's uncle, Henry Duveen—a close friend of Mor-

gan's—had suggested that Berenson was not the right man for the Metropolitan job. Simpson suggests that the Duveens acted with delicate strategy to make sure that Berenson came to work for them. The source of the story, and one of the great sources of information about the firm, is Edward Fowles's memoir of his long career with the firm, *Memories of Duveen Brothers*, a text ghostwritten by Colin Simpson and finished after Fowles's death. Even if the Duveens did not destroy Berenson's chances with Morgan, it is true that Berenson did his first job for Duveen Brothers in 1907, the year after Fry received his appointment. One thing the story points to is that Fowles and Simpson believed that if Berenson had had the support of a museum, he might not have entered the art dealing world as he did.

At any rate, in the fall of 1906, the Berensons went to Paris, and Bernard fell again into the arms of Lady Sassoon. A view of Sassoon, taken around this time in a portrait by John Singer Sergeant, shows her in a voluptuous purple cloak, with jewels and ribbons setting off her pale face and striking dark eyes. Lady Sassoon accompanied Berenson as he made the rounds of the dealers and is supposed to have taken him to meet Joseph Duveen.

There is a well-known apocryphal version of this encounter, reported by S. N. Behrman in his pieces on Duveen, in a form possibly ornamented by Berenson.[15] In this version, Sassoon and Berenson, in London, arrived at Duveen's luxuriously appointed Bond Street gallery, in an atmosphere of secrecy. Berenson had told Sassoon that he would go only if he was not introduced. In the beautifully lit galleries, Berenson is supposed to have immediately noticed one painting worth having. Behrman relates that Berenson offered $150,000 for it on the spot, hoping to get it for Gardner, and that Duveen turned to Sassoon and said, "This fellow knows too much."[16] (Duveen was reported to have later sold the painting for $300,000.)

Berenson and his elegant consort left without his name ever having been pronounced, but Duveen is said to have guessed who it was.

The actual meeting seems likely to have been more ordinary, and indeed Fowles recollects simply approaching Berenson for help with the attributions of the Hainauer collection, but the story's elaborate secrecy seems appropriate for the relationship Berenson and Duveen went on to have. And in the fall of 1906, Duveen was keeping secrets of his own. He knew that he was about to become one of the world's leading picture dealers and that he was particularly in need of an expert in Italian pictures such as Bernard Berenson.

In photographs, Joseph Duveen is often captured looking a bit upward, as if toward something wonderful just beyond the horizon that only he can see. The atmosphere of possibility in which he moved was persuasive not only to collectors but to dealers and politicians and press agents and juries and customs officials and even to the members of the family firm in which he got his start. Joseph Duveen's father, Joel Duveen, had begun by trading in Delft porcelain from his native Holland. He, together with his brother, Henry Duveen, whom everyone called Uncle Henry, ran an international firm with offices in London and New York. This older generation—known for dealing in tapestries and furniture—was dubious about entering into the territory of paint and canvas, where many families of their acquaintance had been at work for generations and had trained in the museums as Berenson had. But Joseph Duveen, by far the most forceful presence among the eight Duveen sons, wanted to be the greatest picture dealer in the world. He wanted to work closely with Uncle Henry, the most astute trader in the family, and he wanted a beautiful office in Paris, which he began having designed and built in the Place Vendôme, though as yet he had no stock to put in it. Then, in 1905, an opportunity came

to him, and he saw that with it he could transform the firm: Rodolphe Kann, the man with the greatest private picture galleries in Paris, and possibly in Europe, died.

Kann had used his wealth—from diamond and gold mines in South Africa—to acquire everything from early Italian works to ten glorious Rembrandts. Joseph Duveen, acting without his father's knowledge, negotiated, over the course of the next two years, the acquisition of this prize collection for $4.2 million. He was able to get it away from more experienced dealers in part because he had the backing of J. P. Morgan, who was willing to put up $2 million in order to be guaranteed first pick among the paintings.

In 1906, a second golden opportunity arrived in the shape of the Hainauer collection. In this purchase, Duveen outdid Berenson's formidable rival, Wilhelm von Bode, considered by many to be *the* foremost expert in Italian paintings. Bode directed the Kaiser Friedrich-Museum; he was a man used to his preeminence who treated others with a mixture of arrogance and tactlessness. He had offered the troubled widow Hainauer less than half of what the collection was generally considered to be worth and told her that the kaiser would be angry with her if she refused. The widow Hainauer thought that she might look elsewhere to place her husband's collection. According to one of Joseph Duveen's cousins, "[Hainauer's] widow became increasingly perturbed by the threatening political atmosphere and the growing anti-Semitic spirit that the Prussian aristocracy showed even at court."[17] Duveen's successful offer was 4 million marks, more than three times what Bode had allotted. This was fair, and it was good business. Duveen went on selling things from these two extraordinary and voluminous collections (and sometimes buying them back from their original purchasers and selling them again for a second or third profit) for decades.

When Joel Duveen discovered his son's plans, he was out-

raged. Giant, nearly fratricidal family negotiations ensued, at the end of which, very much as Joseph Duveen had wanted, he emerged with clear authority and an understood working relationship with Uncle Henry in America. Duveen first wrote to Berenson on December 18, 1906, to thank Berenson for an introduction to Isabella Gardner, an introduction one imagines Berenson had been somewhat loath to make. Duveen was blithe: "I am sure it will lead at some future time to pleasant business relations. She is indeed a very charming lady."[18] Eager and flattering, in another early letter, Duveen wrote, "I hope if there is anything you at any time wish me to do for you in London you will not forget that I am entirely at your disposition."[19]

Berenson went back to Italy at the end of 1906, and in the spring of 1907, Morgan and Fry arrived to buy some more of Italy for their museum. It is in a way not surprising that one of the new financiers like Morgan should have been drawn to works from the Italian Renaissance, which, especially in Florence, was sustained by an early financial culture. The great patrons of Florentine art—the Medici, the Rucellai—were chiefly banking families, and Florence in the Renaissance was the banking capital of Europe. Finance, as the Gilded Age was beginning to see for itself, gave men and women powers and responsibilities, and shadowed their futures with uncertainties. The men and women from these Florentine families look out from their portraits with a worldliness, a sense of the capacities and limitations of human endeavor, that could not but make sense to the touring J. P. Morgan.

Morgan's buying was on a gargantuan scale. He bought the contents of whole churches; he bought libraries; he bought private collections; he bought as a whale takes on seawater, sifting for plankton far down in the cavernous mouth. To Berenson, in later recollections, Morgan seemed "cyclopic, demonic."[20] A cartoon of the period shows Morgan—with the familiar top hat

and famously carbuncled nose—holding a giant magnet that draws all the world's treasures toward him. Berenson remembered that as he himself went about Italy, "I could scarcely look at a church treasure without being assured that *Birbo Morgo* had offered *cento mila* lire for it."[21] With Morgan and Fry, perhaps thinking of what he himself might have done if given the chance to build the Metropolitan Museum's collection, Berenson did not entirely mask his resentment. Fry wrote home that B.B. was "quite absurd wanting to catch me out over his pictures" and tried "to make my ignorance as apparent as he could."[22]

By the summer of 1907, Berenson had agreed to authenticate the Rodolphe Kann collection for Duveen. He hoped not only for a profitable stint of "expertising" but also to get a commission by selling one of the Kann pictures to Isabella Gardner. She wanted an Andrea Castagno, which Berenson thought she could get, though he knew Morgan had an option on thirty pictures from the collection and might want the Castagno. In October, Berenson, who now often seemed to have a physical ailment and was complaining of liver trouble, sat for a portrait with the well-known painter William Rothenstein. Berenson's old friend, the niece who made up half of the poet Michael Field, saw in the painting a "sad Bernhard—the record of much nerve-suffering in the face."[23] Rothenstein recorded furrows and shadows in the face that had been smooth and assured only a few years earlier.

Not long after the painting was completed, in November, one of the sources of the "nerve-suffering" finally entered the world: Berenson's *North Italian Painters of the Renaissance*. Roger Fry wrote privately, "You have surpassed yourself," but then, reviewing the book in the *Burlington Magazine*, said that its "condensation and compression" had given its critical judgments "a certain amount of distortion and exaggeration."[24] He did, however, think "brilliant" the concluding essay, which was called, mournfully, "The Decline of Art." When, the following

year, Rothenstein included his portrait of Berenson in a British exhibition, Berenson found it an occasion to exult over his English enemies: "I am vain enough to enjoy being exhibited as a portrait by Will Rothenstein in the teeth of Floppy Fry and Gloomsbury and all its hosts."[25]

Meanwhile Fry's benefactor, *Birbo Morgo*, was engaged in rescuing the American economy from collapse. In October 1907, in the midst of a terrible financial panic, J. P. Morgan, through the sheer power of his personality and prestige, cobbled together deal after deal to save failing firms and banks. On what would be the final night of the crisis, he gathered some fifty of the most important American bankers in the library, keeping them there all night while, with a few close associates, he hammered out a last deal in the "North Room," which was the office of his librarian, Belle da Costa Greene. Berenson's future lover may have been there, too—Greene was not only the head of Morgan's library acquisitions but his trusted assistant and in many instances his private secretary. In the early hours of the morning, the men in the library signed; when morning came, President Theodore Roosevelt announced his approval, and the markets rallied strongly.

Berenson followed these maneuvers closely and was hopeful that they would so occupy Morgan that Gardner might be able to get the Castagno after all. Berenson wrote to Gardner: "Morgan should be represented as buttressing up the tottering fabric of finance the way Giotto painted St. Francis holding up the falling Church with his shoulder."[26] Morgan was equal to the task, though, and took the Castagno after all. Gardner, miffed at Duveen's "double dealing," would have nothing further to do with the firm.[27]

By December, the Berensons worried that they had so little money that they might be advised to move to England. Nevertheless, they saw a chance and decided to buy I Tatti. They

offered the owner, Lord Westbury, the equivalent of $28,000, and having recently lost quite a lot in Monte Carlo, Westbury accepted.

Despite their precarious financial situation, Mary immediately began to think of renovations and expansions, "so there will be room for endless parties of Young People such as I delight in."[28] She seems to have meant one young person in particular: Lytton Strachey wrote cattily to another friend about Geoffrey Scott that "his queer secret history (and it's extraordinarily secret—above all in Florence) is that Mrs. Berenson is frantically in love with him. He remains a confirmed sodomite, and she covers him with fur coats, editions of rare books, and even bank notes and all of which he accepts without a word and without an erection."[29]

Mary Berenson tried to understand her own feelings in her journals and her correspondence with her mother. She wrote to her mother that Scott was her "favourite kind of lame duck; young, handsome, highly educated and very neurotic."[30] Her situation was further complicated by the fact that Berenson fancied himself more and more in love with Lady Sassoon. In the pained moment of having discovered and read one of Bernhard's effusive love letters to Sassoon, Mary compared their two straying hearts and observed ruefully of her own affections that "literature has nothing but contempt and scorn for old women growing fond of boys."[31]

Both Berensons saw in travel the promise of solutions to the fractiousness and financial needs of their household. In 1908, they decided to go to America again. On this visit of some months, they propounded and criticized and they were taken to see innumerable private collections. They were even invited, in the fall of 1908, to the great library of Morgan himself, although the librarian was then in England. But J. P. Morgan's beautiful and powerful head of acquisitions, a woman rumored by many to be Morgan's mistress, had returned when Bernhard

Berenson went back to the library, in January 1909.[32] He fell precipitously in love with Belle da Costa Greene.

Later Greene would write to Berenson of a private evening from that first winter in New York, "I remember every little bit of that evening so well, even to the clothes I had on and how you liked my hair and how you went back of my chair and kissed it."[33] They had several rendezvous before Berenson returned to Europe but did not sleep together, a decision she regretted in her letters. Greene was a woman who appeared to others sexually experienced, and her contemporaries were sure she was having an affair with Morgan, but Morgan's biographer Jean Strouse thinks this wouldn't have been consistent with Morgan's pattern of affairs, and Greene's own biographer, Heidi Ardizzone, conjectures that Greene was a virgin at the time she met Berenson. What is known is that Greene was then twenty-nine, though she generally gave her age as younger, and that, although she'd been interested in different people, and certainly had strong feelings for her employer, her passion for Berenson felt to her like an extraordinary new expression of her soul.

When Berenson tore himself away to go back to Italy, he had a parting gift delivered to her: a beautiful sixteen-volume edition of a French translation of the *Arabian Nights.* "I am *so* excited by possessing them," she wrote. She had been "all alone in *my* library when they arrived" and had decided to stay home that night in her "most comfortable peignoir & go off into les nuits enchantées—I shall take you with me & we won't come back at all—never."[34] Berenson liked to begin apart, and in letters, and then he liked to go traveling together. It was clear from the outset that he meant to show her Europe. Greene had been to Europe only once, earlier that same winter, with her mother as chaperone, and had triumphed in a purchase of some of Lord Amherst's valuable early printed books. With this success in her pocket, an increasingly important role at Morgan's, and the new excitement of Berenson, she worked in New York,

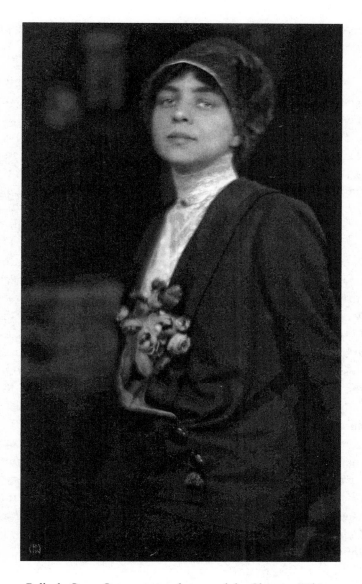

Belle da Costa Greene, 1911, photograph by Clarence White.
Biblioteca Berenson, Villa I Tatti—The Harvard University
Center for Italian Renaissance Studies, courtesy of the
President and Fellows of Harvard College.

mastering her trade and longing to see the treasures of Europe for herself.

Generally, when asked, Belle da Costa Greene would give her ancestry as Portuguese, and the "da Costa" in her name was meant to support this assertion.[35] She was a mystery, part of her allure for many. But in fact, her father was Richard Greener, the first African American man to graduate from Harvard, and her mother was Genevieve Ida Fleet, a music teacher from a successful African American family in Washington, DC. The brilliant Richard Greener was passionate about art and its history and, even a little earlier than Berenson, had dreamed of going to Europe to study art when he graduated in 1870. He became instead, in succession, the University of South Carolina's first African American professor and librarian; the dean of Howard University; the secretary of the Ulysses S. Grant Monument (J. P. Morgan was its treasurer); and eventually US consul to Vladivostok. It was, however, a life of struggles, and Belle Greener saw her father treated demeaningly and dismissed from his hard-won positions. Her mother wanted to be taken for white, which was divisive in a household where the father was known for his racial pride. The marriage came apart, and as an adult, Greene almost never saw her father.

Living on the Upper West Side of Manhattan, the remaining Greeners came to be identified as white in the censuses, and their name changed, too. The story of Belle Greene's early education is cloudy—there seems to have been a summer library course at Amherst, possibly a job at the New York Public Library—she surfaced at the library at Princeton, in 1902. Like her father a gifted librarian, she drew the attention of Junius Morgan, J. P. Morgan's nephew, who held a position at the Princeton library and was looking for someone to bring order to his uncle's massive collections. Junius Morgan apparently felt confident, in 1905, that the twenty-six-year-old Belle

da Costa Greene was the woman for the job, and her subsequent career bore him out.

It was through her job with Morgan that she found a place in the world. There she built a rich and varied collection that conserved an enormous number of valuable texts and made them available to scholars. Perhaps her most famous acquisition was the entire discovered archive of the Coptic monastery of Saint Michael in Egypt, now known as the Hamouli manuscripts. Greene worked with great autonomy; in the case of the Hamouli manuscripts, it was she who negotiated the price, decided to have them restored at the best facility in the world, the Vatican Library, and located the experts to catalog them. Owing in significant part to her choices, the Morgan Library remains one of the great collections of manuscripts and books in the world.

By the time she met Berenson, in 1909, she had been working for Morgan nearly four years, and she lived in a world densely related to Morgan's. She had the use of Morgan's box at the opera, she spent summer weekends at the Vanderbilts'. But these pleasures came with costs: Greene worked early and late at the library; she was on call whenever Morgan wanted her, which was often; she supported at home her mother and sisters, and often her brother or, later, a nephew; and she never told her employer of her background or who her father was. She faced the same pressures that Berenson did—how to make a living for herself and a large family from being a skilled perceiver of books and pictures—and her life was supported and constrained by the same class of Gilded Age patrons who supported and constrained his. Like Berenson, she was tolerated along the margins of genteel society, even encouraged, the outsider who assures those inside of their dominance.

All the women who were already part of Berenson's life were rapidly involved in this new affair. Senda Berenson went to visit and sent her impressions: "distinctly American . . . a most

vivid and alert, at the same time human spirit . . . a stunning looking creature."[36] Mary's first recorded thoughts on Greene came in a letter arranging for a meeting between Greene and her daughter, Rachel (Ray) Costelloe, who was traveling in the United States speaking on behalf of women's suffrage. The tone of Mary's letter to her daughter is strange: "Mr. Pierpont Morgan's secretary, Belle Greene, a most wild and woolly and EXTRAORDINARY young person, wants thee and Ellie to go to the opera with her, in her box, on Thursday March 4th."[37] Later that season, in part to know Berenson better, Greene paid a call on Isabella Gardner in Boston. Greene did not much like Gardner and sent her impression to Berenson: "a rude, boresome, underbred, unlovable person."[38] Meanwhile, having heard that Greene at a dinner party had been critical of her museum, Isabella Gardner wrote to Berenson, with the coarseness she sometimes displayed, "It turns out she is a half-breed and I suppose can't help lying."[39]

Greene moved in an atmosphere of such speculations; it is hard to tell how much they mattered to the men most important to her. Morgan may have had his suspicions, and there is some evidence that Berenson asked probing questions about her life history. In her letters to him, in an offhand way, she often mentioned her own dark coloring and her jealousy of blondes. But it is hard to know what Berenson knew, because, toward the end of her life, she followed J. P. Morgan's example and burned all her papers, including Berenson's letters. He had scrupulously kept more than six hundred of hers and felt betrayed by her decision, as though some earlier part of himself had been killed, lamenting to a friend that, in the early period, he had written to her "nearly every day—all destroyed."[40]

Berenson, the ardent correspondent, was often frustrated by how long Greene took to reply. Her letters to him are in a sprawling black ink and give the impression that she crammed her thoughts on to the page as they raced by. Thinking of Beren-

son often seems to have led her to thinking of Morgan. For example, she wrote: "I am yours within & without—& think of you & love you *always* & in fact I really love you more every day—the Big Chief has succeeded in acquiring all of the world here now & most [?] of the world without & keeps us very busy every minute—I cannot understand his unfailing energy & grasp. It is quite marvellous."[41]

In some way, she was in love with them both together. "I wish you two were one person," she wrote to Berenson, "then I would not have a thought for anyone else in the world."[42] Morgan did not like Berenson—he refused to let Greene send photographs, probably of his collection, to B.B., and even told her not to write to him. She relayed this to Berenson. Of all the women Berenson desired to wile away from other men, Belle Greene was attached to the one most powerful in his world. Berenson's restlessness to get at her, his morbid jealousy when he didn't hear from her, and the periods of illness and depression he suffered during their affair, all testify to the unusual intensity of the situation for him.

From Greene's perspective, Berenson, like Morgan, lived in a world of culture that her father had been denied. Belle Greene's letters were full of a possessive and secretive desire for Berenson—"I shall shut you in my heart and lock the door and throw all the bolts—I kiss you until my breath leaves and my body melts into you"—but they were also full of desire for Italy.[43]

In August 1910, a year and a half after their first encounters, Belle Greene disembarked in England, and Berenson was in London to meet her. She had changed her plans so many times that he had despaired and had made plans to go to Munich with Mary, but when Greene wrote that she was really coming, he threw everything over. Life was electric, life was dizzying. Mary was in England, too. After watching Berenson

with Greene, she couldn't resist giving advice: "One thing dear, I want to say in thy ear, Don't boast to her, either of thy moral or intellectual qualities. . . . Excuse this marital word but I want thee to appear at thy best."[44] As they went from England to Germany, he wrote all about it to Mary. "I read aloud a great deal of French and English verse (How one returns to one's old tricks but with what stiff joints!)." He was astonished that youth should have been returned to him in this way: "A sheer miracle it is. I get what I can out of it now and what a glory it will be to look back to."[45] His wife was ambivalent: "Thee is growing old and probably this is the last. Make the most of it, if thee can without doing her harm."[46]

In Munich, Berenson and Greene went to an exhibition of Islamic art that is still referred to as a landmark; it opened Berenson's eyes to a new aesthetic realm.[47] He said the exhibition was a "revelation," in describing it to Mary (who would arrive in Munich to see it a little later; she came with Geoffrey Scott).[48] Even before the exhibition, he had written to Edith Wharton, "The tide of my interests is flowing fast and strong to eastward."[49] Part of what distinguished both Berenson and Greene from many of their contemporaries in the art world was the breadth of their knowledge and interests. In the several years when he was most impassioned about Belle da Costa Greene, Berenson returned to his college interest in the Arab world and entered into a brief spate of collecting illuminated manuscripts in the Islamic tradition, about which Greene could have advised him. Berenson, so displaced in his own personal history, liked to find geographical and historical connections with the backgrounds of his lovers. His gift of the *Arabian Nights* could suggest that Berenson interpreted the Portuguese ancestry that Greene claimed as being descended from the Arab presence in Iberia. An Arabian Greene would have shared with him a Semitic and Mediterranean heritage. Berenson began his collection of illuminated manuscripts in 1910 and

stopped about 1914, as the affair began to dwindle and the war changed everyone's direction of mind.

From Munich, Berenson and Greene went down to Italy. They watched the sunset as they sat out on one of the old walls of Siena and dodged friends of Morgan's in Ravenna. It was still considered extremely compromising for a man and a woman who weren't married to travel together, and when another companion for Greene fell through, the couple wrote to Mary asking her to act as a chaperone for them in Rome (she even agreed to come, but ill health mercifully prevented her).

Berenson loved that Greene was "incredibly and miraculously responsive, and most of all to the things I really care most about."[50] Writing to him later, Greene said that his way of looking at works of art was "stamped into my memory and a part of my very flesh and blood."[51] He was impressed, too, by her decisive authority to buy—she acquired manuscripts and etchings along the way, cabling to Morgan now and again for confirmation or to let him know what she'd bought. Surely it was a further charm of the experience that he was there, in Italy, at the very site of Morgan's acquisitions, with a woman whom Morgan in his own way loved and whom Morgan would not at all have wanted to be there with Berenson. Though they complained loudly about their clandestine maneuvers, the secrecy, for these two experts at hiding in plain sight, seems to have been part of the delight.

The idyll did not last, though it was not undone by the exposures they had feared. In Venice, Greene had an unclear illness. She and Berenson parted; she went to England; there is an unexplained gap of a week in their correspondence, after which she was on strict bed rest and being taken care of by a doctor and two friends. Heidi Ardizzone argues persuasively that Greene probably had an abortion. If Berenson was her first lover, Greene may have had very little idea of how to protect against pregnancy. And pregnancy, for a single woman working

for J. P. Morgan, was not a possibility. For Greene, there would have been the added fear that a child might reveal her racial background. Berenson had not changed his mind about children. He was not far away, in Paris, while she was in England, but there was a train strike, and miscommunication. She went back to America without seeing him again.

After this, although for many years they went on protesting that they were just as thrilled, she seemed no longer to have confidence in his love. Later she would write to him: "Why did we ship me off to London?"[52] And later still, in 1921, she explained that, after "I left you to go to London," she could no longer feel the "really innocent . . . utter and world-excluding worship I once gave you."[53] For the next several years, he continued to write her fervent letters, often every few days, and she replied, though more often with news of weekends away, or of business transactions. He also sent her gifts of important works of art: Bernardo Daddi's *Madonna and Child Enthroned with Four Saints*, and Spinello Aretino's *Angel of the Annunciation*. For her part, Greene worked to further Berenson's career and kept him apprised of the doings of New York collectors.

After Greene's return from Europe, J. P. Morgan made his annual trip to the Continent, and Greene arranged for him to meet Berenson in early 1911—she wanted to change the fact that Morgan was "unaccountably prejudiced" against Berenson but was worried that Morgan might discover that she and Berenson were lovers.[54] "He is terribly jealous and considers me his property," she explained to Berenson, but she felt that "the two people that I love best in the world must love each other."[55] These attentions hardly relieved Berenson, who was tormented by uncertainty. Greene seemed to have many beaux; the whirl of her social life was unending. He languished in Italy, more in love with her than ever, depressed and funneling all the unhappiness of his many-sided crisis—his domestic relations with

Mary, his inability to write, the way he was beholden to the market—into his passion for Belle Greene.

Shortly after the encounter with Morgan, Mary Berenson saw her husband fall into despair and, in February 1911, sent Senda Berenson from Boston down to see Greene and reconnoiter. Senda, who would be married herself later that year, to Herbert Abbott, had grown in flexibility since the days when she had disapproved of Berenson's illicit relationship with Mary Costelloe. She asked Belle Greene if she would marry Bernhard, were he free. Greene said no. Senda Berenson wrote to Bernhard to give up his idea of life with Belle: "You would be separated in two months." She made plain what she felt Mary did for him and what Belle would not: "She could never for one moment wait upon you—care for you (in the homely sense) make paths smooth and easy for you."[56] Greene would sometimes say that she would only consider marrying for money, lots of money. But it also seems evident that she did not want to leave her profession, the institution she was building, her city, or the world of the "Big Chief." And perhaps she was disillusioned with Berenson. A few years later, in March 1914, the affair rekindled when the Berensons were in America. But when Berenson wrote full of passion, she reacted swiftly:

> Given our mutual self interests, our mutual desire for the coin and other perquisites of this world, and your great love of people and sassiety, and my one or two tiny ambitions—it is pretty much tommy rot. . . . I, at least, am frank enough to admit that I would not cast aside my material life for you, and as I know you feel the same, why waste time hot airing about it.[57]

By this point, in 1914, Berenson's material life had, for two years, been bound up in a contract with Duveen Brothers.

Duveen and Berenson had decided to tie their fortunes together as a new market for pictures emerged, a market shaped at first by Morgan's domineering presence and later by his absence. When Berenson had proposed the Botticelli *Lucretia* to Gardner in 1894, £3,200, or about $16,000, had seemed a steep price. Eighteen years later, after the main years of Morgan's purchases, Duveen Brothers sold department store magnate and collector Benjamin Altman a Botticelli *Saint Jerome* with a letter of Berenson's certification and praise for something on the order of $50,000. In 1909, the Paris house of Duveen Brothers by itself had done $13 million in sales. These figures reflected changes in taste, in the consolidation of capital, and in the tax code. In the first half of 1909, Congress debated and passed a new tariff bill that ended the 20 percent import tax on art more than a hundred years old. This seems to have been done specifically with J. P. Morgan in mind. (Morgan, who was philanthropically inclined to give his collection of paintings to the Metropolitan Museum, had been sheltering them in England.) Anticipating that the tax change would only accelerate the market's climb, the international dealers—Knoedler, Seligmann, Glaenzer, and Gimpel and Wildenstein—all set up shop in New York.

Duveen Brothers had made a specialty of avoiding customs costs, but after the law changed, Joseph Duveen sent Duveen Brothers' *actual* books to New York, as opposed to the dummy books they had been keeping there. Tipped off by a resentful employee, US Customs investigated and raided. More than one Duveen was taken to jail. Uncle Henry's bail of $75,000 was paid by Benjamin Altman and J. P. Morgan. The long arm of Morgan protected his friend Uncle Henry from every angle. The price of the settlement was negotiated from a possible $10 million down to $1.2 million; this money was put up by First National Bank, which listened to Morgan; Uncle Henry, in-

stead of going to jail as the prosecutor had demanded, walked free with a $15,000 fine. These events held up Joseph Duveen's plans to build a new gallery and to forge ahead with business, but they may also have demonstrated to Berenson that in the new world the people to be connected with were the Morgan-backed Duveens.

The contract between Berenson and Duveen was hammered out in the summer of 1912 and signed in Paris that September. According to the historian of the art market Gerald Reitlinger, the following year, 1913, was "the most lavish in all the recorded annals of art history."[58] A great many Italian paintings were part of the haul. But that year also began a changing of the guard. Benjamin Altman, on the cusp of spending £103,300 for *The Holy Family* by Andrea Mantegna, died in October. And before that, in March, suffering from age and strain, J. P. Morgan died in Rome.

When Morgan died, Berenson sent Belle Greene his condolences, and she cabled a reply: "My heart and life are broken."[59] In a letter that followed, written on the black-bordered stationery of mourning, she attempted to describe her grief: "I think you will know how almost impossible it is for me to write—but you are all I have left now. . . . I feel as one engulfed in a dense fog. . . . Not even *you* knew all that he was to me—besides every other relation he was a *son* and a father confessor."[60] Greene worked all the rest of her illustrious career to preserve and expand the Morgan Library. As the rest of Morgan's art collection was eventually disbursed, the library and the bank came to be the two institutions that carried his name. The Berensons sometimes speculated that Greene would move into the more lucrative world of dealing, but she never did. Morgan and his son Jack Morgan after him remained her patrons. Whether or not the implicit presence of Morgan was a primary part of the impulsion for the affair between Berenson

and Greene, it is true that after his death, the fantasy that the two lovers might make a life together seems to have irrevocably receded.

The contract between Berenson and Duveen, renewed every few years with endless haggling until 1937, was to define twenty-five years of Berenson's life. The terms were that Berenson was to be paid 25 percent of the net profit on any picture that Duveen Brothers had acquired on his advice. All these pictures were to be entered in what the contract called "the 'X' book," kept at the Paris office. At various times the contract was adjusted to have more of a retainer or a different percentage or to take out clauses that made Berenson, as if he were a partner, share in Duveen Brothers' losses as well as its profits. In general, the understanding was that Berenson was to represent Duveen in the complex Italian market, to keep his eye out for pictures that would suit, and to be available to consult on photographs of paintings he was sent or, sometimes, on actual paintings that would be brought down by courier. He was also expected to be amenable to being summoned to Paris, to be "on the spot." Finally, the contract was a secret one, which has since been the occasion of much commentary. Secrecy served each man differently. Berenson hardly relished the idea of being generally known as Duveen's in-house authenticator. For the Duveens, secrecy was a business advantage; they wanted to be able to assure their clients that the world's foremost expert had *independently* certified the firm's paintings.

Berenson was part of Duveen's strategy in a cut-throat market in which auctions were showdowns and private detectives went through clients' wastebaskets. Firms of art dealers were frequently made up of partnerships of extended families; they relied on marriage bonds to cement all-important loyalties and swore their associates to secrecy. Berenson was not supposed to work on a percentage basis for other dealers,

but the contractual provisions about this were ambiguous, and throughout the period that he was with Duveen Brothers, he was also periodically paid fees or percentages by Arthur Sulley, Otto Gutekunst, Nathan Wildenstein, the F. Kleinberger company, Boehler and Steinmeyer, Jacques Seligmann, and René Gimpel (who worked independently but was married to Joseph Duveen's sister). At the same time, Berenson was constrained by the contract. He had private clients with whom he could not keep up satisfactory relations because he was channeling the best paintings he knew about to Duveen's.

Berenson's letters to the Duveen firm could be generous, charming, firm, and clear-sighted, but they were, almost from the outset, also angry, querulous, plaintive, resentful, supercilious, enraged, and impatient. That is, when he wrote them himself, for he often deputized Mary Berenson to handle this most enervating correspondence. Subjects of dispute included: whether Duveen's would have other representatives in Italy; whether Berenson was, as he wished, also to be consulted in matters of Italian sculpture; whether Duveen's had properly recorded, in the "X" book, its sales of pictures and commissions owed (it often hadn't, and the firm frequently had to acknowledge it was in arrears to Berenson); whether Berenson was willing to consider different attributions for paintings (usually he wasn't); and whether Berenson was willing to publish articles praising paintings Duveen was trying to sell (generally, he did not want to do this either, but on a few occasions he did). Through all this ran a constant argument about large sums of money, which sometimes changed hands, and sometimes were delayed for years. In 1927, according to Edward Fowles, Berenson made in the neighborhood of $190,000 from Duveen Brothers. But in 1932, the firm admitted that it had kept back payments totaling $152,161.86.[61] They were a little short of cash and preferred to wait and pay Berenson 5 percent interest in order to keep liquidity for buying more paintings.

Berenson had most of his dealings with the Paris office, and especially with Fowles, with whom he got along reasonably well; Berenson tried to hold Duveen at a distance. In Fowles's recollection:

> Unfortunately, Joe and Berenson neither liked nor trusted each other. They said fine things in public, and to their mutual acquaintances, about each other's business acumen and scholarship, but behind the scenes there was constant bickering and at times outright antagonism. The result was that although they were in at least weekly, sometimes twice weekly, correspondence, they used me as a postbox. BB would write to me personally and I would pass his messages on to Joe. Joe would give me his answers and I would then reply to BB myself. This curious relationship continued for twenty-seven years.[62]

Signing with Duveen and longing for Greene had not done much to settle Berenson's tumultuous state. But one relationship that was to provide steadying and supportive companionship and eventually to exert a real influence on Berenson's course became much stronger in the years just before the war, and this was Berenson's friendship with Edith Wharton.[63] Berenson had met Wharton in 1903 and disliked her. Mary described the initial meeting in her diary: she and her brother had driven to the Villa La Doccia "to meet the great Edith Wharton. We found B.B. there, already, it was clear, loathing her. We also disliked her intensely."[64] Berenson avoided Wharton for years but eventually was reintroduced. He wrote to Mary: "Just as I was about to leave Henry Adams yesterday, Mrs. Cameron came in with another lady wh. I did not recognize. It was Mrs. Wharton. She did not look the least like the woman we met of 7 years ago."[65] About a week later came a further report: "Thursday night dined in upper chamber at Voisin's with Henry Adams who had also invited Mrs. Wharton with Fuller-

ton & Mrs. Cameron. . . . Mrs. W. was affable to the last degree, & so I buried the hatchet, & called on her yesterday."[66]

Berenson, with his pleasure in myths, combined elements of these early meetings into a more dramatic account that had the touch of secrecy he often added. In this version, Henry Adams strove to bring together two people whom he knew ought to be friends and did so by having Edith Wharton at dinner, veiled, so that Berenson knew only that it was a charming woman, whose identity was later revealed.

As he came to know her, Berenson was impressed by Wharton's rigorous self-discipline, her constancy in her relationships with friends and lovers, the independence of her life, and the fortune she made from her creative efforts. The well-ordered quality of life around Wharton immediately provided a striking contrast in his mind with life in the vicinity of his wife. In the letter in which he mentioned re-meeting Wharton, he went on to give Mary Berenson what had become a fairly typical, and harsh, dressing down: "*Our* situation — I mean between you and me — is nearly more than I can bear, & you seem deaf to reason, to pity, to common humanity. And with that, I abominate my relation to the whole art dealing & buying world. It seems to be my lot to be victimized, bamboozled & exploited all around." Berenson's next sentence, abruptly, was, "Codman sends me the address of the landscape gardener."[67] This quick segue to domestic aspirations also bears a reference to Wharton; Codman was Wharton's coauthor on the book *The Decoration of Houses*, in which they had set forth their ideas about bringing European taste and historical appreciation into the homes of America's moneyed classes. Wharton's houses in France would be places that Berenson would love, as his library at I Tatti was to be a refuge for her, over the twenty-eight years of their close friendship.

They approached one another a little warily at first, but then the ice was broken. In July 1910, Berenson wrote, "You really were like unto a fairy god-mother to me at a moment

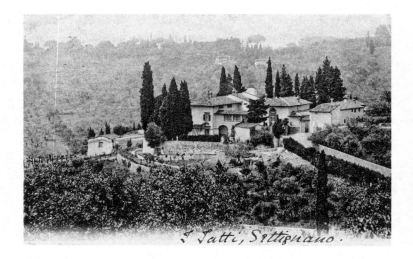

Postcard of I Tatti sent by Edith Wharton to Henry James, October
1911. Reproduced courtesy of Yale Collection of American Literature,
Beinecke Rare Book and Manuscript Library, Yale University.

when I peculiarly needed just that kind of treatment. . . . You
must allow me to feel affectionately grateful. And I want more
of you. When are you and dear Berry coming over?"[68] Wal-
ter Berry, the man in Wharton's life, did go with Wharton to
stay at I Tatti, and the two sent Henry James a postcard with a
view of the Berensons' house up in the Settignano hills. Whar-
ton was a careful reader of history and passionate about the art
and architecture of Italy. After another visit in 1913, she wrote
"Wait 'til I get at the Tatti shelves again!"[69]

In the fall of 1913, Berenson and Wharton took a driving
trip through Germany. It was a turning point in the relation-
ship, though the trip itself was rather trying. Each was then
roughly fifty and long accustomed to setting the agenda for his
or her companions. Wharton was also exhausted. Her marriage
to the mentally ill Edward Wharton, known as Teddy, had at
last ended that summer in divorce. And before leaving with

Berenson, she had raced to finish the last chapters of *The Custom of the Country*. She wrote to Berenson that at all costs she would be ready for their trip but hoped for his patience: "Remember that everything the all-beneficent Mary does for you falls on me alone—household, cheque book, publishers, servant questions, business letters, proofs—*and* my book!"[70]

She asked if they couldn't take just a few days "in some green woody *walky* place" before plunging into the museums, and she did, in fact, collapse, after the journey began.[71] At first Berenson thought she might be "half shamming illnesses so as to have her way."[72] Famous for his rages and fussiness in travel, he was very impatient with her requirements. "Edith," he reported to Mary, "travels in the first place for motoring, than for porcelain baths, then for country, & finally for 18th century architecture & gardens."[73] But, despite his complaints—"not once since we have been in Germany has the salad been to her taste"—she grew on him. As he explained to Mary, using their private word for connoisseurship, "conosh," Wharton's "company is delightful. She is ready to talk & to listen on so many topics & nothing is too small for her if it be characteristic or significant on a point of conosh."[74]

For her part, Wharton wrote to Berenson afterward that his conversation had been a joy and his attentiveness to her much appreciated: "I look back d'un oeil attendri on every stage of our little trip, & should regret more & more my unlucky physical & mental incapacity . . . if that chance disability hadn't brought out in my travelling companion such treasures of indulgence & dearness that they have made me more & more his affectionate & grateful, Edith."[75] Wharton's biographer Hermione Lee writes that, "at exactly the time when she was most in need of support," Wharton and Berenson chose each other "for that rare achievement, a close, platonic, mid-life heterosexual friendship between equally successful and well-known contemporaries which would last until death."[76]

Berenson found in Wharton's companionship something wonderful and restful, in her conduct during the war an important example, and in her writings the satisfying fulfillment of things to which he had aspired as a young man. For her part, often shy and proud, she felt frank and at ease in his company. In what she called "our long & wide & many-dimensioned talks," her thoughts came readily to her, as she wrote to him: "With everyone else I have the sense of having to fit into a space that cramps me—hitting my head or my funny-bone, or having to sit with my knees drawn up to my chin. You're the only person who has given me, for a long time past, what I used to call 'a good swim'—& what, after all, if I honestly survey my past, I find I've really cared for more than anything else."[77]

The Berensons were in England when the war broke out, and got caught up in the initial fervor. But World War I, though a "total" war by any previous standard, still left many pockets of Europe relatively untouched, and the Berensons chose to spend the bulk of the war in Florence, where life went on much as usual. In 1915, Bernhard Berenson dropped the "h" from his name and became Bernard Berenson. After five decades in which he found a certain distinction in his German-sounding name, it now seemed to him to connote aggression. Until 1918, this was the most public sign of his thinking about the war. In Florence, there were garden parties and small quarrels. The improvements at I Tatti, effected by Scott and Pinsent, overseen by Mary, and stormed over by Berenson, continued, and so did the picture trade. Edward Fowles, who was "the only senior member of Duveen's to be called up," wrote, "Thinking back, it is quite remarkable how few people in art dealing actually participated in the war. . . . The vast majority of critics, dealers and museum officials seemed immune from it all."[78]

After the first shock, millionaires went back to buying paintings; in fact, they bought more of what seemed an especially cer-

tain and precious commodity. Many people made a great deal of money off the war and had it to spend on pictures, while others lost their collections when they were ruined or had to flee. Paintings had always been spoils of war; in the Great War, the spoils were much greater, and many of them went to America. In 1916, Duveen's was in touch with Berenson twenty-six times regarding paintings, but in 1917 Berenson was asked to pronounce opinions on 250 paintings. A significant number of Berenson's publications in this period—including the many articles he wrote for the new magazine *Art in America*, some of which were incorporated into his book *Venetian Painting in America* (1916)—were intended to educate American audiences and to draw attention to paintings newly arriving in American collections.

Meanwhile, Wharton, in Paris, was ever aware of the front and indefatigable. Although she had already lived in France for seven years, during the war it became clear to her that she would never live anywhere else. She took the burning of the library at Louvain and the bombing of Reims Cathedral personally and fought back against the German attacks with every ounce of her considerable fortitude and administrative skill. Sleeping five hours a night, she organized workshops for seamstresses to supply men at the front, established homes to shelter thousands of Belgian refugees, and was an early female war correspondent, touring the front, and even coming under fire, while writing for American journals. She was made a Chevalier of the Legion of Honor for her services to France.

Wharton's letters to Berenson paint a vivid picture of wartime Paris. She wrote to him of "blinding . . . grinding cold . . . dust . . . dearth of coal & 50 % reductions of light." It wasn't so bad for them, "but it takes one's thoughts so persistently to the freezing starving prisoners, & the deportés, & the trenches, that one's nerves are on the rack."[79] Her reliance on his friendship deepened. Two weeks later, she wrote, signing with her official title, La Vice-Présidente, on the stationery of Les Tu-

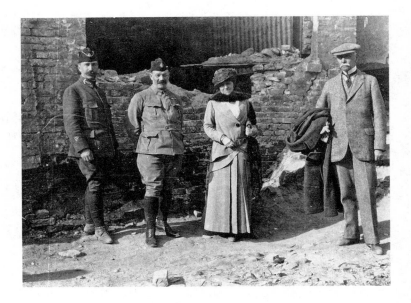

Two French officers, Edith Wharton, and Walter Berry at the front,
1915. Reproduced courtesy of Yale Collection of American Literature,
Beinecke Rare Book and Manuscript Library, Yale University.

berculeux de la Guerre (French tuberculous war victims): "I
do hope you can arrange to come and help us soon. . . . We
find it especially difficult to get American workers who speak
French."[80] Then she wrote more personally, explaining how she
missed him during the war: "I can't help hoping that my official
summons on behalf of the Tuberculeux may bring you back! —
What a joy if it did. As the hymn says, 'I need you every hour.'
You're the one person who understands everything, '*from the
centre all round to the sea.*'"[81] Berenson sent letters and cheques
but, explaining that Mary Berenson was ill, which she was, did
not go to Paris.

Each of the two wars was a period of significant decline for
Mary Berenson. While her husband adapted again and again

to new worlds, her health became more and more seriously impaired, and she found that people she loved turned from her. In the first war, her daughters, always a passionate interest for her, began to live adult lives that she could not enter into. Ray worked during the war for legislation to protect women working in factories and in 1918 was one of the first women to stand for Parliament. In her *Remarkable Relations*, Ray's daughter Barbara wrote that Mary, remembering her own difficulties with her first husband's political inclinations, "never became reconciled to Ray's taste for politics and public life." [82] Meanwhile, Mary's other daughter, Karin, studied philosophy and would eventually become a psychoanalyst, a profession for which the Berensons had little use. Worse still, from the point of view of the vigorously partisan Berensons, during the war, Karin and her husband, Adrian Stephen, were conscientious objectors.

Family affairs were hard enough, but romantic ones became catastrophic. Trying to hold on to her good cheer, Mary wrote to her sister, Alys, "By the way, since thee said that love affairs were my crazy spot, I have looked into the matter, and I find *it is true* . . . thanks for the hint." [83] But this good resolve wasn't enough to sustain her the following year, through the defection of Geoffrey Scott. Scott believed, painfully, that he ought to overcome his own proclivities and attempt heterosexuality and over time played out a complicated dance of traded affections with both Berensons. Mary had tolerated Scott's brief infatuations with Berenson's sister Bessie and with her daughter Karin. She supported his friendship with Edith Wharton, who adored Scott. (Scott made several driving trips with Wharton before Berenson did and went to work as her assistant in Paris for a while during the war.) Mary Berenson even encouraged Scott's unrequited love for Elisabetta (Nicky) Mariano, who was soon to play a very important part in the lives of the Berensons.

Scott was strongly drawn to the young, kindhearted, and

beautiful Baltic-Italian intellectual, and Mary Berenson saw no reason why Mariano couldn't be integrated into the already complex household at I Tatti. After a brief introduction before the war, Mariano had gone to a family home in the Baltics and been caught there for the duration of the fighting. Scott pined for her, and Mary wrote Scott encouraging letters about a possible marriage to Mariano and schemed with him to employ Mariano at I Tatti after the war. Out of some obscure combination of motives, Mary Berenson decided to pursue this possibility even after the bewildering and painful events that closed the war for her.

What crushed Mary Berenson was when Geoffrey Scott decided, just as 1917 turned to 1918, to marry Berenson's recent mistress, Lady Sybil Cutting, whom Mary particularly despised. Berenson had effectively ended his affair with Lady Sybil by deciding at last to heed Wharton's call and go immerse himself in Paris war work. When Berenson heard of the intended marriage, he was derisive and amused: "I feel deliciously, benevolently out of it, with a faint touch of irony and humor."[84] A few weeks later, though he knew Mary was desperately unhappy, he wrote to her that he knew "no more obstinate person, none more unscrupulous, more self and other deceiving than you when and where an appetite of yours is concerned. Forgive my nastiness as I forgive yours."[85] Mary Berenson left the wreckage of her hopes about Scott and joined her husband in Paris, only to find that Berenson had now taken up with the Baroness La Caze. Bernard wrote to Mary thrilled about his new sexual passion, and these letters, she felt, "destroyed my universe."[86]

Now came the onslaught of illnesses that were increasingly to debilitate Mary in the coming decades. According to the Smith family account, Mary "developed first acute cystitis, then agonizing gallstones, and finally a full-scale nervous breakdown, in the course of which she nearly succeeded in throwing

herself out of the window."[87] Her daughter Ray went to Paris and was not entirely sympathetic, feeling that Mary was giving way to depression. Ray wrote home, "I cannot leave her alone with B.B. as they have the worst possible effect on each other, though poor B.B. is a perfect saint."[88] Finally, Mary was transported to a nursing home in England. She could not be moved without being drugged.

In the fall of 1917, Berenson toured northern France in a Red Cross car with Edith Wharton and was shocked at the "nightmarish visions."[89] With the political influence of Wharton's close companion Walter Berry, Berenson was engaged to work for the US Army Intelligence Section, though he was still not sure he wanted to give up "my holiday life" for the "aridity of a work-a-day one."[90] But he found he loved the social life of diplomacy. His assigned task, of keeping his ear to the ground, involved going to dinner parties and engaging in the kinds of debates he found most stimulating. His cultural life went on—he had encounters with Marcel Proust, Maxim Gorky, André Gide, Jean Cocteau, and Cole Porter—but his attention was now focused on the diplomatic maneuvers anticipating the end of the war. He was very impressed by a meeting with Greek prime minister Eleutherios Venizelos; he spent many hours over long, and appreciated, reports to Army Intelligence. His always subtle perceptions of people gave him an acute political understanding, and he enjoyed speaking his mind where formerly he had been silent.

He had begun, he wrote to his old English professor Barrett Wendell, with the innocent belief that there was a "fundamental difference between the two camps of belligerents," but the more he saw, the more disillusioned he became with what seemed to him "an unchanged lust for subjugation."[91] The Allies' talk was more and more of how to carve up the spoils. As the end of the war approached, Berenson left Paris for a

while to be a companion to Mary in England. Mary's situation was known among their acquaintances to be very bad, and their neighbor from the Via Vincigliata, Janet Ross, was writing to Mary every day in an attempt to help keep up her spirits.[92] Mary was out of the hospital, but her mood swings were wide. With her husband relations were acrimonious, and he returned to Paris. He was there at the time of the Armistice, which had an unexpectedly overwhelming effect on him. The actual declaration of the end of war brought him to "a dreadful fit of convulsed sobbing."[93]

Berenson, like many, hoped that the Versailles negotiations of the end of the war would be the beginning of a new era of international cooperation and peace. Watching the failures of these negotiations from close by laid the foundation for Berenson's political outlook of the next forty years. In Paris, he had become a good friend of the journalist Walter Lippmann. Lippmann's anger at what Berenson called "propaganda . . . reaction and annexationism" was close to Berenson's own, and Lippmann had pointedly not been asked to join the American negotiating team.[94] The two men watched in dismay as the French played the Wilsonians for suckers, the Germans were mercilessly bankrupted, and the English stood back and watched their empire grow. "The harvest of the war," Berenson wrote to Wendell, "will be as poisonous as its conduct has been murderous."[95]

After the war, Berenson became sharply critical of anything he saw as propaganda. He had often expressed anti-imperialist ideas but otherwise for years had been reflexively conservative, largely, it seems, to fit in with the social mores of the crowd to which he desired to belong. Now he became—and this was relevant very shortly in Italy—strongly anti-Fascist and impatient with American political dilettantism. Politics were also soon to be important in his personal life; shared political convictions were one of his first connections with the new librarian at I Tatti.

When Nicky Mariano began working for the Berensons, she worried that her sympathy with suffering German civilians would be out of place among the hotly anti-German Italian aristocrats whom she thought of as the Berensons' milieu. She found instead, as she described it in her memoir *Forty Years with Berenson*, that "B.B.'s indignation over the policy of the Allies . . . [was] in absolute harmony with my convictions. . . . This created the beginning of a bond between us."[96]

A crisis does not take just one form—like an amoeba it shifts its shape as it pulls itself forward. So the man who "walked a corpse" in writing became the man who began serious travails in the picture trade, who in turn became the man desperate and dejected in his love for Belle da Costa Greene, who in turn became the man to sign a secret agreement with Joseph Duveen. But the basic form of the crisis—how was Berenson to reconcile his many "warring selves"?—went on. For Berenson this was not resolved by publishing "huge tomes" or ceasing to, by his work for Duveen or his resistance to that work, by his love for Belle Greene or its frustrating limbo. It began to change only as he changed with the war. And when the war was over and the household at I Tatti began its return to normalcy, he had a stroke of profound good fortune. The resolution of his crisis arrived on his doorstep, and in a roundabout way, the arrangement of his future was made by Mary.

In 1919, Nicky Mariano was at last able to leave Russia. She was in Switzerland, with relatives, worried about how to earn a living, when a friend passed on a proposal that Mary Berenson wanted to make. They would be needing a librarian at I Tatti, and might Miss Mariano be interested in the job? Mariano felt herself underqualified but promised to brush up her Latin and do her best. She stayed nearly fifty years.

7

Nicky Mariano and the Library

In reality nothing would induce me to quit my
books. O the wild joys of getting back to them, the
leaping from shelf unto shelf, the strong rending of
favorite pages, the cool silver shock of half-forgotten
marvels. *J'y suis, j'y reste.* [There I am, there I stay.]
—Berenson to R. C. Trevelyan, 1919

NICKY MARIANO BEGAN by organizing the enormous num-
ber of books acquired for the library. She and Mary Berenson
together worked on the interminable lists that gave Berenson
such rages. And Mariano dealt with the rages with a combina-
tion of sympathy and humor that seemed to right things almost
before they'd gone wrong. She had a gift for seeing where help
was needed and offering it. After four years or so, recogniz-
ing that Mary was "getting increasingly tired of the household,
the receiving of guests, the kitchen, the planning of meals,"

Mariano stepped in there, too.[1] In the mornings, and again after the day's tasks, she read out loud to the Berensons with what John Walker recollected as her "lovely, polyglot accent, each word so clearly enunciated."[2] She read French histories, Russian tales, German poetry, Yiddish memoirs, and translations from Chinese and Arabic, following what she called Berenson's "omnivorous" appetite for books.[3]

After her mother's early death, Mariano had grown up as librarian and reader to her solitary and cantankerous father (who was a scholar of church history). Her voice was soothing, and so was her lovely physical presence—her hair was soft about her face, her garments hung in gentle folds, her eyes were wide, intelligent, amused. It seems to have suited her amazingly well to be the bearer of peace and comfort in the Berensons' life. By late 1921, when the Berensons departed to go on a long-planned expedition to Egypt, they had gotten no farther than Naples before they realized that they were ill-assorted on their own. Mary wrote to Nicky Mariano asking her to come and join them. She arrived promptly and presided over the organization of every aspect of the trip—when Mary decided she'd rather ride a donkey than be carried in a palanquin, Mariano found a tailor and had an appropriate skirt made. Mariano's own account of the trip, in *Forty Years with Berenson*, seems untroubled by these tasks—for her the days were full of "enchantment."[4] These were great traveling years. Berenson and Mariano, sometimes with Mary and often without her, went to Greece more than once, to London and Paris, to Stockholm, Denmark, Germany, Vienna, and Switzerland, to Constantinople and Jerusalem, to Spain, Tunisia, and Algeria, and all up and down Italy. Berenson rarely traveled without Mariano, unless it was to make one of his long visits to Edith Wharton in her home in the south of France at Hyères.

Between Berenson and Mariano there grew a romance that was to last until the end of his life. She learned all the rituals

of Berenson's life—his finicky eating, his mode of travel and methods of looking at pictures, what clothes he needed at what times, the sacrosanct walks and naps, the evening chamomile tea. With her, his childhood and Jewish background were no longer something to be dismissed or gibed at. He had, for example, what he called a "superstition," of carefully looking out for the new moon each month. "I feel more hopeful," Berenson wrote, "if I have seen the new moon not through glass, have made three bows to her, and have turned over three times the loose cash in my pockets."[5] According to Mariano, Mary Berenson thought this was "pure folly and childishness," but Mariano took seriously this ritual, a version of that observed by devout Jews at the time of Rosh Chodesh, the ceremony that marks the new moon.[6] For Berenson, the natural world was a place of deep spiritual feeling; he said that the practice of greeting the new moon came from his having been brought up in "a magical world" and that people who hadn't been so raised were like "trees growing out of a ground where there was no grass."[7] Away from him and staying with her sister, some fifteen years into her relationship with Berenson, Mariano wrote to him that she had managed to see the new moon, describing its hue and the mist surrounding it. She said she had made her wish, that the next month and for many more afterward, she would be looking at the moon with him. Early on he declared to her: "You are the real center of [my normal] life, and without you I no longer feel at home with myself."[8]

The forceful elements of Berenson's life and personality pulled hard against one another, but with Nicky Mariano in residence he was able to feel that things were in balance. The period from her arrival, in 1919, until 1937, when a number of important changes occurred, was one of great stability. Not all the compromises were happy ones—Berenson still desired money and abhorred trade, and he worked, hard, for Duveen and other dealers, and blamed, hard, Duveen and Mary—

but this was tenable, and the arrangement survived with only minor modifications for these eighteen years. In this period for Berenson, the verbs—writing articles, making attributional lists, visiting friends, traveling to see art, working in the picture trade—are all in the present continuous.

It was not long before the Berensons' associates began to reorient themselves toward Mariano. In 1923, Mary Berenson told Duveen that they had settled £5,000 on Nicky in case something should happen to them, and she wrote home to B.B. that Duveen had said, "'It's the best investment you ever made' and he beamed all over when I said that it was because of him we could do it."[9] Hermione Lee detects that in the mid-1920s, Wharton's allegiance "was shifting . . . from Mary, always unwell and depressed, to the benign and sympathetic Nicky Mariano, who by the early 1920s had become Berenson's virtual wife and the manager of I Tatti."[10] Belle da Costa Greene adapted to her, too; Greene, Berenson, and Mariano met repeatedly in different parts of Italy in the 1920s. Traveling together in 1926, Greene and Mariano shared a room.

Nicky Mariano was not, in general, delighted with Greene: "Great vitality and plenty of intelligence, a provocatively exotic physical type and something unharmonious, almost crude, in speech and manner" was her impression, though she did recognize Greene's "wit and her zestful approach to her work."[11] Mariano was sometimes jealous, though she wrote, philosophically, of Berenson's flirtations and affairs and of the great many women who made up what she called "B.B.'s Orchestra."[12]

As he aged, Berenson's seductive power became somewhat legendary. Lee Radziwill (Lee Bouvier when she visited Berenson in 1951 with her sister, who became Jacqueline Kennedy Onassis) still thought of Berenson as "one of the most fascinating men I ever knew," sixty years later. She compared his powerful appeal to Jawaharlal Nehru's: they were "seductive

mentally, rather than physically."[13] Berenson's catalog of mistresses and of epistolary romances, like all his other collections, was exhaustive. He had first found both sexual tolerance and a large network of youthful romantic friendships with women and men in bohemian and Edwardian circles, and among the expatriates in Italy. In the years of his maturity, he found a similar atmosphere among his mistresses and flirtations in the aristocratic milieu of the European art world. Berenson adored, and was adored by, titled women, and he was interested in beauty wherever he saw it. Attractive young women who visited I Tatti were regularly surprised by his physical attentions. Despite, or perhaps because of, his fear that he was "always, always being parted, separated," Berenson never really did anything once; all his pursuits had dozens of repeating figures; everything he wanted he wanted again.[14]

Still, Nicky Mariano knew that she had a place apart from the "orchestra," and when she objected to one of its members, there was usually a further reason. In the case of Belle Greene, Mariano was distressed by her politics. She described an encounter with Greene in 1925: "Belle Greene was at that time full of enthusiasm for the Fascist regime because the steward on her boat had kissed Mussolini's photo in her presence and had raved about the *Duce*. What B.B. or other people had to say on the subject could not make her change her mind."[15] Of Belle Greene's political understanding, Mariano remarked drily, "Like so many Americans she had no discrimination about where information on European affairs came from. One source was as good as another and the first one more likely to be preferred."[16]

On their travels through Europe and the Middle East in the 1920s, Mariano and the Berensons remained keenly aware of the underlying political meanings of their encounters. When

the three went to Germany in 1922, Nicky Mariano observed that curators and librarians were initially distrustful of "all foreigners as base exploiters of the relative cheapness of living in Germany," but when they saw Berenson going through their manuscripts with such care, appreciation, and knowledge, they warmed to him and spoke with him as an old friend.[17]

Meanwhile, Mary Berenson was writing to Isabella Gardner that one of their meals would have cost "a professor or museum director" two weeks' salary. She knew the inflation came from the impossible economic burdens placed on the Germans after the war, and "one couldn't help," she said, "feeling ashamed of 'our side' for going on year after year, piling atrocious misery on the best people."[18] Traveling by herself back to Italy, Nicky Mariano encountered for the first time a group of Fascists from Trent, who stormed her train, "wild looking fellows with huge tassels hanging down over their foreheads from their black caps and armed with clubs. . . . These heroes," was her cutting observation, "behaved like real barbarians."[19]

Later that month, on October 28, 1922, Mussolini staged his famous march on Rome. (This was actually a victory parade; Mussolini had kept the Blackshirts in a neighboring town and used their ominous presence as a negotiating tool in convincing the king to recognize him as the prime minister of a new coalition government.) Berenson wrote of recent events to his friend Judge Learned Hand, noting the rate of German inflation and calling the results of the Versailles Accord and the subsequent policy of the Allies "one of the most appalling fatalities of history." He foresaw terrible consequences: "It has produced a disequilibrium that it will take generations to right. And of course it can end but in one way. . . . Here we are all pretending like five year olds that Santa Claus will bring us all things—yes all things, prosperity, peace, perpetual Sunday within, prestige, profit, first-super-ultra-prime-great-poweriness without.

And all by believing in Mussolini and the *Stellone d'Italia* [Italy's lucky stars]."[20]

Fascist activity had begun in Italy in 1919, almost as soon as the war was over. When the Fascists came to power in 1922, the dealer René Gimpel happened to be in Florence and recorded in his diary Berenson's comments: "I've lived here for thirty-two years and I've never seen a government, and that's their way of governing."[21] It's true that the Italians, until 1871 not a nation at all, were often more a loose federation of regions than a national power. And the political parties, including the socialists, who were an opposition party with a strong base, and the new Catholic populist party, had difficulty in agreeing among themselves and with one another. Industrialists couldn't see past their fear of the Bolshevik fervor that swept Europe after the Russian Revolution, former military officers were at loose ends, traditional parliamentarians seemed unaware of their obsolescence, and the Catholic church was interested in its own power.

Mussolini, who before the war had been an editor of socialist newspapers and had been thrown out by the socialists for arguing that Italy should enter the war, saw fragmentation that he could exploit. His Blackshirts, some of them feckless ex-officers, beat up, tortured, terrorized, and killed socialists and members of workers' parties but were yet seen to be somehow for "law and order." The Fascists had the support of many industrialists, the connivance of the police, and, in general, the polite indifference of the army. Berenson explained to Gimpel: "When the government comes up against some difficulty, they disappear; when everything is settled by the nature of things, they reappear, triumphant."[22]

Mussolini—by threats and blandishments, by creating disagreeable alternatives and then presenting himself as the best among them, and by never letting people forget, as Berenson would later observe, that Fascism was to "save the world

from Bolshevism!"—succeeded in making himself sole dicta-
tor of Italy. He was also a popular figure internationally, with
considerable support from American and other banks. In his
diaries from World War II, Berenson bitterly lamented how
people had supported the Fascist and Nazi reactionary move-
ments out of their "crazed horror" at "Bolshevism," concluding
angrily, "I trust the shades of the bankers who boosted Musso-
lini with a huge loan are satisfied."[23]

In America, the period after the first war was an era in which
luxury easily forgot poverty. From 1921 until 1933, Andrew Mel-
lon, with his dogged belief in the prerogatives of capital, was
the secretary of the treasury in the United States. In 1923, Mel-
lon paid $250,000 to acquire from Duveen Sir Thomas Law-
rence's portrait *Lady Templeton and Child*. Duveen worked in a
world of people who had dozens of servants, owned a million
dollars' worth of china, and did not want pictures that could be
had easily or cheap.

Duveen's schemes for cajoling these clients were endless.
Delightful, semi-apocryphal stories mushroomed around him.
When Henry Clay Frick was having his house designed with
the intention of making it a museum, S. N. Behrman reports,
Duveen found the architect and had him make niches for spe-
cific statues he intended to sell to Frick. Duveen is supposed to
have booked the Huntingtons in to the Gainsborough Suite on
the steamer *Aquitania*, and they are supposed to have fallen in
love with the reproduction of Gainsborough's *Blue Boy* in their
dining room. It's sometimes left out of the story that Hunting-
ton had long coveted the picture, but it is true that Duveen
eventually sold them the original (for $728,800).

American millionaires had quickly seen how possessing
Gainsboroughs and Lawrences, the pictures of the English
aristocracy, would elevate their own status, and they had taken
easily to the gentle French countryside in the nineteenth-

century Barbizon school paintings. It took a little more persuasion for these new collectors to see the relevance of the pictures of the Italian Renaissance, but here Duveen and Berenson were a powerful team. Duveen could argue that nothing was climbing faster in value than Italian pictures, while Berenson could point out that these invaluable pictures represented the discerning taste and life of aesthetic experience that money couldn't buy. The millionaires came around pretty quickly. As early as 1919, Berenson noted that "the same collector who thirty years ago would have bought nothing that was not Barbizon, who then had no familiarity with other names in Italian art than Raphael and Leonardo and Michelangelo, will now send out runners to secure him Cavallinis, Margaritones, Vigoros and Guidos, Berlinghieris and Deodatis."[24] Together, Berenson and Duveen were responsible for bringing the lion's share of these Italian works to the American market. As National Gallery curator David Alan Brown has observed, a measure of the success of their endeavor is that "there are now more Italian paintings in America than anywhere else outside their place of origin."[25] Berenson himself observed wryly in the Harvard Class report of his fiftieth reunion, that a huge preponderance of those Italian paintings which had arrived in the United States in recent decades had "my visa on their passport."[26] Berenson and Duveen both cared to bring important paintings before the eyes of a new public, but for each man, although for different reasons, it has turned out this nobler motive is often overlooked.

The lives of Berenson and Duveen, and the way they were seen by others, make a study in contrasts. Duveen had come from money, Berenson had not. Duveen had security and latitude for his behavior far beyond what Berenson felt he could afford. Duveen was willing to be taken as a buffoon—it was part of how he succeeded at selling paintings to rich people. For Berenson to be a buffoon would have been anathema. Duveen was the sort of person who made others feel that he stood in

the sun, that it was great fun to be wherever he was, and that everything was a great get-up-and-go of bubbling optimism near him. Andrew Mellon is supposed to have said that paintings never looked as good as they did when Duveen was standing in front of them.

By contrast, as Edward Fowles once said, the glow Berenson cast was one that "made one feel that, at least for the time being, one was the only person in the world of interest to him."[27] This quality, so appealing in the moment, ran the risk of being painfully disappointing in the long run. No one minded much if Duveen bounded on to other enthusiasms, but Berenson's audiences became thoroughly invested in their relationship to him and in what seemed the purity of his insight and the perfection of his taste. They could be bitterly wounded if they found he had been sullied by trade or become interested in other people or moved on to new artistic convictions.

Toward both Duveen and Berenson, people were, and continue to be, indulgent, competitive, exculpatory, and dismissive—but, whereas Duveen is seen as charming, Berenson is both adulated and condemned. So, for example, Colin Simpson, in his *Artful Partners*, finds Berenson calculatingly duplicitous but remarks, forgivingly, in passing: "Duveen Brothers kept several sets of accounts and misled Berenson with the same insouciance that they meted out to the revenue and customs inspectors."[28] Duveen, as a dealer, was the court jester to millionaires. His clients were no saints, and it still gives delight to see him swagger. But, in the role of scholar, Berenson's triumphs afforded little of that pleasure. Elizabeth Hardwick noticed the effect of the combination of money and scholarship on people's view of Berenson: "He had, it was felt, sold himself to the devil by demanding life on his own terms, by asking more than other scholars, by becoming a *padrone* instead of a simple professor."[29]

One source for this criticism lay in Berenson himself and

in the intolerance for his own actions that he absorbed in one environment after another. "I took the wrong turn," he said in a late memoir, "when I swerved from more purely intellectual pursuits. . . . My only excuse is . . . I too needed a means of livelihood." My trade, he wrote, "took up what creative talent there was in me, with the result that this trade made my reputation and the rest of me scarcely counted. The spiritual loss was great and in consequence I have never regarded myself as other than a failure."[30]

The tastes and foibles, power and prejudices of the new American class that had such an effect on Berenson were of course a central subject for the writer who became in these years one of Berenson's closest friends. Beginning in 1919, on his summer visits to Paris, Berenson would very often drive out of the city to Edith Wharton's house at Saint-Brice, while at Christmas he was generally to be found at her retreat Sainte-Claire, above the town of Hyères on the Riviera. Berenson loved the way Wharton kept her houses: her sense of history, her attention to detail, the combination of period furniture and modern comfort.

Berenson most often went to Wharton without the women of his household. Mary Berenson was glad enough to have I Tatti to herself when her daughters and grandchildren came to visit at the holidays, while Nicky Mariano was occupied with her sister Alda Anrep, brother-in-law Baron Egbert Anrep, and beloved nephew Cecil. Nicky Mariano explained that, for her and for Mary, "it was certainly easier to give ourselves up wholeheartedly to the enjoyment of our families without having B.B. with his restless activities and numerous demands to pull us away from them."[31] But whereas Mariano and Wharton gradually came to have a warm friendship — Wharton called Mariano "Nick" — Mary Berenson began to feel a bit left out of her husband's relationship with Wharton.

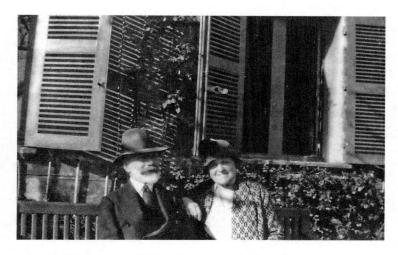

Bernard Berenson and Edith Wharton at Sainte-Claire. Reproduced courtesy of Yale Collection of American Literature, Beinecke Rare Book and Manuscript Library, Yale University.

To begin with, Mary Berenson was happy enough to recognize the appeal of Wharton's houses. When Berenson first went off to visit Sainte-Claire, Mary Berenson imagined it for Isabella Gardner as Wharton's "romantic monastery on the rocky hill."[32] But by 1927, Mary Berenson, struggling on with illness and the ever-more-troublesome upkeep of I Tatti, wrote to her husband in frustration, "Tell Edith her beautifully run household, so full of all human comforts & luxuries, & permeated by her courageous and life-enjoying spirit, has utterly destroyed me, it is all so desirable — so unattainable by me."[33] By contrast, Mariano, sharing her lover's impressions, found the house capacious and warm and appreciated the famous gardens that were a passion of Wharton's: "an enchanting old house, low and long-stretched with a crenellated roof, a long sunny terrace with a wide view over the little town of Hyères to the sea."[34]

Mariano wrote that Wharton was lonely within "the for-

tress of her small intimate circle," and she saw that Berenson was Wharton's choicest company.[35] In one of the pictures of Berenson and Wharton taken at the house at Sainte-Claire, the two friends sit together on a wooden bench in front of a stony, vine-covered wall. Their hats shade their eyes against a bright sun. Her right arm is bent, and her hand rests trustingly on the edge of his shoulder. They were as comfortable together as a pair of old shoes, Wharton used to say.

Berenson described the small convivial society that gathered at Hyères in a letter to William Ivins, another of his close correspondents and the curator of prints at the Metropolitan Museum in New York. In the house at Sainte-Claire, he wrote, "we tell stories, we discuss books and politics or people, we walk a good deal and in the evening we read aloud together."[36] In particular, their hostess read her new work. Berenson wasn't overly impressed by Wharton's projected book on Morocco, feeling that she should return to fiction, but he thought the *Age of Innocence* was getting "better and better" and recognized in it "more solid psychology and deeper humanity."[37] She came to count on him as a listener and a reader. From wartime Paris, she had written of his reaction to her novel *Summer*, which she felt she had woven in the way that the old French tapestry-makers worked at their looms:

> Dearest B.B.,
>
> Oh, do you really, *really* think—or better still—feel all that about "Summer"?—It's such a wonderful sensation to find, when one comes out from behind the "haute lisse" frame of the storyteller, that one's picture lives to other eyes as well as to one's own—the picture so blindly woven from the back of the frame![38]

Wharton dedicated *Human Nature* (1933) to Berenson, and her book *The Children* (1928) was for "My Patient Listeners at Sainte-Claire."

It's interesting that Wharton chose Berenson as one of her primary confidantes for matters both personal and literary; Wharton had, as Hermione Lee discusses, a reflexive anti-Semitism possible in her class. With Jews of a certain kind—immigrants, parvenus, outsiders—she took a tone like that of Henry Adams or of Charles Eliot Norton. What Wharton knew of Berenson's background is not entirely clear but may have been close to the more gilded version he offered in his own autobiographies. When Mary Berenson showed Wharton the chapters of her projected *Life of Berenson* in 1932, Wharton wrote to her, "As to the chapters, they are of course full of interest, but I think you could make them much more so by giving some details about B.B.'s boyhood, and his little childhood in Russia, as he has often described it to me; also about his Harvard days, when he was 'stupor mundi' to undergraduates and professors."[39] From this it sounds as though Berenson had given Wharton a nostalgic picture of his childhood, though it is possible that he was genuinely open with her. As in his correspondence with Isabella Gardner, with Wharton, Berenson made a point of distancing himself from others seen as interlopers. On one occasion, Wharton wrote to ask Berenson's advice about how she should handle a request for information about Walter Berry that had come from Leon Edel, who would go on to write a biography of Henry James. In her diary, Wharton described Edel as "a shy little Jew."[40] Wharton was worried, she told Berenson, that "a vulgar gossipy book could be manufactured by Edel."[41] Berenson replied, "Christ what a bore, & how I sympathise with you [for] the time you will waste over this impudent imposition."[42]

Berenson postured with Wharton, but about writing he admitted his insecurities and appreciated her encouragement. During the war, after she had read an article of his about Leonardo, she wrote enthusiastically, "It's *splendid* & such a glorious 'sample' of the big book you promised me to write when

we were motoring toward Denmark—that I feel pretty sure the book is more than half done already."[43] He wrote back two days later, pleased that she had liked the piece but ruthlessly accurate about his own limitations: "I am over 50. I have endless scholar's work to do, I love reading, I love society, and I have business to attend to.—Of course nothing would count if only I had the gift of tongues.—You refer to a book I must have sketched out for you on our tour. I wonder which and what? I have cast so many cloudy symbols of tomes upon the void."[44] Although he was still publishing collections of essays and studies of paintings, and although his epistolary output was astonishing, Berenson was not writing the great works of aesthetic theory that others were gradually ceasing to expect from him. Working for Duveen had been taking a lot of his time.

For the first eleven years of their association, from 1912 until 1923, Duveen and Berenson seemed to go virtually unchallenged in their preeminence. But the market was changing around them in ways that put pressure on their successful contract and especially on its secrecy. In 1923 came the celebrated Hahn trial, and Berenson almost lost his footing.[45]

Mrs. Hahn, who was at first sight an American woman from Kansas, was, on closer inspection, a French woman of uncertain background who had married an American captain after the war. She had left France shepherding what she had been promised was a very valuable painting, not only a Leonardo, but the original of a painting whose mere *copy* was *La Belle Ferronière*, the celebrated portrait in the Louvre. Hahn proposed to sell her painting to the Kansas City Art Institute. A newspaperman whose curiosity was piqued asked Joseph Duveen for a comment, and Duveen, who never curbed his tongue, replied immediately that the Louvre's was the original and Hahn's the copy. She sued Duveen for slander of title and $500,000 damages. Duveen adored a fight—he practically hummed with plea-

Joseph Duveen waiting to appear in New York court
for the Hahn trial, 1929. Corbis.

sure in the witness box. He stepped up to the challenge. The
suit was filed in New York, but since the Louvre painting could
not travel, evidence would first be entered in Paris.

Duveen and his lawyers thought they would get both
paintings in Paris, and get as many important picture experts
as possible to pronounce their opinions. Duveen would de-
finitively establish his authority in the mind of the public. He
cabled Berenson to come to Paris. Berenson, who knew that
certain kinds of publicity would not be at all good for his au-
thority, demurred. Duveen cabled again: "Much disappointed.
In fact cannot take refusal. You will have to stand by and help
us. Everybody expects your opinion on this matter. . . . Do not
disappoint me. . . . Joe."[46] Berenson sighed, and went.

For Berenson testifying was made more complicated by the fact that he, like many other experts, was already on record as doubting whether Leonardo had painted the Louvre *Belle Ferronière* in the first place; at one point he had attributed the picture to Boltraffio. If he now went and testified that the Louvre painting was a Leonardo, he was vulnerable to the accusation of selling his attribution to support Duveen.

Berenson had a strange antipathy for Leonardo's works. This might have come in part from the fact that Berenson's career could have been ruined when he was slow to recognize that the so-called Donna Laura Minghetti Leonardo was a fake.[47] Certainly Berenson the iconoclast delighted in taking on a painter who was considered by many to be the greatest of all. Still, his piece debunking Leonardo, published during the Great War, had an especially odd ring, given the xenophobic propaganda then in force all over the world. Berenson described the figures in Leonardo's *Last Supper:* "What a pack of vehement, gesticulating, noisy foreigners they are, with faces far from pleasant, some positively criminal, some conspirators, and others having no business to be there. . . . But I never dared say it out loud."[48] It was this article that Edith Wharton admired, and her response is suggestive both of a social atmosphere and of Berenson's stature at the time: "I must dash off a word of gratitude & rejoicing; for on the very first page I find are 'execrations' of the Last Supper. Ever since I first saw it (at 17) I've wanted to bash that picture's face, & now, now, at last, the most-authorized fist in the world has done the job for me! Hooray!!!"[49]

Perhaps Berenson in some way identified with Leonardo — an exile in France, a man beholden to the whims of kings, and one who left many of his projects unfinished? B.B.'s repudiation of *The Last Supper* was of the sort that a person might reserve for the things he least wants to be true of himself, "a pack of . . . noisy foreigners . . . some positively criminal . . . having no business there." It seems fitting that a pair of possible Leonar-

dos became one of the most public tests of whether Berenson and Duveen could hold on to their position as *the* determiners of the value of old master paintings.

The witness stand at the Paris trial gives a good view of how Berenson appeared to his contemporaries in that moment of his renown. Nearly a hundred people crowded into the American consulate to see Berenson give his attribution. At fifty-eight, he was charming, distinguished, and disdainful of what did not pertain to culture as he saw it. He counted on sympathetic women to take care of him, and they did. (Mary Berenson wrote to Isabella Gardner that, after hours of testimony, "BB softly said 'I do want my tea,' and all the ladies in the audience murmured, 'Isn't he just *too* sweet?!'")[50] Mary Berenson and Nicky Mariano each saw the proceedings in characteristic fashion. Mariano wrote that she was a little late arriving for the testimony. She slipped into her chair beside Mary, asking, "'How is it going?' Mary whispered back: 'Bernard has already made a fool of himself.'" But Mariano couldn't figure out why she thought so: "The answers I heard him give seemed very simple and convincing."[51]

One of the hearing's revealing moments was when the Hahns' lawyer asked Berenson if he'd studied another supposed Leonardo, at the Prado, and Berenson said that he had. Well, then, the lawyer wanted to know, was the painting on canvas or on wood? Berenson said he thought wood, but that it hardly mattered: "It's not interesting on what paper Shakespeare wrote Hamlet."[52] Versions of this line were repeated around Paris as a clever rhetorical stroke, but in it were signs of what Mary Berenson saw could be her husband's difficulties. When Berenson did his training, in the 1880s and 1890s, studies of materials were considered relatively unimportant. But the market was becoming much more technically specialized. Berenson and the other assembled experts judged the Hahn paint-

ing by its "feel," by qualities hard to measure, though Berenson as always was good at communicating them to nonexperts. "It fails to display the vitality and vibrant energy of a Da Vinci," he testified. "The eyes stare, the mouth is too luscious, the shadows are too dark and it is all too smooth. To me its surface produces an effect much like oil-cloth. The right eye appears deader than the left—if possible. And I cannot honestly say that the cheeks look as if there were any bones under them. When I regard the face I see it something like a child's balloon."[53] But were these qualities of feel and style sufficient corroboration when authenticity had such a high price?

In the Paris depositions, although the experts might have had doubts about the attribution of the Louvre painting, they closed ranks against the outsider Hahns and their second-rate picture: the Louvre painting was the original. In European social circles, the matter was considered settled. The Hahns kept the case alive, however, and the trial moved from the old world to the new, resuming in New York in early 1929. Berenson remained in Europe. The Hahns' lawyers felt that the jury would respond better to material evidence than to the testimony of a seeming cabal of experts, and they directed the proceedings toward the technical. They submitted pigment analysis, which proved that, at least, their painting was old. Duveen was unimpressed; experts on his side also made cogent points about pigment, but he was not interested in pigment. The Hahn's lawyers then presented a new technology, X-ray photographs, but the only person they could find to read them was a radiologist. The judge struck this evidence, and Duveen said that he "did not believe in" X-rays.[54]

The jury in America was made up of an assortment of clerks, real estate agents, people who worked in upholstery and ladies' wear, and two artists. They may not have followed all the technical arguments, but technical matters were still more straightforward than issues of sensibility. According to Duveen's biographer, Meryle Secrest, the Hahn lawyers understood the jury's

wariness, and Duveen and his lawyers did not. In the end, the best technical evidence was actually on Duveen's side. Late in the process, an expert from Harvard University's Fogg Museum brought forward X-ray shadowgraphs that showed that in the Louvre painting the figure had been completed and then her jewelry added in a separate layer, while in the Hahn painting the flesh and the jewelry had been painted on at the same time. The Louvre painter had made a decision; the Hahn painter had copied the decision. But Duveen's team failed to make use of the technical advantage, preferring to ground their argument in the superior sensibility of their experts. It didn't work. The jury stated in its opinion that its members had been left with "an exotic vocabulary and a distrust for connoisseurs."[55] The jury believed the pigment analysis at least demonstrated something concrete, voted against Duveen nine to three, and was unable to come to a determination. In the end, the judge ordered a retrial, and Duveen settled out of court for $60,000.

Unlike the law courts, the newspapers still subscribed to the authority of old-fashioned expertise. Meditating on the trial and the role of the "Art Expert," a columnist for the *New York Tribune* naturally chose Berenson as the foremost representative of the type and concluded that "when expertise justifies itself," it does so on the basis of "an instinct akin to a pianist's touch or a singer's feeling for pitch."[56] Other members of the press urged the protection of specialists' freedom of speech. The *Evening Post* opined: "How can anyone outside of a comic opera expect the authenticity of an old painting to be settled by a lawsuit?" and worried that the possible "silencing of all expert comments in our country" would have been "a very real calamity."[57] But the press was not the market. The trial had made clear to the millionaires who constituted the all-important American market that, if it were up to a jury to decide, a connoisseur's testimony was not enough.

In fact, the case had begun to erode Berenson's authority

long before the New York jury's deliberations. At the 1923 deposition in Paris, the newspapers reported that one of the Hahns' lawyers, Mr. Ringrose, had asked Berenson whether his opinion that the painting in the Louvre was a Leonardo had changed since he had become an employee of Duveen's. The *New York Herald* described Berenson's awkward response: "Mr. Berenson replied that he objected to the term 'employ of Sir Joseph Duveen,' as he was not by any means regularly employed by the Duveens, but only expertised Italian paintings from time to time at their request. Mr. Ringrose asked him if he received money for so doing, and Mr. Berenson replied that he did."[58] It thus became a matter of public record that Berenson did not merely live on air and genius. Other art dealers were quick to see what that revelation would do to Berenson's stature. René Gimpel crowed to his diary, "So compromised in the face of the intellectual world his mask fell, that mask which so many enemies have sought to tear away."[59]

Part of what the Hahn trial revealed was that Berenson was losing his place in the changing art world. When Berenson and Duveen started out, combining learning and a talent for commerce had often been the only open path for Jews. Now the two men found their methods caricatured in anti-Semitic terms. After the Hahn trial, Hilaire Belloc and G. K. Chesterton even wrote a comic novel, *The Missing Masterpiece*, with stereotypical characters modeled on Berenson and Duveen. The relation between art and the market was now being mediated in a new way. American universities had departments of art history, and American cities had museums that took shadowgraphs. These institutions (staffed by people who trained under Berenson and full of paintings sold by Duveen) carefully cultivated a position of independence from the market.

Not surprisingly, the newly vociferous demands of the market put enormous pressure on those middlemen who were

still supposed to guarantee not only the authenticity but the significance of the paintings in their charge. Berenson and Duveen suffered bouts of ill health, about which Duveen was silent and Berenson complained continually; they worked long days; they made questionable choices; and they quarreled, often about money.

Mary Berenson bore much of the burden of the financial negotiations with Duveen, which Berenson hated. She would stop off in the Paris office on her way to or from her family in England. As she was an authoritative connoisseur in her own right, she sometimes took care of an attribution or two. But the main purpose of a visit was generally, as she said, to "screw money out of [Duveen]."[60] She argued for transparency, although she knew secrecy was useful to Duveen: "We are in some sense partners in your great Italian adventure. . . . B.B.'s advice would be more valuable to you if he knew what you sold and how much you got for each picture."[61] After one of Duveen's long delays in paying, she pointed out, "You swim in ever widening and deepening floods and have endless credit for times of drought. We sail our little bark on a shallow stream," and, thinking of their families, "Many people who are dependent on us . . . sail lighter barks in still shallower streams."[62]

For his part, Duveen knew that the percentage terms of the contract put Berenson in a vulnerable position: he stood to get higher fees if he shifted his attributions. The suggestion that Berenson did actually do this is still widely considered to be the most damning ethical criticism raised against him. It isn't easy, though, to decide how to evaluate this concern: Should one attempt a numerical accounting of the many thousands of attributions? Or go by the significance of the works that Berenson got right or erred about? How much weight should one give to his worst mistakes? Ought one to compare Berenson's record with that of other comparable connoisseurs, and who would make an apt comparison?

In the archive, there are many cases in which Berenson did not give in to requests for improved attributions. As Mary Berenson explained to her family in 1913 regarding their relationship with the Duveens: "They are continually at him to make him say pictures are different from what he thinks, and are very cross with him for not giving way and 'just letting us have your authority for calling this a Cossa instead of a school of Jura. . . .' They have found B.B. very unyielding."[63]

Berenson's refusals sometimes saved Duveen from awkward situations:

> Dear Duveen. I am returning the photograph of the Portrait of a Lady represented as the Magdalene & ascribed to Andrea del Sarto.
>
> It is by his pupil Domenico Puligo & very good of its kind, but of course as such you can not pay £3000 for it.[64]

In another instance, Mary Berenson explained on her husband's behalf that he couldn't simply wave a wand and turn a painting into something it was not—attributions, to carry any weight at all, must be the sort of thing other people can agree to. She tried to explain to Duveen in practical, not ethical, terms and typed, hurriedly:

> You can imagine that he *wanted* to think it by that master quite as much as you can want it! He naturally would have greatly preferred getting the rpofit [*sic*] that would have accrued to him. If he could have passed it as a Raphael. He does not, however, really believe that anybody, as things now stand, would dare to present it as a Raphael, or that, if he did, it would take on. . . . B.B. remains quite unshaken in his belief that it is *not Raphael* in spite of all the qualities you mention.[65]

The requests came steadily over the decades, and Berenson went on replying: "As for the so-called Pintoricchio, it is by an assistant of that master's."[66] Sometimes, in telegraph form,

he was even more concise. On May 28, 1912: "NOT VERONESE: BERENSON."[67]

Nevertheless, stories of Berenson changing attributions on request resurface regularly in studies of his life and work. Some of these tales have their source in Edward Fowles's memoir, ghostwritten by Colin Simpson, and in Simpson's own *Artful Partners* (1986). Simpson was given access to the then-embargoed archives of Duveen Brothers, but in his book he did not include reference notes, and since the archives have become available in the last ten years, corroborating material for some of the described incidents has been difficult to find. Still, stories of Berenson's misdoings are told and retold, sometimes with a shade of anti-Semitism in the background, and the stories and the telling of them point to something interesting. Berenson excited suspicion. The stories seemed to fit.

Berenson clearly did act badly in a neighboring, sometimes overlapping, territory: he regularly wrote letters about paintings for the benefit of Duveen's clients in which he would make the works sound more wonderful than he thought they were. Of a fairly interesting painting he believed to be by Pollaiuolo and which he wanted Gardner to buy from Duveen's Hainauer collection: "The most vigorous, the most plastic, the most characterfull in existence, and the grandest achievement of the greatest draughtsmen of the whole Florentine school . . . jewel-like in its glory."[68] By this point in his career regularly working from photographs, Berenson sometimes seemed almost unaware of what might be restoration. He called a badly repainted Bonfigli "a perfect fairy-tale of sentiment and colour" and was hasty in declaring his thrilled admiration for a possible Masaccio that later seemed a mere patchwork of additions.[69] In considering these florid descriptions, it is worth pointing out that, from the art historian's perspective, there is a significant difference between making a painting out to be beautiful and making

it out to be a Raphael. Tastes change and are unpredictable, but all great painters made some lesser works, and an authenticator may take some latitude in matters of taste without actually erring in attribution.

On his side, Berenson felt that, if he was sometimes in the position of praising badly restored paintings, it was because of Duveen's slapdash practices, against which he regularly protested. Duveen, and many of his clients, liked paintings to be nice and bright and spruce, not cluttered up with darkness and shadows and other things that had been of interest to old master painters. Duveen's house restorers were told to scrub paintings in a hurry for impatient clients, and these changes were irrevocable. Mary wrote regularly with admonishments: "Good, careful restoration *can't be hurried*, &, as things are, the Firm cannot be too cautious about the restorations. People are beginning to take notice and to complain."[70] Or, about Duveen's favorite, Madame Helfer: "Every restorer has a tendency to *prettify* [double-underlined] & to make slight rectifications here and there which end by destroying the character of the master. Mme. Helfer is as good as anyone, but yet pictures under her hands get to looking all alike."[71] Berenson had given a full statement of the problem as early as 1912:

> I am having the Lazzaroni "Pintoricchio" transferred at once and here. . . . You are always in such an infernal hurry. Now picture transferring and restoring entail processes of drying which require time and attention. If hurried over, the varnishes will be sure before long to begin to play dirty tricks. The consequences may be very annoying for you, and it is to save you from your own rashness that in the future wherever possible I shall see that the picture is already transferred before you get it. Of course, and unfortunately, it will seldom be possible.[72]

Duveen could not be persuaded to temper his idea of how things should look, and this led to one of his worst mistakes. In

one of his many large philanthropic works, he had his favorite architect build a new hall for the Elgin Marbles at the British Museum and then took charge of their cleaning. But his chosen methods radically eliminated the ancient patina on them, and he even had the workers chip away with metal tools to reach what he believed should be their pure whiteness. Lord Crawford, one of the trustees of the British Museum, wrote in his diary, after being that day "lectured and harangued" by Duveen, "I suppose he has destroyed more old masters by overcleaning than anybody else in the world."[73]

In the end it may be impossible to make a perfect accounting of the accuracy of Berenson's thousands of attributions or to decide by how many gradations he on occasion caved to Duveen or to his own financial desires. Perhaps it is more fruitful to try to grasp his view of what attributing pictures was fundamentally about. Berenson's attributions are based on the idea that, contrary to what the market would like, the works of an individual painter are not discrete fragments that can be run through machines and given definite labels but the manifestations of an artistic character at work, to be approached by the connoisseur's well-informed, human understanding. Attribution, at its best, is a human enterprise, fallible but truthful. Berenson himself wrote to his friend and colleague Paul Sachs at Harvard's Fogg Museum, "I do not flatter myself that my attributions are final, but I dare hope that, at the worst, they are on the way to truth and not to error."[74]

Paul Sachs, with an independent fortune from the family firm, Goldman Sachs, did not have to worry that people would accuse him of changing attributions for money. Many people who work in art authentication have independent sources of income, and the clients in the art market find this comforting. As the documentation of Berenson's world becomes more

fine-grained, it emerges that the real danger for his reputation was not a specific act of malfeasance, or the fact that he had money, but that his money, like that of his tin-peddling father, depended on trade.

Berenson's fortune *was* substantial. According to Ernest Samuels, before the market crashed in 1929, Berenson had put about $300,000 of his earnings into stocks. This may have been less than the cost of individual paintings bought by Mellon and Frick, but at a time when the average factory worker made about 52 cents an hour, Berenson's investments gave him the economic power of someone with about $44 million today.

And yet his fortune put Berenson in a bind. According to his extremely subtle understanding of the sources of power, his wealth at once solidified and threatened to upend his reputation. One of the most revealing documents in the Berenson archive is the draft of a letter he wrote to his cousin and lawyer, Lawrence Berenson, in 1922. Lawrence Berenson was then settling some of B.B.'s financial affairs and would later be the executor of his will. The letter was intended to help Lawrence Berenson explain to the Internal Revenue Service why the appearance of wealth was necessary and why Berenson's books and pictures and travels about the continent were legitimate business deductions. "[The IRS] make[s] a difference between personal expenditure & outlay on business. In my case however almost all I spend is calculated, & more than calculated, imperatively demanded if I am to make an income. I do not earn money by trade. I earn it by enjoying such authority & prestige that people will not buy expensive Italian pictures without my approval."[75]

It was not just the money but what the money meant, "authority & prestige," that persuaded wealthy clients to take Berenson's advice on pictures. Travel and acquisition, then, were necessities: "To keep that authority & prestige I must keep myself in constant training by contact with works of art &

by being surrounded by them in my own house." Also necessary was entertainment. Although it was "regrettable," it was "a fact that the people who have been entertained by us do more than a little to *advertise* me & to keep up & even increase my authority & prestige." Berenson saw no choice for "a person of my kind" but "to treat himself & to *organize* himself as a *business*." Wealth was a necessity, but the kind of wealth that supported authority and prestige was not to be made in trade, and certainly not in the picture trade. Berenson's actual business, therefore, had to be secret, and the secrecy exacted its price.

Of course, the problem of separating the authority and prestige of one's wealth from its actual sources was one familiar to the clients of Berenson and Duveen. It was part of what the Mellons and Fricks wanted from Duveen and Berenson: the acquisition of high culture would cover over, to a certain extent, the getting of their gains. Henry Clay Frick's gorgeous museum-mansion certainly has no placard declaring that it was paid for by the crushing of the Homestead Strike.

But it is a slightly uncomfortable feeling to purchase culture from a man who knows that you didn't used to have any. Duveen's clients retained the privilege of keeping up their self-respect by mocking Duveen. Edward Fowles tells a story of sitting with Duveen in the Paris office while the collector Henry Edward Huntington, always referred to as H.E.H., was paying a visit. Duveen was about to go into a flight of eloquence over a new picture when Huntington cut in. "'Wait a minute . . .' H.E.H. exclaimed, rising to his feet. I will give you the works.' Waving his arms, he shouted at me, 'The greatest picture I have ever owned! It's simply stupendous,' in mimicry of Joe's sales talk. He sat down again, laughing uproariously."[76] Fowles remembered that he felt very awkward in the silence afterward.

Europeans in the era of Berenson and Duveen used an old term for a man who advised the wealthy on the intricacies of their affairs and served as a repository for confidences, the

homme de confiance. A difference of religion between the con-
fider and the confidante often made the relationship seem more
secure. There were shades of the homme de confiance in the
roles that Berenson and Duveen played for their clients. Beren-
son, in turn, relied for such help on Lawrence Berenson. Curi-
ously, Nicky Mariano adduces Lawrence Berenson's position
as proof that Berenson was not "uncomfortable about being a
Jew," as, she said, he had been "repeatedly accused of being."
Her argument was that "had [Berenson] had any snobbish wish
not to be taken for a Jew, he would have certainly tried to find
a Christian *homme de confiance* and he would have fought shy
of his Jewish relations."[77] But it may have been that Berenson,
like his own clients, preferred to have his private financial deal-
ings in the hands of someone Jewish, with an outsider's under-
standing of his situation. These are precarious and powerful
positions. Duveen and Berenson, Jews to whom certain mem-
bers of high society voiced regular objection, nonetheless were
arbiters of taste for a significant portion of America's wealthi-
est class. Their opinions, not only about which paintings were
authentic, but about which paintings it was important to own,
were accepted as law by a great many anti-Semitic millionaires.

In the 1920s, while the Hahn trial was affecting Beren-
son's reputation in the American art world, his position as an
intellectual was making him the object of Fascist suspicion in
Italy. Fascism in Italy was not in an organized way anti-Semitic
until Mussolini came to an understanding with Hitler and an-
nounced the Race Manifesto of 1938. Before that a great many
Italian Jews were active members of the Fascist party.[78] Beren-
son was against Italian Fascism not because he was a Jew but
because he opposed state control of the media and disregard
for the rule of law. By the mid-1920s, Fascism began to affect
Berenson and his friends more directly. Doro Levi, an archae-
ologist who held a chair at the University of Cagliari, was dis-

missed from his job by the Fascists, and Berenson helped him to find shelter in the United States. In 1925, when the great anti-Fascist writer and activist Gaetano Salvemini was arrested, his wife and friends sent the Berensons two requests. They asked the Berensons to help collect international reactions to the arrest, and they wondered if it was practicable to use Berenson's passport for Salvemini to try to flee the country. (The heads of the two men looked quite alike.)

Berenson's close friendship with Salvemini, who was a history professor, had begun long before the first war, and the Salveminis were often at I Tatti. In 1917, when Berenson had entered the diplomatic service and was supposed to keep track of the movements of the Italian press, Mary hired Salvemini's wife, Fernande, to manage the job. Nicky Mariano wrote of the friendship of the two men that "temperamentally they were very close to each other, impetuous, passionate and at the same time wise and penetrating in their analysis of events and able to help each other in throwing new light on various historical questions."[79]

Because of his friendship with Salvemini, Berenson came to be connected with many other anti-Fascists. The scheme of switching passports was not taken up, but the man who brought the request, Count Umberto Morra, became one of the closest friends of the Berenson household, spending many weeks traveling with them and staying at I Tatti, often for months, every year. Morra was a broadly educated young nobleman who would have followed his father's military career had not a childhood illness rendered him slight and lame; he considered his friendship with Berenson a great blessing of his youth. Morra would later write one of the books that best gives the impression of Berenson's genius for talking, what Morra said came through in a "pungent and burning" way in his speech: "the liveliness and the richness of his reasoning, the graphic quality of his examples," and the "long, subtle, and unforeseeable dis-

courses."[80] Called *Conversations with Berenson*, it is a record of nine years of their shared talk. "You ask about Morra," Berenson wrote to Mariano, "He is simply perfect and I feel not a thin sheet of paper between us. He takes almost as much interest as your darling self in all that pertains to me."[81] Through Morra, Nicky Mariano explains, "B.B. ended by belonging to a network of anti-Fascist intelligentsia and wherever he went he could be sure of meeting kindred spirits."[82]

When Salvemini was released, as part of a general king's pardon in August 1925, he went to England and stayed with Mary Berenson's sister and brother, Alys and Logan. This was known to the Fascist authorities and did not tend to increase the Berensons' popularity with them. The denizens of I Tatti adopted the practices of coded reference that can become second nature under totalitarian regimes. Among themselves they called Mussolini "Teddy." Mary Berenson explained in a letter to Walter Lippmann, "That makes things safer, and also a bit ridiculous."[83] She must not have been too worried that their mail was being read.

Mary Berenson had loved traveling through Italy and was expert in its painted history, but she had never really learned to speak Italian and tended to maintain a kind of Anglo-American scorn for much of Italian life. Nicky Mariano was Italian, and her life with Berenson was of Italy, though still rooted in the Anglo-American world ringing Florence. She took Fascism much more seriously than Mary Berenson did. In her book, Mariano almost never allows herself a note of anger toward Mary Berenson, but she is sharp about the occasions when Mary's carelessness and proclivity for telling everybody everything endangered all the inhabitants of I Tatti, as happened a number of times.

Mariano's place in, and understanding of, Italian society saved Berenson's life on more than one occasion during World War II. Even much earlier, she extricated him from a number

of difficult situations. In late 1926, Berenson and Mariano were traveling with the young Kenneth Clark, who had been helping with a new edition of *The Drawings of the Florentine Painters*. (Clark, like many of Berenson's pupils, displayed a certain ambivalence about his mentor. He was rather glad to get married and leave behind the I Tatti duties of attending to Berenson's conversation and working on Berenson's lists, but he also wrote to Berenson, "All the work I do in the history of art will have foundation in what I learned from you," and, after Berenson's death, declared, "I owe him far more than I can say and probably more than I know.")[84] On this journey with Clark, Berenson and Mariano were roused in their hotel rooms in Brescia in the middle of the night and told by the Fascist militia that they would have to go to prison, that they had stolen something from the church. Mariano "persuaded them of the impossibility of our running away with our car in a distant garage and made them wake up the director of the museum who had been with us all through the afternoon."[85] It transpired that there actually had been a theft and that the thieves had paid the sacristan to denounce the Berenson party to the police. It became an amusing story, but Berenson's vulnerability as a foreigner, and an anti-Fascist intellectual, was ever clearer.

On another occasion, in the late 1930s, Berenson and Mariano were on an Italian ship bound for Smyrna. Mariano described how, "as dessert . . . the waiter presented us with a huge chocolate cake decorated with a swastika in spun sugar" because, the waiter said, today "the Fuehrer arrives in Italy." Berenson said, "in a shrill and penetrating tone: *'Il giorno della vergogna'*—the day of shame." At the next table an Italian official blushed crimson, covered his ears, and left, "obviously in a rage." Mariano followed him out onto one of the boat's decks, where at first he said it was his duty to denounce both Berenson and Mariano in Smyrna. She pleaded to ask one question: "Is your father still alive?" When he said yes, she asked if the father

was happy with Italy's current state, and the man admitted that his father hated it. She argued that Fascism was for the young, and then she told him about Berenson and his life in Italy, and it ended with "a very friendly talk." Mariano felt the narrowness of the escape: "I know that several protecting saints must have been on my side on that occasion."[86]

In 1928, about to depart for travels in the Near East, the Berensons made new versions of their wills, and they made a further version in 1934. Berenson was concerned about his legacy, and a series of deaths in this period made him more conscious of his mortality. Some of these deaths affected him more nearly than others; about some the record is silent and the significance for him can only be surmised. To begin with, Isabella Gardner died in 1924. Then, Edith Wharton's lover Walter Berry, leaving behind distressing legal complications, died in 1927. Berenson's father, Albert Berenson, died in 1928, at the age of eighty-three. Senda's husband, Herbert Abbott, after several strokes and a prolonged attempt to recover at I Tatti, died after long suffering in March 1929. Geoffrey Scott, divorced from Lady Sybil Cutting and, having gone to America, seemingly at last on his way to a satisfying literary career, contracted fatal pneumonia in the summer of 1929. And, shockingly, Berenson's sister Rachel Berenson Perry died suddenly in 1933, at the age of fifty-three.

The death of his youngest sister reduced Berenson to "numbness." As he wrote to a friend, he could find no words, "not even halting ones," to send to his brother-in-law, and it took him a month to write to their mother.[87] The death of his father had brought a more reflective grief. He wrote of his father to his brother, Abie, with a mixture of emotions: "I who had for many years little to suffer from the disagreeable side of him, must confess to having had a soft spot in my heart for him. He was very gifted and eloquent and fascinating, but

spoilt, inadequately educated and uprooted. I always wondered what would have become of him if he had had my chance."[88] In some ways, Berenson's whole adult way of life was a display of how different he was from his peddling father, but underneath, Berenson remained conscious of their shared giftedness and eloquence and of how the education that had made a home for him had depended on fortune and circumstances.

The consciousness of what his chance had been—how Harvard and Boston and Isabella Gardner had made way for him, and the particular way that they had made—was crucial to how Berenson came to conceive of his legacy. Ever since that first visit to see Gardner's Fenway Court, Berenson had been laying plans for leaving I Tatti to Harvard. To Gardner and to Berenson a house, like a work of art, was an expression and artifact of a personality; a house might carry the life of its inhabitants forward long after their deaths.

During the year before Gardner died the Berensons knew she was not well, and their letters to her were tender and affectionate. On the first of 1924, B.B. sent Gardner a New Year's greeting, hoping his habit of writing to her at that season might "last on for many years. . . . How I wish I could see you," he added, "lots and lots. There is no company like you."[89]

Gardner died on July 14, 1924, at the age of eighty-four. She had seen to everything, leaving minute instructions about her museum and "Directions for my Funeral" that were specific to the smallest imperious detail. "Carry my coffin high—on the shoulders of the bearers," she had written, as she wanted the treatment a queen would receive. She added, characteristically, "They will have to be told exactly how to do it."[90]

For Berenson, both Gardner and his father would be memorialized, along with all the rest of his gains and losses, in his library. As his friend and pupil J. Carter Brown remarked, "Berenson always regarded that library as his most significant

achievement and, in a sense, as his autobiography."[91] Toward the end of his life he wrote down some thoughts and directions for the future of I Tatti. "I have provided a library," he said, "covering nearly every field of art and literature as well as all the ancillary material historical, philological, and critical for rendering the arts intelligible, suggestive and inspiring." Such a library would give the fellows he imagined at I Tatti the very thing his father had been missing, that education which combated uprootedness: "A person properly prepared who would use the I Tatti library for four years could not help coming out as a cultivated appreciator of all that art is and of what it has done to humanize mankind."[92]

Two weeks after Gardner's death, Belle Greene responded to Berenson's request for advice about how to manage his intended bequest of I Tatti. Greene, who had done a great deal to institutionalize the Morgan Library, had the clear vision of experience. She said I Tatti ought to be lodged at an institution, or well endowed and set up with wise trustees, otherwise it would "degenerate into a wayside inn for loafing scholars."[93] She heartily recommended that Berenson work with Paul Sachs in his position at the Fogg Museum and Harvard. Sachs had been a close correspondent of Berenson's for a decade, and Greene's advice confirmed his own inclination. In 1926, Sachs came for a long visit to I Tatti, and he and Berenson came to an understanding about how to endow the library and fellowships as a permanent institute at Harvard. It would, however, take several decades to finalize the negotiations, and Berenson was often distraught that the whole thing seemed to be falling through. It was evidently a matter of peculiar importance to Berenson that Harvard, which had made it possible for him to be a connoisseur and, in some ways, had prevented him from being anything else, should now accept as a gift his library, as he wrote of it, "the surest and completest biography of myself."[94]

The institute exacerbated the bitter conflict between B.B.

and Mary Berenson over money. In her view, as she explained it to Edward Fowles once when he was visiting, "'our marriage is not of the usual type, but a union of intellects. I want my share of the profits resulting from our joint efforts for my daughter and granddaughter.'"[95] This in itself seems reasonable, but as Mary's granddaughter Barbara Strachey later explained in her book *Remarkable Relations*, "Bernhard was perfectly willing to be generous, but his goodwill was undermined by the rash and reckless way in which Mary did her giving." Rather than a steady allowance for her daughters and grandchildren, Mary gave extravagances, fur coats and theater tickets. "Mary could not be stopped," Barbara Strachey wrote. "The gifts went on, and grew more impulsive and more frequent as her addiction grew." She hid her debts from her husband, he would eventually have to pay them, and this "drove him almost mad with fury."[96]

In Mary Berenson's family, mania intensified with age. Nicky Mariano and B.B. kept track of Mary's swings. On one occasion, Mariano gravely thanked Berenson for forwarding a postcard from Mary, adding that she was somewhat alarmed by its euphoric tone. Mariano was sympathetic, but Mary felt alone in plaintively remembering the beginnings of her work with B.B. In 1928, contemplating the probable disposition of their property, Mary Berenson wrote repeatedly to Mariano: "I do not see my way to change anything as B.B. does not recognize that I had any share in building up his career, though indeed without me in the beginning he would have drifted and never written a line," and although sometimes she, too, was proud of what they had built at I Tatti, "alas that all the money goes into the cursed Institute."[97]

Other women in Berenson's life—Belle Greene, Edith Wharton, and especially Nicky Mariano—were less ambivalently committed to Berenson's vision. When Paul Sachs brought home the report of the latest plan, he went immediately to have a "long pow wow" with Greene about it. She was

thrilled by the prospect and wrote immediately to Berenson, "B.B., you are, at last, a great Big DIVINE Critter—." Greene's idea of I Tatti suggests something about what her relationship with Berenson meant to her: "The thing which American student life or whatever one chooses to call it, now needs more than anything else—The thing I Tatti stands for—no classroom stuff etc. etc. but culture in the real sense of the word—a soaking in of an atmosphere, which to *me* means more than anything all the consolidated universities of the world can give." She felt strongly that the institute should bear his name: "Your career has meant everything to the art world and it certainly should not pass into oblivion," and finished her letter in double-high capital letters, "And I'm so DAMN PROUD of you!! B."[98]

Berenson's closest companion in the building of the library was Nicky Mariano. In Mariano's memoir, she describes how B.B. spent a daily hour with the secondhand book catalogs and then how she spent many more ordering, cataloging, reading, and indexing. The new books were a shared excitement. Her letters to Berenson refer to the arrival of certain books, the unpacking of cases, the careful choices that she and Berenson made together as his mind ranged widely over aesthetic developments in Asia and the Near East and through millennia of European history.

A significant part of Berenson's contribution to his field was in offering his library to people who needed it and knew how to use it. Leo Stein used to walk up the hill at Settignano quite regularly to spend an afternoon hunting and browsing. Arthur Kingsley Porter, the great architectural historian and close friend of Berenson's, wrote important sections of his monumental work *Romanesque Sculpture of the Pilgrimage Roads* while at I Tatti using the library.[99] The Japanese scholar Yukio Yashiro, working there on his study of Botticelli, found both material and inspiration. Other men with deep experiences

of the library included John Pope-Hennessey, Sydney Freed-
berg, Kenneth Clark, later director of the British National Gal-
lery, and John Walker, later director of the National Gallery in
Washington, DC, as well as various future curators at, among
many others, the Boston Museum of Fine Arts, the Cleveland
Museum of Art, and the Frick Collection.[100]

Perhaps Edith Wharton expressed best what the library
meant to Berenson and what he hoped it could be for others.
"Such a library as that of I Tatti," Wharton wrote after her
many days of working and reading there, "is a book-worm's
heaven, the fulfillment of all he has dreamed that a great work-
ing library ought to be . . . not a dusty mausoleum of dead
authors but a glorious assemblage of eternally living ones."[101]

Copies of Wharton's books, too, are to be found in the
I Tatti library, on the long shelves that gave her and Beren-
son a reassuring sense of being part of imperishable culture.
Her books bear loving inscriptions, like the one in her *Human
Nature*, where she wrote, under the dedication to him: "To
Bernard Berenson, because he liked some of these stories, &
to Mary, in the hope that she will too, From their affectionate
Edith."[102]

In the 1930s, it was generally Berenson who went to see
Wharton. Sometimes he grumbled about this, pointing out
that he could not work without his library and that Wharton
could come to I Tatti, where she worked well. In the winter of
1937, which would turn out to be the last year of Wharton's life,
Berenson must have pled writing as a reason he could not visit.
Wharton replied to his excusing letter on February 1:

Dearest B.B.,
 Of course I understand — & of course I'm heart-broken.
How much of life is spent in reconciling these two antago-
nistic states of mind! My only hope (& not *quite* a selfish one)

is that you may later feel the need of a break & a "recul" (my masterpieces have never been achieved without) & that you may then leap into the train with Nick & land at Toulon — after all![103]

If he could not always write at Hyères, he could reach a state of rest there, one necessary for looking. As these two bibliophiles entered their seventies, each felt that the other's house upheld an idea of culture fast fading elsewhere.

In that last year, Wharton wrote to Berenson, in a tone that seems premonitory, of moments in which each of them had felt, she said, the rare, but sustaining, "inalienable owner-ship of beauty": "Oh me, how thankful I am to remember that, whether as to people or as to places & occasions, I've *always* known the gods the moment I met them. Oh, how clearly I re-member saying to myself that day by the stream, as I looked up at the scene through the pink oleanders: 'Old girl, this is one of the pinnacles — .'"[104]

It was the middle of August 1937 when Edith Wharton died. Berenson broke the news to Mariano, who was staying with her family, and she wrote back to him of her great sadness that Wharton was gone and of how she would miss Wharton's language and the places that had grown up around her, those two gracious houses. Berenson told Mariano that he felt "numb and dumb and as if my bodily temperature had lowered to the freezing point."[105] He did in fact, later in the fall, become ill, and spent two months in Vienna having medical treatment.

After Wharton's death Berenson wrote a letter of condo-lence to her niece, the landscape architect Beatrix Farrand. Her reply was like that of many bereaved people who received one of Berenson's letters of sympathy. She wrote that his letter "has touched me more deeply than any other that has come, because yours is the only one that has mentioned Edith's affection for me or her having spoken of our love and taste for the same

things. She was always poignantly shy with me, & only occasionally gave entry to her inner depth and feeling that is sometimes easier to show one's friends than one's own kin." In the margin of the letter, Berenson noted, "Edith takes large part of our world with her."[106]

He repeated this sentiment to another friend, explaining that along with Wharton had gone "a great part of my past and no little of the present. All that a woman who was neither wife nor mistress could be to a man she has been to me for a good thirty years." With her death "a great mass of the iceberg of life," which was his support, "broke off and plunged into the abyss."[107] It seems that in his acute state of loss, he felt, as he had in the past, that he was out, alone, freezing in the cold. The thought of death approaching may have made him want to attend to his legacy in another way. News of Wharton's death came a few weeks before Berenson decided to make his final rupture with Duveen.

In the fall of 1937, twenty-five years after he had first signed a secret contract with Duveen, Bernard Berenson broke off relations. There was a clear reason in the foreground. Once again, Duveen and Fowles felt they were on to a big coup, the Allendale *Nativity*, later called the *Adoration of the Shepherds*, which Duveen had begun selling in his imagination as early as 1924. There was a longstanding argument among the experts about whether the painting was a late Giorgione or by Giorgione's pupil, the young Titian, or by some combination of the two. Duveen was well aware that there are so few verifiable Giorgiones that these works are much more valuable than any by Titian, and he knew someone who badly wanted a Giorgione, the man then considered the greatest living collector, Andrew Mellon.

Duveen had recently, assiduously, been helping Mellon to

finish the collection that Mellon intended to donate as the core of a new National Gallery. (Mellon, a philanthropist on a grand scale, founded the National Gallery in Washington and had it built at his expense.) Mellon wanted Italian old masters, and Duveen was going to incredible lengths to get them to him. One of Duveen's finest inspirations of salesmanship had come the previous year, in 1936, when Mellon was being choosy and recalcitrant and insisted on studying Duveen's offerings before committing to any of them. That fall, Duveen rented the apartment below Mellon's in Washington, DC, "decorated it with carpets and tapestries and porcelain," as well as thirty paintings and twenty-one sculptures, and gave Mellon the key.[108] Mellon used to come down in his slippers. Within two months he had agreed to buy most of what was there for $8 million.

This was something of a comeback for Duveen, who had been sorely disappointed to be left out of Mellon's most famous collecting coup, which had happened through Knoedler's in 1930 and 1931 and through which Mellon managed to acquire twenty-one of the world's greatest masterpieces from the Hermitage Museum. Mellon seems to have viewed the transaction as a victory over his archenemies, the Communists, but the Soviets also may have gotten something they wanted. Mellon, in his official capacity as treasurer, subsequently made rulings favorable to the Soviets in both the lumber and the manganese trades. It was these kinds of deals that formed the basis of Joseph Duveen's conviction, a conviction in which history continues to bear him out, that paintings are not just the accessories of power, they are a form of power itself.

In 1937, then, with his eye on the possible Giorgione *Adoration*, Duveen asked Berenson for his attribution. Berenson, who was on record as saying the painting was an early Titian, cabled reaffirming this view. Duveen, though, saw competitors coming after the picture and bought it anyway, as Fowles then had to

explain in attempting to persuade Berenson to change his mind. They had procured the picture at "not . . . even a Titian price, but a Giorgione price. . . . We must sell it as a Giorgione."[109]

Duveen dispatched letters and cables. When he didn't get the response he wanted, he sent Fowles, who brought the picture with him.[110] Berenson had refused to make attributions before, and business had gone on much as usual; for both men, circumstances were obviously different this time. The letter Berenson dictated for Nicky Mariano to send to Duveen went as follows:

> Lord Duveen has always flattered him into feeling that for him, Lord Duveen, and for his clients, there was only one authority, his, B.B.'s. . . . [He] does not choose to climb down at the end of his career from that height and submit to the opinion of critics whose competence he respects no more now than he and Lord Duveen and Lord Duveen's clients have respected hitherto. If therefore Lord Duveen insists on selling the Allendale picture as a Giorgione . . . B.B. no longer sees any reason for retaining his position as the advisor of Lord Duveen. It would be utterly below his self-respect, let alone his dignity, to be kept on as a pet, and not as an unquestioned authority.[111]

There were many reasons for both Berenson and Duveen to be intransigent on this occasion. Berenson had been angry for years about being owed $150,000 by Duveen Brothers, and only the previous autumn, of 1936, a new contract had been signed stipulating how this debt was finally to be paid. The contract was to run through 1938 but could be terminated by either party at the end of 1937. Duveen had already decided that, in view of his ill health, he needed to change the ownership structure of the firm, and he stood to gain $40,000 if Berenson left in 1937 instead of waiting until 1938.

Duveen knew, and his biographer Meryle Secrest is reason-

ably certain Berenson did, too, that he did not have that many more magnificent deals to pull off and that the Giorgione was likely to be his last great coup. Berenson could have acted from both principled and cynical motives at once—he seems really to have believed the painting was not by Giorgione, but it also may have occurred to him that, if he wished to dissociate his career from Duveen's, time was running short.

There was also political anxiety in the background that must have suggested to both Berenson and Duveen—those two most astute observers of power—that the picture trade, and their role in it, was changing again. After the Nazis had come to power in 1933, the regime wanted its museums to display only national, German art, and not "degenerate art." Duveen was able to effect a number of last-minute exchanges of second-rate German paintings for wonderful masterpieces. He failed, though, in his negotiations to purchase a Rothschild collection of art that the Nazis had seized; Duveen's intention was to return the collection to the family, but he could not prevent what has been called "one of the greatest art thefts in history," and the pictures were appropriated by the government.[112] Duveen was also active in Spain, when, in 1936, civil war broke out. He was one of the people who raised money for, as Secrest describes it, "an international committee to save Spain's treasures." Duveen "was able to hammer out an agreement that the paintings and other works of art be sent to Geneva for safekeeping."[113] In this environment of crimes on a vast scale, it was hard to know where the trade that Berenson and Duveen had so long practiced might be going.

From Berenson's perspective, the outlook for Italy darkened perceptibly in September 1937, just at the time of his break with Duveen, when Mussolini went to Munich to see Hitler and a great show was made of the two dictators standing on

podiums together. A little later, on December 11, 1937, the London *Times* made public the sale of Lord Allendale's *Nativity*. That same day Italy announced its withdrawal from the League of Nations and signed an accord with the German Reich.

The final irony about the Allendale *Nativity* is that it seems it *was* a Giorgione. Even at the time of the dispute, though some of these opinions weren't known to Berenson, experts had been shifting around toward Giorgione. The picture didn't wind up with Mellon — who died at the end of the summer of 1937 — but Duveen didn't have much trouble selling the painting to department store magnate Samuel Kress. From there it ended up in the National Gallery after all, and it is still listed as a Giorgione. Berenson himself came to hold the opinion that it was in large part by Giorgione and said so in the 1957 list of the "Venetian School."

But for a long time after the break with Duveen, Berenson sent letters justifying his Titian attribution to other experts. These represented his own idea of the nature of expertise: "My proofs?" he wrote to one. "They are in my own head . . . [and] cannot easily go into words, for they come from that sixth sense, the result of fifty years' experience whose promptings are incommunicable."[114] "A sixth sense . . . fifty years' experience" — Berenson knew he was arguing for a whole era of connoisseurship, and one which might well be over.

Something was certainly lost when the art market moved away from experienced sensibility as the basis for determining attributions. In Berenson's life, the reconciliation of pricelessness and price was a continual struggle, but it allowed him to see nuances of the art he studied and the commerce he served that modern authentication procedures pass by. His own understanding of Giorgione had shades no X-ray could render. When Berenson had written his first book on the Venetian painters,

sixty-three years earlier, glorying and delighting in Boston's favorite painters and in his own happy powers of perception, he had said of Giorgione that "his pictures are the perfect reflex of the Renaissance at its height" and that what was most characteristic in his work was "the lovely landscape . . . the effects of light and colour, and . . . the sweetness of human relations."[115]

8

——◆I◆I◆——

The Retrospective View

How I regret that [Proust] did not live to feel, to
analyze and to record the first approaches of old age.
They are worth studying, and to my knowledge
no man of letters has done so yet.

—Bernard Berenson to Charles Du Bos,
December 18, 1922

AFTER MEETING Marcel Proust in 1918, Berenson re-
ported to Mary, "We exchanged compliments and he assured
me that my books had been bread and meat to him. . . . I confess
I often wondered while reading *Du Côté de Chez Swan* whether
my books had not influenced him."[1] Proust's approbation was
welcome, as Berenson read Proust fervently. But Proust's inter-
est in Berenson extended beyond their shared attention to
Ruskin and their attachment to the early Italian painters; with
his unerring eye, Proust seems to have immediately discerned

the interesting fissure in Berenson's character. Many years before their meeting, Proust wrote to a friend, "Have you any idea of Monsieur Berenson's fortune (in the most vulgar sense of the word)?"[2] The reason for Proust's financial question did not make it into his published correspondence. Ernest Samuels speculates that Proust might have been "curious to know how an art critic like Berenson could afford to move in the affluent circles that Proust himself frequented."[3]

Proust, too, had experienced the subtleties of patronage: the support, the oppression, and the sometimes anti-Semitism of the salons in which Berenson made his career. No one had a finer sensitivity than Proust did for the mutual dependencies of art and money. Berenson had expressed his own version of this interdependence, writing to Mary Costelloe in 1890, when he was making his first tentative steps into the art market: "In the last thousand years whenever art has had its day, it has owed it to a merchant aristocracy—the very utmost opposite therefore of a democracy."[4]

Surveying the world around him, Berenson thought it human nature that "one of its chief demands on life" should be "the enjoyment of power as exercised in making and spending money."[5] It is interesting that both Berenson and Proust found a great source of inspiration and influence in the works of the Italian painters of the Renaissance, who produced art in the midst of a complicated skein of patronage relationships. An Italian painter had to shape his work to the physical and financial constraints of his commission—the size and lighting of the chapel walls, the cost of the pigments his patron was willing to pay for—and these became structures in which to work. Watching how painters overcame and made beautiful the limitations set by form and circumstance was for Berenson in part a lesson in self-fashioning.

Berenson certainly thought that life itself could be a sort of work of art. Looking back on his own ambitions from the van-

tage of ninety-two years he wrote, "I wanted to become and be a work of art myself, and not an artist." All along, he said, his "prime object" was "to make myself."[6] It enraged Berenson that he was often not in a position to make himself but was, in fact, getting made, by the forces he had identified: "the enjoyment of power as exercised in making and spending money."

When Berenson regretted that Proust had not lived to document "the first approaches of old age," he was perhaps also regretting that Proust's literary mind, formed on many of the same influences as Berenson's, would not be there to respond to the new age arriving after Proust's death in 1922. Had Proust lived, he might have shared in Berenson's attempt to hold on to the artistic understanding and discoveries of the mid- and late nineteenth century through the very different upheavals of Communism, Fascism, and World War II. Proust would have understood Berenson's dual efforts: his writing of the impressions life had made on him and, in his social life and in his encyclopedic study of Italian painters, his continuing collections of personalities.

In March 1938, Hitler's forces crossed into Austria. Jewish acquaintances of Berenson's in Vienna were made to wash the streets on their knees. Berenson foresaw that things would get still worse and, in a letter to his mother, predicted that this was "a mild beginning."[7] In the coming years, Berenson worked hard to help Jewish friends from Austria, France, Germany, and Italy secure safety and positions in England and the United States. In July 1938, Mussolini, ever-more-allied with Hitler, proclaimed the Manifesto of Race, excluding Jews from much of public life. A few thousand people of Jewish descent left Italy, but as happened in the other European countries when repressive measures were introduced, many more, about forty-three thousand, stayed.

In August of that year, on the day after her ninety-first birth-

day, Judith Berenson died. Berenson told his sisters that he was "stunned" but did not say much more about how his mother's death affected him.[8] Abie had died in 1936, and Senda was now for many years a widow—she and Bessie were all the immediate family in America. "How far away you seemed," Senda Berenson wrote to her brother, "when little mother gave one deep sigh and sank back on her pillow and was no more."[9] Although Berenson had, as an adult, resisted his mother's ministrations, in his childhood, she had been a most important shelter. After his mother's death, it would seem that Senda, Nicky, and his library grew even more important to him.

All fall, Senda tried to persuade Berenson to leave Italy and to come back to America. Senda had always been engaged with political life, and as her biographer Ralph Melnick points out, as she aged, and the world darkened, this seemed only to intensify. She read two newspapers a day, as well as the weeklies and monthly journals; the radio was a constant companion. Senda and Bessie lived and traveled together, supported by the income from the Berenson Fund established by their brother. In March 1939, Hitler invaded Czechoslovakia, and a week later Senda wrote to her brother again, "I have had you in mind constantly since the new horror. . . . I feel so worried about all of you [and] should feel better and breathe more freely if you were in England—better still—in this country. I really think you should make definite plans for the near future."[10]

There were three central reasons why Bernard Berenson was reluctant to leave. He knew, from having watched the art and book trade for decades and studied its history over millennia that their beloved house, its artworks and library, would not be safe during wartime. Second, Mary Berenson, unwell for almost a decade, was now entirely an invalid and often in severe pain. And third, as an Italian citizen, Nicky Mariano could not obtain a visa for herself, even to go to Switzerland. Mariano spent much of the winter of 1940–1941 trying to get

her two charges to Switzerland, but Berenson, who, she wrote, took a "passive and uncooperative attitude," was "of no help to me. His firm belief in Allied supremacy and in the ultimate outcome of the war seemed to make him indifferent to all minor questions." At last Mariano went to see the US ambassador, who gave his opinion: "'My advice would be for B.B. to stay on in Florence and not to try to go away. His property is very valuable and his personal presence would be the best protection for it.'" Mariano was "much relieved" and gave up trying to get the Berensons out of Italy.[11]

Later, Berenson, in his diaries, also gave what he called "spiritual" reasons for staying: he did not want to desert Italy or be forced in some way to fight against it, and he "wanted to round off my acquaintance with the Italian people. . . . I have cherished the hope, amounting almost to a conviction that we shall be treated as humanely as possible."[12] Events bore out this conviction, though perhaps if he had known the risks to which he and his loved ones would be subject, he would have planned differently. However, once he was in the extremity of the war situation, he used his formidable powers of observation with an extraordinary detachment, part of the interest of the writing he did in this time.

When, in 1940, Italy entered the war, Berenson and Nicky Mariano were in Rome. Mary, still at I Tatti, but ill and increasingly subject to fits of what Mariano and Berenson called her "euphoria," followed her practice of manic hospitality and hosted parties for Russian houseguests that began to attract attention from the police. In the wartime atmosphere of suspicion of foreigners, this was very dangerous—Mariano and Berenson wrote begging her to be cautious. In fact, there were not to be too many more such eruptions from her. Terrible news arrived not long after; Mary's daughter Ray had had heart failure during an operation and had died. (Mary would be

Berenson and Nicky Mariano, 1954, photographed by
Judith Friedberg. Biblioteca Berenson, Villa I Tatti—The Harvard
University Center for Italian Renaissance Studies, courtesy of
the President and Fellows of Harvard College.

spared the knowledge of what happened to her other daughter,
Karin, whose depression would become overwhelmingly acute
and who would commit suicide in 1953.) Ray's death was one
significant factor in turning Mary from the euphoric to the de-
pressive side of her constitution. Depression settled in for the
duration of the war and of her illness. She became increasingly
reclusive and worked on what she wanted to be a biography of
Ray. These were difficult times. There was a shortage of gaso-
line, travel was nearly impossible, American visitors came to
Italy no longer, the mail was infrequent and unreliable. The
three denizens of I Tatti read out loud to one another.

Berenson knew he was losing Mary, for so long a presence
both reassuring and stringently critical. Even just before the
war began, at work on what he hoped would be his great work
on decline and recovery in art, of which, in the end, he pub-

lished only the beginning, as *The Arch of Constantine*, Berenson still gave the manuscript to his wife. He recorded her reaction in a letter to a friend: "My wife is tearing it all to pieces. . . . Here she is too ill, poor dear, to do anything but play patience and read detective novels. Yet she pounces on my manuscript as she used to do in her past and more ferocious years, so in the course of demolition displays a mental energy, acumen, and subtlety, simply amazing."[13]

The war brought a change. In February 1944, listless, anxious, and trapped at I Tatti, Mary Berenson wrote to her husband (who by that point was in hiding with Nicky Mariano), wondering if she couldn't edit the manuscript he had told her he was working on. Ernest Samuels says that Berenson "tactfully explained that it had to first be put in order."[14] In this late period, freedom from Mary's interventions seems to have loosed both his pen and his self-criticism together.

The period of the war, and the fourteen years he lived after the war, were possibly the most productive decades of B.B.'s writing life. He wrote more broadly about art, in *Aesthetics and History in the Visual Arts* and *The Arch of Constantine or the Decline of Form*, and he also wrote short meditations and diary entries that were collected and published. These passages — about the incursions of age, Italy's wrongful attack on Abyssinia, friends, living and dead, the movements of history, what he guessed American military and industry were likely to become after the war, the look of trees of oranges "glowing golden . . . in the shelter of the house" — became his five late books.[15] There was his version of an autobiography, *Sketch for a Self-Portrait*; his record of his reading, *One Year's Reading for Fun*; the journal of his hiding during the war, *Rumor and Reflection*; the diary of his late years, published posthumously, *Sunset and Twilight*; and his last meditations, *The Passionate Sightseer*. These five books of personal reflections form a kind of symmetry with

the four gospels on Italian painting. His first books had considered coming of age, and they read, in a way, as if one of the great French diarists had lived among the painters of the Italian Renaissance; his last were on the years of decline and consider the shaping of personality in his own age. The later books amplify what was already present in the early ones: an acute attention to the inner experience of his own apprehension. Berenson's gifts of self-reinvention were prodigious, but whether he would have made this last leap into personal writing without the exigencies of circumstance is impossible to say. It was this final incarnation of himself, as diarist and detached observer of himself, that came together with his last and greatest fame.

From November 1940 until July 1941, Berenson worked on the meditations that were published after the war as *Sketch for a Self-Portrait*. It was in this book that he criticized himself severely for turning away from the life of the intellect and said that he had "never regarded myself as other than a failure." The center of the book was organized around a digressive inquiry into why this turning away happened. Although Berenson comes to no conclusive answer, he does, at one point, return to an early, powerful condemnation: "I cannot forget that when [I was] still an undergraduate at Harvard, Charles Eliot Norton said to Barrett Wendell who repeated it, 'Berenson has more ambition than ability.' Norton never changed his mind."[16]

After the inward investigations of the *Self-Portrait*, Berenson turned outward again to his life as a reader. For the year of 1942 he kept a reading diary: every day of the year has its short paragraph with observations on the three or four or five books that the household together, or Berenson by himself, had read all or part of that day. To try to understand modern Germany, he read the German romantics; to think about political life, he imbibed Neville Chamberlain and Herodotus, along with histories of the Versailles Accord and of Napoleon's invasion of Russia.

Berenson's disciple John Walker, writing an introduction to *One Year's Reading for Fun* when the book was first published, in 1959, saw, looking back, the role of outside circumstances in pushing Berenson into his library: "His library is his fortress, and it is filled with the smoke of the battle raging outside." But Walker also realized that Berenson's response was in many ways consistent with the life he had led thus far: "B.B. turns to his books in this crisis with the same insatiable curiosity, the same confidence in a personal revelation that he has always brought to his study of the visual arts." Berenson didn't write autobiographically to render incident; rather, faced with a book or a painting, he sought the "IT" of personal revelation, and in conveying this to a reader, he conveyed himself. As Walker noticed, in *One Year's Reading for Fun*, "there gradually emerges a remarkable portrait of B.B. . . . like a painting by Vuillard, the figure fusing with the background, here a library."[17]

About two-thirds of the way through the reading year, Berenson reread Walter Pater's *Marius* and watched again its Roman hero charting the growth of his own spirit by the sequence of aesthetic experiences that impressed themselves on him. Berenson's entry for August 16, 1942, reads in its entirety:

> Rereading Pater's *Marius*, I am surprised to discover to what extent it is my own spiritual biography. Its direct influence on me was no doubt great. Still, no outside influence could have affected me so deeply, pervasively, and permanently if the current of my spirit had not been in the same direction. Surely I read and reread much else at that time, but never when rereading have I felt myself so identified with the thought, aspirations, doubts, and consents that I rediscover in *Marius*.[18]

This remarkable consistency was apparent to the people who had known Berenson the longest. In the fall of 1939, shortly after the German campaign in Poland, Berenson went to

Bernard Berenson with art historians Michelangelo Muraro,
Vittorio Moschini, Raffaello Levi, Guido Perocco, and Rodolfo
Pallucchini at the Bellini exhibition in Venice, 1948.
Copyright Archivio Cameraphoto Epoche Srl.

Venice to see a Veronese exhibition and by chance encountered
his old college classmate George Santayana, who subsequently
sat down and wrote a somewhat caustic letter to one of their old
Boston cohort: "Berenson surprised me by talking with juve-
nile enthusiasm about 'art' (as if we were still in the 1890s). . . .
It is lucky for B.B., in one sense, that he keeps the old flame
alive."[19]

It was always Pater's flame, the stimulation of art and per-
sonality, to which Berenson returned. When he could no longer
reach the great stream of humanity and pictures that had for
so long sustained him, he read. And the connections with other
people that he had, for more than fifty years, established in

Italy were a significant part of what, during the war, saved his life and brought the works of his last period to fruition.

Jews who survived the war in Europe had, for the most part, many people who attempted in small and large ways to protect them. Berenson—despite his earlier conversions, understood to be a Jew—was prominent, anti-Fascist, and possessed of a desirable house and collection. He had high-level enemies, and it seems unlikely that he would have survived without correspondingly powerful protectors. Two days after the Japanese attack on Pearl Harbor, an article appeared in *Vita Italiana* announcing, according to Samuels, that "Berenson's art studies were merely a blind for his work as a political agent and that he deserved to be put in a concentration camp at forced labor."[20] The next day Galeazzo Ciano (the Italian foreign minister and son-in-law of Mussolini, later executed for treason against Mussolini) telegraphed the Florence police headquarters to leave the Berensons alone. Later that day, Mussolini declared war against the United States, and the first act of one group of Fascists in Florence was to go to police headquarters and demand Berenson's arrest. Ciano's telegram and an assistant police chief, who may have had his private sympathies, saved Berenson.

A few months later, laws were passed to allow for the so-called nationalization, really the appropriation, of "the property of enemy aliens." Carlotta Orlando, who was the daughter of ex-prime minister Vittorio Orlando, intervened so that the person responsible for dealing with the property at I Tatti was an anti-Fascist. The Marchese Serlupi, who would later shelter Berenson and Mariano for a year in his home, came and completed a thorough inventory of every single photograph and poinsettia at I Tatti, and then quietly filed the inventory away. After some British officers escaped from the nearby Castello Vincigliata (where British officer-prisoners were held at a

proximity to I Tatti that encouraged constant suspicion about Berenson), the I Tatti house telephone was cut off. Serlupi arranged for one to be installed at their estate manager's office. Mariano went down to thank the prefect of police for his part in this kindness; he proclaimed loudly, near what was probably a bug in his desk, that Berenson was an enemy alien but said to her sotto voce near the door that he would do what he could.

When the Allies landed in Sicily in July 1943, King Vittorio Emmanuel at last decided to try to put a stop to Mussolini and asked for a vote of confidence by the Fascist Grand Council. They voted against Mussolini, and he was imprisoned. This, however, put Berenson in still greater peril, for when the new Italian authorities negotiated a surrender to the Allies, the Germans immediately occupied the north of Italy, got Mussolini out of jail, and installed him as the head of a puppet republic in the north. The Germans then fought, inch by inch, as the Allies ascended the Italian peninsula. Under the Italian government, Jews had not been deported to German camps, and in fact some Jews in the occupied zones of France, Yugoslavia, and Greece had even been evacuated to Italy and saved. In the new phase of the war, the occupying Germans deported Jews, although this was more difficult in Italy than it had been elsewhere—about 8,500 Jews were taken to the camps, and altogether some 40,000 survived in Italy. But survival involved going into hiding, and as soon as the intentions of the Germans to occupy became clear, friends of Berenson's warned him to be gone, and quickly.

Nicky Mariano made an immediate decision that it was no longer safe for B.B. to stay at I Tatti and the day after the armistice went to ask advice of the Marchese Serlupi, who offered sanctuary at his house, called Le Fontanelle. The plan was for Mariano's sister Alda Anrep and brother-in-law Baron Egbert Anrep (both of whom had also worked at I Tatti in various

capacities for years) to safeguard the collections and to take charge of Mary Berenson, while Mariano went into hiding with B.B. They decided not to tell Mary Berenson where they were going, fearing her too-confiding tongue. They believed, in large part correctly, that Quaker American Mary Berenson, being cared for by three nurses and much too ill to move, would be left alone by all sides. And they also knew that the Anreps, who were of Baltic origin and who spoke perfect German, would be adroit.

An incredible operation to hide and preserve Berenson's library and artworks was set in motion, with the help of Giovanni Poggi, who was the superintendent of art in Florence. The most precious paintings were walled up at the Anreps' own apartment in Florence or sent up to Le Fontanelle. Lesser works were rearranged on the walls so that it would not look as if anything were missing. From the library, twenty thousand volumes and the photograph collection went to Quarto, a great villa belonging to Serlupi's mother-in-law, the Baroness Kiki Ritter de Zahony, who eventually vacated her villa, turning it over to refugees. She, too, came to live at Le Fontanelle. As Berenson noted with irony later, the Anreps' apartment was bombed (fifteen of his paintings were damaged and seven destroyed), whereas his own house, though occupied first by Italian Fascists and then by German soldiers for a significant period of time, was left intact. Still, had the collection been out on the walls, there is no telling who might have made off with it.

Berenson kept track of German art machinations with great interest. His later information was that, in the spring of 1942, Hermann Göring's "art buyers," had already been asking about Berenson's collection. Friedrich Kriegbaum, one of several German anti-Fascists in Florence and the head of the German Institute of Fine Arts, had put them off by saying that "at I Tatti there were no paintings except of Catholic subjects, and no books of more than local interest."[21] Kriegbaum was

later killed by a falling bomb in Florence, and his successor, Ludwig Heydenreich, also protected the I Tatti collection by what Mariano called "calculated bureaucratic slowness."[22]

No one expected the hiding out to last more than a few months—the Allies were supposed to vanquish the Germans and arrive immediately—but Berenson and Mariano stayed at the Serlupis almost a year. The Serlupis were kind and gracious people, who managed to keep laying in stores of good food and necessary fuel as these things became more scarce, and their house had the advantage of diplomatic neutrality because the marchese was the ambassador of San Marino to the Holy See.

In the end, the Nazis retreated out of Florence by the road toward Bologna, which ran right near Le Fontanelle. Diplomatic neutrality became extremely difficult to maintain, and at one point, more than forty clamoring soldiers were on the point of occupying the house. Had this happened, the works of art hidden inside would surely have been confiscated, and Berenson, who was well aware of the camps, thought he himself would be "sent to Lublin if not killed first." The resourceful Nicky Mariano set out again on a mission to the overseeing German officers. "As Nicky can speak Germans fair in their own Ladeen [dialect] . . . she succeeds in softening them and gaining their confidence," Berenson explained to his diary. Mariano persuaded the harried and retreating Germans to leave the house in diplomatic immunity. Berenson finished the day's report: "We are not occupied. The owner's magnificent collection of incunabula and rare books as well as my own works of art, and perhaps even my own life, are safe. All recognize that we owe our relative safety to Nicky."[23]

The German soldiers, though, occupied all the nearby houses, from some of which other refugees and older people were forced to leave. Allied bombs fell night and day, and the inhabitants of Le Fontanelle slept all together in the thick-

walled back corridors deemed safest. There was a seemingly in-
terminable state of unknowing. Berenson was now quite elderly
and moved carefully. He relied on Nicky Mariano for every-
thing from making his tea to keeping up his spirits. Mariano
kept a journal of these days, through which one begins to see
how her daily bravery on Berenson's behalf—as she walked
among minefields and German officers, did the laundry, and
read aloud to him several times a day—made an atmosphere
in which, despite the extremity of their circumstances, Beren-
son could, as Kenneth Clark wrote, "regain the contemplative
life." In Clark's opinion, it was due to Mariano that Berenson
"achieved this sense of peace and wholeness," it was "because, in
Mrs. Berenson's favourite phrase, he had found his natural pro-
tector." [24] Berenson's New Year's vow of 1949 could have been
made in many years: "To live for Nicky's sake, and to write." [25]

While they were in hiding, one of the subjects Berenson
took up in his daily writing was the Jewish Question. He at-
tempted to define his position by writing most of an essay, never
published, called "Epistle to the Americanized Hebrews." In it,
he began, in a very angry and clear-sighted way, by outlining
the origins and progress of anti-Semitism in Europe. He saw
Jews as a convenient scapegoat for capitalism:

> It is notorious that whenever comfortable society in the re-
> moter past, and capitalism in recent days, wanted to draw
> attention away from its own privileges, and its own exploita-
> tion of the working classes, (whether agricultural, handicraft
> or manufacturing), they tried to make out it was the doing of
> the Jews, gave them up to massacre as so lately in Rumania,
> Holy Russia & now in all Hitler-savaged lands; or to con-
> tumely and contempt in less barbarous countries.

Perhaps Berenson here alluded to the share of "contumely and
contempt" that had been part of his own experience. Late in

the essay, he simply stated that anti-Semitism would not end "within our historical horizon." His strongest hope was a meager one: "I can promise the Jew pleasant intervals between massacres and, further, that these intervals may be extended." He saw no hope in resistance and instead conceived of two starkly opposed alternatives, which he repeated in various places and with which he concluded the draft of his essay, "The alternative remains: complete isolation or assimilation."[26]

Isolation, of course, was terrible to him, and assimilation had been the choice of his whole life. In his essay, he lectured his readers on aspects of assimilation they ought not to neglect: "Will you listen to my advice, Jews of America?" His recommendations were an odd combination, some of them things he had done and some he decidedly hadn't: do not be ostentatious, do not excite envy, try to buy land and live close to it, "take to sports," do not make a lot of money, "intermarry to the utmost feasible extent," and above all remember not to be arrogant. The lament of exile merges into the plea for assimilation: "You whom Hitler for years to come has reduced to being a thing apart, a stranger in your land, cannot be too modest, too unassuming, too discreet." Remember, read his final injunction, "what Heine more than a hundred years ago said to his fellow-scapegoats: 'In order to be taken for silver you must be of gold.'"[27]

Berenson apparently gave this manuscript to his cousin Lawrence Berenson to read and edit; Lawrence Berenson, despite his great admiration for B.B., struck through this passage of advice. After the war, Berenson did mitigate some aspects of his stance. He came, for example, to feel that establishing the state of Israel was necessary. Still, his basic sense was that the situation of a Jewish person was a tragic one: the Jew was either to be cut off from other people or from himself. The way he admonished the Jews of America had a close parallel in his self-criticism. Sometimes he preferred to feel that the sources of

his failures were not in the world but within himself; this was better than to think that he had been outfoxed from the very beginning.

When the Allies liberated Florence at the end of August 1944 and Mariano and Berenson were released from hiding, they went to I Tatti to see Mary and the house. The house was damaged in places but could soon be repaired; Mary, Nicky was saddened to find, was "listless and indifferent to political events."[28] Mariano had not known Mary in her best and most vital years, and Mary's tactless impetuosity had frequently been a burden to their younger companion, but Mariano lived with Mary and her idiosyncrasies uncomplainingly for twenty-five years and really attempted to do justice to her. In her memoir, Nicky Mariano quotes a long passage from a late letter Mary wrote to her while they were in hiding. It was February 1944, Mary felt she was dying, and the fullness of her spirit comes through:

> The truth is I am dying only I cannot die. . . . I suffer so much that the gate is already open on the long road we have to travel alone, but I cannot start. However all this is not important. What I want to express . . . is the love and admiration and affection of many years. There is no cloud in the thought of you as there is in almost everything else. The end of life, if you remain conscious, is a sort of purgatory in which all your sins and mistakes come crowding upon you, but between you and me there is nothing of the kind — all is perfectly serene and I think of you with the deepest love.
>
> If I die in time I hope you will marry B.B. You will have my deep sympathy, but all the worldly things are fading away. . . .
>
> . . . I am almost glad that B.B. should not see me in my pain and weakness. I love to think how in spite of all our failings and so-called infidelities we have always stuck together

and stuck to Italy and when I am able to think at all I think of him with tender affection.[29]

From their hiding place, Nicky Mariano replied to "My darling Mary," in a letter full of feeling, and "miserable over this long and ever-lengthening separation from you." She already felt, what would turn out to be the case, that she did not think "B.B. and I would get married if you should die. Surely everybody would find my living near him and for him perfectly natural."[30] Berenson wrote, too, encouraging Mary to fight on. He said, "If you left me I should feel as if the spool on which the threads of my life had been wound had disappeared leaving behind only a shapeless tangle."[31] There was a truth to this, but it was also true that, in the decades after the first war, B.B.'s new life with Mariano had often left Mary Berenson quite alone.

Mary Berenson was eighty-one when she died, on March 23, 1945. She and Bernard Berenson had been each other's close companions, goads, sympathizers, interlocutors, opponents, and objects of love and jealousy for fifty-five years. In the letters he wrote after she died, Berenson's grief sounds remote, as if it was more his history with Mary that he mourned rather than her actual passing. He wrote to Judge Learned Hand of how he had first beheld her in the glories of her youth and of how she had then deteriorated. He seemed almost to see her as one of the works of art he had long studied. Of Mary at the last he concluded: "In death she looked heroically beautiful, like the grandest tomb statues of the French 12th century."[32]

Through the last years of the war Senda and Bessie stayed in Santa Barbara—they found the difficulties of aging a little easier to manage in California—living quietly and working for the Red Cross. They "wept with joy to see dear B.B.'s handwriting" when the first letters began to get through.[33] It had been more than two years since he had been able to write to them.

The three Berenson siblings were able to share the ends—of the war, of their epoch, of the life of Mary Berenson—as they had shared many beginnings. Senda wrote saying that Mary's death came as "a great shock." "Her going," she said, "closes a long chapter in our lives."[34]

After the war, Berenson more than once invited his sisters to come to Italy at his expense—they all knew there could not be many more reunions. In 1948, Senda and Bessie felt well enough to make the attempt and managed not only happy weeks at I Tatti but also to revisit Rome and Venice and to see the Giorgione Madonna in Castelfranco that Senda, now eighty, remembered first loving when her brother had taken her to see it in 1900. When they parted, Senda's letter showed how closely the women in Berenson's life still followed every detail of his passing days. "We think of you and Nicky and the household very often," Senda wrote, "and we think—Now he is taking a walk in the garden—lunchtime—who is there—who is amusing him now?" She wrote that she wanted to call out to him a conviction which seems to apply to more than just the visit: "What a blessed and *wonderful time* we had!!!"[35]

In those years Berenson also began to correspond with Belle Greene again. He still thought of her as "part and parcel" of himself and, once again, felt neglected by her desultory correspondence, though she had lost a number of members of her family and close friends and was herself very ill with the cancer from which she would eventually die.[36] When she did not write, he consoled himself by exchanging gossip about her with others in his far-flung epistolary network. A group of women friends cared for Greene in her last illness in 1950, and Berenson rapidly became a close correspondent of theirs, too. After Belle Greene's death, Berenson contributed to a Festschrift volume organized in her memory. At the party for this volume, her friends all signed a card to B.B.: "The only person we miss at this occasion more than B.G. is yourself!"[37] Beren-

son also dedicated his book *Seeing and Knowing* "To the Memory of Belle Greene, Soul of the Morgan Library." Her death for him was one in a procession of losses—Isabella Gardner, Edith Wharton, Mary Berenson—the women with whom he had shared the dream of building libraries, museums, houses, benevolent oases of culture in a mercantile world.

The following year, in 1951, his sisters came again, but by that point Senda's health was failing. She had a small stroke while in Florence and had to spend some time recovering in a nursing home. Despite her illness, Berenson did not alter the regular course of his peregrinations; the hay fever season meant that he went to Ischia. He did manage to say his last good-bye to Senda when the sisters' ship docked briefly at Naples en route to America.

Senda remained vividly aware of political and literary life and was to be found writing letters worrying about Joseph McCarthy not long before her death. She died in February 1954, with Bessie watching over her. (Bessie would survive them all and live on to be a familiar presence in the lives of her great-nephews and great-niece, not dying until 1975, at the age of ninety-eight.) Bessie wrote to Bernard that Senda's death was a release: "she was so tired."[38] After Senda died, some of Berenson's written reflections had to do with money. Senda herself seems to have been content with her modest portion, but her brother felt sure that "God made her a woman to have money, a society position." Perhaps he had never quite been able to distinguish between his ambitions and what he thought hers should be. Bernard wrote mournfully in his diary that Senda was "the last person . . . who had more or less the same horizon, the same values from youth up."[39]

In the 1950s, Berenson, entering his nineties, was outliving a second generation and, especially with the losses of the war, in some cases a third. His hunger for new people did not dimin-

Berenson on the grounds at I Tatti with Dario Neri, Nicky
Mariano, Alda Anrep, and Luisa Vertova, 1948, photographed
by Barsotti. Biblioteca Berenson, Villa I Tatti—The Harvard
University Center for Italian Renaissance Studies, courtesy
of the President and Fellows of Harvard College.

ish, and in this era he played host to Ernest Hemingway and de-
lighted in a risqué correspondence with him, wrote hundreds
of letters to Judge Learned Hand, Walter Lippmann, Sydney
Freedberg, J. Paul Getty, Hugh Trevor-Roper, Prince Paul of
Yugoslavia, late paramours Clothilde Marghieri and Frances
Francis, and many, many others. As Berenson did with authors
and painters, he assembled inwardly a giant catalog of his corre-

spondents' personalities, which he kept track of with incredible precision and a phenomenal memory for detail. The archive of forty thousand letters that remains at I Tatti is a record of an age.

Berenson's gift for seizing the lineaments of character made the people he corresponded with and the ones who came to see him at I Tatti feel that he understood them as no one else did. "In living personalities," Elizabeth Hardwick noted of her visits to the Berenson household in this period, "he was extremely in-the-know, open to feeling, to humor, to affection, to wild originality."[40] And at the same time, his own personality, and his long, unswerving devotion to the wonders of art and the natural world, seemed, in the aftermath of the war, to set a beautiful example. Once again he appeared to be a magician. There were those who found his presence staged, but others felt that even to be near him was a magical experience. The young sisters who became Jackie Kennedy and Lee Radziwill wrote to their mother of visiting Berenson in the summer of 1951 and of how they saw him approaching through the woods at I Tatti. Berenson sat down and immediately began to speak to them of love, distinguishing between people who are "life-enhancing" and "life-diminishing." "He is a kind of god like creature," they wrote. "He is such a genius, such a philosopher, such a pillar of strength and sensitivity, and such a lover of all things. He is a man whose life in beauty is unsurpassable."[41]

Novelists, in particular, seemed to feel an extraordinary degree of allegiance to Berenson. In 1954, after Berenson wrote the young author a fan letter, Ray Bradbury came with his wife to visit I Tatti; they talked about *Farenheit 451*, Berenson dispensed advice on looking at pictures, and Bradbury left thinking of himself as Berenson's "everlasting son."[42] That same year, Hemingway won the Nobel Prize but told a journalist he would have been happier if the prize had gone "to Bernard Berenson, who has devoted a lifetime to the most lucid and best writing on painting that has been produced."[43] John Steinbeck arrived

in 1957. Berenson had admired the *Grapes of Wrath* and now diagnosed in Steinbeck "that like Faulkner, like Hemingway, he has come to the end of his tether, has written himself out and does not know what next."[44] Steinbeck's letter to Berenson gives a sense of what people were seeking when they walked up the winding road to I Tatti: "By some magical formula, compounded of example and clean clear thinking, you made for me at once a medicine and a cloak of fine mail. One does not thank the doctor who saves one's life, but it is natural to be grateful that he exists and practices."[45]

It had been a kind of liberation, of both mind and desire, that Berenson had discovered in reading the works of Walter Pater and in beginning to study the paintings of the Italian Renaissance, and this still rang through to his visitors seventy years later. Lewis Mumford wrote to Berenson of a visit in 1957, "To behold your own spirit burning so purely and brightly still, gave a new meaning to Pater's old figure: 'a hard gem-like flame.'"[46] With Katherine Dunham, the African American anthropologist, choreographer, and dancer, Berenson had a sort of platonic love affair when he was just shy of ninety. He wrote that Dunham "is herself a work of art, a fanciful arabesque in all her movements and a joy to the eye in colour."[47] She from the first felt in him the "vitality, charm, and wisdom that are found only in truly great people" and would eventually write to him, "I left a part of myself that is deep and inner with you."[48]

Berenson had undergone the transformation, noted by Kenneth Clark, from "a Hebrew Prophet into a sage."[49] And if this transformation was in part internal—requiring the time of the war, the writing of the memoirs, the companionship of Nicky Mariano—it was also in part external. If there had been no war, no extermination of the Jews, no collapse of European intellectual culture, Berenson would have been either the resisted representative of the old guard or a quaint vestige of a long-ago time, but there had been the war, the extermination,

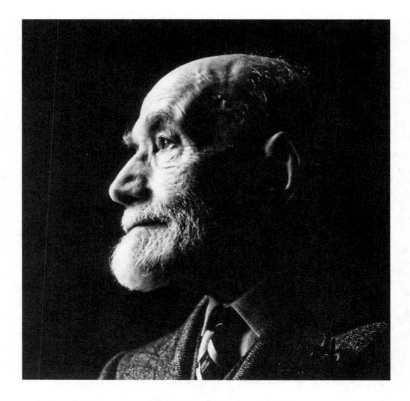

Bernard Berenson at Villa I Tatti at Settignano near Florence, 1957, photographed by Roloff Beny. © Library and Archives Canada. Reproduced with the permission of Library and Archives Canada.

the collapse, and now Berenson stood as the last in what seemed a precious line. People had for him, his house, his writing, a fierce nostalgia and protectiveness. Laudatory articles appeared in *Time* and the *Atlantic Monthly* and *Life*. These were illustrated by portrait photographs of B.B.'s ancient, finely modeled head from which his eyes, still penetrating, gazed.

In their last years together, Berenson and Mariano lived quietly. They made some sightseeing excursions in Italy. They

went on spending their summers at the home they loved, which Berenson had encouraged Mariano to buy so that she would have a place of her own when he was gone. This was the Casa al Dono, which was on the road to Vallombrosa, some twenty miles southeast of Florence up in the piney hills that reminded them both of the Baltics.

Berenson's tiny frame now appeared, to some of his visitors, wraithlike. The fine bones of his face and shoulders seemed even more delicate and shadowed under his burgundy velvet skullcap and mantle. His nephews passed down to their children an impression of him wrapped in shawls and carried about like a "breakable egg."[50]

"Yes," he wrote to Frances Francis, one of the last of his "orchestra," "extreme old age at last has overtaken me." It was February 1956: "The bodily functions all on strike, memory shrinking and getting dim and dimmer almost daily. . . . I seem to live entirely on potions, pills, tablets, injections, massages. Scarcely a quarter of an hour without my being made to swallow something or to be pricked." But the mind was "still working when properly stimulated."[51] Still enjoying the attention and provocation of a steady parade of guests; still, remarkably, contributing lengthy cogent reflections for his regular column for the *Corriere della Sere;* still, through Nicky Mariano and the young scholar William Mostyn-Owen, dispensing upon request his opinions over disputed attributions; Berenson went on being Berenson right up through his ninety-fourth birthday. By that small birthday party, though, some of his guests could see the flame was dimming.

Toward the end of his life, Berenson wrote down his directions for the future of I Tatti, his "library with living-rooms attached."[52] He explained to its future directors that it was to "provide leisure and tranquility" for those "promising students" whose intellectual attitude was "founded on direct and loving

contact with the work of art."[53] These students were to live at
I Tatti very much as he had done—working there half the year
and traveling the other half, making use of the library, looking
at the art, which was to remain "distributed over the house,"
and walking about the grounds. He warned its new stewards
to leave the grounds intact, in order "to serve as a protection
against the invasion of the suburbs and to promote a feeling of
free space and of distance." He modeled his own benefaction
quite closely on Gardner's, although he did want to leave a little
more room for people in the future to make what they wanted
of the institution he was building. Still, his unwavering idea
was that it was to be a place apart, where the young Mariuses
of the future could immerse themselves in contemplation of
the Italian Renaissance as he himself had and where the kind of
cultured perception that he had trained himself in could go on
being practiced. In the end, he said, "I venture to confess that
I would like the fellows of I Tatti to continue what all my life
long I have been trying to do but have only faintly succeeded
in doing."[54]

The irony, a suitable one for Berenson's career, was that,
despite his seeming life of luxury, he still didn't have nearly the
private fortune that his clients could command in setting up
their legacies. The gift of his library was obviously meant to
make good an old and difficult combination of feelings about
the support and rejection of his alma mater, but relations with
Harvard went on being complicated. The university did not
especially want the gift. I Tatti was far from Boston, it would be
expensive to maintain, and it served a rarified group of schol-
ars. Berenson and Mariano exercised much persuasion and en-
listed the help of many friends to eventually overcome Har-
vard's final objections. Berenson sometimes wondered if his
dreams for I Tatti were feasible and would say, as Mariano re-
membered: "'Why do I go on making plans for the future? One

cannot project one's own personality beyond the grave as Isabella Gardner and others have tried to do. Everything changes, currents of taste, interests, methods of study. One must trust those who follow us to make the best possible decisions or at any rate the least bad ones.'" Nevertheless, he placed his hopes in the library. Mariano's sister, Alda Anrep, oversaw some final construction on it, which was much to Berenson's satisfaction, and, in the last year of his life, when he had grown too weak to read much or to study pictures, he liked, Mariano said, "to walk or to be carried through the libraries."⁵⁵ He wrote once that after his death, he would like to be able to return to his house and "be the indwelling soul of my house and library. . . . I should like to haunt it, and use it the way the archangels did in one of Anatole France's stories."⁵⁶

Toward the end of the summer of 1959, Berenson went into his final decline. His sister Bessie Berenson was summoned from California and managed to arrive in time. He died in the nighttime of October 6, 1959, surrounded by his familiars: Bessie, Nicky Mariano, Alda Anrep, the intimates of the household. The dim room of the final hours was, said Anrep, like "a scene from Rembrandt."⁵⁷

Many people thought of paintings during the rituals that marked the close of Berenson's life. He was laid out in the library, his coffin resting on a great fifteenth-century table. His tiny body was wrapped in an ivory white shawl with a Sienese cross lying on it. Great tapers burned nearby. Hundreds of people came to pay their last respects.

The next afternoon, the casket was raised on the shoulders of workmen from I Tatti, and the procession, bearing lighted torches, stretched half a mile up along the road to Vincigliata, a road thought to be in the background of a famous Gozzoli fresco of the Adoration of the Magi. The mourners walked up

Berenson's funeral procession, Foto Levi. Biblioteca Berenson, Villa
I Tatti—The Harvard University Center for Italian Renaissance Studies,
courtesy of the President and Fellows of Harvard College.

to the small church of San Martino, where the funeral took
place. In this church are five gold-ground paintings, one of
which is an annunciation attributed to Beato Angelico, about
whom Berenson had written, "The sources of his feelings are
in the Middle Ages, but he *enjoys* his feelings in a way which
is almost modern."[58] For Berenson the life he had left in the
Pale was medieval; his own capacity to savor and enjoy was the
modernity he had found for himself.

Berenson was buried in the chapel at I Tatti. He and Mary
had both said that they wished to be cremated, but Nicky
Mariano had persuaded them that this would be troubling to
the people who worked at I Tatti, and the Berensons had agreed
to follow the Catholic customs. Mary's coffin would later be
brought down from the Settignano cemetery, so that both Ber-

ensons lie interred on the grounds of the estate that was the center of their shared enterprise.

In the end it was left to Nicky Mariano to make the final record and to take care of the remaining details. The last of the women with whom Berenson collaborated on the projects of his lifetime, Mariano was the one who entered most fully and tenderly into all the conflicting shades of his experience and personality. She held on to an understanding of his many exiles and was able to go on imagining something of the transformations he had undergone, even when knowledge of the places he had come from and of the struggles he had faced faded from the busy modern world. She watched him observe, to the end, the long-ago ritual of finding, each month, the new moon in the sky: "early in September of 1959, a month before his death, we discovered the new moon in an apple-green sky and his nurse carried him in her arms like a small child to his bedroom window. With a wistful smile he greeted the silvery shape for the last time."[59]

In the nine years that she survived him, Mariano, with help from her sister, tended to Berenson's legacy: the bequest to Harvard; the publication of his two posthumous books of reflections; the clarifying of the last of the lists; the writing and publication of *Forty Years with Berenson*, her own portrait, which completes and balances the self-portrait he made. Mariano's memories of Berenson were strongest when she thought of him just looking, enjoying the impressions that art and nature made on him, as his nature had beautifully fitted him to do. "He had the capacity of making one see more clearly and feel more intensely without saying a word himself. It was as if his rapt absorption in the work of art communicated itself to his companions without any need for explanation or instruction."[60]

She wrote much of her memoir at the Casa al Dono, where they had spent their summers together, and as she worked to

give her own impression of Berenson, she remembered an excursion in Greece, in the summer of 1923, when they rode on horseback out to Bassae. To see the ruins there was for Berenson "the fulfillment of a long-cherished dream." It came back to her: "Again I see him before me, galloping away fearlessly and unmindful of the narrow path along a precipitous ravine."[61]

Bernard Berenson's life in art has been over for more than half a century now, but the precipitous ravine he galloped along is familiar to many of us who feel caught between the memory of what seems a medieval world, an old country where religious ritual made the rounded year, and a bright new culture of commerce and personality, where wealth and privilege seem tantalizingly near. As he made the difficult passage between these two worlds, Berenson struggled to hold on to and to convey his love of art, and to make of his inner self a unified whole, and he did not pretend that he had triumphed. His self, he wrote in *Sunset and Twilight*, seemed to him in constant inward contradiction. Unlike the "well-trained bourgeois self . . . *My* self seems to toss and whirl and dive and dip." Of others' perceptions of his whirling soul, he noted ruefully, "I have become a myth, or rather two myths, a kindly flattering one and a hostile, damaging one."[62]

Berenson's portrait—with all its conflicts between his passion for painting and his desire for wealth and security—had cracks that he himself was never able to mend. In a diary entry written a year before he died, he looked back over his life and at first turned upon himself: "Short of violence, I seem to have been capable of any sin, any misdemeanor, any crime." But then again he felt, resignedly, that he had lived as he could, subject to forces much greater than himself: "With horror I think what I should have been if I had lived the life of an ill-paid professor, or struggling writer, how rebellious if I had not lived a life devoted to great art, and the aristocratically pyramidal structure

of society it serves, and worse still if I had remained in the all but proletarian condition I lived in as a Jewish immigrant lad in Boston." After a lifetime of deftly taking hold of the personalities of the Italian painters and those of his own age, Berenson said, "I remain sceptical about my personality. It really seems to have reached its present integration in the last twenty years, with the wide and far vision I now enjoy, in a *tout comprendre c'est tout pardonner*, expecting little and trying to be thankful for that, the serenity for which I am now admired." But a life driven as his had been, across continents, through wars, from first impoverished borrowings to daily commerce with great works of art, a life of such velocity would never quite find repose. "I keep hearing the Furies," he wrote, "and never forget them."[63]

NOTES

Abbreviations

Metropolitan. Duveen Brothers Archive, Metropolitan Museum of Art, New York.

I Tatti. The Bernard and Mary Berenson Papers (1880–2002), Biblioteca Berenson, Villa I Tatti—The Harvard University Center for Italian Renaissance Studies.

Introduction

1. BB, *Italian Painters of the Renaissance*, 2:34–35.
2. Ibid., 1:64, 2:13.
3. Hardwick, *View of My Own*, 211.
4. Clark, *Moments of Vision*, 108; Fowles, *Memories of Duveen Brothers*, 65.
5. Behrman, *Duveen*, 159.
6. BB, from notes, c. 1938, *Berenson Treasury*, 193.
7. SB to BB, June 17, 1930, quoted in Melnick, *Senda Berenson*, 148.
8. MB, *Life of Berenson*, I Tatti version, chap. 3, p. 15.

1. Jews of Boston

1. Gimpel, *Diary of an Art Dealer*, February 13, 1918, 4. EW to MB, June 4, 1932, I Tatti; I am grateful to Michael Rocke and Jonathan Nelson at the Villa I Tatti for drawing my attention to this letter.
2. Morra, *Conversations with Berenson*, vi; NM, *Forty Years with Berenson*, 24.
3. Louis Brandeis to Alfred Brandeis, January 15, 1887, quoted in Samuels, *Berenson: Legend*, 287–288.
4. BB to NM, September 5, 1928, quoted in ibid., 362.
5. Clark, *Moments of Vision*, 114.
6. BB, *Aesthetics and History*, 21.
7. Sprigge, *Berenson*, 29–30.
8. Ibid., 31.
9. Elizabeth B. Gates, quoted in Secrest, *Being Berenson*, 23.
10. MB, *Life of Berenson*, I Tatti version, chap. 10, p. 7.
11. Sprigge, *Berenson*, 29.

12. Rachel Berenson to Judith Berenson, June 15, 1912, Houghton.

13. Rachel Berenson to Judith Berenson, n.d. [ca. 1916–1919], Houghton.

14. Undated letter, Rachel Berenson folders, Houghton.

15. Private correspondence with the author.

16. SB to Abraham Berenson, June 28, 1921, Houghton.

17. Secrest, *Being Berenson*, 45.

18. BB, diary, February 13, 1954, quoted in Melnick, *Senda Berenson*, 186.

19. There is now an animatronic figure of her in the Women's Basketball Hall of Fame.

20. SB to BB, October 10, 1911, Houghton.

21. Rachel Berenson to Bessie Berenson, January 29, 1905, Houghton.

22. SB to Berenson family, [ca. 1904], Houghton.

23. NM, *Forty Years with Berenson*, 71.

24. Bessie Berenson to SB, May 23, 1899, Houghton.

25. BB, *Rumor and Reflection*, 48.

26. Secrest, *Being Berenson*, 46.

27. BB, *Sketch for a Self-Portrait*, 50.

28. Berenson remembered, "I recall from my childhood in Lithuania hearing of Israelites making most urgent and piteous appeals to be allowed to take up land and farm it. The Russian government turned a deaf ear" (*Rumor and Reflection*, 194).

29. Lederhendler, *Road to Modern Jewish Politics*, 144. Lederhendler quotes reporting in *Ha-Melitz* 4 (1878): cols. 69–70, which reprinted the minutes of the Vilna commission and the petition of the delegates.

30. BB, *Rumor and Reflection*, 28.

31. Samuels, *Berenson: Connoisseur*, 5.

32. BB, *Sketch for a Self-Portrait*, 130.

33. Ibid., 131.

34. Samuels, *Berenson: Connoisseur*, 3.

35. Sarna, "Jews of Boston in Historical Perspective," 13.

36. Sprigge, *Berenson*, 31.

37. MB, *Life of Berenson*, I Tatti version, chap. 1 drafts.

38. S. N. Behrman, *People in a Diary*, quoted in Samuels, *Berenson: Connoisseur*, 18.

39. See William A. Braverman, "The Emergence of a Unified Community, 1880–1917," in Sarna, Smith, and Kosofsky, *Jews of Boston*, 76–77.

40. Sarna, "Jews of Boston in Historical Perspective," 13–14.

41. Ibid., 6.

42. Samuels, *Berenson: Connoisseur*, 17.

43. Sarna, "Jews of Boston in Historical Perspective," 9.

44. Louis Brandeis to Alfred Brandeis, quoted in ibid.

45. On BB's views of Brandeis, see Samuels, *Berenson: Legend*, 208.

46. Samuels, *Berenson: Connoisseur*, 21.

47. Everett, *Orations and Speeches*, 611.

48. BB, *Sketch for a Self-Portrait*, 145.

49. Ibid., 144.

50. BB to EW, February 19, 1917, quoted in Lee, *Edith Wharton*, 416.

51. Samuels, *Berenson: Connoisseur*, 25.

52. BB, "How Matthew Arnold Impressed Me," 53–54.

53. BB, *Sketch for a Self-Portrait*, 12.

54. BB to Albert Berenson, July 19, 1922, quoted in Samuels, *Berenson: Connoisseur*, 16.

55. Pater, *Renaissance*, 236.

56. BB, early journal notebook, quoted in Samuels, *Berenson: Connoisseur*, 22.

57. Ibid.

2. First Conversions

1. See Rosovsky, *Jewish Experience at Harvard and Radcliffe*, 8.

2. BB, "Talmudo-Rabbinical Eschatology." This manuscript was recently discovered at I Tatti. The handwriting corresponds with BB's in his senior year of college and first years abroad.

According to his Harvard grade report, BB received a 95 on his "Thesis in Semitic."

3. For an idea of this course, see James, *Manuscript Lectures*, xlviii–xlix.

4. Samuels, *Berenson: Connoisseur*, 33.

5. BB to ISG, July 4, 1888, *Letters*, 24.

6. BB to MC, February 1, 1891, quoted in MB, *Life of Berenson*, I Tatti version, chap. 7, p. 7.

7. John Ruskin quoted in Vanderbilt, *Charles Eliot Norton*, 59.

8. BB, "Talmudo-Rabbinical Eschatology," 52.

9. Recommendations in Harvard Archives, quoted in Samuels, *Berenson: Connoisseur*, 50.

10. Ibid.

11. BB, "Third Category," 70.

12. Ibid. 74.

13. Dowling, *Charles Eliot Norton*, 125.

14. Vanderbilt, *Charles Eliot Norton*, 134.

15. MB, *Diary*, November 26, 1903, quoted in Samuels, *Berenson: Connoisseur*, 413.

16. Josephine Preston Peabody, quoted in Vanderbilt, *Charles Eliot Norton*, 119.

17. E. L. Godkin, quoted in ibid., 109.

18. BB to Charles Eliot Norton, December 23, 1885, quoted in Samuels, *Berenson: Connoisseur*, 50.

19. BB, *Sketch for a Self-Portrait*, 52.

20. BB to MC, November 6, 1890, transcribed in MB, *Life of Bernard Berenson*, I Tatti version.

21. Rosovsky, *Jewish Experience at Harvard and Radcliffe*, 30.

22. Issac Adler, "Jews at Harvard," 69–70.

23. Application, March 30, 1887, quoted in Samuels, *Berenson: Connoisseur*, 49–50.

24. BB, *Diary*, August 16, 1945, quoted in ibid., 33.

25. MB, *Life of Berenson*, I Tatti version, chap. 2, p. 1.

26. BB, "Third Category," 68.

27. For details of this first publication, see Johnston, "Mary Berenson and the Conception of Connoisseurship," 590.

28. On Boston Bohemianism and its idea of the Middle Ages, see Shand-Tucci, *Ralph Adams Cram*; and Melnick, *Senda Berenson*. Melnick quotes Louise Imogen Guiney: "To emigrate to some hamlet that smells strong of the Middle Ages, and put cotton wool in my ears, and aiming out clear from this very smart century" (*Senda Berenson*, 6).

29. Berenson, "Third Category," 75.

30. Ibid., 68.

31. Ibid.

32. Ibid., 77, 76.

33. Ibid., 81.

34. Ibid., 73.

3. Isabella, Mary, Italy

1. Tharp, *Mrs. Jack*, 109, 110.

2. Newspaper cited in Carter, *Isabella Stewart Gardner and Fenway Court*, 90.

3. Henry James to ISG, January 29 [1880], quoted in Saltzman, *Old Masters, New World*, 53.

4. McCauley, "Sentimental Traveler," 20.

5. See Saltzman, *Old Masters, New World*, 51–52, for documentation of Gardner's miscarriage.

6. For further discussion, see ibid., 52; Shand-Tucci, *Art of Scandal*, 83–84; Simpson, *Artful Partners*, 50; and Sox, *Bachelors of Art*, 12–13. The telegram sent to inform Gardner of Joe Junior's death came from Logan Pearsall Smith.

7. MB, *Life of Berenson*, Houghton version, p. 5.

8. MB, *Life of Berenson*, I Tatti version, chap. 1.

9. Smith, *Unforgotten Years*, 123.

10. BB, *Sunset and Twilight*, 90.

11. BB to ISG, August 24, 1887, *Letters*, 5.

12. Ibid.

13. BB to MC, 1890, quoted in MB, *Life of Berenson*, I Tatti version, chap. 2, p. 22.

14. BB to SB, February 18, 1888, I Tatti.

15. BB to MC, November 10, 1890, quoted in Melnick, *Senda Berenson*, 19.

16. BB, "Contemporary Jewish Fiction," 591.

17. Ibid., 587–588.

18. ISG to BB, December 13, 1897, *Letters*, 110.

19. BB to ISG, May 23, 1888, ibid., 21.

20. Samuels, *Berenson: Connoisseur*, 60.

21. Berenson, "Third Category," 74.

22. BB to SB, February 10, 1888, I Tatti.

23. Ibid.

24. BB to ISG, February 25, 1888, *Letters*, 17.

25. BB to SB, March 14, 1888, quoted in Samuels, *Berenson: Connoisseur*, 71. On Wilde, Secrest writes, "He was careful to make clear to at least two friends that Wilde never approached him sexually. . . . He gave the reverse impression to others. . . . Henry P. McIlhenny of Philadelphia said, '. . . B.B. always told me that Oscar Wilde had made a pass at him. He was very proud of it'" (*Being Berenson*, 126). Further considerations of the unresolved question of whether Berenson ever slept with any of the men in Warren's Oxford circle is to be found in Sox, *Bachelors of Art*, 22–24. Sox remains doubtful.

26. BB, *Sunset and Twilight*, 10.

27. BB to "Deborah," Baroness Léon Lambert, née Rothschild, 1906, quoted in Samuels, *Berenson: Connoisseur*, 64–65.

28. Lee, *Edith Wharton*, 614.

29. NM to MB, December 19, 1930, quoted in NM, *Forty Years with Berenson*, 175.

30. MB, *Life of Berenson*, Houghton version, p. 5.

31. Ibid., p. 2.

32. Gertrude Burton to MC, August 25, 1887, quoted in Samuels, *Berenson: Connoisseur*, 65–66.

33. BB to ISG, March 18, 1888, *Letters*, 18.

34. BB to ISG, April 19, 1888, *Letters*, 20.

35. BB to MC, quoted in MB, *Life of Berenson*, I Tatti version, ch. 2, p. 23.

36. MB, *Life of Berenson*, chap. 10, p. 5, quoted in Samuels, *Berenson: Connoisseur*, 147.

37. MB, *Life of Berenson*, p. 2, I Tatti version.

38. [Norton], "Lorenzo Lotto."

39. BB, "Isochromatic Photography and Venetian Pictures" (1893), quoted in BB, *Berenson Treasury*, 70.

40. For the sense of Berenson's early awareness of the market and of the role of Jean Paul Richter as a model, I am indebted to Dietrich Seybold, "Berenson and Jean Paul Richter: The Giambono's Provenance," forthcoming in Connors and Waldman, *Berenson at Fifty*, and consulted by permission of the author.

41. BB to ISG, April 28, 1889, *Letters*, 31.

42. Ibid., 30.

43. Samuels, *Berenson: Connoisseur*, 93.

44. BB, *Sketch for a Self-Portrait*, 59–60.

45. BB to MC, 1890, transcribed in MB, *Life of Berenson*, I Tatti version, chap. 2, p. 21.

46. Brown, *Berenson*, 25.

47. BB, *Sunset and Twilight*, 168.

48. Logan Pearsall Smith, *Unforgotten Years*, 33.

49. Hannah Whitall Smith to MC, February 1, 1888, quoted in Strachey, *Remarkable Relations*, 99.

50. This tendency is simply called "the family manic-depression," in an editorial footnote in MB, *Self-Portrait*. The note is appended to a letter from MC to BB: "Uncle Horace, in one of his 'happy fits,' is here, and we are all occupied in rushing from room to room to escape his incessant flow of talk. He can't even eat, he is so busy talking" (*Self-Portrait*, August 24, 1898, 76–77).

51. Whitman quoted in Samuels, *Berenson: Connoisseur*, 117.

52. Ibid., 118; Walt Whitman to MC, February 10, 1890, ibid.

53. MB, *Life of Berenson*, I Tatti version, chap. 1.

54. See Johnston, *Mary Berenson and the Conception of Connoisseurship*, 587.

55. MB, *Life of Berenson*, I Tatti version, chap. 1.

56. BB to MC, 1890, quoted in ibid., chap. 2, p. 6.

57. Hutchins Hapgood to MB, January 1926, quoted in Samuels, *Berenson: Connoisseur*, 171.

58. BB, letter, probably to MC, May 25, 1893, quoted in MB, *Life of Berenson*, I Tatti version, part of notes included with manuscript, "Notebook entries, 1892–1929."

59. MB, *Life of Berenson*, I Tatti version, chap. 10, p. 5.

60. Ibid., chap. 6, p. 1.

61. Ibid., p. 4.

62. BB to MC, January 15, 1891, quoted in ibid., pp. 9–10.

63. BB to MC, February 1, 1891, quoted in BB, *Berenson Treasury*, 57–58.

64. BB to MC, February 13, 1891, quoted in ibid., 58.

65. MB, *Life of Berenson*, I Tatti version, chap. 4, pp. 6–7.

66. MB to Ray Costelloe, January 21, 1893, quoted in MB, *Self-Portrait*, 51.

67. BB to MC, December 1, 1890, quoted in BB, *Berenson Treasury*, 54–55.

4. Looking at Pictures with Bernhard Berenson

1. BB to MC, 1890, recopied in MB, preparatory notes for *Life of Bernard Berenson*, I Tatti version, p. 20.

2. Ibid., chap. 6, p. 3.

3. Ibid., chap. 2, p. 26.

4. BB, "A Possible and an Impossible Antonello," in *Three Essays on Method*, 88.

5. BB, "A Neglected Altar-Piece by Botticelli," in ibid., 83.

6. BB to MC, November 27, 1890, quoted in BB, *Berenson Treasury*, 53.

7. MB, *Life of Berenson*, I Tatti version, chap. 3, p. 17.

8. Ibid., chap. 4, p. 28.

9. BB to SB, February 10, 1888, I Tatti; BB to ISG, April 28, 1889, *Letters*, 31.

10. BB, *Rumor and Reflection*, 397.

11. William James quoted in Johnston, *Mary Berenson and the Conception of Connoisseurship*, 503.

12. Ibid., 502.

13. Samuels, *Berenson: Connoisseur,* 149.

14. MC to Robert Pearsall Smith, Nov. 24, 1893, quoted in Strachey, *Remarkable Relations,* 170-171.

15. See Fisher, *Artful Itineraries,* 158-166.

16. SB to BB, March 20, 1894, quoted in Melnick, *Senda Berenson,* 37.

17. MC to HWS, December 2, 1893, quoted in Strachey, *Remarkable Relations,* 170.

18. MC to Robert Smith, November 24, 1893, excerpted in MB, *Self-Portrait,* 54-55.

19. Ibid., 55.

20. BB, *Italian Painters of the Renaissance,* 1:21.

21. Ibid.

22. BB, *Lorenzo Lotto,* 146.

23. [Norton], "Lorenzo Lotto," 481.

24. Samuels, *Berenson: Connoisseur,* 213.

25. Samuels paraphrasing Hutchins Hapgood, in ibid., 171.

26. Hughes, "Only in America."

27. Rinehart, "Bernard Berenson," 94.

28. McComb, Introduction to BB, *Selected Letters,* xiii.

29. MB, *Life of Berenson,* I Tatti version, chap. 8, p. 11.

30. Ibid., pp. 11-12.

31. BB, "Isochromatic Photography and Venetian Pictures" (1893), in BB, *Berenson Treasury,* 69.

32. MC, *Diary,* July 1895, quoted in Samuels, *Berenson: Connoisseur,* 229.

33. BB, *Italian Painters of the Renaissance,* 2:2, 2, 17, 4-5.

34. Ibid., 8, 6.

35. Ibid., 41.

36. Ibid., 90.

37. For further discussion, see Calo, *Berenson and the Twentieth Century.* See also a discussion of Berenson's ideas of plasticity in Rothko, *Artist's Reality: Philosophies of Art,* 43-45.

38. Berenson, *Italian Painters of the Renaissance*, 2:17. For Berenson's influence on Fry, see also Spalding, *Roger Fry*, 62–63.

39. Clark, *Moments of Vision*, 125.

40. Vernon Lee and Clementina Anstruther-Thomson, for example, drew attention to James's passages on the sensations associated with "aesthetic emotion" in James, *Principles of Psychology*, 1:473, 2:468–470; see Lee and Anstruther-Thomson, *Beauty and Ugliness*, 94–95.

41. William James, quoted in Samuels, *Berenson: Connoisseur*, 258.

42. William James to BB, June 15, 1898, quoted in Geoffrey-Menoux, "Henry James and Family," 78.

43. Noted in Samuels, *Berenson: Connoisseur*, 152.

44. Quoted in Calo, *Berenson and the Twentieth Century*, 13.

45. BB, "Lorenzo Lotto: An Essay in Constructive Art Criticism" (1894), quoted in BB, *Berenson Treasury*, 87.

46. For descriptions of this pattern of mutual influence, see Calo, *Berenson and the Twentieth Century*, 33–34, 46–55, 56–57.

47. MC, *Diary*, May 22, 1900, quoted in Melnick, *Senda Berenson*, 69.

48. Indeed, the art historian Dietrich Seybold, working in consultation with the Nietzsche scholar Andreas Urs Sommer, believes that Berenson's idea of "life-enhancement" may have come quite directly from a passage in section 9 of Nietzsche's "Anti-Christ," published in November 1894. Private communication with the author.

49. BB to ISG, April 28, 1889, *Letters*, 30.

50. Vernon Lee to BB, January 1, [1894], quoted in Samuels, *Berenson: Connoisseur*, 174.

51. BB, *Sunset and Twilight*, 375.

52. Ibid., 22, 103.

53. MC, diary entry, May 16, 1896, quoted in Samuels, *Berenson: Connoisseur*, 259.

54. Roger Fry, quoted in Spalding, *Roger Fry*, 59.

55. Leo Stein to Mabel Weeks, September 19, 1902, quoted in Samuels, *Berenson: Connoisseur*, 382.

56. Roger Fry to Robert Trevelyan, quoted in ibid., 316.

57. Lee and Anstruther-Thomson, *Beauty and Ugliness*, 92–93.

58. William James, quoted in Johnston, "Mary Berenson and the Conception of Connoisseurship," 503.

59. BB to MC, 1890, transcribed in MB, *Life of Berenson*, I Tatti version, p. 6.

60. BB, *Italian Painters of the Renaissance*, 1:25.

61. BB, "On Jewish Self-Government."

62. For illuminating discussions of the particular forms nostalgia took among immigrants from the shtetl, see the essay by Steven J. Zipperstein in Helzel, *Shtetl Life;* and Frankel and Zipperstein, *Assimilation and Community.*

63. BB, "On Jewish Self-Government."

64. Ibid.

65. NM, *Forty Years with Berenson*, 76.

66. BB, *Italian Painters of the Renaissance*, 15.

5. Selling and Building

1. MB to HWS, February 23, 1901, excerpted in MB, *Self-Portrait*, 94.

2. ISG to BB, November 21, 1897, *Letters*, 101.

3. MB to her family, November 16, 1911, excerpted in MB, *Self-Portrait*, 174.

4. MC to Karin Costelloe, November 25, 1899, quoted in Samuels, *Berenson: Connoisseur*, 252.

5. MC to her family, March 15, 1900, excerpted in MB, *Self-Portrait*, 90.

6. BB to ISG, March 11, 1894, *Letters*, 38.

7. ISG to BB, March 15, 1894, ibid.

8. BB to ISG, August 1, 1894, ibid., 39.

9. BB to MC, September 14, 11, 1894, quoted in Samuels, *Berenson: Connoisseur*, 196.

10. BB to MC, August 3, 1894, quoted in BB, *Berenson Treasury*, 84.

11. BB to SB, December 26, 1896, quoted in Samuels, *Berenson: Connoisseur*, 275.

12. ISG to BB, January 20, 1898, *Letters*, 120.

13. For details of this transaction, see Alan Chong in Howard, *Colnaghi, Established 1760*, 28.

14. ISG to BB, September 19, 1896, *Letters*, 66.

15. BB to ISG, November 19, 1898, ibid., 159.

16. Colby, "Palaces Eternal and Serene."

17. BB to ISG, July 31, 1898, *Letters*, 148.

18. ISG to BB, May 25, 1900, ibid., 218.

19. For an intriguing discussion of how ideas about Altamura may have influenced a second structure at the Gardner, since torn down, see Colby, "Palaces Eternal and Serene."

20. Henry Adams to ISG, February 9, 1906, quoted in Carter, *Isabella Stewart Gardner and Fenway Court*, 204.

21. ISG to BB, September 25, 1898, *Letters*, 154.

22. MC to BB, October 9, 1898, I Tatti.

23. MC to BB, October 11, 1898, ibid.

24. MC, diary, June 23, 1898, excerpted in MB, *Self-Portrait*, 76.

25. ISG, undated note from the Isabella Stewart Gardner Museum Archive, quoted in Saltzman, *Old Masters, New World*, 88.

26. See Chong, *Eye of the Beholder*, xii; and Saltzman, *Old Masters, New World*, 88.

27. OG to BB, June 16, 1899, quoted in Saltzman, *Old Masters, New World*, 85.

28. BB to MC, October 11, 1898, quoted in Samuels, *Berenson: Connoisseur*, 302.

29. Bertrand Russell to Alys Russell, June 27, 1902, quoted in Strachey, *Remarkable Relations*, 213.

30. BB to MC, July [June] 9, 1899, quoted in Samuels, *Berenson: Connoisseur*, 306. For a discussion of Berenson's uneasy position of authority, see Fisher, *Artful Itineraries*, 146.

31. Behrman, *Duveen*, 152–153.

32. Samuels, *Berenson: Connoisseur*, 317.

33. MC to BB, May 3, 1900, quoted in ibid., 331.

34. Zangwill to BB, May 29, 1901, quoted in ibid., 386.

35. Ibid.; MB, diary, November 23, 1902, quoted in ibid.

36. MC, diary, May 18, 1899, quoted in ibid., 329.

37. Ibid., 200. See also Strachey, *Remarkable Relations*, 141–143.

38. MC, diary, November 7, 1895, excerpted in MB, *Self-Portrait*, 65.

39. Samuels, *Berenson: Connoisseur*, 280.

40. MC, diary, November 14, 1897, excerpted in MB, *Self-Portrait*, 73.

41. BB to MC, October 11, 1898, quoted in Samuels, *Berenson: Connoisseur*, 301.

42. MC to BB, October 9, 1898, I Tatti.

43. BB to MC, October 11, 1898, quoted in Samuels, *Berenson: Connoisseur*, 302.

44. MC to BB, October 12, 1898, I Tatti.

45. BB, *Italian Painters of the Renaissance*, 2:88, 89.

46. Ibid., 55, 75, 93, 95–96, 99.

47. As recently as 2010, Carmen Bambach, curator in the Metropolitan Museum of Art's department of drawings, wrote a two-part consideration of these volumes and marveled at their accomplishment as "colossal" ("Berenson's Michelangelo," part 2).

48. BB, *Drawings of the Florentine Painters*, 4.

49. Ibid., 5.

50. BB to SB, January 7, 1900, quoted in Samuels, *Berenson: Connoisseur*, 337.

51. BB to ISG, January 9, 1900, *Letters*, 199.

52. BB to MC, January 24, 1900, I Tatti.

53. BB to MC, February 10, 1900, ibid.

54. BB, *Sunset and Twilight*, 170.

55. MC to SB, October 31, 1900, quoted in Samuels, *Berenson: Connoisseur*, 347.

56. Judith Berenson to MC, July 17, 1900, quoted in ibid., 339–340.

57. HWS to MC, June 15, 1900, quoted in ibid., 339.

58. BB, *Sunset and Twilight*, 470.

59. Downing, *Queen Bee of Tuscany*, quoted by permission of the author.

60. BB to SB, November 21, 1900, quoted in Samuels, *Berenson: Connoisseur*, 350.

61. BB to SB, no date, quoted in ibid., 351.

62. ISG to BB, August 3, 1900, *Letters*, 225.

63. Samuels, *Berenson: Connoisseur*, 402.

64. MB to BB, September 6 1901, quoted in ibid., 362.

65. MB to BB, December 14/15, 1901, excerpted in MB, *Self-Portrait*, 99.

66. MB, diary, March 1901, quoted in Samuels, *Berenson: Connoisseur*, 333.

67. BB to ISG, December 12, 1901, *Letters*, 278.

68. BB to Abraham Berenson, May 15, 1902, quoted in Samuels, *Berenson: Connoisseur*, 379.

69. BB to Hutchins Hapgood, August 12, 1905, excerpted in BB, *Berenson Treasury*, 126–127.

70. BB, *Sketch for a Self-Portrait*, 41.

71. Ibid., 27.

72. See Carter, *Isabella Stewart Gardner and Fenway Court*, 184–185, 189–190. In *The Art of Scandal*, Douglass Shand-Tucci argues that Gardner was so substantially involved in every aspect of construction and design that she ought to be given much more credit than she has been as one of the first woman architects and interior designers in the United States.

73. William James to ISG, 1903, quoted in Carter, *Isabella Stewart Gardner and Fenway Court*, 201.

74. MB to HWS, quoted in Samuels, *Berenson: Connoisseur*, 396.

75. MC to her children, October 27, 1900, quoted in Strachey, *Remarkable Relations*, 181.

76. These panels, together with the rest of the altarpiece, are the subject of an important monograph, *Sassetta: The Borgo San Sepolcro Altarpiece*, edited by Machtelt Israels (Cambridge, MA: Harvard University Press, 2009).

77. BB, *Sunset and Twilight*, 489.

78. Strachey, *Remarkable Relations*, 209.

79. OG to BB, March 14, 1901, quoted in Saltzman, *Old Masters, New World*, 86.

80. MB to BB, April 2, 1901, quoted in Samuels, *Berenson: Connoisseur*, 357.

81. OG to BB, December 22, 1909, quoted in Samuels, *Berenson: Legend*, 39.

82. Samuels, *Berenson: Connoisseur*, 406.

83. MB to HWS, December 31, 1903, excerpted in MB, *Self-Portrait*, 114.

84. Samuels, *Berenson: Connoisseur*, 411; see also Johnston, "Mary Berenson and the Cultivation of American Collectors."

85. As Stanley Mazaroff has pointed out in his study of Berenson's effect on one such collection, that belonging to Baltimore railroad magnate Henry Walters, "What ultimately emerged as a result of his criticism was a collection that had been shorn of pretension and replaced by an array of notable paintings by outstanding although lesser-known artists. . . . It was a triumph of scholarship over embellishment" (*Henry Walters and Bernard Berenson*, 10).

86. La Farge to Adams, January 1904, quoted in Samuels, *Berenson: Connoisseur*, 413.

87. BB on Adams, quoted in Samuels, *Berenson: Connoisseur*, 429.

88. For a thorough account of the Minghetti Leonardo, see Samuels, *Berenson: Connoisseur*, 415; and esp. Seybold, "Mysterious 'Donna Laura Minghetti-Leonardo.'"

89. Theodore Davis, quoted in Samuels, *Berenson: Connoisseur*, 415.

90. MB, diary, November 13, 1903, quoted in ibid., 413–414; MB to HWS, no date, quoted in ibid., 414.

91. Reitlinger, *Economics of Taste*, xii.

92. MB to HWS, January 10, 1904, excerpted in MB, *Self-Portrait*, 115.

93. Ibid.

94. MB to HWS, December 31, 1903, quoted in Samuels, *Berenson: Connoisseur*, 422.

95. MB to HWS, November 17, 19, 1903, quoted in ibid., 415.

96. MB, diary, November 14, 1903, quoted in Brown, *Berenson*, 18. Brown notes that this part of Mary's diary was published in Myron Gilmore, "The Berensons and Villa I Tatti," *Proceedings of the American Philosophical Society* 120 (January 1976): 7–12.

97. For a full account of the Cellini case, see Chong, "Afterlife of Cellini's Bust of Bindo Altoviti."

98. MB, diary, November 20, 1904, quoted in Samuels, *Berenson: Connoisseur*, 416.

99. Roger Fry, quoted in Saltzman, *Old Masters, New World*, 2.

100. MB to ISG, May 27, 1904, *Letters*, 338.

6. The Picture Trade

1. BB to Michael Field, August 28, 1905, excerpted in BB, *Berenson Treasury*, 127.

2. MB to BB, August 22, 1904, quoted in Melnick, *Senda Berenson*, 90.

3. NM, *Forty Years with Berenson*, 71.

4. Hardwick, *View of My Own*, 208.

5. NM, introduction to *Bernard Berenson*, ix.

6. Rubin, "Portrait of a Lady," 38.

7. Mazaroff, *Henry Walters and Bernard Berenson*, 9.

8. MB, diary, April 14, 1927, quoted in Strachey, *Remarkable Relations*, 295.

9. Clark, *Moments of Vision*, 111–112.

10. Strachey, *Remarkable Relations*, 209.

11. Berenson, *Three Essays in Method*, xi.

12. MB to HWS, June 28, 1904, quoted in Samuels, *Legend*, 13.

13. BB to MB, December 30, 1904, quoted in ibid., 23.

14. Samuels, *Berenson: Legend*, 31.

15. In this conjecture I am following Samuels; see ibid., 39.

16. Behrman, *Duveen*, 169.

17. James Henry Duveen, quoted in Secrest, *Being Berenson*, 75.

18. JD to BB, n.d., quoted in Samuels, *Berenson: Legend*, 40.

19. Ibid.

20. BB to Francis Taylor, October 17, 1957, excerpted in BB, *Selected Letters*, 296.

21. Ibid., 295.

22. Roger Fry to Helen Fry, June 2, 1907, quoted in Strouse, *Morgan*, 567.

23. Field to Rothenstein, quoted in Samuels, *Berenson: Legend*, 55.

24. Roger Fry to BB, January 11, 1908, quoted in ibid., 47; Fry, *Burlington Magazine*, quoted in ibid.

25. BB to Robert Ross, December 3, 1928, quoted in ibid., 55.

26. BB to ISG, November 7, 1907, *Letters*, 412.

27. ISG to BB, October 3, 1907, ibid., 409.

28. MB to HWS, February 24, 1908, quoted in Samuels, *Berenson: Legend*, 58.

29. Lytton Strachey to Duncan Grant, June 18, 2007, quoted in Dunn, *Geoffrey Scott and the Berenson Circle*, 46.

30. MB to HWS, January 16, 1907, quoted in ibid., 33.

31. MB, diary, January 26, 1908, quoted in Samuels, *Berenson: Legend*, 50.

32. The specific date and place of the meeting have proved elusive. See Ardizzone, *Illuminated Life*, 115–123.

33. BG to BB, August 12, 1912, quoted in ibid., 128.

34. BG to BB, April 9, 1909, quoted in Strouse, *Morgan*, 517.

35. The work of uncovering Greene's actual heritage began only recently with work done by Jean Strouse in *Morgan: American Financier* (2000) and continued by Heidi Ardizzone in *An Illuminated Life: Belle da Costa Greene's Journey from Prejudice to Privilege* (2007.)

36. SB to BB, January 28, 1910, quoted in Melnick, *Senda Berenson*, 119; Ardizzone, *Illuminated Life*, 151.

37. MB to Ray Costelloe, February 18, 1909, quoted in Ardizzone, *Illuminated Life*, 123.

38. BG to BB, November 12, 1909, quoted in ibid., 143.

39. ISG to BB, December 18, 1909, quoted in ibid., 144.

40. BB to William Miliken, October 29, 1951, quoted in Samuels, *Berenson: Legend*, 541.

41. BG to BB, December 27, 1909, I Tatti.

42. BG to BB, March 19, 1912, quoted in Ardizzone, *Illuminated Life*, 279.

43. BG to BB, February 24, 1910, quoted in ibid., 150.

44. MB to BB, August 21, 1910, quoted in Samuels, *Berenson: Legend*, 110.

45. BB to MB, August 26, 1910, quoted in ibid., 111.

46. MB to BB, July 23, 1910, quoted in Ardizzone, *Illuminated Life*, 173.

47. Organized by Friedrich Sarre and Fredrik Robert Martin. For a fine discussion of the exhibition, its impact on Berenson, and his subsequent collection of Islamic manuscripts, see Casari, "Berenson and Islamic Culture."

48. BB to MB, August 27, 1910, quoted in ibid.

49. BB to EW, May 6, 1910, quoted in ibid.

50. BB to MB, September 4, 1910, quoted in Samuels, *Berenson: Legend*, 111–112.

51. BG to BB, October 14, 1913, I Tatti, quoted in Ardizzone, *Illuminated Life*, 188.

52. BG to BB, September 26, 1919, quoted in ibid., 198.

53. BG to BB, January 4, 1921, quoted in ibid., 198–199.

54. BG to BB, November 12, 1909, quoted in ibid., 229.

55. BG to BB, January 3, 1911, quoted in ibid., 230.

56. SB to BB, February 2, 1911, quoted in ibid., 236.

57. BG to BB, March 13, 1914, quoted in ibid., 324.

58. Reitlinger, *Economics of Taste*, 201.

59. BG to BB, April 2, 1913, quoted in Ardizzone, *Illuminated Life*, 288.

60. BG to BB, April 12, 1913, I Tatti.

61. Duveen Brothers to BB, September 6, 1932, Duveen Brothers Archive, Metropolitan Museum of Art, New York.

62. Fowles, *Memories of Duveen Brothers*, 66.

63. For a beautiful rendering of Berenson and Wharton's relationship, see Lee, *Edith Wharton*, esp. 402–422.

64. MB, diary, February 19, 1903, quoted in Samuels, *Berenson: Connoisseur*, 388.

65. BB to MB, September 26, 1909, I Tatti.

66. BB to MB, October 2, 1909, ibid.

67. BB to MB, September 26, 1909.

68. BB to EW, July 15, 1910, ibid.

69. EW to BB, February 18, 1913, ibid.

70. EW to BB, August 2, 1913, ibid.

71. Ibid.

72. BB to MB, August 12, 1913, ibid.

73. BB to MB, August 16, 1913, ibid.

74. Ibid.

75. EW to BB, September 10, 1913, ibid.

76. Lee, *Edith Wharton*, 402–403.

77. EW to BB, July 28, 1918, quoted in ibid., 414.

78. Fowles, *Memories of Duveen Brothers*, 106.

79. EW to BB, January 28, 1917, I Tatti.

80. EW to BB, February 13, 1917, ibid.

81. EW to BB, February 19, 1917, ibid.

82. Strachey, *Remarkable Relations*, 272.

83. MB to Alys Russell, July 22, 1916, in MB, *Self-Portrait*, 213.

84. BB to MB, December 24, 1917, quoted in Samuels, *Berenson: Legend*, 230.

85. BB to MB, January 19, 1918, quoted in Dunn, *Geoffrey Scott and the Berenson Circle*, 179.

86. MB to BB, November 20, 1918, quoted in Samuels, *Berenson: Legend*, 236.

87. Strachey, *Remarkable Relations*, 280.

88. Ray Costelloe Strachey to Alys Russell, April 22, 1918, quoted in ibid., 280.

89. BB to MB, November 1, 1917, quoted in Samuels, *Berenson: Legend*, 226.

90. BB to MB, November 11, 1917, quoted in ibid., 226.

91. BB to Barrett Wendell, April 18, 1918, quoted in ibid., 233.

92. For an account of this correspondence, see Downing, *Queen Bee of Tuscany*.

93. BB to MB, November 12, 1918, quoted in Samuels, *Berenson: Legend*, 243.

94. BB to MB, October 21, 1918, quoted in ibid., 244.

95. BB to Barrett Wendell, December 18, 1918, quoted in ibid., 243.

96. NM, *Forty Years with Berenson*, 23.

7. Nicky Mariano and the Library

1. NM, *Forty Years with Berenson*, 95.

2. Walker, Introduction to BB, *One Year's Reading for Fun*, ix.

3. NM, *Forty Years with Berenson*, 101.

4. Ibid., 48.

5. BB, *Sunset and Twilight*, 117.

6. NM, *Forty Years with Berenson*, 65.

7. BB, *Sunset and Twilight*, 117.

8. BB to NM, October 10, 1925, quoted in Samuels, *Berenson: Legend*, 338.

9. MB to BB, July 19, 1923, quoted in ibid., 313.

10. Lee, *Edith Wharton*, 651.

11. NM, *Forty Years with Berenson*, 31.

12. Ibid., 190–199.

13. Haslam, "Real Lee Radziwill."

14. BB, *Sunset and Twilight*, 90.

15. NM, *Forty Years with Berenson*, 125.

16. Ibid.

17. Ibid., 53.

18. MB to ISG, October 6, 1922, *Letters*, 651.

19. NM, *Forty Years with Berenson*, 56.

20. BB to Judge Learned Hand, December 15, 1922, in BB, *Letters*, 94–95.

21. Gimpel, *Diary of an Art Dealer*, October 31, 1922, 193.

22. Ibid.

23. BB, *Rumor and Reflection*, 401.

24. BB, "A Newly Discovered Cimabue," in *Studies in Medieval Painting* (1919), excerpted in BB, *Berenson Treasury*, 150–151.

25. Brown, *Berenson and the Connoisseurship of Italian Paintings*, 17.

26. Samuels, *Berenson: Connoisseur*, 431.

27. Fowles, *Memories of Duveen Brothers*, 65.

28. Simpson, *Artful Partners*, 2.

29. Hardwick, *View of My Own*, 211.

30. BB, *Sketch for a Self-Portrait*, 47.

31. NM, *Forty Years with Berenson*, 173–174.

32. MB to ISG, April 23, 1921, *Letters*, 629.

33. MB to BB, December 25, 28, 1927, quoted in Lee, *Edith Wharton*, 551.

34. NM, *Forty Years with Berenson*, 173.

35. Ibid., 172.

36. BB to William Ivins, Christmas 1931, quoted in Samuels, *Berenson: Legend*, 391.

37. BB to MB, August 19, 1919, quoted in ibid., 262.

38. EW to BB, September 4, 1917, I Tatti.

39. EW to MB, June 4, 1932, ibid. I am grateful to Michael Rocke and Jonathan Nelson at the Villa I Tatti for drawing my attention to this letter.

40. EW, diary, June 25, 1931, quoted in Lee, *Edith Wharton*, 659.

41. EW to BB, February 18, 1931, quoted in ibid.

42. BB to EW, February 19, 1931, quoted in ibid.

43. EW to BB, February 4, 1917, I Tatti.

44. BB to EW, February 6, 1917, ibid.

45. For a nuanced account of the Hahn trial and how it demonstrated transformations of expertise and the market, see Brewer, *American Leonardo*.

46. Quoted in Samuels, *Berenson: Legend*, 315.

47. See Seybold, "Mysterious 'Donna Laura Minghetti-Leonardo.'"

48. Berenson, *Study and Criticism of Italian Art*, 2.

49. EW to BB, June 29, 1917, I Tatti.

50. MB to ISG, September 10, 1923, *Letters*, 662.

51. NM, *Forty Years with Berenson*, 88.

52. Transcript of 1923 testimony, quoted in Brewer, *American Leonardo*, 141.

53. BB, quoted in *Chicago Tribune*, September 5, 1923.

54. Duveen to Louis Levy, February 8, 1928, quoted in Secrest, *Duveen*, 241.

55. *New York Times*, March 3, 1929, quoted in ibid., 242.

56. *New York Tribune*, September 29, 1923, I Tatti.

57. *Literary Digest*, March 23, 1929, quoted in Samuels, *Berenson: Legend*, 318.

58. *New York Herald*, September 5, 1923, 2.

59. Gimpel, *Journal d'un collectionneur*, September 5, 1923 [original journal containing material not in published translation], Archives of American Art, Smithsonian Institution, quoted in Samuels, *Berenson: Legend*, 316.

60. MB to NM, September 4, 1924, quoted in Samuels, *Berenson: Legend*, 327.

61. Copy, MB to JD, July 25, 1924, quoted in ibid., 326.

62. Ibid.

63. MB to her family, October 13, 1913, excerpted in MB, *Self-Portrait*, 192.

64. BB to Louis Duveen, April 14, 1912, Metropolitan.

65. MB to Fowles, December 26, 1924, ibid.

66. BB to Fowles, December 22, 1930, ibid.

67. BB to Duveen Brothers, telegram, May 28, 1912, ibid.

68. BB to ISG, August 14, 1907, *Letters*, 404.

69. BB to Louis Duveen, May 1, 1913, quoted in Secrest, *Duveen*, 108.

70. MB to Fowles, September 18, 1930, Metropolitan.

71. MB to Fowles, November 9, 1930, ibid.

72. BB to Louis Duveen, December 8, 1912, ibid.

73. William St. Clair, quoted in Secrest, *Duveen*, 375.

74. BB to Paul Sachs, April 8, 1926, quoted in Samuels, *Berenson: Legend*, 338.

75. BB to Lawrence Berenson, October 17, 1922, I Tatti. All subsequent quotations from BB to LB are from this letter.

76. Fowles, *Memories of Duveen Brothers*, 71.

77. NM, *Forty Years with Berenson*, 71–72.

78. See Stille, *Benevolence and Betrayal*.

79. NM, *Forty Years with Berenson*, 30.

80. Morra, *Conversations with Berenson*, viii–ix.

81. BB to NM, August 9, 1935, quoted in NM, *Forty Years with Berenson*, 219–220.

82. Ibid., 127. The picture here of Berenson's relationship with Morra is influenced by Robert and Carolyn Cumming, "Do Not Forget Me," paper presented at "Berenson at Fifty," October 14–16, 2009, Villa I Tatti, Florence, and forthcoming in Connors and Waldman, *Berenson at Fifty*.

83. MB to Walter Lippman, April 19, 1926, excerpted MB, *Self-Portrait*, 260.

84. Kenneth Clark to BB, June 20, 1929, quoted in Samuels, *Berenson: Legend*, 363; Clark quoted in Origo, introduction to *Sunset and Twilight*, xii.

85. NM, *Forty Years with Berenson*, 156.

86. Ibid., 260.

87. BB to C. H. Coster, November 19, 1933, *Letters Between Berenson and Coster*, 56.

88. BB to Abie Berenson, August 1, 1928, quoted in Samuels, *Berenson: Legend*, 367.

89. BB to ISG, January 1, 1924, *Letters*, 665.

90. Quoted in Tharp, *Mrs. Jack*, 324.

91. J. Carter Brown, personal reminiscence in BB, *Looking at Pictures with Berenson*, 16.

92. BB, "On the Future of I Tatti," I Tatti, 3.

93. BG to BB, July 27, 1924, quoted in Samuels, *Berenson: Legend*, 325.

94. BB, "On the Future of I Tatti," 3.

95. Fowles, *Memories of Duveen Brothers*, 101.

96. Strachey, *Remarkable Relations*, 267–268.

97. MB to NM, August 28, September 4, 1928, quoted in Samuels, *Berenson: Legend*, 365.

98. BG to BB, July 8, 1926, I Tatti.

99. My understanding of the significant intellectual cross-pollination between Berenson and Kingsley Porter was influenced by Kathryn Brush, "Bernard Berenson and Arthur Kingsley Porter: Pilgrimage Roads to I Tatti," presented at "Berenson at

Fifty," October 14–16, 2009, Villa I Tatti, Florence, and forthcoming in Connors and Waldman, *Berenson at Fifty*.

100. For the legacy of Berenson's connoisseurship among scholars and curators, see NM, *Forty Years with Berenson*, 112; and Brown, *Berenson and the Connoisseurship of Italian Painting*.

101. Edith Wharton, quoted in Weaver, *Legacy of Excellence*, 61.

102. Quoted in Lee, *Edith Wharton*, 550.

103. EW to BB, February 1, 1937, I Tatti.

104. EW to BB, April 9, 1937, ibid.

105. BB to NM, August 12, 1937, quoted in Samuels, *Berenson: Legend*, 432.

106. Farrand to BB, August 27, 1937, I Tatti.

107. BB to Daniel V. Thompson, August 15, 1937, quoted in Samuels, *Berenson: Legend*, 432.

108. Cannadine, *Mellon*, 551.

109. Fowles to NM, September 3, 1937, quoted in Samuels, *Berenson: Legend*, 433.

110. An imagined version of this encounter, in which Duveen himself appears, is the basis of Simon Gray's play *The Old Masters*.

111. NM to Fowles, September 7, 1937, quoted in Samuels, *Berenson: Legend*, 434.

112. Niall Ferguson, *The House of Rothschild*, 472, quoted in Secrest, *Duveen*, 338.

113. Ibid., 340. Secrest draws on the Duveen obituary in the *New York Times*, May 26, 1939.

114. Copy, BB to Duncan Philips, October 28, 1937, quoted in Samuels, *Berenson: Legend*, 438.

115. BB, *Italian Painters of the Renaissance*, 1:15–16.

8. The Retrospective View

1. BB to MB, January 22, 1918, quoted in Samuels, *Berenson: Legend*, 234.

2. Marcel Proust, quoted in ibid.

3. Ibid.

4. BB to MC, October 28, 1890, excerpted in BB, *Berenson Treasury*, 42.

5. BB, *Rumor and Reflection*, 46.

6. BB, *Sunset and Twilight*, 469.

7. BB to Judith Berenson, April 3, 1938, quoted in Melnick, *Senda Berenson*, 158.

8. BB to Bessie Berenson and SBA, August 31, 1938, quoted in Samuels, *Berenson: Legend*, 447.

9. SBA to BB, September 16, 1938, quoted in Melnick, *Senda Berenson*, 159.

10. SBA to BB, March 21, 1939, quoted in ibid., 161.

11. NM, *Forty Years with Berenson*, 275.

12. BB, *Rumor and Reflection*, 60.

13. BB to Daniel V. Thompson, January 9, 1938, quoted in Samuels, *Berenson: Legend*, 440.

14. Ibid., 484.

15. BB, *Rumor and Reflection*, 212.

16. Berenson, *Sketch for a Self-Portrait*, 47, 52.

17. Walker, Introduction to BB, *One Year's Reading for Fun*, xi, x.

18. BB, *One Year's Reading for Fun*, 105–106.

19. George Santayana to Mrs. Crawford Toy, October 10, 1939, quoted in Samuels, *Berenson: Legend*, 458.

20. Samuels, *Berenson: Legend*, 471.

21. BB, *Rumor and Reflection*, 138–139.

22. NM, *Forty Years with Berenson*, 282, n. 9.

23. BB, *Rumor and Reflection*, 384, 386.

24. Clark, Introduction to NM, *Forty Years with Berenson*, xvi.

25. Berenson, *Sunset and Twilight*, 115.

26. BB, "Epistle to the Americanized Hebrews." The final sentence also appears verbatim in *Rumor and Reflection*, 323.

27. BB, "Epistle to the Americanized Hebrews."

28. NM, *Forty Years with Berenson*, 292.

29. MB to NM, February 5, 1944, quoted in ibid., 288.

30. NM to MB, February 9, 1944, quoted in ibid., 288–289.

31. BB to MB, February 8, 1944, quoted in Strachey, *Remarkable Relations*, 305.

32. BB to Judge Learned Hand, July 15, 1945, quoted in ibid.

33. SBA to BB, December 31, 1944, quoted in Melnick, *Senda Berenson*, 168.

34. SBA to BB, April 3, 1945, quoted in ibid.

35. SBA to BB, January 21, 1949, quoted in ibid., 177.

36. BB to William Milliken, October 29, 1951, quoted in Samuels, *Berenson: Legend*, 541.

37. Meta Harrsen to BB, June 27, 1954, quoted in Ardizzone, *Illuminated Life*, 474.

38. Bessie Berenson to BB, February 28, 1954, quoted in Melnick, *Senda Berenson*, 186.

39. BB, diary, February 13, 1954, quoted in ibid.

40. Hardwick, *View of My Own*, 211–212.

41. Onassis and Bouvier, *One Special Summer*, n.p., on "Berenson."

42. Ray Bradbury, quoted in Samuels, *Berenson: Legend*, 554.

43. *New York Times*, November 7, 1954, quoted in ibid., 519.

44. BB, *Sunset and Twilight*, 477.

45. Steinbeck to BB, May 7, 1957, quoted in Samuels, *Berenson: Legend*, 579.

46. Mumford to BB, May 20, 1957, quoted in ibid.

47. Berenson, *Sunset and Twilight*, 162.

48. Katherine Dunham to BB, May 20, 1949, March 11, 1954, quoted in Connors, "Bernard Berenson and Katherine Dunham: Black American Dance," presented at "Berenson at Fifty," October 14–16, 2009, Villa I Tatti, Florence, and forthcoming in Connors and Waldman, *Berenson at Fifty*, consulted by permission of the author.

49. Clark, Introduction to NM, *Forty Years with Berenson*, xvi.

50. Private correspondence of Berenson family members with the author.

51. BB to Frances Francis, February 3, 1956, Gardner.

52. BB, *Sketch for a Self-Portrait*, 167.

53. BB, "On the Future of I Tatti," 1–2.

54. Ibid., 4, 2.

55. NM, *Forty Years with Berenson*, 318, 319.

56. BB, *Sketch for a Self-Portrait*, 175.

57. Alda Anrep, quoted in Samuels, *Berenson: Legend*, 592.

58. BB, *Italian Painters of the Renaissance*, 2:13.

59. NM, *Forty Years with Berenson*, 320.

60. Ibid., 157.

61. Ibid., 84.

62. BB, *Sunset and Twilight*, 285, 48.

63. BB, diary, April 15, 1958, excerpted in BB, *Berenson Treasury*, 394–395.

SELECTED BIBLIOGRAPHY

Grateful acknowledgment is made to the following institutions and individuals for kind permission to reproduce quotations from the unpublished materials of: Bernard Berenson, Biblioteca Berenson, Villa I Tatti—The Harvard University Center for Italian Renaissance Studies, courtesy of the President and Fellows of Harvard College; and Mary Berenson, Courtesy of the Camphill Village Trust, Ltd.

Archives

Berenson Family Papers (MS Am 2013). Houghton Library, Harvard University.

The Bernard and Mary Berenson Papers (1880–2002), Biblioteca Berenson, Villa I Tatti—The Harvard University Center for Italian Renaissance Studies.

Duveen Brothers Archive, Metropolitan Museum of Art, New York.

Isabella Stewart Gardner Museum Archives, Boston.

Unpublished MSS

Berenson, Bernard. "Epistle to the Americanized Hebrews." Biblioteca Berenson, I Tatti, 1944.

———. "On Jewish Self-Government." Biblioteca Berenson, I Tatti, 1892 [possibly 1892–1894].

———. "On the Future of I Tatti." Biblioteca Berenson, I Tatti, n.d. [1950s].

———. "Talmudo-Rabbinical Escatology." Biblioteca Berenson, I Tatti, n.d. Believed to be senior thesis [1887]. Available online at: http://berenson.itatti.harvard.edu/berenson/items/show/2976.

Berenson, Mary. *The Life of Bernard Berenson.* Exists in multiple versions; citations here are from manuscripts preserved at Houghton and at I Tatti, cited correspondingly. Manuscript at Villa I Tatti, Florence, 1929, with later emendations.

Published Works

Adams, Henry. *The Education of Henry Adams: An Autobiography.* Introduction by Edmund Morris. New York: Modern Library, 1999.

Adler, Issac. "The Jews at Harvard." *Jewish Tidings,* February 5, 1892. Reprinted as appendix in Rosovsky, *Jewish Experience at Harvard and Radcliffe,* 69–70.

Ardizzone, Heidi. *An Illuminated Life: Belle da Costa Greene's Journey from Prejudice to Privilege.* New York: W. W. Norton, 2007.

Bambach, Carmen. "Berenson's Michelangelo." Parts 1 and 2. *Apollo* March, April 2010.

Bassani, Giorgio. *The Garden of the Finzi-Continis.* 1962. Translated by William Weaver. New York: Harcourt, 1977.

Behrman, S. N. *Duveen.* New York: Random House, 1952.

———. *People in a Diary.* Boston: Little, Brown, 1972.

Berenson, Bernard. *Aesthetics and History.* New York: Pantheon Books, 1948. Reprint ed., New York: Doubleday, 1965.

———. *The Bernard Berenson Treasury.* Edited by Hanna Kiel,

with an introduction by John Walker and a preface by Nicky Mariano. New York: Simon and Schuster, 1962.

———. *The Central Italian Painters of the Renaissance*. London: G. P. Putnam's Sons, 1897.

———. "Contemporary Jewish Fiction." *Andover Review: A Religious and Theological Monthly* 10 (December 1888): 587–593.

———. "The Death and Burial of Israel Koppel." *Harvard Monthly* 6 (July 1888): 177–194.

———. *The Drawings of the Florentine Painters*. Amplified ed. Chicago: University of Chicago Press, 1938.

———. *Essays in Appreciation*. New York: MacMillan, 1958.

———. *The Florentine Painters of the Renaissance: With an Index to Their Works*. London: G. P. Putnam's Sons, 1896.

———. "How Matthew Arnold Impressed Me." *Harvard Monthly* 5 (November 1887): 53–56.

———. *Italian Painters of the Renaissance*, Vol. 1: *Venetian and North Italian Schools*, and Vol. 2: *Florentine and Central Italian Schools*. London: Phaidon, 1968.

———. *Looking at Pictures with Bernard Berenson*. Selected and with an introduction by Hanna Kiel, with a personal reminiscence by J. Carter Brown. New York: Harry N. Abrams, 1974.

———. *Lorenzo Lotto: An Essay in Constructive Art Criticism*. London: G. P. Putnam's Sons, 1895. Reprint, London: Phaidon, 1956.

———. *North Italian Painters of the Renaissance*. London: G. P. Putnam's Sons, 1907.

———. *One Year's Reading for Fun (1942)*. Introduction by John Walker. New York: Alfred A. Knopf, 1960.

———. *The Passionate Sightseer: From the Diaries, 1947–1956*. London: Thames and Hudson, 1960.

———. *Rumor and Reflection*. New York: Simon and Schuster, 1952.

———. *The Selected Letters of Bernard Berenson*. Edited by A. K. McComb with an epilogue by Nicky Mariano. Boston: Houghton Mifflin, 1963.

———. *Sketch for a Self-Portrait*. New York: Pantheon, 1949.

———. *Study and Criticism of Italian Art, Third Series.* London: G. Bell and Sons, 1916.

———. *Sunset and Twilight: From the Diaries of 1947–1958.* Edited and with an epilogue by Nicky Mariano. Introduction by Iris Origo. New York: Harcourt, Brace and World, 1963.

———. "The Third Category." *Harvard Monthly* 3 (November 1886): 66–83.

———. *Three Essays on Method.* Oxford: Clarendon Press, 1927.

———. *The Venetian Painters of the Renaissance: With an Index to Their Works.* London: G. P. Putnam's Sons, 1894.

———. "Was Mohammed at All an Impostor?" *Harvard Monthly* 4 (April 1887): 48–63.

Berenson, Bernard, and Charles Henry Coster. *The Letters Between Bernard Berenson and Charles Henry Coster.* Edited by Giles Constable in collaboration with Elizabeth H. Beatson and Luca Dainelli. Florence: Leo S. Olschki, n.d.

Berenson, Bernard, and Isabella Stewart Gardner. *The Letters of Bernard Berenson and Isabella Stewart Gardner, 1887–1924,* with correspondence by Mary Berenson. Edited by Rollin Van N. Hadley. Boston: Northeastern University Press, 1987.

Berenson, Bernard, and Clotilde Marghieri. *A Matter of Passion: Letters of Bernard Berenson and Clotilde Marghieri.* Edited by Dario Biocca. Berkeley: University of California Press, 1989.

Berenson, Mary. *A Modern Pilgrimage.* New York: D. Appleton, 1933.

———. *A Self-Portrait from Her Diaries and Letters.* Edited by Barbara Strachey and Jayne Samuels. New York: W. W. Norton, 1983.

Brewer, John. *The American Leonardo: A Tale of Obsession, Art, and Money.* New York: Oxford University Press, 2009.

Brown, David Alan. *Berenson and the Connoisseurship of Italian Painting,* exh. cat. Washington, DC: National Gallery of Art, 1979.

Broyard, Anatole. "Figure in a Landscape." *New York Times,* May 12, 1979. Review of Ernest Samuels, *Bernard Berenson: The Making of a Connoisseur.*

Burns, Sarah. *Inventing the Modern Artist: Art and Culture in Gilded Age America*. New Haven: Yale University Press, 1996.

Calo, Mary Ann. *Bernard Berenson and the Twentieth Century*. Philadelphia: Temple University Press, 1994.

Cannadine, David. *Mellon: An American Life*. New York: Vintage Books, 2008.

Carter, Morris. *Isabella Stewart Gardner and Fenway Court*, 2nd ed., sixth printing, with changes. Boston: Isabella Stewart Gardner Museum, 1925. Reprint, 1963.

Casari, Mario. "Berenson and Islamic Culture: 'Thought and Temperament.'" In Nelson, *Berenson and Harvard*.

Chabod, Federico. *A History of Italian Fascism*. Translated by Muriel Grindrod. London: George Weidenfeld and Nicolson, 1963. Reprint ed., Bath: Cedric Chivers, 1974.

Chapman, Tim. *Imperial Russia, 1801–1905*. New York: Routledge, 2001.

Chernow, Ron. *The House of Morgan: An American Banking Dynasty and the Rise of Modern Finance*. New York: Grove, 1990.

Chong, Alan. "The Afterlife of Cellini's Bust of Bindo Altoviti." In Chong, Pergazzano, and Zikos, *Raphael, Cellini, and a Renaissance Banker*, 237–262.

———. "Isabella Gardner, Bernard Berenson, and Otto Gutekunst." In Howard, *Colnaghi, Established 1760*, 26–31.

Chong, Alan, ed. *The Art of the Cross: Medieval and Renaissance Piety in the Isabella Stewart Gardner Museum*. Boston: Isabella Stewart Gardner Museum, 2001.

Chong, Alan, Richard Lingner, and Carl Zahn, eds. *Eye of the Beholder: Masterpieces from the Isabella Stewart Gardner Museum*. Boston: Isabella Stewart Gardner Museum, 2003.

Chong, Alan, Donatella Pergazzano, and Dimitrios Zikos, eds. *Raphael, Cellini, and a Renaissance Banker: The Patronage of Bindo Altoviti*. Boston: Isabella Stewart Gardner Museum, 2003.

Clark, Kenneth. *Moments of Vision*. London: John Murray, 1981.

Colby, Robert. "Palaces Eternal and Serene: The Vision of Altamura and Isabella Stewart Gardner's Fenway Court." In Nelson, *Berenson and Harvard*.

Connors, Joseph. "Bernard Berenson and Katherine Dunham: Black American Dance." Presented at "Berenson at Fifty," October 14–16, 2009, Villa I Tatti, Florence, and forthcoming in Connors and Waldman, *Berenson at Fifty.*

Connors, Joseph, and Louis A. Waldman, eds. *Berenson at Fifty.* Florence: Villa I Tatti, forthcoming 2014.

Dowling, Linda. *Charles Eliot Norton: The Art of Reform in Nineteenth-Century America.* Hanover, NH: University Press of New England, 2007.

Downing, Ben. *Queen Bee of Tuscany: The Redoubtable Janet Ross.* New York: Farrar, Straus and Giroux, 2013.

Dunn, Richard M. *Geoffrey Scott and the Berenson Circle.* Lampeter, Wales: Edward Mellen, 1998.

Everett, Edward. *Orations and Speeches on Various Occasions by Edward Everett*, vol. 3. Boston: Little, Brown, 1859.

Fantoni, Marcello, ed. *Gli Anglo-Americani a Firenze: Idea e construzione del Rinascimento.* Proceedings from the Conference Georgetown University, Villa Le Balze, Fiesole, June 19–20, 1997. Rome: Bulzoni, 2000.

Fisher, Paul. *Artful Itineraries: European Art and American Careers in High Culture, 1865–1920.* New York: Garland, 2000.

Fowles, Edward. *Memories of Duveen Brothers.* Introduction by Sir Ellis Waterhouse. New York: Times Books, 1976.

Francis, Henry Sayles. Oral history interview with Henry Sayles Francis, March 28, 1974–July 11, 1975. Archives of American Art, Smithsonian Institution.

Frankel, Jonathan, and Steven J. Zipperstein, eds. *Assimilation and Community: The Jews in Nineteeenth-Century Europe.* New York: Cambridge University Press, 1992.

Geoffrey-Menoux, Sophie. "Henry James and Family: Eleven Unpublished Letters." 2003. http://www.paradigme.com/sources /SOURCES-PDF/Sources14-2.pdf.

Gimpel, René. *Diary of an Art Dealer.* Translated by John Rosenberg with an introduction by Sir Herbert Read. New York: Farrar, Straus and Giroux, 1966. Reprint ed., London: Pimlico, 1992.

Gray, Simon. *The Old Masters.* London: Faber and Faber, 2004.

Hardwick, Elizabeth. *A View of My Own: Essays on Literature and Society.* New York: Farrar, Straus, and Cudahy, 1962. Reprint ed., New York: Ecco, 1982.

Haslam, Nicky, "The Real Lee Radziwill." *New York Times*, February 7, 2013.

Helzel, Florence B. *Shtetl Life: The Nathan and Faye Hurwitz Collection*, exh. cat. With an essay by Steven J. Zipperstein. Berkeley, CA: Judah L. Magnes Museum, 1993.

Howard, Jeremy, ed. *Colnaghi, Established 1760: The History.* London: Colnaghi, 2010.

Hughes, Robert. "Only in America." *New York Review of Books*, December 20, 1979.

James, Henry. *The Outcry.* Introduction by Jean Strouse. New York: Charles Scribner's Sons, 1911. Reprint ed., New York: New York Review Books, 2002.

James, William. *Manuscript Lectures.* Introduction by Ignas K. Skrupskelis. Cambridge, MA: Harvard University Press, 1988.

———. *The Principles of Psychology.* 2 vols. Boston: Henry Holt, 1890. Reprint ed., New York: Dover, 1950.

Johnston, Tiffany L. "Mary Berenson and the Conception of Connoisseurship." PhD diss., Indiana University, 2001.

———. "Mary Berenson and the Cultivation of American Collectors." Paper presented at "A Market for Merchant Princes: Collecting Italian Renaissance Paintings in America," November 12–13, 2010, Frick Collection, New York. Cited by permission of the author.

———. "Mary Whitall Smith at the Harvard Annex." In Nelson, *Berenson and Harvard.*

Lederhendler, Eli. *The Road to Modern Jewish Politics: Political Tradition and Political Reconstruction in the Jewish Community of Tsarist Russia.* New York: Oxford University Press, 1989.

Lee, Hermione. *Edith Wharton.* New York: Alfred A. Knopf, 2007.

Lee, Vernon, and Clementina Anstruther-Thomson. *Beauty and Ugliness and Other Studies in Psychological Aesthetics.* London: John Lane, 1912.

Lewis, R. W. B. *The City of Florence: Historical Vistas and Personal Sightings*. New York: Henry Holt, 1995.

Lingner, Richard. "Isabella Stewart Gardner's Spiritual Life." In Chong, *Art of the Cross*, 29–39.

Mariano, Nicky. *Forty Years with Berenson*. Introduction by Sir Kenneth Clark. New York: Alfred A. Knopf, 1966.

Mariano, Nicky, comp. *Bernard Berenson: An Inventory of Correspondence*. Florence: Villa I Tatti, the Harvard University Center for Italian Renaissance Studies, 1965.

Mazaroff, Stanley. *Henry Walters and Bernard Berenson: Collector and Connoisseur*. Baltimore: Johns Hopkins University Press, 2010.

McCarthy, Mary. *The Stones of Florence*. New York: Harcourt Brace Jovanovich, 1963.

McCauley, Elizabeth Anne. "A Sentimental Traveler: Isabella Stewart Gardner in Venice." In McCauley, Chong, Zorzi, and Lingner, *Gondola Days*, 3–52.

McCauley, Elizabeth Anne, Alan Chong, Rosella Mamoli Zorzi, and Richard Lingner, eds. *Gondola Days: Isabella Stewart Gardner and the Palazzo Barbaro Circle*, exh. cat. Boston: Isabella Stewart Gardner Museum, 2004.

Melnick, Ralph. *Senda Berenson: The Unlikely Founder of Women's Basketball*. Amherst: University of Massachusetts Press, 2007.

Morra, Umberto. *Conversations with Berenson*. Translated by Florence Hammond. Boston: Houghton Mifflin, 1965.

Mostyn-Owen, William, ed. *Bibliografia di Bernard Berenson*. Milan: Electa, 1955.

Nelson, Jonathan K., ed. *Berenson and Harvard: Bernard and Mary as Students*. I Tatti online exhibition and electronic catalog, 2012, http://berenson.itatti.harvard.edu/berenson/exhibits/show/berenson.

Nicholas, Lynn H. *The Rape of Europa: The Fate of Europe's Treasures in the Third Reich and the Second World War*. New York: Alfred A. Knopf, 1994. Reprint ed., New York: Vintage Books, 1995.

[Norton, Charles Eliot.] Review of "Lorenzo Lotto: An Essay in Constructive Art Criticism." *Athenaeum*, April 13, 1895.

Onassis, Jacqueline Kennedy, and Lee Bouvier Radziwill. *One Special Summer*. New York: Delacorte, 1974.

Origo, Iris. *Images and Shadows: Part of a Life*. New York: Harcourt, Brace, Jovanovich, 1970. Reprint ed., Boston: Nonpareil, 1999.

Pater, Walter. *Marius the Epicurean*. Introduction by Osbert Burdet. 1885. Reprint ed., London: J. M. Dent and Sons, 1934.

———. *The Renaissance: Studies in Art and Poetry*. London: MacMillan, 1873. Reprint ed., 1910.

Pope-Hennessey, John. "Berenson's Certificate." *New York Review of Books*, March 12, 1987.

Reitlinger, Gerald. *The Economics of Taste*, vol. 1: *The Rise and Fall of the Picture Market, 1760–1960*. New York: Holt, Rinehart, and Winston, 1964–1965.

Rinehart, Michael. "Bernard Berenson." In Smyth and Lukehart, *Early Years of Art History in the United States*, 89–96.

Roeck, Bernd. *Florence, 1900: The Quest for Arcadia*. New Haven: Yale University Press, 2009.

Rosovsky, Nitza. *The Jewish Experience at Harvard and Radcliffe: An Introduction to an Exhibition Presented by the Harvard Semitic Museum on the Occasion of Harvard's 350th Anniversary, September 1986*. Cambridge, MA: Harvard University Press, 1986.

Rothko, Mark, *The Artist's Reality: Philosophies of Art*. Introduction by Christopher Rothko. New Haven: Yale University Press, 2004.

Rubin, Patricia. "Bernard Berenson, Villa I Tatti, and the Visualization of the Italian Renaissance." In Fantoni, *Gli Anglo-Americani a Firenze*, 207–222.

———. "Portrait of a Lady: Isabella Stewart Gardner, Bernard Berenson and the Market for Renaissance Art in America." *Apollo* 150 (September 2000): 37–44.

Saarinen, Aline. *The Proud Possessors*. New York: Random House, 1958.

Safran, Gabriella, and Steven J. Zipperstein, eds. *The Worlds of S. An-Sky: A Russian Jewish Intellectual at the Turn of the Century*. Stanford, CA: Stanford University Press, 2006.

Saltzman, Cynthia. *Old Masters, New World: America's Raid on Europe's Great Pictures.* New York: Viking, 2008.

Samuels, Ernest. *Bernard Berenson: The Making of a Connoisseur.* Cambridge, MA: Belknap Press of Harvard University Press, 1979.

———. *Bernard Berenson: The Making of a Legend.* Cambridge, MA: Belknap Press of Harvard University Press, 1987.

Santayana, George. *Persons and Places,* 2 vols. London: Constable, 1944–1953.

Sarna, Jonathan D. "The Jews of Boston in Historical Perspective." In Sarna, Smith, and Kosofsky, *Jews of Boston,* 3–20.

Sarna, Jonathan D., Ellen Smith, and Scott-Martin Kosofsky, eds. *The Jews of Boston.* Boston: Northeastern University Press, 1995. Reprint ed., New Haven: Yale University Press, 2005.

Schapiro, Meyer. "Mr. Berenson's Values." *Encounter* 16 (January 1961): 57–65.

Secrest, Meryle. *Being Bernard Berenson.* New York: Holt, Rinehart and Winston, 1979.

———. *Duveen: A Life in Art.* New York: Alfred A. Knopf, 2005.

Seybold, Dietrich. "Berenson and Jean Paul Richter: The Giambono's Provenance." Paper presented at "Berenson at Fifty," October 14–16, 2009, Villa I Tatti, Florence. Forthcoming in Connors and Waldman, *Berenson at Fifty.* Consulted by permission of the author.

———. "The Mysterious 'Donna Laura Minghetti-Leonardo': Re-Opening the Case." Paper presented at "A Market for Merchant Princes: Collecting Italian Renaissance Paintings in America," November 12–13, 2010, Frick Collection, New York. Consulted by permission of the author.

Shand-Tucci, Douglass. *The Art of Scandal: The Life and Times of Isabella Stewart Gardner.* New York: HarperPerennial, 1998.

———. *Ralph Adams Cram: Life and Architecture.* Amherst: University of Massachusetts Press, 1995.

Simpson, Colin. *Artful Partners: Bernard Berenson and Joseph Duveen.* New York: MacMillan, 1986.

————. "The Berenson Scandals." *Connoisseur*, October 1986, 126–137.

Smith, Hannah Whittall. *A Religious Rebel: The Letters of "H.W.S." (Mrs. Pearsall Smith).* Edited by Logan Pearsall Smith, with a preface and memoir by Robert Gathorne-Hardy. London: Nisbet, 1949.

Smith, Logan Pearsall. *Unforgotten Years.* Boston: Little, Brown, 1939.

Smyth, Craig Hugh, and Peter M. Lukehart, eds. *The Early Years of Art History in the United States: Notes and Essays on Departments, Teaching, and Scholars.* Princeton, NJ: Department of Art and Archaeology, Princeton University, 1993.

Sox, David. *Bachelors of Art: Edward Perry Warren and the Lewes House Brotherhood.* London: Fourth Estate, 1991.

Spalding, Frances. *Roger Fry: Art and Life.* London: Granada, 1980. Reprint ed., Norwich, UK: Black Dog Books, 1999.

Sprigge, Sylvia. *Berenson: A Biography.* London: George Allen and Unwin, 1960.

Steegmuller, Francis. *The Two Lives of James Jackson Jarves.* New Haven: Yale University Press, 1951.

Stein, Leo. *Appreciation: Painting, Poetry and Prose.* Introduction by Brenda Wineapple. New York: Crown, 1947. Reprint ed., Lincoln: University of Nebraska Press, 1996.

Stille, Alexander. *Benevolence and Betrayal: Five Italian Jewish Families Under Fascism.* New York: Summit Books, 1991.

Strachey, Barbara. *Remarkable Relations: The Story of the Pearsall Smith Family.* London: Victor Gollancz, 1980.

Strehlke, Carl Brandon. "Bernhard and Mary Berenson, Herbert P. Horne and John G. Johnson." *Prospettiva* 57–60 (1989–1990): 427–438.

Strouse, Jean. *Morgan: American Financier.* New York: Harper-Collins, 2000.

Tharp, Louise Hall. *Mrs. Jack: A Biography of Isabella Stewart Gardner.* New York: Peter Weed Books, 1965.

Thomas, Michael. "Indi(c)ting Bernard Berenson: A Review of

Artful Partners by Colin Simpson." *New Criterion*, March 1987, 66 ff.

Tomkins, Calvin. *Merchants and Masterpieces: The Story of the Metropolitan Museum of Art*, revised and updated. New York: Henry Holt, 1989.

Updike, John. "How to Milk a Millionaire." *New York Times*, March 29, 1987. Review of Colin Simpson, *Artful Partners*, and Ernest Samuels, *Bernard Berenson: The Making of a Legend*.

Vanderbilt, Kermit. *Charles Eliot Norton: Apostle of Culture in a Democracy*. Cambridge, MA: Belknap Press of Harvard University Press, 1959.

Weaver, William. *A Legacy of Excellence: The Story of I Tatti*. New York: Harry N. Abrams, 1997.

Wharton, Edith. *A Backward Glance: An Autobiography*. Philadelphia: Curtis, 1933. Reprint ed., New York: MacMillan, Charles Scribner's Sons, 1964.

———. *Edith Wharton Abroad: Selected Travel Writings, 1888–1920*. Edited by Sarah Bird Wright, with a preface by Shari Benstock. New York: St. Martin's Griffin, 1995.

———. *Italian Backgrounds*. Illustrated by E. C. Peixotto. New York: Scribner, 1905. Reprint ed., Hopewell, NJ: Ecco, 1989.

———. *Old New York*. New York: D. Appleton, 1924. Reprint ed., New York: Simon and Schuster, 1995.

———. *Roman Fever and Other Stories*. Introduction by Cynthia Griffin Wolff. New York: Simon and Schuster, 1997.

Wharton, Edith, and Ogdan Codman, Jr. *The Decoration of Houses*. Rev. and expanded ed. New York: W. W. Norton, 1997.

Wineapple, Brenda. *Sister Brother: Gertrude and Leo Stein*. New York: G. P. Putnam's Sons, 1996.

ACKNOWLEDGMENTS

THIS BOOK IS GROUNDED, gratefully, in the work of many wonderful biographers and art historians. My understanding was shaped by three insightful biographies of Bernard Berenson: those of Sylvia Sprigge, Meryle Secrest, and Ernest Samuels, whose thorough and perceptive documentation of Berenson's life was of great importance to my work. Several conversations with art historians helped me early on, and I want to thank Alan Chong, Patricia Rubin, Dietrich Seybold, and Carl Strehlke for their kindness in sharing their own long-considered views of the figures I've depicted. For wise guidance, and a first chance to present my thinking about Berenson and Duveen, I'm very grateful to Brenda Wineapple.

I was fortunate to begin work on this project after a number of books had newly illuminated the figures in Berenson's life. I am glad to have the chance to acknowledge the work of Heidi Ardizzone, Geoffrey Dunn, Hermione Lee, Ralph Melnick,

Tiffany Johnston, Meryle Secrest, Frances Spalding, Barbara Strachey and Jayne Samuels, and Jean Strouse. In understanding the collectors of the Gilded Age art market, I learned a great deal from the books of David Cannadine, Gerald Reitlinger, Aline Saarinen, Cynthia Saltzman, and Frances Steegmuller.

I am grateful to the staffs at the Houghton Library at Harvard University, the library at the Metropolitan Museum of Art, the Morgan Library, and the New York Public Library. For generosity in permitting me to reproduce and quote material, I want to acknowledge the Beinecke Library at Yale University, the Camphill Village Trust, and, especially, the Isabella Stewart Gardner Museum, where Peter Bryant, Lisa Long Feldmann, and Shana McKenna were extremely kind. My debts at the library and archive of the Villa I Tatti are many, and a pleasure to record: to Joseph Connors, Michael Rocke, and Giovanni Pagliarulo, for a warm initial welcome; to Lino Pertile, for his good offices; to Jonathan Nelson, who drew my attention to important sources and included my work in the exhibition *Berenson and Harvard*; and, finally, to Ilaria della Monica, archivist extraordinaire, for her patient labors and her understanding of the Berensons and their household, which furthered my own.

This book was conceived in conversation with my editor, Ileene Smith; she brought thoughtfulness, perspicuity, and generosity to every aspect of the project's realization. I am grateful to Yale University Press, and in particular to John Palmer, as well as to Laura Jones Dooley, Karen Gangel, Katie Golden, James J. Johnson, and Linda Kurz. Steven Zipperstein, one of the editors of this series, provided kind encouragement and detailed feedback, and an anonymous reader at the press made valuable contributions to the final shape of this book.

Aspects of this book came into focus as I taught seminars on writing lives and writing about the arts with wonderful stu-

dents at Sarah Lawrence College. I'd also like to thank the college for supporting my research with release time. My thinking about Berenson and Duveen was given point in writing about them for the *New Yorker;* my thanks to Henry Finder, Giles Harvey, Ruth Margalit, and Robert Baird. I am fortunate to have Eric Simonoff as my agent.

For wide-ranging conversations about art and personality, I'd like to thank Tara Geer, Jessica Francis Kane, Peter Helm, Lucy La Farge, William Louis-Dreyfus, Peter Parnell, Justin Richardson, Beth Schachter, and Vijay Seshadri. The support of Amy Cohen, Hilary Cohen, Sophie Degan, and Laura Helton has mattered a great deal. Certain of the ideas here, ones about artistic personality and character, grew out of discussions I had with my father, Michael Cohen; there are others that I wish I had had the chance to talk over with him before his death.

As I worked on this book, I had my family's joyful company and steady encouragement. Our little daughter, Sylvia Cohen Boyle, shared her optimism and resourcefulness. And these pages reflect years of conversation with my husband, Matthew Boyle, who helped give conceptual shape to this material at the outset, listened attentively to years of research findings, read this book first, and incisively, and was generous and lucid every day.

INDEX

Page numbers in *italics* refer to illustrations.